BOOKS BY L. JON WERTHEIM

VENUS ENVY
A Sensational Season
Inside the Women's Tennis Tour

TRANSITION GAME
How Hoosiers Went Hip-Hop

FOUL LINES
A Pro Basketball Novel (with Jack McCallum)

RUNNING THE TABLE
The Legend of Kid Delicious,
the Last Great American Pool Hustler

BLOOD IN THE CAGE
Mixed Martial Arts, Pat Miletich,
and the Furious Rise of the UFC

STROKES OF GENIUS
Federer, Nadal, and the Greatest
Tennis Match Ever Played

BLOOD
IN THE CAGE

MIXED MARTIAL ARTS, PAT MILETICH, AND THE FURIOUS RISE OF THE UFC

L. JON WERTHEIM

MARINER BOOKS
HOUGHTON MIFFLIN HARCOURT
BOSTON · NEW YORK

First Mariner Books edition 2010

Copyright © 2009 by L. Jon Wertheim

ALL RIGHTS RESERVED

www.hmhbooks.com.

Library of Congress Cataloging-in-Publication Data

Wertheim, L. Jon.

Blood in the cage : mixed martial arts, Pat Miletich,

and the furious rise of the UFC / L. Jon Wertheim.

p. cm.

ISBN 978-0-618-98261-5

1. Mixed martial arts. 2. Miletich, Patrick Jay, 1968–

3. Martial artists — United States — Biography.

4. UFC (Mixed martial arts event) I. Title.

GV1102.7.M59W47 2009

796.815 — dc22 2008036764

ISBN 978-0-547-24779-3 (pbk.)

Printed in the United States of America

DOC 10 9 8 7 6 5 4 3 2

PHOTO CREDITS:

2008 PAUL THATCHER/*Fight* magazine 2008: Sitting Pat, Friendly Fire, And You Should See the Other Guy, Big Ben, Full Monte, Wrestling Matt, Haute Couture.
MICHAEL FARR: Defending His Honor, Blood in the Cage.
EVAN HURD/Sygma/Corbis: UFC, The Early Days.
TIFFANY BROWN/*Las Vegas Sun*/Reuters/Corbis: Liddell–Ortiz 2.
MICHAEL J. LEBRECHT II/1Deuce3: Octagon Girl, Covering Yourself, Mat-adores, Kiss of the Spider, Ripped and Ready.
INTERNATIONAL FIGHT LEAGUE: Working the Corner, On Guard.

FOR EUGENE M. WAITH

A GENTLEMAN
A SCHOLAR
A REAL MAN
1912–2007

It is not the critic who counts: not the man who points out how the strong man stumbles or where the doer of deeds could have done better. The credit belongs to the man who is actually in the arena, whose face is marred by dust and sweat and blood, who strives valiantly, who errs and comes up short again and again, because there is no effort without error or shortcoming, but who knows the great enthusiasms, the great devotions, who spends himself for a worthy cause; who, at the best, knows, in the end, the triumph of high achievement, and who, at the worst, if he fails, at least he fails while daring greatly, so that his place shall never be with those cold and timid souls who knew neither victory nor defeat.

— THEODORE ROOSEVELT,
"Citizenship in a Republic" speech, 1910

Contents

INTRODUCTION

There is always danger, and I should try not to defend it now, only to tell honestly the things I have found true about it. To do this I must be altogether frank, or try to be, and if those who read this decide with disgust that it is written by someone who lacks their fineness of feeling, I can only plead that this may be true. But whoever reads this can only truly make a judgment when he has seen the things that are spoken of and knows truly what their reactions to them would be.

— ERNEST HEMINGWAY, *Death in the Afternoon*

"LEMME BUST YOUR NOSE."

The cocked fist was a few inches from my face, close enough so that I could see bruised knuckles and fine hairs. Small white bones and squiggly cables of veins protruded from skin pulled tight. Study a fist up close — this ball of fury with its uneven shape and unlikely angles — and it's easy to see why it has caused so much damage over the centuries. Fortunately, this particular fist unballed and dropped when I reasserted my position: no, thanks, I did not want my nose broken.

Early in this project, during the first of what would be many of my visits to Pat Miletich's training gym in Iowa, I spoke with Jens "Lil Evil" Pulver. A charismatic, slightly mischievous, professional mixed-martial-arts fighter, Pulver was curious about my intentions. We spoke a bit. I explained that my goal was to write a book that tried to make some sense of the mixed-martial-arts phenomenon. At one point he turned and asked, "When was the last time you've been in a fight?"

"Twenty years ago, maybe?" I said, unsure. "Eighth grade? That wasn't even really a fight."

Had I claimed to have been wearing fishnet stockings underneath my jeans, it would have been received with the same mix of shock and disbelief. "No, seriously," Pulver said.

"Seriously."

"How can you write about mixed martial arts when you've never been in a real fight?"

I started to explain that participation wasn't essential, that people could be movie critics even if they had never been actors or directors or . . . He cut me off.

"Lemme bust your nose," Pulver suggested, no trace of kidding on his face. Suddenly, one fist was cocked. With his other hand he reached for a clump of paper towels. "Your eyes'll water but you won't bleed that much. And I can reset it, real easy."

Maybe he was joking. I wasn't sure. "Nah, that's okay," I said.

"Come on, I'll just crack it a little," he said. "Then you'll have more appreciation for what we go through. And your friends'll be impressed."

"It's no big deal," another fighter added. "I've had my nose busted a bunch of times and look how pretty I still am."

I declined again, disappointing the small crowd of fighters that had gathered around.

"If you change your mind," Pulver said, "let me know."

If I had lingering doubts that he would follow through, they were extinguished when I returned to Miletich's fighting gym later that night. By the time I had arrived, a few minutes into a typical sparring session, blood was skidding down Mark Holata's face, cabernet-colored at first, then flaming red, and then nearly pink as it traveled south and mixed with his sweat. Bruises expanded under his eyes. A red ring, not unlike one of Saturn's, had already formed inside his left eye. Scrapes mottled his cheeks and chin.

But the real stab of pain came from the heckling. The first rule of this fight club is that you *can* talk about this fight club. Every movement is fair game for discussion and commentary and critique. And on this evening the serenade was deafening. "Finish the round, pussy!" yelled one of the regular fighters, looking over at the carnage as he pounded rhythmically on a speed bag. "Finish the round!"

"Pick up your mouthpiece!" a second fighter bellowed.

"Show that you want to be here," screamed a third. "Show us some balls, big boy!"

Holata did all of the above. And still the ass-kicking continued. The sound of a leather glove colliding with his kidney echoed through the room, the popping *thwaaaackk* resembling the sound from a shot-

gun barrel. Scissoring kicks to his calf made a mockery of his pads, causing him to teeter and drop like a felled redwood. Slowly, gamely, he rose, only to encounter a knee to the nose that unleashed another stream of blood. Another knee to the gut had him doubled over.

It wasn't the pain. Hell, the hurt hadn't registered, at least not yet. It was probably just the spike of adrenaline, but he was feeling weirdly disconnected from his body. No, his real undoing was the fatigue. Holata had figured that he was in decent physical shape. But he was accustomed to training for three-minute rounds, not the five-minute rounds they were now making him fight — particularly not in a room with the thermostat dialed up to 100 degrees, the heat meant to simulate extreme conditions. He was used to taking a few blows, but back home he'd always landed the majority of the shots. Above all, he'd always fought opponents who were equally tired. Here, he kept fighting but his counterparts kept rotating in and out every few minutes. They were fresh. He was sucking air as if it were the most precious commodity on earth. It was all, he assumed correctly, part of the hazing ritual.

Holata's body resembled a lowercase *r*, his legs stable but his thick torso curled in a semicircle with his head below his shoulders. "*UUHHHhhhhhrrrrgggg*," he whimpered meekly. The sound soon died. Even the groaning required reserves of energy he no longer had. Slowly and methodically, his sparring partner* leaned in. He was a big blond kid, with a stubbly face and an abundance of tats, named Ben Rothwell.

While Holata hadn't spoken to Rothwell yet, he'd overheard his strong midwestern accent and the playful lilt of his voice and took him to be a good guy. Now, Holata hoped to hell that Rothwell was nearing to offer a show of mercy, maybe a welcome-to-the-club knock of the gloves or a pat on the back that implied the message *You okay, man? You're one tough motherfucker.*

Holata wasn't quite so lucky. Smiling, Rothwell reached around and starched him with a stiff right jab. The blow knocked out Holata's mouthpiece onto the sweat-saturated mat. "*Urrrgggg*," he moaned again, more meekly than before. Mike Tyson once remarked that "boxing is a hurt business." Watching Holata struggle, it was clear that box-

*"Sparring partner" struck me as an oxymoron, as if the two fighters had the same objective.

ing didn't have a monopoly. This sport — mixed martial arts, or MMA — is a hurt business. The real hurt business.

Holata made it to a back door, practically crawling off the mat. Shafts of light from this hot summer evening in the Midwest poked into the gym as Holata, like plenty of others before him, sought sanctuary from the violence. His stomach reverberated as it tried to puke the carbs he'd eaten for lunch four hours earlier. But his dry heaves yielded nothing but a mouthful of blood-saliva gumbo. "Come on back, big fella," came a serenade from inside. "Who said you could leave? You ain't got more balls than that?"

Holata had fully expected to take a beating in these mixed-martial-arts sparring sessions. A few days before, he had hauled his 260-pound carcass into his truck outside Oklahoma City. Holata and his buddy, Mark Lindsay, himself an old fighter, pointed the truck northeast. They started driving under a big dome of Middle American sky, and ten or so hours later they were in Bettendorf, Iowa, one of the Quad Cities, a cluster of hard-nosed industrial towns — two in Illinois, two in Iowa — that feel more Rust Belt than Grain Belt and straddle the brown of the Mississippi River. Specifically, they were headed to Miletich's gym, Champions Fitness, a low-slung brick building a few blocks back from the river, hemmed between a barbershop, a used-car lot, a gas station selling six varieties of bait, and a bar that offered Saturday-night karaoke. It's at Champions that aspiring mixed-martial-arts fighters come to cut their teeth — sometimes literally. It's where they come to train with Pat Miletich.

As Holata began to drive, he asked Lindsay, his running mate, what he might expect at these sparring sessions. What sort of mental stance should he adopt when pitted against some of the world's most skilled MMA fighters, guys who not only weighed as much as he did but had been in innumerable knock-down drag-outs, some sanctioned, some not? "It's gonna be like nothing you're used to," Lindsay said with a sadistic chuckle. "You're fresh meat. You need to approach every session like you're going into a real fight. They're gonna wanna see what you're made of. These are real tough dudes, Mark."

By any conventional definition, Holata is a tough dude too. A self-

described "country kid from Oklahoma," he has the build of a silo but still looks athletic. He stands nearly six foot three, and most of his 260 pounds are distributed in his barrel chest and Popeye biceps. Half Caucasian, half Creek Indian, Holata had designs on joining the military when he left high school, but he got an offer to go to the University of Tulsa on a football scholarship. By the time he transferred to the University of Central Oklahoma, he was entering strongman contests, bench-pressing in excess of seven hundred pounds. When a shoulder injury stalled his promising weightlifting career, he turned to mixed martial arts. Though he'd never been in a street fight, he was a quick study. His punches packed force and, probably from all those football footwork drills, he had surprising agility.

A few months back, he'd had his first professional cage fight. He needed barely a minute to pummel the other guy. "Just used my striking and pretty much beat the guy up real quick," he said in summary. "It was kinda over before I knew it. I was hoping for more of a test, to be honest." He got paid $500 simply for showing up and another $500 for winning, decent money for a twenty-three-year-old still finishing college. But really, the purse was irrelevant. "I just love fighting," he says, in a voice flavored with an Okie twang, a soft tenor at odds with his hulking physique. "Nothing else gives me that kind of rush, man."

Yet here he was in the back room of this Iowa gym, taking an unholy amount of abuse — absorbing a Holata punishment, you might say — playing the role of mobile home to someone else's tornado. Returning from the back alley, where he sought refuge from the onslaught, if only for a moment, and again lured inside by all that trash talking, Holata stopped in front of an electric fan, sucking in as much cold fresh air as he could. He then lumbered back to the mat. His previous partner, Rothwell, a 300-pound monster,* at the time the star heavyweight for the Quad Cities Silverbacks in the International Fight League, had moved on. The new oppressor was six-foot-seven, 280-pound Brad "the Hillbilly Heartthrob" Imes, a former offensive tackle on the University of Missouri football team, now fighting professionally. After that? Tim "the Maine-iac" Sylvia, a world-renowned fighter

*Like most fighters, Rothwell's "walking around" weight is roughly 10 percent greater than his fighting weight of 265 pounds.

who had been a heavyweight champ until recently, when he'd gotten rocked in a title defense by the mighty Randy Couture.

To the background soundtrack of Kid Rock, Limp Bizkit, Rage Against the Machine,* and other angry male psych-up music, the barrage of elbows and haymakers and leg whips continued. It may have made the odd observer cringe, but the beat-down administered to Holata did little to catch the attention of the thirty-two other fighters on the mat. Directly under an American flag and a U.S. Olympic banner, Pulver was basted in sweat. A few weeks away from a Las Vegas fight that would be carried on national television, Pulver focused on his defensive techniques, hitting the ground and popping back up like that Whack-a-Mole game at the arcade. ("Lil Evil" would end up losing to the great B. J. Penn.)

Drew McFedries, an abundantly muscled African American and one of the few Quad Cities local products, was a week removed from a fight in Florida. He wore a mask of concentration as he fired punches into a trainer's mitt, each blow thwopping thunderously. (McFedries would win that fight with a devastating knockout.) Spencer Fisher, a lithe and deceptively strong lightweight from the sticks of North Carolina, was preparing for a rematch. In the previous fight against his opponent, Fisher was a late substitute and dropped 23 pounds in two days to make the 155-pound weight limit, and he lost a split decision. (He would win the rematch with a unanimous decision.) Ben Uker, once a star wrestler at the University of Iowa, positioned himself in the corner, throwing hundreds of kicks as part of his ongoing attempt to integrate martial arts with his world-class ground skills.

These are men who take the warrior ideal to a new level. Broken bones and pulled muscles are mere annoyances. Those lacking bruises and cauliflower ears are considered social deviants. Imes was sparring despite nursing a bruised kidney. McFedries was fighting despite his Crohn's disease. A lightweight fighter, L. C. Davis turned his ankle during the session and writhed in the corner as if he'd been shot, yet ten minutes later he was back on the mat. Another fighter had contracted a staph infection — the bane of all fight clubs — on his forearm. After applying electrical tape (yes, electrical tape) to the lesion and covering it with a wristband, he continued training. Another fighter had misplaced

*Without a doubt, Rage is the official band of MMA.

his mouthpiece and improvised by jamming paper towels between his cheeks and gums. Their T-shirts say it all: "Pain is weakness leaving the body." "Fighting solves everything." "Fight till you puke."

By extension, a baby-faced heavyweight newcomer from Oklahoma getting roughed up hardly merited anyone's attention. When Holata's session blessedly drew to an end, he shook his head in the manner of a kid who had just stumbled off the world's scariest roller coaster. He'd been battered by the Miletich regulars. But he'd survived. He walked gingerly to the drinking fountain, droplets of blood falling from his face. He was greeted by his buddy Lindsay, who flashed him a look that said, *What'd I tell you, boy?* Holata mustered a faint smile in return. Without exchanging so much as a word with the other fighters, he walked into the humidity of the Iowa evening.

The beating itself carried no price tag. Holata hadn't paid a dime to train at Champions. Under his famed open-door policy, Miletich didn't charge the walk-ins a fee. Nevertheless, Holata had been saving up for this opportunity for months, having taken a menial job lifting vats at a food services plant to fund the trip. He'd graduated from college the week before, and this was his gift to himself. His budget was $800, which evaporated all too quickly, what with criminally high gas prices and a truck that got only twelve damn miles to the gallon. He and Lindsay headed to Chili's for dinner, where they gorged themselves on grilled chicken platters. They repaired to the Heartland Inn, a slightly shabby no-tell motel a few blocks from the Miletich gym. The two Okies economized further by sharing a room, and Holata made heavy use of the motel ice machine, loading up plastic bags in an attempt to soothe his aching body.

But damn, he was going back to the gym the next day. He wasn't a full-fledged pledge brother in the Miletich fraternity yet. Far from it. But he wasn't about to quit the hazing ritual either. "I'm sore but not hurt — they gotta beat me worse than that," he announced. "I guess this is just one more thing I gotta go through if I want to be a fighter in the UFC."

It was the great sportswriter Jimmy Cannon who once remarked that boxing was the red-light district of sports. I wonder what he would

have made of mixed martial arts. In the Ultimate Fighting Championship — the dominant MMA league, the Kleenex to everyone else's facial tissues* — combatants are stripped down to nothing but a pair of shorts, a pair of fingerless gloves, and, at least from this wimp writer's perspective, a pair of testicles the size of cabbages. They enter a steel Octagon, four feet high and thirty feet in diameter, and are called upon to use an expansive vocabulary of skills and techniques to beat the other guy into submission.

The sport — and let's be clear before we proceed: it *is* a sport — can be stupendously violent, marrying the "ground game" of jiu-jitsu and wrestling with the "striking" and "stand-up" of boxing, kickboxing, and Muay Thai. For the most part, though, fighters can be who they want to be, do what they want to do. The grappler can grapple, the kickboxer can kick and box. The jiu-jitsu expert can entwine his body around his opponent and start squeezing like an anaconda.

MMA is, unmistakably, an acquired taste. Pitting two men against each other inside a steel cage carries medieval echoes. *Two men enter. One man leaves.* While MMA is not, contrary to common belief, no-holds-barred fighting, prohibitions such as "No putting a finger into any orifice or into any cut or laceration on an opponent" and "No attacking an opponent under the care of the referee" don't exactly call to mind Marquis of Queensbury rules.

And the action can be gruesome. In the National Basketball Association, at the first drop of blood, a player must leave the game until the wound is treated and stanched. In MMA, blood is so commonplace, it may as well be sweat. In part this distinction is practical: unlike NBA players,† fighters are given extensive blood tests before they're cleared to compete, so one assumes that an opponent is not carrying a disease that can be transmitted through bodily fluids. But there's also a symbolic component to the blood: it's a way to show "what's inside you," a way to demonstrate how real this all is.

*Let's get the disclaimer stuff out of the way: Ultimate Fighting Championship®, Ultimate Fighting®, UFC®, The Ultimate Fighter®, Submission®, As Real As It Gets®, Zuffa™, The Octagon™, and the eight-sided competition mat and cage design are registered trademarks, trademarks, trade dress, or service marks owned exclusively by Zuffa, LLC, in the United States and other jurisdictions.

†See: Johnson, Magic.

Even when there's no bleeding, it's easy to get squeamish. In a fairly representative UFC fight from 2007, a muscled Brazilian heavyweight, Gabriel Gonzaga — at the time the reigning world heavyweight Brazilian jiu-jitsu champion — bloodied the face of his opponent, Mirko Cro Cop,* with a hail of elbow shots. Then, when the fighters returned to their feet, Cro Cop suffered blurred vision. Perhaps sensing this, Gonzaga delivered a roundhouse kick to the head. Cro Cop was slow to react. Gonzaga's bare foot collided with Cro Cop's noggin and instantly knocked him out. As Cro Cop collapsed, his right knee and ankle bent at the kind of hideous angle that recalled Joe Theismann's look-away-gruesome *Monday Night Football* injury. Even hard-core UFC fans recoiled. Those who claim MMA and the UFC represent a stiff blow to the solar plexus of civilized society . . . well, they certainly have fodder.

Yet to others there is something noble and honorable — dare I say majestic? — about the sport. In early 2007, I begged my editors at *Sports Illustrated* for an assignment to let me try and figure out why mixed martial arts and the UFC seemed to be exploding in popularity. My knowledge of the subject was such that when Randy Couture, then the heavyweight champ, visited my office for an interview, I first needed to spark up Wikipedia to match a face with a name. I'd covered plenty of boxing matches and had always taken a libertarian approach to combat sports: if two guys want to fight and are willing to assume the risks, why stop them? Still, like many, I'd reflexively dismissed the UFC as so much cultural rot. I recalled Ernest Hemingway's thoughts on bullfighting before he wrote *Death in the Afternoon:* "I expected to be horrified and perhaps sickened by what I had been told would happen . . . Most people who wrote of it outright condemned it as a brutal business."

I viewed this assignment as anthropology — a neutral examination of the UFC phenomenon and the rapidly expanding MMA subculture, neither advocacy nor condemnation. But that quickly felt dishonest. I came to see how seldom fighters are seriously injured — at the time, no MMA fighter in America had died in sanctioned combat — and how little bloodlust has to do with the exercise. I saw the degree of

*Real name: Mirko Filipovic. When he's not fighting, Cro Cop, a former Croatian anti-terrorism officer, is a member of his nation's parliament.

technical skill. I met with Carlon Colker, a Connecticut physician and physical trainer for dozens of elite athletes, from Shaquille O'Neal to Andre Agassi to Olympic skiers, and listened as he explained: "MMA fighters might not be the fastest or the strongest or the highest jumpers, but on balance they are the best athletes in sports."*

It wasn't just that I was unbothered by MMA; I liked it. And it wasn't that I simply liked it; I found it oddly addictive. Asked to justify the appeal of mixed martial arts to a disgusted spouse, I went through the various explanations about "self-determination" and "redefining athleticism" and "complexity in the simplicity." I explained, "These guys put their asses on the line — literally." I ranted about the hypocrisy of giving a free pass to the National Football League, a sport predicated on violence that encourages concussed players to get back on the field. I rhapsodized that in the UFC there's no ambivalence or spin: there's a winner and a loser and not much else matters. It's a global sport. It combines the raw decisiveness of boxing with an element of social tragedy.

But in the end, the appeal of MMA is more visceral than intellectual. I know that, at least on paper, as a physically unimposing father of two small kids who gets queasy at the mere thought of confrontation, I am *supposed* to be repelled by Ultimate Fighting. I'm *supposed* to cite it as another signpost on the road to Armageddon, another indication of a coarsening of culture. I'm *supposed* to be sufficiently civilized to rail against the human animal. But just as I am supposed to like opera or soccer or French cooking, and simply don't, in my gut I can't muster any genuine outrage for men fighting in cages. Quite the opposite. Sorry, honey.

A friend of mine, a silk-scarf-wearing novelist who lives in London and orders the UFC fights on pay-per-view, makes this analogy: other sports are to MMA what bodice-ripping romance novels are to pornography. "It's complete deconstruction, a stripping away of all pretense. It's the real thing," he says. "You used to wonder what happened when the couple closed the bedroom door or dimmed the lights. With porn,

*Consider this: in the summer of 2007, Johnny Morton, a former NFL star receiver, entered a low-level MMA fight. He was knocked out thirty-eight seconds into the fight and taken to the hospital, where he tested positive for anabolic steroids.

you find out what's behind the veil. In sports, the essence of everything is sheer aggression. In the UFC, we have it."

During my research for this book I kicked this theme around with the UFC television commentator Joe Rogan. A former competitive kickboxer and a stand-up comedian by trade, Rogan has become the UFC's answer to John Madden, a knowledgeable broadcaster as popular as any fighter. He has an explanation that goes even further. "If you really want to be honest, it's super-exciting because it's as close to killing someone as you can get, but because these guys are trained athletes, everyone walks out relatively unscathed afterwards. It's close to primal. There's a part of our genetics that likes watching ultimate competition. When you break it down, what are sports all about? One guy dominating another guy, within a sport." In mixed martial arts "you shed away as much as possible: goalposts, helmets, most rules. The purest form of sport is fighting, and the purest form of fighting is mixed martial arts . . . I can't even watch other sports now. A guy hit a ball over a fence? A guy put a ball through a metal hoop? Big fucking deal. In this sport one guy punches and kicks or knees another guy in the face. No one — no one! — is bored by that. You may hate it and you may fuckin' love it, but no one says, 'Oh well, just another guy getting blasted.' Someone does that to someone else and it has meaning. It's for real!"

Clearly, my novelist friend, Rogan, and I are not alone in this. MMA is for real. It's become riotously popular — the UFC in particular — the biggest phenomenon in sports since NASCAR. In a short span of time, the UFC has gone from an underground pursuit, kept alive mostly as an Internet-based subculture, to a business that Wall Street values (conservatively) at $500 million. The sport has penetrated the mainstream and applied a chokehold to that golden 18-to-34 male demographic. The UFC's weekly reality show, *The Ultimate Fighter,* on the Spike television network, often eclipses the ratings of the NBA and the baseball playoffs in that target audience. More of those young male fans *pay* to watch UFC than watch college bowl games for free.* The names of UFC fighters are some of the most popular entries in Internet search engines. Come fight time, UFC events often do bigger pay-per-view numbers than any pro wrestling or boxing cards.

*In 2007, seven of the top ten highest-grossing pay-per-view events were UFC fights.

The evidence is anecdotal as well. At a recent UFC card, I watched a clot of fans surrounding Randy Couture in a hotel lobby become so thick that he needed to use back doors — at one point cutting through a kitchen, Britney Spears style — to get to his room. Walk around a college campus and you'll see as many kids wearing UFC hoodies as wearing NFL jerseys. Drop the name Chuck Liddell or Anderson Silva around young sports fans and it will carry more currency than that of any major league baseball player.

What accounts for this? We'll start with the obvious: violence sells, and it would be naïve to contend otherwise. One sound bite I heard countless times while writing this book: "If they're playing baseball on one corner, basketball on one corner, football on a third, and fighting on the fourth, want to guess what everyone will watch?" To many, there is simply something irresistible about two men pitted against each other, a sort of referendum on their masculinity. Tied to that, there's the lure of danger. People — particularly male; particularly males of a certain age — tend to engage in risky behavior. It's why roads require speed limits and amusement parks exist and countries can recruit armies. And the danger and recklessness are seductive to spectators as well as participants.

Dismissing MMA as something base and primal, aimed at the parishioners of the Church of the Lowest Common Denominator — sadistic hounds following the scent of blood — is not just simplistic. It's wrong. Fans might watch two guys beat the holy bejesus out of each other on a street corner. But would they become partisan, devoting untold hours to discussing their favorite fighters on message boards? Would they really wear a likeness of a fighter on a T-shirt? Or ricochet around the country to watch his next fight? For that matter, would they pay fifty bucks each time to watch him on TV?

The UFC is singularly well suited to today's vibe. Modern trappings are everywhere in the presentation. The fights begin with pulsating lights, carefully chosen music, and taunting interviews played on the Jumbotron. A sport for the Internet generation, the UFC has spawned a seemingly infinite number of message boards, chat rooms, and fan sites. A reality show, that contemporary touchstone — cleverly branded *The Ultimate Fighter,* or *TUF* for short — has been vital to the sport's

growth and attainment of some legitimacy. As for the actual fighting, it often assumes the feel of a video game, with its spasms of action and multiple ways of winning and losing. In this anyone-can-do-anything YouTube culture, here is a sport with few rules and few barriers to entry. Couture didn't take up MMA until he was in his thirties. Rich Franklin, another popular fighter, was a high school math teacher when he launched his career.

But if the sport is fiercely contemporary, it's decidedly ancient as well. The roots of organized MMA almost certainly can be traced to the hyperviolent Greek sport of *pankration* (literally, "all strength"), first introduced in the Olympic Games in 648 B.C. — according to lore, the Spartans boycotted *pankration* when sissifying rules prohibiting eye-gouging were introduced. In his book *The Naked Olympics*, Tony Perrottet writes that some fights were won when a competitor ripped out his opponent's intestines. Some fighters chose death over surrender.*

Today, old-school sports values play a significant role in the appeal of MMA. There's something brutally, outdatedly democratic about an organized fight. All the more so when you're not restricted to punching. "Trust me, no lies get told when you're in there," Couture told me once as we sat together watching a UFC card. "It's the most honest place in the world."

What's more, fans of the NBA, the NFL, and even European soccer have wearied of watching underachieving, overpaid babies go through the motions, disconnected from their performances. Athletes signed to guaranteed contracts can (and do) dog it and still get paid. In the UFC, no one is half-assing it. Fighters are traditionally paid a flat fee, which doubles if they win. Besides the economic incentive, you don't worry about a guy's "investment level" when he is spitting out his teeth or leaking blood. I once asked a UFC fighter what it really feels like to lose,

*Others contend that the first MMA fight was chronicled in Genesis 32:24, where Jacob wrestles all night with God at Peniel. Despite a dislocated hip, Jacob refuses to submit, and by sunrise he has won the Lord's respect. "And Jacob was left alone; and there wrestled a man with him until the breaking of the day. And when he saw that he prevailed not against him, he touched the hollow of his thigh; and the hollow of Jacob's thigh was out of joint, as he wrestled with him. And he said, Let me go, for the day breaketh. And he said, I will not let thee go, except thou bless me."

to leave the Octagon knowing the other guy was better.* After taking ten or so seconds to reflect on this, he came up with this analogy: "Losing feels like sucking a thousand dicks with your mom watching."

When Jimmy Cannon called boxing the red-light district, one suspects that, beyond the nature of the sport, he was referring to the shadowy cast of characters, the backstabbing promoters and Mob figures seated ringside and the fighters who had sharpened their skills in jail. Not so in MMA. Still uncorrupted by big money (at least so far), the fighters are authentic and accessible. The stars are thoroughly approachable, likely to get carpal tunnel syndrome from signing too many autographs. (UFC fighters are contractually obligated, in fact, to interact with the fans. Those who don't have to answer to the suits.) Chuck Liddell, the popular star, may look like a bouncer at a biker bar, but he was also an accounting major in college. Tito Ortiz, the sport's porn-star-dating light-heavyweight bad boy, is more moody than malicious. The first time I met Ortiz, I asked him for his agent's contact information — standard procedure when dealing with mainstream athletes — to set up another interview. "Agent?" he said, somewhat dumbfounded. "Just take down my cell and call me whenever, dude."

In the fall of 2007, I sat in the Team Quest gym in suburban Portland, Oregon, watching an intense training session. A distinguished-looking woman sat on the folding chair to my left, appearing more than a little out of place. She occasionally glanced up from her knitting to observe the sparring in a makeshift cage where her son, Chael Sonnen, was a few days' removed from a fight in a World Extreme Cage Fighting event. Her take on why MMA fighters tend to stay out of trouble was probably the most reasonable one I heard. "The ones who train seriously — cutting the weight and sparring every day — are too tired," she said with a motherly chuckle. "And the ones who don't train seriously don't make it."

Perhaps the popularity of MMA is a backlash not just against the controversial behavior of Mike Tyson, Barry Bonds, Roger Clemens, Michael Vick, and others, but against society more generally. Aggression has become a bad word, and testosterone a banned substance. Danger

*"I mean, it's not like the other dude needed fewer strokes to hit the golf ball in the cup," I said. "Physically, he imposed his will on you. He made you bleed. He broke you down."

is something to be avoided, aggression something to be neutered. Traditionally manly arts — tracking a deer, fixing an engine, settling a schoolyard feud with fists — are now things to be sneered at. Diving boards and trampolines and riding bikes without helmets and kneepads are forbidden. Competition (even in dodge ball!) can hurt the soul and blunt self-esteem.

Well, MMA is a stiff jab to the overprotective social engineers waging "the war against boys," as a recent book calls it. It's a sport for Hemingways in a culture of Dr. Phils. In the Octagon, no one gives a shit about your satirical blog or the updates to your Facebook profile or your iPod playlist. It's you and another guy fighting. Where else do you find that anymore?

As much by necessity as by choice, most karate dojos throughout the country now advertise that they teach mixed martial arts. Even the U.S. Army teaches it as part of its training doctrine for hand-to-hand combat. "I'm impressed with how many guys know moves before they get here," says Matt Larson, a retired military man who created the Army's hand-to-hand fighting program. "It's just a wonderful training tool for soldiers."

And they're doing it everywhere. MMA might be the most global sport besides soccer — and not simply because fighting is universal. There is a mini-Olympics contained within each MMA fight, Brazilian jiu-jitsu specialists taking on Japanese karate stylists, former NCAA wrestlers taking on Russians originally trained in kenpo. UFC cards have recently been held overseas and, apart from the countless imitation organizations popping up in the United States, there are growing MMA leagues in Asia, Europe, and South America. As I write this, in the winter of 2008, the champions in the UFC's five weight classes include two Brazilians, an African American (who then lost to a Georgia country boy), a Hawaiian, and a French Canadian. When the UFC's colorful president, Dana White, predicts that his organization "is going to be the hugest fucking thing in the fucking world since sliced fucking bread," well, who are we to argue?

For all the fast-spreading appeal of mixed martial arts, you'll find its heart and soul in a boxy gym in small-town Iowa. It's an unlikely cruci-

ble for a sport with global ambitions. But it is here you'll find Pat Miletich, the man who serves as a bridge between the sport's past and future. For most of the 1990s, Miletich staked a claim to the mythical title of Toughest Man in America. Though only 170 pounds, he was a lavishly skilled mixed-martial-arts champion who, just as important, became a legend for his appetite for training and his threshold for pain. When the sport resided in the underground and the UFC was consigned to the margins, Miletich was a cult figure, making more successful defenses than any fighter in UFC history.

Today he trains the next generation of fighters. From Maine to Alaska, and in some cases from overseas, prospects are attracted to Miletich's gym like iron filings to a magnet, sometimes hitchhiking to get there, sometimes selling pints of their own blood to pay for the Trailways bus ticket. As Ben Rothwell, the affable heavyweight, once put it to me, scanning the thirty or so full-time Miletich Fighting Systems members, "If Pat Miletich weren't here, none of us would be here either. If he moved to somewhere else tomorrow, we'd pack our bags, cancel our leases, and go with him."

Miletich has a piece of mashed cartilage for a nose, dense eyebrows, a square jaw, the obligatory cauliflower ear — equal parts badge of honor and fashion statement among MMA fighters — and a dip can all but surgically attached to his hand. Thanks to a bulging disk in his lower neck, suffered while sparring a few years back, he has a hunched walk that fighters joke (never to his face, of course) is a few strides short of an ape's. But if you can imagine Buddha with a chiseled and solidly proportioned physique, that's Miletich. He often sits cross-legged on a gym mat, pensively watching the fighters who have made the pilgrimage to Bettendorf. He speaks in unhurried rhythms, but only when he thinks he has something worthwhile to say. "If you were as tough as Pat," says Rothwell, "you probably wouldn't feel the need to say much either." Fair enough.

Yet Miletich's presence is everywhere. In addition to his reputation as a fighter, he projects a natural authority. Fighters executing that guillotine choke or landing that perfect blow to the kidney reflexively look around afterward, hoping to lock eyes with the master. *Did Pat catch that one?* Years after the fact, fighters still quote his words verbatim: "It's not whether you get knocked down. It's whether you get back up."

When the sparring sessions end, Miletich sticks around, happy to work with anyone whose nose is still attached to his face. Eventually he shuts the door to the "battle box" and heads down the hall to his office, an unremarkable room except for a three-foot-high spittoon. An overhead TV is perpetually tuned to Fox News. The sign on the door reads: "CAUTION, Beatings Likely to Occur Around the Clock." An accompanying drawing shows a man bleeding from the head.

There is a single criterion for training with Miletich: you stick it out. There is an open-door policy: anyone is welcome to descend on eastern Iowa and spar with the regulars. All but a few realize that being a badass in their hometown means little inside Miletich's gym. After being turned into a human piñata and leaking blood (or "mud," in the Iowa parlance) rather than candy, most beat a hasty retreat to Sarasota or Spokane by sundown. Miletich figures that it's basic Darwinism, a natural thinning of the herd. There's no favoritism, no bullshit. The few guys who get sifted out and are ushered into Miletich Fighting Systems are either the best fighters or the toughest guys or both.

In the case of poor Mark Holata, the Okie heavyweight, he gamely returned to the back room of Champions Fitness the day after his inaugural beat-down. And then the next day, and the day after that. The beatings became increasingly less severe, a small, tacit expression of admiration for his fortitude, if not his skills. A few of the regulars even talked briefly with him. At the end of the third day, Miletich sidled up to Holata during a break. "You know, no one here has your strength, big boy," he said. "I'm not going to fill up your head with too much stuff, but keep working hard."

For Holata, this was the equivalent of getting an audience with the Pope. By then, his budget and his body had been severely taxed. And besides, the weather reports indicated that a tornado was a day or two away. He and Mark Lindsay, his buddy, hightailed it to Oklahoma. A few nights later, when Holata was back in tribal housing, I reached him by phone. Had it been worth it spending the better part of a week in Bettendorf? He laughed at the very absurdity of the question. "Hey man, this ain't no hobby. I want to be a UFC champion and I didn't know if I could take it," he says. "Sure I got beat up pretty good. But I hung in there. I feel like I didn't just prove myself. I proved myself in

front of Pat Miletich. In front of Miletich, man. You have to understand, that's like doing something good in front of God."

When I first revealed to friends and colleagues that I was falling hard for MMA, it was as if I had announced I was having a shameful affair. How could I be so disloyal to tennis, basketball, boxing, and the other conventional sports I usually covered? How could I be seduced by this dirty, amoral hooker of a sport that played to man's basest instincts?

Like the fighters I was watching, I countered with an attack that was equal parts offense and defense. When I got some position, as they say, and passions cooled, more often than not I would be asked the following questions: How the hell did this UFC thing ever get so popular? What the hell kind of person decides to be a cage fighter? In the following pages, I'll try to shed some light on both.

1

THE OPENING BELL

HE WHO MAKES A BEAST OF HIMSELF GETS RID
OF THE PAIN OF BEING A MAN. — SAMUEL JOHNSON

"FIGHT!"

"Fight!" "Fight!" "Fight!"

"Fuck him up!"

Pat Miletich wasn't sure what he had done to piss off the bully. But it didn't much matter. Miletich was a scrawny kid with buzzed straw-blond hair, headed home from kindergarten that afternoon in the early 1970s. He had entered the world in September 1966 with his fists balled. But he had never thrown a punch in his life when John McCutcheon, a bigger kid with bigger self-belief, attacked him that day. Hurtling himself at Miletich like a human blowtorch, McCutcheon tackled his victim and they both hit the ground.

"Fight!" someone yelled again, a universal siren song, luring the voyeurs. Instantly the other kids formed a circle around the combatants, creating the effect of a small arena. McCutcheon, the son of a wrestling coach in Bettendorf, Iowa, had clearly been taught a few moves by the old man. He overwhelmed little Pat and was soon mounted on top of him, hands whapping like helicopter blades, one big smear of motion. Most of the haymakers carved the air, but a few connected, turning the kid's face flaming red.

Both scared and exhilarated, Miletich finally offered some resistance and tried to escape. But, skinny enough to fit through a sewer drain, he couldn't dislodge the bigger kid. After landing a few more punches, McCutcheon uttered two words that no self-respecting boy in Iowa, the cradle of wrestling, ever wants to hear: "You're stuck." It's wrestling's equivalent of "checkmate." Flat on his back, Miletich nodded in reluctant surrender, a way of acknowledging the other kid's physical superiority. Uncle. Mercy. I give. He had just tapped out.

McCutcheon walked away sneering, trying to wipe the grass stains from his jeans before he got home. The classmates who'd crowded around to watch scattered. Beaten and, worse still, humiliated, Pat Miletich had just been in the first fight of his life. It was not a promising start to what would become a gilded career in the combat arts: his record stood at 0–1.

Even so, there had been something indescribably thrilling about the experience. It was weird. Miletich had wrestled with his three older brothers and been roughed up pretty good by them. But this was different. It was real. All sorts of new chemicals — adrenaline, testosterone, endorphins, cortisol — sped through Miletich's fifty-pound body. As he walked the rest of the way home to the family's small, single-story house above the Mississippi River, in what was surely the hilliest neighborhood in all of Iowa, he replayed the fight over and over in his head.

In the years to come, the kid's curiosity about fighting would be fueled at family gatherings. The Miletich clan had come over from Croatia at the turn of the twentieth century, leaving the mines of the Adriatic Coast for the mines of southern Iowa. The brother of Pat's grandfather, John Miletich, was a free spirit who left Iowa to work in the Detroit auto plants. Of modest height but endowed with a thick chest and a pair of logs for arms, "Uncle Johnny" would fight carnival strongmen for fun. During the Great Depression, he made extra money by entering boxing cards. A purveyor of violence under the nom de guerre of "John Miler," mostly so his mother wouldn't catch wind of his moonlighting, John Miletich won club fights around the Midwest. By 1935 he was a full-fledged pro, narrowly losing a ten-round decision to Maxie Rosenbloom for the light-heavyweight title. He later served as a training partner for the Italian behemoth Primo Carnera. As a newspaper once reported from one of their sparring sessions, Miletich/Miler "put enough leather in Carnera's face to shoe the entire Italian army."

At family get-togethers, Pat would seek out Uncle Johnny, who'd entertain the kid with fighting stories and show him the basics. *Cock your fist like so. Duck under and counter with the left. Don't lead with your chin.* Above all else, Uncle Johnny impressed upon the kid the virtue of competition. "The most exciting thing in life is winning," he once said. "But the next most exciting thing is losing."

The talks with Uncle Johnny made for one of the few happy memories from Miletich's childhood. A. J. Liebling once wrote that the boxer Archie Moore was "the product of a fortunate mix of genius and moderate adversity." That's the perfect description of Pat Miletich as well. He was the youngest of five kids — four brothers and a sister — and he reckons that his conception was a last-ditch (and ultimately failed) effort to repair his parents' broken marriage. His father, also named John Miletich, was volatile, complex, and intense. He had dreams of being a football coach, and as he watched games at local fields and on television, images of novel formations and revolutionary offenses would dance in his head. Pat's mom, Mona Miletich, a pragmatic farmer's daughter, figured, quite reasonably, that if her husband fancied himself the second coming of Vince Lombardi, he should have thought of that before there were seven mouths to feed.

So each morning John Miletich went clanking over the metal bridge, crossing the Mississippi River into Illinois. Iowa was an agricultural state, but the Quad Cities were four sooty industrial towns filled — at least at the time — with manufacturing jobs. John Miletich worked at the Rock Island Arsenal, the largest government-owned weapons plant in the country. It was steady, reasonably well-paying work, but it was drudgery. And it wasn't going to help him achieve his goal of working on the NFL sidelines.

At night, John would often drink. Once soused, he'd take his frustrations out on his wife and sons, they say. Pat's older brother John (he defiantly refused to be called Junior) recalls bringing home his ACT exam scores during high school. To his pleasant surprise, they were quite high. "You're not going to college," the father growled, tearing up the papers. Pat watched his dad shove his mother into furniture and heard the accompanying soundtrack of curses and screams. He had watched his brothers as they ate punches, emotionally frozen, unable to bring themselves to fight back against their drunken father. By the time Pat was eleven, his father had moved out, taking up with a woman scarcely older than his own daughter. *American Gothic* this was not.

That Iowa farm ethic imprinted in her DNA, Mona tried to keep the household together. "You make the best with what you got" was her credo. She worked long hours as a nursing director at a public Quad

Cities hospital, on the Illinois side of the river, and made sure the kids had what they needed. Anything beyond food, shelter, and clothes was a luxury, but no one ever went hungry.

Still, she was put through hell, first by her abusive husband and then by athletic, aggressive sons, full of unspoken anger because their father had left them. Even after the wife beater had moved out, violence remained a persistent theme in the house. No guns or knives or gangs. This, after all, was a quiet town in the guts of the heartland in the 1970s and '80s. Just rambunctious, ungovernable brothers, constantly vying for supremacy. Their fighting usually consisted of wrestling moves and not punches, but blood was often spilled. The boys all slept together on bunk beds — having converted the garage into a bedroom they called "the Dungeon" — and if testosterone were crude oil, the Miletich home would have been a gusher. The oldest boy, Bill, picked on Tom, who picked on John, who picked on Pat. "Shit rolls downhill," says Pat. "And I was at the bottom."

Like a lot of rudderless boys, Miletich's salvation came through sports. He wasn't necessarily the fastest runner or the highest jumper. He wasn't the strongest kid or the most agile. He wasn't the biggest. Far from it. Nevertheless, he was a sensational athlete, one of those jocks who was much more than the sum of his various parts. Like a gifted musician, he had a sixth sense for timing and anticipation. He quickly mastered technique. He could throw a tight spiral. He could cast his fishing line into a swift current. He could execute a full nelson. He thrived on pressure, performing his best when the outcome of the competition hung in the balance. He was willing to practice harder than the other kids, pushing his body to places — say, vomiting from outright exhaustion — that few others dared to approach.

Above all, Miletich was tough. Almost cartoonishly so. Even as a wispy kid, he savored the impact that comes from colliding with another body. He was all fight, no flight, genetically incapable, it seemed, of retreat or fear. Given the choice, he would prefer to barrel into a defender than dance around him. And as one childhood friend described it, Miletich didn't just have a high threshold for pain; he was indifferent to it. Injuries that sidelined other kids for weeks didn't keep Miletich out of the game. It was almost as though the hurt failed to register.

Fittingly, his boyhood football hero wasn't a fleet-footed running

back or a polished quarterback. The other kids could admire Joe Montana or Walter Payton. Miletich preferred Jack Lambert, a famously brutal middle linebacker for the famously brutal Pittsburgh Steelers. In one youth football game, a concerned teammate saw blood seeping through Miletich's uniform. "What happened?" he asked. Miletich looked down at the stain. "Not sure," he responded with a shrug, fixing his gaze on the field. "Guess I'm bleeding somewhere."

Though he was one of those jocks who played several sports, Miletich was most passionate about football. As an eighth-grader in Midget Football — Iowa's politically incorrect name for Pop Warner — he was a star quarterback on a team that went 12–0 and surrendered just two points the entire season. The team's coach? A local man named John Miletich, who seldom let on that he was the quarterback's dad. The coach was a bit of an odd duck, drawing elaborate chalkboard diagrams and running advanced veer offenses and wishbone formations. The coach thought of his son as a player. The son thought of his dad as a coach. "Practice would be over," recalls Pat, "and I'd go home to my house and he'd go home to his."

The closest thing Iowa has to a professional sports team is the University of Iowa wrestling program. That was particularly true when Miletich was growing up. The iconic Hawkeye was Dan Gable, the coach of the team and perhaps the greatest amateur American wrestler who ever lived. Under Gable, the Hawkeyes would win the NCAA championships as regularly as corn would get harvested in the fall. Naturally, Miletich wrestled too. He wasn't a typical Iowa wrestler, one of those stocky grapplers — "hammers," they're called — who lack necks and look as though they swallowed a blast furnace. He was too wiry for that. But his agility, his easy mastery of technique, and, of course, his ridiculous toughness served him well. He also liked the concept of an individual sport. There was accountability. No teammates to rely upon, no cold-shooting point guard who could lose you the game, no star running back to siphon the glory of victory. There was nowhere to hide in wrestling, and that suited Miletich just fine.

One night when Pat was fourteen, his brother John came home drunk. "Be quiet," Pat scolded him, "Mom's sleeping." John put his baby

brother in a vise grip of a headlock, the kind that makes you feel your entire cranial cavity is going to explode. Mona Miletich, now wide awake, couldn't break up the fight. So she called the police. When the cops arrived, John charged at them, and one of the officers clocked him with a flashlight. Blood splattered the side of the house all the way to the roofline. John was in his underwear, and it was the dead of winter. Pat charged out of the house, made a headlong dash at the policeman, executed a perfect takedown, and pinned him in the snow, all the while yelling "Leave my brother alone." Both Miletich boys were hauled to jail, the younger one also in his underwear, the older one still leaking blood from where he'd been struck with the flashlight. There was no first-aid kit at the jail, so John was given a supply of Maxi Pads to close the gashes on his head. If nothing else, Pat figured he had some ammunition to use against his brother in the future.

Pat ended up with a year of probation. But that was as much trouble as he'd gotten into as a kid. Tough as he was, he didn't get into many scraps. Having been roughed up so often by three older brothers, he didn't think of himself as much of a fighter. "I knew I was tough in the sense that I had more determination than other kids and could play through pain," he says. "But it wasn't like I went around beating kids up."

And as he waited for that teenage growth spurt — the one he hoped would enable him to stand eye to eye with his brothers, who were all between six-three and six-five — there were constant reminders that he could be dominated physically. When Miletich entered Bettendorf High, a large, sprawling midwestern public school, one bully in particular tormented him. He was a star on the football team, a good fifty pounds heavier than Miletich, and he used the typical tactics to break the kid down — knocking books out of his hands, shoving him into the bank of metal lockers, calling him a pussy, the ultimate insult in the Iowa vocabulary.

After one football game, Miletich went to a party and the bully was there. This time he went beyond slugging Miletich on the arm or insulting his masculinity; he challenged the kid to a fight. As the bully rolled up his sleeves and a crowd massed around the two, Miletich felt that he was left with no choice. Something switched inside him. As rage came surging, he too rolled up his sleeves. When the bully attacked, Miletich

instinctively reared back and threw a punch. For all the time he had spent wrestling, Miletich had never thrown many punches. But the motion seemed natural. He landed a straight right hand that exploded when it connected with the bully's face.

More than twenty years later, Miletich can still recall the punch with absolute specificity. The bully's head snapped back, and a shock of hair flew in the opposite direction. His face was like a cubist painting; the guy's cheek was at an angle with the rest of his features. The kid was probably unconscious as he was falling, toppling backward. He was certainly out cold when he landed. The crowd responded awkwardly, in awe of Miletich, and now a little scared of him too.

Miletich was flooded with conflicting emotions. "I knew I wasn't going to be bullied anymore, at least not by that asshole," he says. But he was slightly stunned by what had just happened. "For all the times I'd fought with my brothers, for all the times I'd watched two other kids throw down, I couldn't recall anyone getting laid out quite like that, dropping almost as if they had been shot."

At the same time, the rush that came from matching mettle with another dude was intoxicating. Winning the fight felt sweet. But, contrary to the cliché, winning wasn't everything. Just competing, just being in the battle, was the real source of excitement.

By the time Monday rolled around and the new school week started, Miletich had achieved new status. Everyone knew this about Miletich: he could beat your ass. Along with screwing the prom queen, cleaning the clock of the rugged senior football player was the kind of conquest that flies at escape velocity through high school gossip channels. Miletich was no longer a scrawny, scrappy kid with a bunch of older, bigger brothers who'd been sports stars. The word was out at Bettendorf High: you messed with him at your peril.

In spite of his modest build — that growth spurt never did come; he topped out at five foot ten — Miletich was an exceptional football player. At the time, Bettendorf High was a football factory that sent players to Division I college programs and sometimes to the NFL. Miletich played varsity for three years. As a senior, he weighed 165 pounds and still managed to become an All-State nose guard. He

routinely lined up against other players who outweighed him, some-times by as much as a hundred pounds, but realized that leverage and technique could offset the difference in body mass. Uniformly, the coaches described him as the toughest and meanest player they'd ever seen.

By then John Miletich had become the offensive coordinator at St. Ambrose University, in the neighboring town of Davenport, Iowa.* He would go to games at Bettendorf High, sit near the top row of the stands, and quietly watch his youngest son. When the games ended, he'd file out with the rest of the fans. Pat knew his dad was watching. Why couldn't he have at least patted him on the back and said "Good game," the way all those total strangers did?

Though Miletich wrestled only as an athletic afterthought — it was a way to stay in shape for football during the winter and spring — he was a force on the mat, capable of imposing his will on most of his opponents. He once wrestled in a tournament in Sigourney, Iowa, and, after pinning an opponent, he looked into the stands to lock eyes with his mother. She was nowhere to be seen. Miletich was upset she had missed his meet. Until a few hours later, when he learned that she'd had a heart attack — the first of many, it would turn out — and didn't want to distract her son. A week later, she had triple bypass surgery in Iowa City.

Around the same time, Pat got a call from his dad's new wife. John Miletich had been diagnosed with cancer and didn't have much time left. Pat never went to see his old man. "He didn't give a fuck about us," he reasoned. "I don't give a fuck about him." He died a few weeks later, never having bridged the gulf with his youngest son. Emotionally, the kid was a wreck. And like the unhappy yuppies in Chuck Palahniuk's book *Fight Club,* Miletich filled the void in his life with violence.

Once, after a party, he was attacked by two kids from a rival Quad Cities high school, brandishing baseball bats. Miletich figured out a way to make them each swing and miss, and then clocked them both. The fight exploded into a full-scale riot; a friend of Miletich jumped in and stabbed one of the rivals with a pitchfork.

*Thanks largely to the team's creative offense, St. Ambrose had one of the highest scoring averages in the country at the time.

Another legend still retold in the Quad Cities: during Miletich's senior year, he bloodied a classmate. The kid returned in his Jeep and tried to run down his tormentor. Instead of running away, Miletich grabbed a handful of rocks. When the kid gunned the engine and headed toward him, Miletich tossed the rocks at the vehicle and darted out of the way. Miletich then stood and beckoned the driver to return. Again the driver bore down on Miletich, who once more chucked a fistful of rocks and spun away at the last minute. "It was Pat Miletich against a Jeep," says Miletich's friend John Sharoian. "We all considered that a fair fight."

Then there was the time Miletich fought five guys at once outside McButt's, a Davenport bar. One guy would charge Miletich, who'd grab him by both legs, lift him up, and slam him to the concrete. With five bodies writhing on the pavement, Miletich gloated. "You idiots! When you outnumber a guy five to one, you come at him all at once. You don't take turns. You gotta —"

His tutorial was interrupted. A sixth member of the posse had run behind Miletich and blasted him in the mouth. Miletich spat his teeth into his hand. Then, like a river breaching its banks, his mouth started gushing. Bloodied and nearly toothless, he turned to his attacker and said just one word, "Run."

The guy took off and Miletich chased him. After maybe fifty yards, Miletich caught the guy and pushed him from behind, sending him headfirst into a parked car. As Miletich went to work the guy over, he felt a firm hand on his shoulder and a piece of metal on his temple. "Police! Get the fuck off him!"

Someone had called the Davenport cops when Miletich had left the bar to start fighting. Now they had him pinned at gunpoint. "That guy just cheap-shotted me," Miletich said, his mouth bloody.

"Don't whine just because you got your ass kicked," the cop said. "You got a choice. Go to jail. Or calm down, go home, and get your teeth fixed."

Miletich picked door number two, and later got fitted for a set of fake choppers, which he wears to this day. But as he walked away from the scene, he screamed at the cops, "I beat up five of his friends and he cheap-shotted me! I *did not* get my ass kicked."

Fighting was a way to transfer anger, an emotion that he had in

abundance. A little of the despair — over everything from his bad grades to his dead dad — trickled out when he fought. It was a rush, too, an experience a hundred times more intense than playing football or even wrestling. There were times when he was so jacked with adrenaline that, after kicking some guy's ass, he'd walk away and vomit. He lost track of the number of times he'd fought in high school, but no one disputes his claim that he made it through with an undefeated record.

In a weird way, for all the blood and sweat and collateral damage, fighting provided some order amid all the chaos. You either got worse than you gave or vice versa. Miletich didn't spend much time examining the morality or pondering the consequences of his actions. Like anyone with an innate talent, he had found something at which he excelled, and he wanted to perform as often as possible. Perhaps trying to rationalize what he was becoming, Miletich always drew a firm distinction between violence and fighting. He wouldn't bully anyone or instigate or randomly attack people. But if someone wanted to engage him willingly, he was happy to oblige. "It's not violence," he once explained to his mom. "It's just a form of competition."

With graduation looming in 1984, Miletich faced an uncertain future. He'd been an indifferent C student, easily distracted and antsy. It wasn't that he was a dumb jock. Miletich was a history buff, happy to devour, say, a book on Sir Edmund Hillary's ascent of Mount Everest. But he had no use for sitting at a desk and learning algebra or chemistry. He was a stubborn kid, not fond of authority. It was hard to blame him. His three older brothers and his sister were now out of the house. And even before her heart attack, Mona Miletich seemed to have burned through her reserves of patience and discipline on her four older kids. Various coaches at Bettendorf High served as surrogate dads to Miletich, but, unable to accompany the kid home at night, they could do only so much.

His hopes of earning a college football scholarship had dimmed. No matter how outsized the player's heart, it is the rare college coach who is interested in recruiting a 165-pound lineman. It burned Miletich that other kids from the area who were less talented but blessed by the genetic gods with 250-pound frames were headed to Iowa and Illinois

and Nebraska to play big-time ball. Meanwhile, he was going to . . . well, he wasn't quite sure. A few small regional schools had expressed interest in giving him a scholarship, but after stringing him along into the summer, nothing panned out. In addition to being freakishly tough, loyal to a fault, unflappable, and resourceful, Miletich was deeply patriotic, and if ever there were a born soldier, he was it. He considered wrestling for the Marine Corps, becoming a Navy SEAL, or emulating his brother Tom and flying jets in the Air Force. Undecided, and lacking an adult to direct him, he never brought himself to enlist.

Finally, he enrolled halfheartedly at Sioux Empire Junior College, in tiny Hawarden, Iowa, clear across the state. Presumably he was there to wrestle, continue his education, maybe transfer to a bigger school if all went right. But he spent his first months drinking and feeding what had become almost an addiction to fighting.* Before the semester was over, when he might well have been expelled for bad grades, Miletich transferred to Kirkwood Community College, in Cedar Rapids, an hour or so from home. His time in Kirkwood was brief too. He was thoroughly uninterested in school, and he had recently watched his brother Bill, who owned a cable contracting business in Texas, cash a check for $80,000. *Hell, Bill didn't go to college and look at him. Why do I need school?* He was on the verge of quitting when his mom suffered another heart attack, this one so severe that she could no longer continue working. With all five kids out of the house, there was no one to care for her. Pat, the baby of the family, dropped out of school and moved back home.

Miletich entered what he calls his "angry years." He worked a se-

*One night, Miletich went to an off-campus watering hole in Hawarden and struck up a conversation with the bartender. Before long, the barkeep was plying Miletich with free shots of Southern Comfort. Miletich stumbled off to the bathroom and, as he passed, a patron who looked like a biker laughed at the way Miletich walked. "Quit dragging your feet like an ape," the man said. Miletich told the guy to fuck off. The guy followed him to the bathroom. Bad idea. Miletich spun, grabbed the heckler by the neck, and broke a toilet with the guy's head. The next morning, Miletich woke up and realized that his necklace was missing. He wasn't sure what had happened but had a vague recollection of being in the bar and drinking too much and then fighting. He returned to the bar in hopes he could retrieve his necklace. Walking in, he saw the owner cleaning up pieces of porcelain. "Hey, I'm looking for part of my necklace," he said. The man stared coldly at Miletich. "Get the hell away from here," he said, "and don't ever come back." "How come?" Miletich asked. "You don't remember? You put a bunch of guys in the hospital last night. And you broke my damn toilet."

ries of menial jobs — bouncer, pouring concrete, puffing his chest as a security guard — in order to pay off utility bills, grocery bills, his mother's medical bills. (He never could grasp how his mother, a saint of a woman, after devoting her life to the health care profession, now had to struggle to pay for her own care.) He was uncertain about everything in life, except for his own toughness.

Miletich's reputation was the stuff of regional legend. He once stared down a bucktoothed goon in a Rock Island bar. The goon shook his head at Miletich, who assumed it was a typical drunken Iowa tough guy with a buzzcut. "You know who you're fuckin' with?" the goon asked. "I'm Pat Miletich, motherfucker."

"Who'd you say you were?" Miletich said, trying to suppress a smile.

"You heard right," he said. "I'm Pat fuckin' Miletich. You're not so tough now, huh buddy?"

Straight-faced, Miletich reached into his wallet, pulled out his driver's license, and flung it at the goon. "Read that." The goon's friends leaned in to read the fine print. "Who'd you say you were again?" Miletich (the real one) asked.

A look of horror and embarrassment etched on his face, the goon tossed the license back. His friends laughed so hard it killed the tension. Miletich simply smiled, shook his head, and walked away without throwing down. "You gonna leave me alone now?"

Usually the fights ended with the other guy skulking off with a bloody nose or a black eye. There were a few close calls with the cops. But Miletich managed to stay out of trouble. When it came to fighting, at least in Iowa, a certain libertarian thinking obtained. If person A attacked person B, there was going to be an arrest and an assault-and-battery charge. If person A and person B fought voluntarily, well, that was different. They both understood the risks, and so long as no one else got hurt and no property was damaged, hell, let 'em fight all night if they want. Which is how Miletich beat up a sizable chunk of eastern Iowa's citizenry without spending a night in jail.

On a sticky summer day in 1986, Miletich scored a ticket and ducked work to attend a PGA Tour event called the Quad City Classic, held at the swank Oakwood Country Club. It was hot. There was a snarl of traffic. All those monied golf fans reminded Miletich of his humble

station in life. He was barely out of the car and already his low-grade anger was bubbling.

On the grounds, he spotted Mark Hanssen working as a security guard. The former center for the football team at Davenport Central, Bettendorf High's bitter rival, Hanssen had lined up against Miletich. Their hatred was mutual. After every play they'd curse at one another and throw in a cheap shot if the refs weren't looking. Now, on this stifling day, they were again in each other's face. Hanssen was on break from Northern Iowa University, where he was the starting center and rumored to be destined for the NFL. Like so many college dropouts who find themselves adrift, Miletich had his high school highlight reel playing on a sort of infinite loop in his head. With nothing remarkable going on in the present and no real plan for the future, he took refuge in the past. His football battles with Hanssen were still fresh. So was the injustice that he'd never grown much, while this lug had a chance of playing in the NFL.

"Fuck you, Hanssen," Miletich muttered as he walked by.

"What's your problem?" Hanssen said, looking straight ahead, his eyes obscured by sunglasses.

"We got some business to finish," said Miletich.

"Where and when," said Hanssen.

They met the following day at Duck Creek Park. In retrospect, they probably could have gotten a pay-per-view special out of it: a top college lineman and NFL prospect pitted against an undersized brawler quickly gaining a reputation as the toughest raiser of hell in all of Iowa. But this wasn't for show. It was for honor. Miletich had called out Hanssen. The code mandated that he either show up or decline to fight, thereby conceding that he was less of a man.

When Hanssen rolled up on his motorcycle, Miletich was already waiting, flanked by his buddies. Yet Hanssen didn't worry about being jumped. This too was part of the code: your pals could transport you to a fight and cheer you on, but they would no sooner jump into the fray than they would wear tutus and dance the mambo. It was man against man, not man against men. Another clause of the code: props that often accompany a street fight today were prohibited — no knives, no firearms, no broken bottles. You might get punched and kicked and thrown to the ground, but you didn't fear getting stabbed or shot.

Without uttering a word, Miletich and Hanssen removed their watches and surplus clothing. Then they kicked off a blizzard of haymakers, thrown with, if not murderous intent, at least with damaging intent. Though he had no formal fight training, Hanssen knew enough to use his weight and size advantage. His strategy was simple. "Grab the guy, throw 'em down on the ground, and start punching," he says. Miletich's fight plan wasn't much more evolved. He'd do what he always did: ambush the guy and start whaling away, eating punches as necessary.

The quicker man, Miletich got off the first clean shot, tagging Hanssen in the face, giving him a shiner (or, as they say in Iowa, "dotting his eye"). Hanssen retaliated, slamming Miletich to the ground and loosening a few of his fake front teeth. After ten or so minutes, both men were bloodied, covered in grass stains and mud, and gassed.

Without exchanging many words — besides the occasional "motherfucker" — they'd had a dialogue, and made a declaration. Miletich was a tough son of a bitch, unafraid to throw down with a football star outweighing him by nearly a hundred pounds. And Hanssen wasn't afraid to brawl with a notorious badass. Now they both knew there was no sense continuing. They looked at each other, nodded slightly, and took off in opposite directions. Their faces may have been landscaped a bit — a bump here, a discoloration there — but their honor was intact.

The next few years, his early twenties, melded into a blur for Miletich. He was working like hell — that work ethic again — mostly so his mother could stay out of bankruptcy. He was pouring concrete one day when he got into an argument with a coworker over whether a karate man could beat a wrestler. Miletich, partial to wrestling, asserted that someone skilled in grappling could drive a martial artist to the mat and work him over. The coworker, a brown belt in karate, fiercely disagreed. "Tell you what," the man told Miletich, reaching into his pocket and pulling out a pass for a free week at his karate school. "Train a few times and then come back and tell me what you think."

What the hell, Miletich thought. He showed up at a traditional Okinawan-style karate school and had to stifle giggles as he bowed to the instructor and learned a series of blocks. By the third day, he was ready to quit and tell his coworker what he thought of karate. Then he

saw an advanced sparring class, a group of experienced fighters, some of them black belts, punching and kicking each other.

Miletich recalled his bar-fighting m.o. He would punch a guy, knock him down, and, if necessary, throw him on his back and start thumping away. This was different: sweeping kicks and spins and slick defenses. Miletich's reputation had preceded him, and the instructor could see him staring at the advanced fighters. "Think you could hang with those guys?" he asked. "Get in there. I'll get you a partner."

Miletich saw that the sensei was pairing him with . . . Mark Hanssen. A knee injury had forestalled Hanssen's football career. He had returned to the Quad Cities and joined the Davenport police force. Still weighing 260 pounds or so, he'd recently taken up martial arts at the suggestion of a field officer. He and Miletich looked at each other and couldn't help grinning. They had beaten the animosity out of one another that afternoon in Duck Creek Park. They bowed and started sparring. Both white belts, they had little idea what they were doing. But they had sharp instincts, natural athleticism, and a willingness to learn. After his initial skepticism, Miletich realized that he was becoming mesmerized by martial arts. The communion had begun.

2

THE SEDUCTION

A JOURNEY OF A THOUSAND MILES MUST BEGIN
WITH A SINGLE STEP. — LAO TZU

MILETICH HAD ALWAYS *played* sports, particularly football. And he had always *practiced* sports, often to the point of sheer physical exhaustion. But he had never *studied* sports. At least not until he was seduced by martial arts and made that Davenport karate studio a second home. Right from the beginning, when Miletich was so raw he may as well have been wearing one of those paper trainee hats, he hung on every word of the sensei, an authoritarian, abundantly muscled black belt whose manner brought to mind the Martin Kove character from *The Karate Kid*.

Plenty of times, class would end and Miletich would stay late to spar with Mark Hanssen or whomever else he could wrangle with. If no one was available, he'd fight the striking dummies. In the main room hemmed with mirrors, and in the dank basement, his body filmed with a second skin of sweat, he would practice and practice maneuvers until they became etched in his muscle memory. He also experimented, treating the dojo as his personal laboratory. *What if I fake shooting low and came with a roundhouse kick? Will that work?* With what little disposable income Miletich had, he bought karate tapes and nearly wore out the buttons of his VCR, breaking down the minutiae and trying to mimic the most nuanced moves.

Miletich may never have been much of a student in conventional school, but at the karate academy he was almost nerdish in his devotion to learning. Martial arts offered history, physics, biology, geometry, anatomy, and philosophy all rolled into one. It also instilled in him the discipline, self-respect, and honor — those concepts he once thought fit for sissies — that had been missing from his life.

The dojo was the kind of storefront that most people passed with-

out noticing its existence. And the interior was nondescript: slats of wood on the floor and lots of cheap floor-to-ceiling mirrors. The décor, if you could call it that, consisted mostly of yellowing posters and fliers for upcoming martial arts seminars and small midwestern tournaments. The instructor was still competing; his trophies were displayed everywhere. In the basement, where Miletich and the other advanced students usually trained and sparred, the smell of sweat meeting wet cardboard hung in the air. In opposite corners stood free weights and some old truck tires — "the poor man's trampoline," the sensei called them — used for agility exercises. The joint was as hot as a kiln.

Yet to Miletich, this low-slung building became his sanctuary, a sort of sensory-deprivation chamber. His life had been a study in chaos. But here in this dingy gym he found order and structure and logic. He finally got a break from all the unpleasantness and noise in his life. As much as he struggled to explain it to his friends and his siblings — "it just makes sense to me" was Miletich's fallback explanation — martial arts fed something in him. In other sports, you wait for the ball to come to you. This was *action*.

And while Miletich was a feared street fighter, that was all instinct. The choreography of brawling was pretty simple: Miletich would find provocation, real or imagined, and suddenly he'd be wrestling and pummeling the snot out of someone. There was no art. No training. No philosophy. No history. It was "Go. Fuck him up. Leave." Martial arts, though, was combat, but with an overlay of civility. Miletich learned to kick and defend and punch and sweep and throw elbows to the soft underside of an opponent's jaw. He also learned that the violence was essentially irrelevant. It wasn't about who was tougher than whom. Hell, half of the black belts had no more intention of testing their skills in the real world than a weightlifter has of lugging pianos for a living. The students simply savored the discipline or the physical workout or the spirituality or the security that came with knowing they could defend themselves. And there was a critical emotional difference. "When I fought on the street, I was angry. I wanted to hurt the other guy," he says. "In martial arts you're not being fueled by rage, you're fueled by the competition, the same way a tennis player or a basketball player is. You're not trying to hurt anyone. That makes all the difference in the world."

Miletich also relished the incremental aspect of martial arts, the

belt system that rewards progress. Bruce Lee once said: "There are no limits. There are plateaus, but you must not stay there, you must go beyond them. A man must constantly exceed his level." This mentality was precisely what appealed to Miletich. Presented with a clear goal, he would act as if his very salvation rested on achieving it. As Miletich progressed, his belts seemed to change color as quickly as mood rings.

When he wasn't working on his kicks or clinches or his spinning backfists, Miletich was displacing huge slabs of iron in the downstairs weight room. He had recognized years before that while he couldn't do anything about his height, he could improve the horizontal axis. With the same intensity he applied to everything physical, he worked out to the point of exhaustion. Sometimes he used free weights; sometimes he used the resistance machines. Regardless, he pushed himself until his muscles trembled.

For most fighters, weightlifting is essentially an offensive exercise: the bigger the biceps and triceps and quads, the firmer the abs and obliques, the more dynamite you can pack in your punches. Miletich realized that adding this shell, this armor of musculature, was really about defense. The sit-ups would pay off when the other guy kneed him in the gut, only to run into an impenetrable surface shaped like an ice cube tray. Likewise, the legacy of that time on, say, the hip sled was not simply a pair of strong legs. It was a slab of muscle that could absorb even the hardest kick.

Though he ran a traditional Okinawan-style school, the Iowa sensei had spent time in Thailand and was particularly drawn to Muay Thai. For hours, a half dozen or so of the most committed students in the dojo slammed and kicked and punched each other and cracked ribs as if they were made of balsa wood. Then they'd return the next morning and do it again. Miletich got beat up plenty. Kicks and punches would connect with his thigh or his arm or his nose. But, as when he played football, the pain was little more than an annoyance, a minor cost of doing business. Looking back, he knew it was an ass-backward way to train, all that sparring with no days of rest in between. He didn't know better. Plus, he was having too much fun.

These sessions took the place of street fighting. Clad in a gi, fighting barefoot on a mat, he was able to offload the aggression and simulate the adrenaline rush he once achieved brawling in the parking lots

and bars and parks of the Quad Cities. He lost that volatility and came to see fighting as an almost spiritual exercise. Besides, street fighting now brought real danger. Not only could a broken hand from a bar fight disrupt his martial arts training for months, he was now capable of killing a man.

Miletich's self-perception was changing. He no longer saw himself as a fearless tough guy. As his black belt confirmed, he was becoming an expert fighter, determined to compete at the highest level. For the most part, he kept these ambitions secret. What self-respecting male over the age of, say, eleven aspires to a career as a professional fighter? The one person who "got" it was his mom. Not least because she'd been a battered spouse, Mona Miletich hated violence. And she was such a traditionalist that, after she and her husband divorced, she never dated again. *That's the man I committed to, period.* But she was nothing if not a pragmatist, and to her it was simple: she loved her youngest son more than she hated what he was doing. This wasn't the line of work she had envisioned for him. But she saw that it made him happy and made him feel alive. And that was good enough.

In 1994, feeling a need to test himself in organized competition, against someone other than a familiar opponent he battled every day, in 1994 Miletich entered an amateur kickboxing tournament in Chicago. He treated it the way a boxing champ would treat a million-dollar title defense, upping the intensity of his training sessions. Other fighters looked on disbelievingly as Miletich sparred in the morning, lifted weights after lunch, ran the roads of Bettendorf and Davenport, and then returned to the gym for a second sparring session. He monitored his diet and his sleep patterns and did without alcohol and caffeine in the weeks preceding the fight.

His first opponent in the kickboxing tournament was an older black belt from Chicago who resembled a casino pit boss, flush with a square jaw and a no-bullshit disposition. When Miletich attempted to lock eyes with his opponent and give a deferential nod of the head, the man looked away. Less than a minute into the fight, Miletich elevated and threw a spinning backthrust, aiming for his opponent's face. His right arm connected with his opponent's forehead, but did so at an

awkward angle. Miletich recoiled, as if he had just touched a hot flame. *Son of a bitch!* He knew right away that he'd just snapped his right arm.

Panic engulfed Miletich. He knew that he had little chance of winning the fight now, and even if he could pull it out, he wouldn't be able to advance to the next round. Breathing heavily during clinches, striking almost entirely with his feet, and throwing no punches with his damaged right arm, he continued. He landed a few swift kicks, and the small crowd, admiring that the scrappy guy with the broken arm hadn't quit — "Jeez, kid, it's only an amateur tournament!" — squarely backed Miletich. Though clearly gassed, he finished the fight, his right arm dangling loosely like a sleeve that needed refastening. When it was announced that Miletich had lost by a split decision, the crowd booed.

As he gingerly changed into street clothes and struggled to stuff his gi into his gym bag, Miletich was livid. Not with the decision. Not with the broken arm, which he would have to either treat himself or pay money he didn't have for a doctor to set — he had no health insurance. Instead, he was pissed off at himself for his reaction during the fight. As he saw it, he had lost his composure when he snapped his arm. The anxiety siphoned all of his energy and fatigued him. All of that damn roadwork for nothing. Even though he scarcely had a mark on his body, he'd lost. Worse, he had convicted himself of cowardice, the ultimate disgrace.

Back in Iowa, Miletich went to a doctor to treat his broken arm. When the bill came, and it was more than $5,000, he laughed, knowing it would be years before he could pay it. "Just add it to the pile," he said to himself, chuckling. It seemed that no matter how many hours he worked, he was chronically short of cash. Miletich still held down three jobs at once. He economized when he could — say, spray-painting his crappy pickup truck himself rather than taking it to a detail shop — but debt never relinquished its grip. He would look at his pay stub and feel his pulse quicken when he saw all the deductions. State tax, federal tax, Medicare. What a scam.

Miletich was too proud or stubborn to file for public assistance, much less accept food stamps. He'd once seen a man in the grocery store pay for steak with food stamps and drive off in a Cadillac. He was so disgusted he couldn't restrain himself: "Looks like welfare is treating you pretty nice."

"Fuck you" was the predictable reply.

Still, Miletich was glad he confronted the man. "I'll hunt for my own food or go fishing every morning at dawn before I take a handout," he told friends. Sometimes, though, money was so tight that, late at night, he'd drive to a grocery store and, instead of parking in the lot, he'd go around back, by the dumpster. Once secure that no one was watching, he'd ferret into the sludge for expired foods. Bologna, cheese-infused hot dogs, Cap'n Crunch cereal, carrots, milk, orange juice. He'd burrow through whatever he could. Then he'd jump in his truck and peel out. Pitted against Miletich's instincts for survival, shame had no chance.

Bad as things were, they got worse on an oppressively hot July night in 1992. Pat and his mom got a call: Bill, the oldest of the Miletich brothers, had been in an accident. Blessed — which is to say, cursed — with the mentality of a riverboat gambler, Bill was only thirty-five, but he'd lived several lives. A millionaire by his early twenties, he'd settled in Texas and lived forcefully. As a kid, Pat recalls his brother gleefully reporting that he had spent the weekend in Las Vegas and returned to Texas with $50,000 in the pockets of his jeans. Then, riding the wave, he'd flown back to Vegas the following weekend and lost it all.

By the early nineties, the one-two punch of gambling and tax trouble had knocked Bill, a high-flying Burt Reynolds look-alike, on his ass. For the first time anyone could remember, he no longer dreamed big. He was back in Iowa, working for Hawkeye Paving, the same company for which Pat worked the hopelessly dull job of pouring concrete. That July night, Bill was putting up barricades on Interstate 35 between Ames and Des Moines when he walked in front of a semi and was struck head-on. He probably died before his body landed in a roadside ditch. It was somehow symbolic that Bill was buried in Pleasant Valley, Iowa, across the river from his father's plot.

The death of his oldest brother — the life force who always seemed to be indestructible — flattened Miletich. He compares it to getting drilled unexpectedly with the most powerful punch ever thrown. He spent the next few months in a thick haze, unable to concentrate on the simplest tasks. Martial arts became his grief therapy. But even at the karate studio, his one safe haven, he only pantomimed kicks and sweeps

and blocks. If he did anything correctly, it was because of muscle memory, not focus. Most nights, Miletich and his mother, both of them too filled with grief to sleep, got out of bed and stared blankly at the TV until the sun came up. "It's gonna be okay, Mom, we're gonna get through this," he said in a voice that suggested he was trying to convince himself. "Somehow it'll all work out for us."

3
THE SECRETS OF
BRAZILIAN JIU-JITSU

WHEN YOU DISCOVERED JIU-JITSU, YOU WOULD
RATHER DIE THAN DO ANYTHING ELSE. — RICKSON GRACIE

IN LATE 1992, Miletich, now a black belt, noticed a flier on the wall of the karate studio. Someone, perhaps with a sense of irony, had printed it on pink paper. The flier featured a crude drawing of one man mounting another. It was adorned with this sales pitch: "Unlock the Secrets of Brazilian Jiu-Jitsu."

The details were at the bottom. Renzo Gracie, of the "legendary Gracie family," would be conducting a daylong Brazilian jiu-jitsu seminar in a few weeks at a martial arts studio in the Chicago suburb of Palatine. The cost was $100 per person.

Miletich had barely heard of Renzo Gracie, much less his "legendary family." Miletich had at least a passing familiarity with Asian striking forms, a byproduct of watching badly dubbed Bruce Lee movies and David Carradine television specials. But he found Brazilian jiu-jitsu to be totally foreign. When the fight moved to the ground, it was as if you were watching a movie that suddenly switched from English to another language. *I'm watching, but I'm not getting it. What the hell's going on?*

In part this was due to pop culture: it's hard to film fighters rolling around on the ground; therefore you didn't find too many jiu-jitsu tournaments on television or many jiu-jitsu movies being pumped out by Hollywood. There is also a cultural divide militating against jiu-jitsu's popularity. In general, when it comes to combat sports, Americans like hard, clean, unequivocal punching. Fighter A and fighter B stand toe to toe and try to incapacitate each other. Jiu-jitsu offers the exact opposite: it's a sport predicated on closing the distance so the other guy can't clock you.

When he served as New York City's police commissioner, Theodore Roosevelt tried to teach grappling to his force. But much later, the sport hardly caught on with the generation of red-blooded Yanks weaned on John Wayne and Steve McQueen movies. As the playwright David Mamet, a passionate mixed-martial-arts enthusiast, once wrote in *Playboy:* "Jiu-jitsu in the main languished in the American imagination as a subspecies of Orientalism, akin perhaps to opium eating, something pursued only after dark and in a part of town smelling of incense."

Nevertheless, Miletich's curiosity was tickled. He knew how to punch and wrestle and kick. But a submission? That was something entirely new. He'd tried to teach himself a few basic chokes and armbars, but nothing much ever came of it. If nothing else, jiu-jitsu appealed to Miletich in theory. It was supposed to be the "equalizer," the discipline that enabled a man to offset the physical advantage of a bigger opponent. When you're as tough as they come but only five-ten, 165 pounds, and have been body-slammed by heavyweights — starting with your brothers and moving on to your best friend — a fighting style that empowers the underdog sounds ideal.

"You see this?" Miletich asked Mark Hanssen, pointing to the Gracie seminar flier.

"Yeah," Hanssen said. "Want to go?"

"Yeah," Miletich said with a shrug. "Not sure where I'm gonna get the money, but why not?"

Jiu-jitsu is often portrayed by the media — and, naturally, Hollywood — as the epitome of violence. The uninitiated hear about submissions and "chokes" and they think of strangulation, of one guy crushing the other guy's windpipe. In fact, it's based on defense more than offense. Thumbing its nose at brute force, jiu-jitsu uses leverage and angles and techniques to offset a disparity in size. Maneuvering almost entirely on the ground, jiu-jitsu grapplers wriggle like eels to avoid danger and lure opponents into traps. They win not by pyrotechnics — the concussing roundhouse kick or the atomic knockout punch — but by putting pressure on key joints or applying various chokes.

Even the chokes, if not benign, are not as dangerous as one might think. In jiu-jitsu, a choke is designed to put pressure on the carotid artery, cutting off the blood supply — and thus oxygen — to the brain, resulting in unconsciousness. (Applied properly, this can be achieved with as few as two fingers.) In most cases, not much pain is involved, and when fighters are caught in an untenable position, on the verge of being choked, they simply "tap out," banging the ground as if to say "mercy."* If anything, the fighter who is overcome by so much hubris and immodesty that he allows himself to be "put under" is accorded the shame.

Though jiu-jitsu began in India roughly two thousand years before migrating to China and Japan, the Brazilian variety is relatively new. It traces its roots to the early twentieth century. In 1914, a Japanese jiu-jitsu master, Mitsuo Maeda, descended on the port city of Belém, Brazil. There, a wealthy power broker and dynamite wholesaler, Gastão Gracie, helped Maeda establish business ties and become a consul. Owing Gracie a debt of gratitude, Maeda offered to teach Gracie's son Carlos the rudiments of jiu-jitsu. Not unlike Miletich — only sixty or so years earlier — Carlos was an aggressive, undersized kid with a hair-trigger temper. Though hardly physically imposing, he was happy to fight all comers, never mind that he had little technical skill to complement his toughness. (He came by his belligerence honestly: local lore has it that Gastão blew up the electric company when his power was cut off in a billing dispute.)

Carlos took to jiu-jitsu immediately, spending the bulk of his waking hours slithering on the ground. He especially liked the intellectual challenge of a sport invariably described as "human chess." Every move had a natural countermove. Think multiple moves ahead of the opposition and you'll win every time. Within a few years, Carlos started adding his own twists to the Japanese-style basics. He enlisted his four brothers as crash-test dummies, so to speak, and experimented with their bodies.

*Roberto Duran might have said "No mas," two words that, sadly, came to encapsulate his fighting career more than any accomplishment in the boxing ring. To some, that one remark unfairly branded him a coward for life. Likewise, the image of Sonny Liston quitting on his stool against Muhammad Ali (then Cassius Clay) in 1964 is forever burned in the memory of fight fans. A jiu-jitsu fighter who taps out suffers no such loss of honor.

In time, they too mastered the technique. Carlos then had an inspiration: why not turn this ground-bound martial art into bona fide competition?

In the twenties, Carlos moved to São Paolo and brought his unique fighting style with him. He stood only five foot nine and weighed perhaps 150 pounds soaking wet. No matter. He believed he had the key to winning any fight. To prove his point, he issued what would later be known as the Gracie Challenge, placing an ad in the national newspaper, *O Globo:* "If you want to get your face beaten and smashed, your butt kicked, and your arms broken, contact Carlos Gracie" at such and such an address.

The contests were *vale tudo* style, Portuguese for "anything goes," the Brazilian version of no-holds-barred. With the exception of eye-gouging and fishhooking, challengers were free to punch or kick or head-butt, anything they pleased. The purpose wasn't to invite brutality; it was simply to demonstrate the superiority of jiu-jitsu. The rationale was simple: most fights end up on the ground anyway, so if you're armed with intricate maneuvers, once you hit the canvas (or pavement) you'll be fine.

Carlos never lost. He beat the boxers by getting them on the ground — taking a punch first, if need be — and pretzeling them into submission. He beat the kickboxers by taking advantage of their instability and shooting for their legs. He knew how to neutralize the moves of the conventional wrestlers. Perhaps the easiest prey were the martial artists, who had no idea how to escape armlocks and chokeholds.

Carlos's brother Helio, twelve years his junior, was a frail, sickly kid prone to dizziness. He'd walk up a flight of stairs and faint when he reached the top. Against his parents' orders, Helio joined his older brother in jiu-jitsu. Watching from the sidelines, he had observed its intricacies and felt that by adding a few twists he could improve his precision and leverage and timing. (He would later characterize his improvements to jiu-jitsu as "shooting someone with a shotgun versus shooting someone with a sniper rifle.")

By the time Helio was a teenager, he'd become his big brother's equal. In one *vale tudo* fight, Helio applied so much pressure to his opponent's kidney that the man died shortly after the bout. In the 1930s a

rival teacher accused the Gracie family of fixing the outcomes of its fights. Helio confronted the man in the street and broke several of his ribs before the police could pry him off. The Brazilian president, an admirer of the Gracies and their homegrown jiu-jitsu, not only commuted Helio's thirty-month jail sentence but pardoned him too.

Helio is also said to have challenged a number of boxers, including Joe Louis and Primo Carnera, to a *vale tudo* fight, but none ever accepted. Helio, it should be noted, stood five-eight and weighed 135 pounds in his prime. Another story from the compendium: one night Carlos and Helio returned home to find a burglar crouched in their bedroom. They pinned the man against the wall and gave him a choice: he could either fight them or go to jail. The man opted to fight. Within seconds, a keening scream echoed through the neighborhood: "Jail! Jail! Jail!"

When they weren't choking out opponents, the Gracie brothers were siring children, particularly Carlos, who had twenty-one kids. The branches of the family tree resembled nothing so much as an Amazon rain forest. Obsessed with the letter *r,* they gave all their male children names beginning with that letter, pronounced like an *h* in Portuguese. The Gracie issue included: Ralf, Reila, Relson, Renzo, Reylson, Reyson, Ricardo, Rickson, Rilion, Robin, Robson, Rocian, Rolange, Rolker, Rolls, Rorion, Rosley, Royce, Royler, and Ryan. More important, each was weaned on jiu-jitsu.

By the middle of the twentieth century, the Gracies had become the Kennedys of jiu-jitsu, a dynastic (and sometimes feuding) clan that became a subject of endless fascination for the locals. Brazilians placed a high premium on machismo, so an extended family of ass kickers was accorded royalty status. As the story goes, one aspiring jiu-jitsu fighter tried to legally change his surname to Gracie just so he would be associated with the family.

Like missionaries, the Gracies began leaving Brazil for the United States in hopes of spreading the gospel of jiu-jitsu to the heathens. Some members of the clan — notably Helio's son Rorion — immigrated to Southern California. A lawyer by trade, Rorion realized that the Gracie myth had achieved maximum currency in Brazil. It was the late 1970s, when Americans worshiped Bruce Lee and Rambo and Chuck Norris,

and he figured there was a jiu-jitsu boom waiting to take root. "A real fight isn't Bruce Lee kung fu," Rorion told anyone who'd listen. "It's about knowing what to do when the fight reaches the ground."*

Meanwhile, Renzo Gracie, a descendant of the paterfamilias, Carlos, set up a base first in San Diego and then in New Jersey, but mostly he barnstormed the country giving seminars. So it was that he ended up at a charm-deprived martial arts studio in the Chicago suburbs one cold Saturday in 1992. Wearing a gi and a wide smile, Renzo, then in his late twenties, extolled the virtues of Brazilian jiu-jitsu before fifty or so midwestern martial arts enthusiasts. In heavily accented English he explained how technique conquers all. How the slightest leverage to a joint or bone can induce submission from the biggest bully. How immobilization is the antidote to force. How the philosophy, inseparable from the moves, is the key to happiness.

There were a few skeptics in the crowd, Miletich and Hanssen among them. They took one look at Renzo Gracie and simply couldn't believe he could "destroy Mike Tyson," as he matter-of-factly stated. The guy was no bigger than Miletich, south of six feet tall and maybe 165 pounds. He looked fit, but he wasn't bulging with muscles. His arms

*In the 1990s, submission fighting was slowly coming into vogue in American martial arts. One story that made the rounds of many dojos became a more convincing advertisement than any marketing campaign. Gene LeBell, a legendary stuntman and no-holds-barred fighter, was known as the Godfather of Grappling. In the early 1960s, he'd taken on heavyweight boxer Milo Savage and choked him out in the fourth round. Even at 160 pounds, "Judo Gene" fought as a heavyweight. In Hollywood, he appeared in nearly a hundred episodes of *The Fall Guy,* and in a triumph of cinematography he threw a chair at himself in *Raging Bull.*

In the early nineties, he was working as a stuntman on the Steven Seagal movie *Out for Justice.* During the fighting scenes on the set, Seagal had supposedly been rough with the stuntmen, aware that, as the movie's star, no one was going to lodge a complaint. Between takes, Seagal boasted that he held a black belt in aikido. A stuntman pointed to LeBell, then pushing sixty years old, and said, "Yeah? That old man could choke you out easy." Seagal laughed dismissively, adding that he'd never heard of the guy. Word drifted back to LeBell, and a few days later Seagal joked to him, "Old man, these guys are saying you could choke me out."

"I've been around since the Last Supper," LeBell is said to have responded. "I'm so old, my first movie was *Birth of a Nation.* But could I choke you out? Yeah."

With that, he grabbed Seagal, threw him to the ground, and choked him out. When Seagal came to, he cursed LeBell and told him he hadn't fought fair.

"You ready now?" LeBell said calmly.

Seagal nodded.

were almost doughy. Plus, he was funny and personable and projected nothing close to menace. Then Gracie began to demonstrate his techniques.

He picked a tai chi master from the audience. The man came at Gracie with a swooping kick and was soon on his back. Next, a Muay Thai fighter took a swing at Gracie, and suddenly the guy was prone and staring at the ceiling, pounding the mat in surrender before he was put to sleep. Gracie didn't humiliate anyone or flex his muscles, literally or figuratively. On the contrary, he complimented the volunteers and smacked them on the butt. "Zhou might-a had me, but then you gay-va me zhour shoulder, and den all-a I had-a to do was fleep you!" he enthused. "Zhou are really good fighter!" For all his praise, it was clear who was boss.

As they were being twisted and turned, the other fighters could scarcely grasp what was happening — both the blessing and the curse of Brazilian jiu-jitsu. It was essentially a foreign language. While those with training had a magic set of skills, those without fluency were thoroughly lost. Many suspect that one reason jiu-jitsu is not an Olympic sport, despite meeting the basic qualifications, is because it's incomprehensible to most observers. Even if one watches closely, the sport looks like two men writhing and spasming on the ground, seemingly in a faintly homoerotic way, neither man holding an advantage. Until, of course, the loser makes a slight mistake and suddenly appears to be on the verge of dying an agonizing death.

As he had just done, LeBell again lunged for Seagal, pinned him to the ground, and put him to sleep in a rear naked choke. According to one version of the story, while unconscious Seagal lost control of his bowels — having had, quite literally, the shit beaten out of him. LeBell then dragged Seagal to a storage area as the other stuntmen gleefully looked on. When the star awoke, LeBell was standing over him. "You know, you ought to show a little more respect." LeBell never worked on another Seagal movie.

It took several days for me to track down LeBell to confirm all this. Now in his mid-seventies, he still does Hollywood stunt work. That is, when he's not testing motorcycles for Honda. LeBell, in fact, married his wife while doing a wheelie on a motorbike. One voicemail he left warned, "If you call me before ten in the morning, I'll burn your house down. But call as late as you want." When I finally reached Judo Gene and questioned him about the Seagal episode, he was coy. "My mother said if you put someone down to put yourself up, you're a loser. Seagal is a great martial artist and a terrific actor," he said, pausing mischievously. "But there were thirty other guys there you could ask." Did Seagal really leave a loaf in his pants? "I didn't look all that closely," says LeBell. "But [it] happened right after he had lunch."

Though Miletich scarcely knew what Gracie was doing, he was mesmerized by the mix of simplicity and complexity. The actual maneuvers sure didn't look particularly difficult. But it was about the journey, not the destination. It was anticipating moves that enabled Gracie to apply that rear naked choke. It was immobilizing an arm so he could get the guy in his "guard." At one point Miletich turned to Hanssen. "Mark," he whispered, "I'm loving this shit."

Eventually it was Miletich's turn to step up and spar with Gracie. They were nearly identical in build and age, but their fighting styles represented a study in contrasts. Gracie could go on for months without throwing a punch or kick. At the time, Miletich didn't know an armbar from a crowbar. They faced each other on the mat and Miletich, the natural wrestler, took Gracie to the mat and was surprised at how little resistance his opponent offered. Within seconds, he learned that forcing a jiu-jitsu expert to the ground is like taking an alcoholic to the basement of a fraternity. Miletich had committed the grave error of leaving his neck and arms exposed, and with a series of motions that were at once violent and elegant, Gracie soon had his man in a compromising position. It looked as though he was doing a weird variation of the YMCA dance with Miletich's limbs, manipulating them any way he pleased.

Miletich, being Miletich, declined to tap out. Gracie didn't relent, twisting Miletich's elbow to the point of hyperextension. Pain shot up his arm. He turned one way and Gracie applied pressure that only intensified the pain. Miletich turned the other way and Gracie pantomimed a punch to the face, his way of making the point that he had his man checkmated. A smile of resignation on his face, Miletich used his free arm to smack the mat in surrender. Class dismissed.

"Keep practicing, Pat," Gracie said. "Zhou're strawng, man, and zhou have some great fighter's instincts."

Though Miletich was eager to master jiu-jitsu the same way he'd mastered karate and Muay Thai, he was distracted from his studies. In September 1993, he was at home when his mom got a call from John, the brother before Pat. John had three kids and, until recently, a wife. But he'd found the poison of drugs and alcohol years before, and, especially after Bill's death, he'd taken a turn for the worse. John would go for

weeks without checking in and would "forget" to attend family func-
tions. Pat had tried to persuade his big brother to get off what he called
"the road to self-destruction." He'd hear secondhand about his brother
stumbling around downtown or acting crazy at a party. Now, as John
spoke into the receiver, he sounded desperate.

"Um, I'm in jail, Mom," he said.

"How much is it going to cost to bail you out?" Mona Miletich
asked with a sigh.

"It's not really going to go down like that," he said.

On an alcohol-fueled bender, John had armed himself and robbed
a Quad Cities gas station. In retrospect, he can't even recall if he needed
the money for drugs or if he'd simply been acting irrationally on his
high. Whatever, he was identified on the surveillance video, and by the
time he was caught, in the passenger seat of a friend's car, officers had
not only drawn their weapons but pressed them so close to his face that
he could read the small "Made in Austria" etched on the guns. Wisely
suppressing the urge to run, he surrendered.

By this point John had burned through Pat's reserves of sympathy.
Tom Miletich flew down from Minneapolis to attend the sentencing at
the courthouse. Pat, living a few miles away, refused to go. Convicted of
armed robbery, John began serving a twenty-five-year sentence in the
medium-security unit of Iowa State Penitentiary in Fort Madison. The
first such penitentiary built west of the Mississippi, Fort Madison is a
three-hour drive from Bettendorf. But Pat didn't have much interest in
visiting. "God doesn't give us our destiny," he told John. "He gives us
free will to make our own choices. You've been making bad ones for too
long. You cooked your own goose, brother."

4

BIRTH OF UFC NATION

HOW MUCH CAN YOU KNOW ABOUT YOURSELF IF YOU'VE
NEVER BEEN IN A FIGHT? — BRAD PITT, playing the character
Tyler Durden, in the movie *Fight Club*

WITH THE EXCEPTION of an occasional trophy or a new belt, there was no material reward for all the sweat, all the drudgery of repetition that Pat Miletich endured during the early nineties. There were no college scholarships — much less moneymaking opportunities — for no-holds-barred fighters. The local newspaper didn't devote much coverage to, say, kickboxing feats. Not even in Iowa, the country's Fertile Crescent of wrestling, was anyone particularly interested in jiu-jitsu mastery.

Not that Miletich cared. The self-fulfillment and happiness that seemed to elude him everywhere else in life? It came when he snapped off a series of perfect kicks or threw a hail of tat-tat-tat punches at the heavy bag or held a sparring partner in his guard before flipping him and applying a submission hold. Fighting was a constant challenge. It was a process. It was a way of getting to the root of his own self-worth.

In that dingy basement of the karate school, the most advanced students sometimes held no-holds-barred contests. Any combat art was permitted. A karate expert could unfurl a kick and the opponent could counter by slamming him to the mat with a wrestling move. Once on the ground, they might punch each other. There was an unspoken rule that forbade biting or stomps on the head or elbows in the groin. Otherwise, it was anything goes. Regardless of the size of the opponent, Miletich would invariably win these fights. He was a born wrestler but had expanded his combat vocabulary. Like a skilled debater, he had a response to any line of attack. He might force Hanssen, the mountainous ex-football player, into submission one way and then beat the next

comer with a completely different set of skills. He had a natural ability to combine fighting styles in a synergistic way. Little did he know it — hell, the term hadn't really entered the fighting dictionary — but he was excelling at mixed martial arts.

Meanwhile, two time zones and a million cultural miles away in Southern California, Rorion Gracie, the jiu-jitsu missionary from Brazil, was succeeding in his efforts to convert the masses. Martial arts had long been the second most popular sports activity in the world after soccer, and now American kids were becoming fascinated with kung fu. They were destined to be disappointed when they went to the local McDojo and realized that no, they weren't going to be taught how to rip the pumping heart out of the bad guy's chest like Bruce Lee, but at least they were gaining an appreciation of martial arts.

Then Rorion would make the hard sell: "As long as you're interested in martial arts, why not learn the most effective one, the one that transforms the little man into a giant? My father went from being the biggest wimp in Brazil — a kid who couldn't walk up stairs without getting dizzy — into a national hero, a Babe Ruth figure. And it was all because of jiu-jitsu."

For all the Californicators who needed second jobs to supplement their meager acting pay, Gracie had the opposite problem. When he came to California in the late seventies, he opened a jiu-jitsu academy in his garage and paid the bills with a steady flow of Hollywood work. His Portuguese accent foreclosed speaking roles, but he was sufficiently handsome to land gigs as an extra on television shows like *Starsky and Hutch* and *The Love Boat*. Before long, he didn't need to moonlight in front of a camera; he began attracting hundreds of students from all over Southern California. Soon he had to summon his brothers from Brazil to help with the teaching. Fearful that other Brazilians would try to draft off his success, Rorion registered the term "Gracie Jiu-jitsu" with the U.S. Patent and Trademark Office.

Gracie's abundant charm and self-confidence — "I happen to be the best teacher in the world, you know," he still flatly asserts today — helped lure students. But his most effective marketing maneuver came when he held the Americanized version of the Gracie Challenge. Often,

a skeptical new student would approach Rorion with a declaration: "My karate teacher says jiu-jitsu is bullshit and he can kick your ass." Gracie would shrug and invite the teacher to fight him. Every few months, students would line the perimeter of Gracie's garage and watch him take on the boastful karate (or kickboxing or hapkido or boxing) teacher. Invariably, Gracie would manipulate the opponent's body, apply a submission hold, and the fight would end.

The legend of the smooth Brazilian with the funky fighting technique spread through Southern California's martial arts community. It was helped by a series of self-serving videos Rorion produced, *Gracie Jiu-Jitsu in Action,* which began as cult hits and ended up selling tens of thousands of copies. In the late eighties, the kickboxing expert Benny "the Jet" Urdiquez offered to fight Rorion. Urdiquez's representatives made an offer: if Rorion put down $100,000, Benny the Jet would wager his kickboxing belt. "What the hell do I want with a kickboxing belt? I'm no kickboxer," Rorion said. "Tell Benny I'll put down $100,000 if he puts down $75,000." Rorion says he never heard back from Urdiquez.

In 1989, *Playboy* commissioned Pat Jordan to write a piece on Rorion. In an article titled "Bad: Rorion Gracie Is Willing to Fight to the Death to Prove He's the Toughest Man in the West," Jordan asserted that the subject was indeed "the toughest man in the United States [though] he holds no official title."* Not long after the *Playboy* article appeared, Art Davie, a Vietnam veteran and California advertising executive, happened by the Gracie studio. Davie was awestruck as he watched Rorion's brother Royler torment a much larger karate expert. Davie had recently witnessed an underground no-holds-barred fight on a trip to Thailand,

*In addition to boasting about the power of Gracie jiu-jitsu in the *Playboy* article, Rorion revealed some — how to put this? — traditional social views. At one point he exclaimed, "In the Gracie family, the men are peacocks. Women are along for the ride . . . Women become feminists because of men's weakness. Every woman wants her man to treat her like a woman or he loses his position of strength with her. Women are meant to be mothers. Having kids is the only thing a woman can do that a man can't. Most Gracie men do not believe in birth control. We believe sex is a holy thing. For procreation of the species. If [my wife, Suzanne] does not want to get pregnant, we don't have sex. Before we got married, I told her that she was my vehicle for having sons. As many as possible. She said, 'Would ten be enough?' I want to have sons to keep the Gracie myth alive. I want to raise as many jujitsu champions as I can. We are like a family of Magic Johnsons. I told Suzanne that it is possible I may want to start another family, like my father. If I can find a woman with the right karma. But that would be hard. The only thing harder to find than a good woman is a good man."

but this was more exciting. He seized on an idea. What if someone were to hold a sporting contest among experts of the various combat arts? No rules. No weight classes. No rounds. Essentially no-holds-barred, may the best man win.

Recalling the *vale tudo* anything-goes fights in Brazil, Rorion was agreeable to the idea. He also had an ulterior motive: these fights would be the perfect format to demonstrate the superiority of Gracie jiu-jitsu. Rorion and Davie formed a production company, War of the World (WOW), to promote the event and persuaded John Milius, the director of *Conan the Barbarian* and one of Rorion's many Tinseltown students, to join the venture.

As they sketched out a format, Milius suggested that the competitors fight in a pit, recalling the *pankration* of the ancient Greeks. Davie favored a boxing ring surrounded by a moat, perhaps filled with alligators. Then inspiration struck Rorion. Having seen too many fighters in Brazil escape danger by ducking under the ropes of a boxing ring, he suggested that combatants fight in some sort of cage, perhaps an octagonal one.

An informal survey revealed that fighters and fans would be easy to come by. Every boxer thinks he can whip a black belt. Every black belt thinks he can beat up a wrestler. As long as Davie and Gracie could duck the constraints of state athletic commissions, finding a venue wouldn't be tough. Then they needed a broadcast partner. Given the level of violence, it was clear that conventional broadcast and cable networks weren't going to come within striking distance of a no-holds-barred fight held in an octagonal cage. How about pay-per-view? That was another matter.

Enter Bob Meyrowitz, a smart, savvy New York entertainment entrepreneur who first gained prominence by creating the *King Biscuit Flower Hour* radio show in the seventies. Meyrowitz's talent for trend-spotting was such that he had Bruce Springsteen appear on his show before the Boss had cut his first album. In the eighties, he was a pioneer of pay-per-view event broadcasting. As he saw it, pay-per-view was available in twelve million homes, "and so every concert was a chance to hold a concert in an arena with twelve million seats." His first pay-per-view event was an Ozzy Osbourne concert. It was a smash. His next show, featuring the Who, was a fiasco. He'd recently scored a huge hit

with a New Kids on the Block pay-per-view concert. "I would have preferred the success had been with the Who," he says sheepishly. By the early nineties, the company he owned jointly with the BMG music combine, Semaphore Entertainment Group (SEG), was looking for a new, offbeat venture. In particular, he wanted a serialized franchise, a way of promoting the next show from the previous one.

A former competitive boxer, Meyrowitz was speaking one day with a friend who headed the New York State Tae Kwon Do Association. The conversation — which took place on horseback, at a polo match on Long Island — turned to fighting. Meyrowitz asked his friend, "Who could beat up who: a tae kwon do guy or a karate guy?"

"They couldn't even compete," the friend said, confused. "They have different rules."

"You mean, if I got into a fight, I'd have to ask what the rules were, and if we didn't agree we couldn't fight?"

"They're separate sports," the friend said. "The premise is ridiculous. It's not about fighting. You don't understand the beauty."

Meyrowitz wasn't satisfied. At a creative meeting he had told his employees, "Everyone says that music is the international language, but it's not true. For example, no Japanese music comes to America. With the exception of a few giant acts, music is regional at best. But wherever I go, I see fighting. *Fighting* is the international language. The styles might be different but everyone does it. Everyone understands it."

Within a week, another SEG executive, Campbell McLaren, an MIT-educated marketing whiz, tracked down Art Davie and Rorion Gracie. Soon, WOW and SEG were wed. They would coproduce a pay-per-view show and call it *The Ultimate Fighting Championship*. Gracie and Davie would find the fighters and the venue. SEG would take care of the broadcast. Together they would share the proceeds. And so it was that the UFC was born.

The inaugural UFC event was held in Denver, where the state athletic commission was, not coincidentally, notoriously toothless. On November 12, 1993, with the NBA's Denver Nuggets on the road, a motley crew of combatants converged on shopworn McNichols Arena. The field in-

cluded a pro boxer, Art Jimmerson, who was scheduled to fight the great Thomas Hearns the following month; a massive sumo wrestler, Telia Tulia; and a local kickboxer, Patrick Smith, whose record was advertised as 250–0. The promotional material did not exactly obscure the violence. Victory could be attained only by "knockout, surrender, doctor's intervention or death."

No one was quite sure what to expect. No-holds-barred? No weight classes? No judges? Death? No rule against hair-pulling or soccer-style kicks to the head of a downed opponent? *Death?* Still, the novelty of it all helped draw a reasonable crowd, mostly heavy-duty white trash, the curious, and the bloodthirsty. No one, of course, realized that they were attending a seminal sports event; that fifteen years later there would be nearly one hundred UFC cards (and counting), packing tens of thousands of fans into prime arenas and drawing hundreds of thousands of pay-per-view buys. This was more on the order of a one-night-only vaudeville show.

There were the usual opening-night glitches: microphones that didn't work and dressing room doors that had been inadvertently locked. When fighters caromed against the Octagon, as the cage was officially named, the gate sometimes swung open. Bill Wallace, the television commentator, referred to the UFC as the "Ultimate Fighting Challenge" and at one point described the combat arena as "an octagonal octagon." The ring announcer repeatedly called the fighters "contestants," as though it were all some macabre game show.

At odds with the sensationalistic promotion — *death?* — a number of the fights were uninspired mismatches. As a chorus of boos echoed off the many empty seats, it became clear that the prospect of a ponderous sumo wrestler taking on a journeyman boxer was more appealing in theory than in practice. And even the spasms of excitement seemed to come with unintended consequences. In the first fight, Gerard Gordeau, a karate and savate champion from the Netherlands, deployed a roundhouse kick to the face of Tulia. The kick connected with Tulia's jaw and dislodged several teeth. One of them sailed into the audience as a souvenir, the UFC's equivalent of a foul ball hit into the stands at a baseball game. Responding to humane impulses, the referee jumped in and waved off the fight. Technically, however, that wasn't allowed. The only way a fight could end was by a fighter quitting or his

cornerman throwing in the towel — not by referee determination. And neither Tulia nor his corner indicated that he wanted to quit. Confusion reigned in the Octagon before the fight was declared over.*

Only later did the organizers realize that some of Tulia's other chiclets had lodged in Gordeau's foot. As Clyde Gentry III, a historian of the early years of the UFC, noted in his book *No Holds Barred: Evolution,* other fighters in the locker room, who had yet to enter the Octagon, looked on in horror as doctors worked on Gordeau's foot. Although they were unable to dislodge the teeth, Gordeau continued fighting, and, according to Gentry, when he returned to Europe he endured months of treatment to prevent blood poisoning.

In the next fight, a California kickboxing expert, Zane Frazier, took advantage of the lack of a prohibition on hair-pulling and ripped out clumps from the mane of his opponent, Kevin Rosier, a beer-bellied galoot from upstate New York. Frazier also had no reservations about unleashing groin shots. For good measure, he broke Rosier's jaw. Rosier recovered, however. After a few minutes, with both fighters sucking air — their questionable stamina compounded by Denver's altitude — Rosier won with a series of repeated stomps to the back of Frazier's head.

Watching a tape of the fights, one wonders why the organizers didn't line up a sponsorship with Mutual of Omaha. The primal, animalistic, kill-or-be-killed violence was straight out of *Wild Kingdom.* And from the beginning the crowd of 3,500 or so made its lowest-common-denominator sensibilities clear. In one of the early matches Ken Shamrock, a chiseled Californian who was then toggling between professional wrestling and Pancrase, or hybrid wrestling, took on the local kickboxer. Less than two minutes into the fight, Shamrock shot low and executed a heel hook that hyperextended his opponent's ankle and knee. It was a brilliant, slick move but one that yielded no blood. The crowd went ballistic. "They were throwing things at me," Shamrock recalled to a reporter. "They were so mad at me I had a hard time getting out of the arena. Can you believe it? I broke the guy's ankle and they wanted more."

*Ironically, in other fights a jiu-jitsu master might apply intensely painful knee locks and heel hooks and triangle holds. The referee, however, clueless about jiu-jitsu, would allow the fight to continue, even as the beaten man was repeatedly tapping out.

Just as Rorion Gracie had predicted, the event ended up doubling as a sort of infomercial for jiu-jitsu, specifically for Gracie jiu-jitsu. Rorion had selected one of his younger brothers, Royce, to represent the family, and as it turned out, he won the $50,000 purse. Royce had received his black belt in Brazil before he turned eighteen and shortly thereafter moved to California to live with Rorion. Royce taught jiu-jitsu classes — sometimes for ten hours a day — in Rorion's studio. At six-one, 170 pounds, Royce, then twenty-six years old, was the smallest man in the UFC field. But in a theme that would repeat itself in UFC 2, 4, and 5, his grappling and jiu-jitsu skills were insurmountable. Striking skills and muscle mass were of little use when a fight went to the ground. There, Royce would simply manipulate the bigger fighters into unrecoverable positions, and the fight would end.

Critics would later contend that Royce owed his success to the "purposeful mismatches" that Rorion had orchestrated. But on this night, jiu-jitsu reigned supreme. Royce crowed afterward: "It will open everybody's eyes, especially the weaker guys, that you don't have to be a monster to be the champ. You don't have to be the biggest guy or the one who hits the hardest. And you don't have to get hurt in a fight."

Let's be clear: the first Ultimate Fighting Championship was more spectacle than sport, an orgy of violence and generally reckless fighting. After watching the DVD of the fights, even the most zealous fan would have a hard time arguing that the event didn't lower civilization's limbo bar. It could just as easily have been midget-tossing or Jello wrestling.

But this was equally hard to dispute: the UFC was a smashing financial success. With a minimum spent on promotion, 80,000 households — culled from a 12-million-household universe — paid $14.95 apiece to watch this strange curiosity. Given that the first-place prize was only $50,000, the total purse barely $100,000, the production budget roughly $500,000 . . . well, you do the math. "This is going to be absolutely huge!" Rorion gushed to Chris Stone, a cub reporter for *Sports Illustrated* who was covering the event.* "I have no doubt it will overtake boxing and wrestling!"

*Editors at *Sports Illustrated* were so appalled by the descriptions of violence that the story would never run in the magazine.

For the first time in his career as an entertainment impresario, Meyrowitz hadn't attended one of his own shows. He figured he'd be better off staying home and watching the telecast. He, his former college roommate, and the roommate's thirteen-year-old son sat around the television. With no background in martial arts, Meyrowitz was sometimes shocked by the action — not least when Tulia's choppers became embedded in Gordeau's foot. But all three were riveted. And when it was over, the thirteen-year-old was apoplectic. "The Gracies will rule for the next seven years!" he screamed. The kid formed a focus group of one. Meyrowitz knew then and there that he had another phenomenon on his hands.

By that time, plans were already afoot for a second Ultimate Fighting Championship card. Within a few days of the broadcast, nearly five hundred contestant applications poured into SEG's headquarters from guys begging to fight in UFC 2. There were boxers and wrestlers and judo experts, but the majority of the volunteers were simply self-styled tough guys. It was inconceivable to them that there might be a badder dude out there. Especially when the winner was a 170-pound foreigner named Royce — pronounced *Hoyce*, for some reason — who looked like he'd fought in his bathrobe.

One of the applicants was a student of Rorion Gracie, who'd trained with Royce. John McCarthy, a barrel-chested heavyweight, had seen the first UFC and was convinced he could hold his own. But he recalls Rorion telling him, "Only one of my students can enter, and it's going to be my brother." Rorion, though, had another offer for McCarthy. He had been disappointed with the refereeing of the first UFC card. "Why don't you be the ref?" Rorion asked McCarthy.

"I've never done it before," McCarthy said.

"You know fighting," Rorion shot back. "And besides, the refs don't stop the fights anyway."

There were a few changes in the ensuing UFC events in 1994 and 1995. Fighters were eventually allowed to use gloves — not to protect the opponents' heads, but to prevent the tiny bones of the hand from breaking. Fishhooking was allowed. Groin shots were permitted after fighters complained bitterly that if they had been allowed to strike their opponent in the groin, it would have changed the whole match. Then, later, groin shots were made illegal again.

But the spirit of no-holds-barred prevailed. Perhaps most disturbing was the policy that a referee couldn't stop a match. Before matches, some fighters went so far as to tell their corners, "If you throw in the towel and stop this thing, I'm gonna beat your ass."* That left it up to the fighters, who sometimes took so many blows they weren't able to remember their names but nevertheless refused to quit. "That was all Rorion," says McCarthy. "Rorion didn't give a damn about anyone besides his brother. He knew Royce knew what he was doing and would be okay. He didn't care about the guys who were taking so many [shots] they didn't know where they were."

Not that Rorion Gracie was alone. No one at the UFC thought he was creating a new sport. The organization simply believed it was offering an entertaining platform for fighters in various combat sports to compete against each other on an equal footing. As a result, there was little apology about peddling violence. From Rorion Gracie's point of view, the absence of rules and weight classes was essential for emphasizing the virtues of jiu-jitsu. "The whole point was to show that size doesn't matter when you know jiu-jitsu," he says. For the other executives, the lack of regulations was essential to the marketing. In his role as UFC "commissioner," Art Davie would tell anyone who'd listen that Ultimate Fighting spoke to something primal in people. "In Western culture we look for the 'it' girl, whether she's Marilyn Monroe or Madonna," he explained to a British reporter. "And we also look for Superman. We want to know who the toughest man in the world is."

If hyping the violence and gore was morally questionable, the organizers saw it as essential to the UFC's survival. When combat sports didn't hype the bloodletting, they were doomed. Some world championships — world championships! — in judo and Greco-Roman wrestling drew crowds of a few hundred. The fans attending most professional kickboxing events in the United States could gather comfortably in a phone booth. If the UFC didn't market sensationally, it feared the same fate. When McLaren was grilled by a reporter in 1996 about Ultimate Fighting's growing reputation for barbarity, he shot back: "So what? It's good publicity."

*According to McCarthy, in one instance a fighter's cornermen tossed a towel into the audience beforehand to show that they weren't going to intervene.

Remarks like this, it would turn out, foreshadowed trouble. They almost dared the public to voice disgust and outrage. And these sentiments also revealed a disconnect between the UFC's executives and the product. It was a strange mix. The brass were well-educated, slick marketing types who sometimes seemed to regard their venture with a sense of the surreal. It was a fun cocktail party topic — *You wouldn't believe this crazy-ass cage-fighting shit I invested in!* — at their country clubs and Manhattan expense-account lunches. They were perceived as wine drinkers peddling moonshine.* Initially, anyway, the executives conceived of the UFC not as a sport but as a moneymaking entertainment venture. Royce Gracie or Ken Shamrock might as well be Ozzy Osbourne or a hot new boy band.

Eventually, as some of the suits became more deeply involved, amusement gave way to passion. When Bob Meyrowitz, for instance, witnessed the fighters train and perform, he grew to respect their athleticism. When he spoke to them, he grew to respect their intelligence and commitment. And for a guy who traveled with rock stars — he claims to have once bailed the Who's drummer, Keith Moon, out of jail when Moon was wearing a see-through nightgown — Meyrowitz had a high threshold for awe when it came to off-color fighter behavior. "These guys were great athletes, but also great guys," he recalls. "People assumed they were mean and nasty. Then they'd meet them and immediately think the opposite. To me, it was a great product from the start. If I thought it was wrong, I wouldn't have done it. But I completely believed in the righteousness of Ultimate Fighting."

For other employees, Ultimate Fighting was, shall we say, an acquired taste. In the winter of 1994, Bruce Beck sat in a UFC television production meeting. Beck was a freelance sportscaster who'd hosted Showtime's *Championship Boxing* and done play-by-play of Golden Gloves events. His agent had just landed him a gig covering a fledgling sport called Ultimate Fighting. The plan was for Beck to pair with former Olympic gold medal wrestler Jeff Blatnick and lend a dignified, authoritative voice to proceedings that were too often lacking in both dignity

*Imagine, perhaps, a group of wealthy French investors running NASCAR.

and authority. Jim Brown, the NFL legend and black activist, was signed on as a sideline announcer.

At first Beck had misgivings about the whole enterprise. But, hey, it was paid work. Keeping an open mind, he listened as UFC officials explained the rules and regulations, such as they were. After the bit about no biting and eye-gouging and fingering open lacerations, he waited for the other prohibitions. And waited. And waited. "At least," Beck thought, "it must be hard to cheat in this sport."

Though Beck accepted the job as the pay-per-view broadcaster, he never grew completely comfortable with the spectacle. One of his first fights was UFC 6, dubbed "Clash of the Titans," a fairly typical early UFC card, held in July 1995 in Wyoming, a state that lacked a credible boxing commission. In keeping with the western frontier ethos, the promoters went to extreme lengths to play up the violence and the lack of regulations. Standing before the Octagon's chainlink fence, Blatnick dramatically locked the gate and stared into the camera. In an ominous voice he said: "There's no place to hide. You walk in alone, fight alone, and — hopefully — walk out alone." In front of a crowd that was almost exclusively male and exclusively white,* Michael Buffer, the comically over-the-top ring announcer, intoned: "There are no weight classes! There are no time limits! There are no rules!" Beck was quietly saying a prayer, hoping that no one would die during a bout.

As usual, the combatants were a mixed bag of legitimate martial artists and random tough guys, who looked like they could do some damage in a street fight but wouldn't know an armbar from a strip bar. Beck recalls that fighters without formal martial arts training were quickly and arbitrarily assigned a discipline. "It was like, okay, you're a trapshooter, or you're a pit fighter," he recalls. "No one bothered to ask what exactly a pit fighter was, because no one really knew."

The card was refereed by John McCarthy — now "Big John" Mc-Carthy — who had proven to be an invaluable employee. McCarthy possessed a sixth sense for knowing the fighters, their skills, their pain thresholds, their personalities. He had also persuaded the organizers to permit the referee to stop fights, starting with UFC 3. Particularly in the

*Leon Spinks, the tooth-deprived former boxing champ, was a notable exception.

early days, it's no exaggeration to say that he saved lives with his sensible stoppages.

The cult star of UFC 6 was David "Tank" Abbott, a 280-pound Californian who would become a seminal figure in the UFC. Abbott had a chest the size of a refrigerator, a bald head adorned with a goatee, and a lengthy criminal record, mostly for assault and battery. He declared himself "a master of the ancient martial art of kicking ass." Already a minor legend in Southern California for his alley fighting, Abbott had caught the eye of Art Davie. A 1996 *New York* magazine article, "Getting Medieval: Ultimate Fighting, a Simply Barbaric New Sport, Is Ultimate Proof the Civilization Is Dead," recounted the meeting between Davie and the fighter. Davie had said, "David Abbott is the name of a liberal arts professor at Muehlenberg College. We're going to call you Tank."

Which was fine by Abbott. Tank knew instinctively that the UFC cast — like the cast of professional wrestling — needed heroes, yes, but so too did it need villains. Though he was a college-educated history buff more than capable of holding an intelligent conversation, he played the UFC bad-guy role with great enthusiasm. Abbott was known to prank-call fighters at an ungodly hour the night before a fight and tell them the rules had been changed and their preferred discipline was no longer permitted. In the prefight interview in Wyoming, Beck asked Abbott to list his hobbies. Abbott responded: "Raising hell, going to bars, and going crazy." He added that he was fond of underground fighting. In fact, he explained, he had recently beaten a karate expert for $1,000. "He said, 'Where am I going to hold the cash when we fight?' I told him, 'Just put it in your pocket, and when I knock you out, I'll take it out.' That's pretty much what I did." Abbott was also notorious for his ability to drink a tankard's worth of Stoli on the rocks — "I blow through two fifths, easy," he once bragged — the night before a fight and again afterward.*

Abbott was making his UFC debut on the Wyoming card and demanded to wear small gloves. No one objected, so he became the first UFC fighter who didn't enter the ring bare-knuckled. His first opponent was a mountainous 400-pound Samoan, John Matua. By night,

*Classic UFC story: Later in his career, Abbott was allegedly owed money by the Semaphore Entertainment Group. He is said to have sent one of the company's bean counters an envelope with a bullet inside. He was paid shortly thereafter.

Matua was a bouncer at a California bar called Cowboy Boogie. By day, he fought in bare-knuckle brawls and practiced kuialua — or, as Beck informed viewers, his voice dropping to a near whisper, "the Hawaiian art of bone breaking." Matua was purportedly a distant relative of the famed sumo wrestler Aki Bono, and Matua's ancestors spent their time shaving and rubbing oil on their bodies and going out on raids. He told Beck that he was fighting in order to raise funds for an older brother who had been shot while attempting to stop a rape. The brother had been informed that, with expensive treatment, he might walk again. "You just could not make this stuff up," says Beck.

Behind the Octagon, Meyrowitz sat with his friend David Hasselhoff, the *Baywatch* star turned German pop icon. "You sure this is safe?" Hasselhoff asked.

"That's the thing about this sport," said Meyrowitz. "No one gets hurt."

The instant McCarthy, the ref, barked "Let's get it on" — a phrase he would later trademark — Abbott and Matua ran at each other, nearly 700 pounds of flesh colliding in the middle of the Octagon. Abbott whaled away at Matua, whose reflexes were, as one might expect from a man weighing one-fifth of a ton, frighteningly slow. After an especially brutal punch to his face, Matua crashed to the mat in the manner of a building slammed by a wrecking ball. His head hit first and bounced a good six inches in the air. Out cold just eighteen seconds into the fight, Matua took another shot across the face from Abbott before McCarthy mercifully stepped in. As Matua lay on the ground, motionless except for his spasmodically twitching legs, Beck and Jim Brown sat in stunned silence. "Our thoughts are with Big John Matua," Beck said gravely, having finally regained some equilibrium. A few rows back, Hasselhoff appeared to be nauseated. Abbott was exuberant. "Cakewalk!" he yelled as Jeff Blatnick tried to interview him. "Wooooooo!"

An hour later, Abbott was back in the ring with a trapfighting champion, Paul "the Polar Bear" Varelans, a gigantic Alaskan who stood six-eight, weighed 340 pounds, and tinkered with computers by day. Abbott again made quick work of his opponent, incapacitating Varelans with punches, bloodying him with knees to the face, and leg-whipping him for good measure. The Polar Bear, now fully tranquilized, had the good sense to tap out barely ninety seconds into the fight. "I just

wanted to tickle his brain a little bit," Abbott explained matter-of-factly to Blatnick in the postfight interview. Then, watching a replay of the knockout on the monitor, Abbott remarked, "Wooooo! Oooooh, I'm starting to get sexually aroused. Better turn that off." Blatnick was visibly disgusted, but it was vintage Abbott. In another interview, when asked whether he respected his opponent, Abbott looked dumbfounded as he turned to the reporter and deadpanned, "I don't respect anyone. Not even you."

For his third fight that night, Abbott took on Oleg Taktarov, a former Russian soldier. Taktarov tells the story that he was seventeen when a Russian army commander offered him a deal: if he won a sambo match against a Russian military champ, he could train with the army. If he lost, he'd be stationed in the hinterlands. Despite getting his ankle broken early in the fight, Taktarov won, and trained with the military. He eventually made his way to the United States, and though he was sometimes so short of cash that he slept in his car, he found his way into the UFC.

Taktarov's technique was flawless, but he was a prodigious bleeder. A mere glancing blow would cause a shower of red to irrigate his face. A few minutes into the fight against Abbott, blood stippled the canvas. Taktarov, however, was able to neutralize Abbott's haymakers with vastly superior skills.

At one point, McCarthy looked down and saw that Abbott was attempting to place his hands inside Taktarov's jaws and rip his cheeks apart. The son of a Los Angeles police SWAT team sergeant, McCarthy had once been at a Dodger game with his dad in the mid-seventies. When hecklers picked a fight with Chief McCarthy, "Little John" looked on as his dad hoisted one attacker and ripped the guy's mouth open from his upper lip to his eyes. "I knew all about fishhooking," says McCarthy. "I knew the only defense was biting, so how can you allow fishhooking and prohibit biting?"

After seventeen minutes of action and inaction, the two men were understandably exhausted in this, their third fight of the night. They often seemed to lie motionless on each other before remembering that, oh yeah, they were in a no-holds-barred brawl. Finally, the Russian mustered the strength to choke Abbott. Still bleeding from the face, Taktarov, proclaimed the winner, needed an infusion of oxygen before

he could lift his arm weakly in triumph. Abbott lay prone on the mat. Then, to wild applause, the burly man suddenly rose and walked out of the cage as though he had just returned from mailing a letter. More fodder for the Legend of Tank.

In the main event, Dan Severn, a former wrestling coach at Michigan State, fought Ken Shamrock. In contrast to the preceding fights, their match was all about skilled technique, leverage, and strategy. Though Shamrock was hailed as a striker and not a grappler, he executed an expert chokehold and induced a tap-out two minutes and fifteen seconds into the fight. It was an exciting tactical fight, but there was no bloodletting or brutal blows, no heads caroming off the mat like dribbled basketballs, no noses spurting blood in the manner of a busted fire hydrant. Seconds after the fight ended, the two men hugged in the center of the Octagon and talked warmly. Shamrock vowed to contribute some of his winner's check, $50,000, to buy wrestling equipment for the Casper, Wyoming, YMCA.

It was all comparatively civilized and sporting. And as a result, the main event savored of anticlimax. At least at the time, Ultimate Fighting — as the name, the marketing, and the broadcasts suggested — wasn't about matching technical skills. It was about two guys beating the shit out of each other. One of the fans in the stands stood shirtless with a simple message painted on his bare chest: *Just Bleed*. That pretty much summed up the UFC in its formative years.

After the card had ended, there was one more UFC fight. At the hotel where all the fighters were staying, the customary postevent party was in full swing. At one point a hulking, almost assuredly drunk member of Tank Abbott's entourage sidled up to a ravishing African-American woman and tried clumsily to pick her up. She declined his advances and alerted her brother, who happened to be Patrick Smith, the kickboxer from Denver, who had fought on the card. Smith had won his first fight and then, scheduled to face Taktarov, abruptly withdrew, citing a stomach illness — though, according to the UFC historian Clyde Gentry III, Smith was spotted later in the evening eating a ham sandwich.

Abbott's crony and Smith traded heated words but no punches. It was a typical, forgettable testosterone- and alcohol-fueled exchange. But the next morning at the hotel breakfast, Abbott's running buddy walked up to Smith and cold-cocked him. Abbott then supposedly

kicked Smith in the head. By the time other fighters and trainers broke up the fight — the assault, really — Smith was prone, blood puddling around him. Unlike any fighter on the card the previous night, he went to the local hospital, where he allegedly required a spool of stitches to close cuts on his face.

Art Davie had heard the commotion but was late arriving on the scene. He had been busy interviewing John Wayne Bobbitt, the man accorded a fleeting celebrity in the mid-1990s when his wife severed his penis with a kitchen knife and flung it from a car window. Bobbitt had seen the Ultimate Fighting Championship on television and was interested in joining the show.

5
BATTLE OF THE MASTERS

FIGHTING AROUSES TWO OF THE DEEPEST ANXIETIES WE
CONTAIN. THERE IS NOT ONLY THE FEAR OF GETTING HURT,
WHICH IS PROFOUND IN MORE MEN THAN WILL ADMIT TO IT,
BUT THERE IS THE OPPOSITE PANIC, EQUALLY UNADMITTED,
OF HURTING OTHERS. — NORMAN MAILER

MILETICH TRUDGED THROUGH most of his twenties in a shroud
of gray. He was still pissed off that his father had left him and then died.
Pissed off that one brother was dead and another was in jail. Pissed off
that, while he was improving as a fighter, he had little to show for it. His
therapy was martial arts. With his blend of skill and discipline and pre-
cision, Miletich earned belt after belt and was told countless times that
he had the potential to be a champion. But champion of what? Karate?
Kickboxing, maybe? And what did that get him? If a hundred fans
watched a pro kickboxing event, it was considered a good crowd. Part of
Miletich knew that the nobility of martial arts ought to be enough. The
fulfillment should come from within, not from money or recognition
or opportunity. Yet he couldn't always bring himself to feel this way,
and, well, that pissed him off even more.

It's easy to look in the rearview mirror and marvel at the "charac-
ter-building" fostered in bleak times. It's easy for the comfortable to
romanticize the destitute. It was Andrew Carnegie, the Bill Gates of
his time, who declared poverty "the sternest but most efficient of all
schools." But when you're in your late twenties, living with your mother,
and subsisting on bologna sandwiches and cheese weenies because you
can't afford hamburger meat, it's not much fun. Even if you are the
toughest guy in town.

No matter how hard Miletich worked at a series of blue-collar jobs,
he was hopelessly short of cash. Former high school classmates in their
nice cars would drive past Miletich in his hundred-dollar piece-of-shit-

mobile and look at him with a sort of economic survivors' guilt. His mother's heart problems remained a concern, her bad days seeming to outnumber the good ones. The pain of losing his big brother was still raw. Perhaps above all he had a gnawing feeling that he had done something terrible to anger the Fates. "Can I ever *not* get the short end of the stick?" he once said aloud in a rare instance of self-pity accompanying his usual bitterness. "Just one time can *something* go right for me?"

This he knew: his time at the karate studio was his way of self-medicating. All the energy was bound to escape one way or another. Better that it come pouring out in a gym than in a negative way. And there was this consolation: his persistent anger and tension helped when he trained. He never wanted for motivation to begin with. But his perpetually sour mood, his ineradicable sense that he was being screwed out of what was rightfully his, helped him complete that rep on the bench press or that last series of kicks. The volcano he walked around suppressing? It erupted when he trained. Martial arts became a sort of mirror that told him all he needed to know about himself. It was as much who he was as what he did.

Of late, he'd been particularly obsessed with jiu-jitsu, the perfect match for his advanced fighter's cortex, which anticipated moves and knew where and when to apply leverage. A friend of a friend who was a TV producer had gotten Miletich's name and invited him to audition for a fighting show he was creating. The audition entailed rolling on a mat with Sergio Monteiro, a Brazilian jiu-jitsu expert who was taking a break from fighting to get his master's degree at a Florida university.

Miletich flew to Tampa and met Monteiro. For thirty minutes they contorted on a mat, neither man able to subdue the other. Monteiro possessed superior technical skills, but Miletich was the better athlete and better able to defend himself. For someone who had taught himself mostly by watching videos, he was an ace student. They shook hands and Monteiro told Miletich to come back the following day if he wanted to "learn some tricks." For the rest of the week, Miletich, at Monteiro's knee (often literally), took a crash course in advanced jiu-jitsu. Nothing ever came of the television show, but Miletich went back to Iowa secure in the knowledge that his jiu-jitsu skills were as good as anyone's.

In the fall of 1995, a man named Joe Goytia called Miletich on the phone. Goytia had refereed a few of Miletich's Muay Thai fights in the

Midwest and the two had struck up a friendship. Goytia told Miletich that Tom Letuli, a local martial arts enthusiast, was holding a tournament at St. Andrew's Gym, a sweatbox in Chicago. It was a professional mixed-martial-arts event, open to anyone with expertise in a combat sport. Maybe Miletich wanted to enter?

"They're calling it something like 'Battle of the Masters,'" Goytia said. "And it's NHB — no-holds-barred. Anything goes."

"Which means what, exactly?" Miletich asked.

"Anything goes. No weight classes. No rounds. No rules. No wimps."

"No rules?"

"Well, no biting or eye-gouging. But anything else goes. Groin strikes. Head butts. Whatever you want to do to get the other guy out."

"How many guys are entering?"

"Eight. Single elimination. Keep winning and you fight three times in one night."

"Is there prize money?"

"Yeah," said Goytia. "But it's winner-take-all. Five grand. Nothing to the runner-up."

At that point in his life, Miletich would have entered for free. He wasn't passing up too many opportunities to fight, especially when he'd be able to test his expanding skills on the ground. But five grand? For one night? Shit, that was more than he'd made in months of working two jobs. Five grand would enable him to ward off the bill collectors, help Mom, and maybe fund some repair work on his 1970 Cherokee, an unreliable heap of metal so rust-coated that the back paneling was falling off.

Miletich had no idea which seven fighters he'd be competing against at Battle of the Masters. He didn't know if he'd be fighting converted wrestlers, boxers, or kung fu experts. But he worked on the assumption — a safe one — that at 170 pounds, he'd be the smallest guy in the field. He trained deliriously, working out daily, and sparred a few times a week with his hulking buddy Mark Hanssen, the 260-pound former NFL prospect, by then a black belt in shorei-ryu, an Okinawan-style karate. "If I can handle you, big boy," he joked to Hanssen, "I can't see anyone up there laying a hand on me."

In the weeks leading up to the fight, Miletich recalled his uncle Johnny, the one-time Olympic boxer and light-heavyweight contender.

Uncle Johnny would sometimes tell his family that he was headed to the state fair, neglecting to mention that he wasn't there to ride the bumper cars or troll for girls but rather to box or "catch wrestle" (that is, submission grapple) in the amphitheater or fight the carnival strongman. Miletich didn't keep his participation in Battle of the Masters a secret from his mother or his siblings. But he did play down the brutality of mixed martial arts, sparing them the details, for instance, of the various head-butting techniques he'd been perfecting.

On October 28, 1995, the day before the fight, Miletich, unwilling to trust his truck to transport him the 175 miles, jumped into Hanssen's Chevy Blazer and they headed east across the flat agri-industrial landscape of northern Illinois. When they had crossed the Mississippi Hanssen cranked up Metallica. Hanssen figured it was the right soundtrack for Miletich's first professional fight. All those angry lyrics and guitar riffs, set to a pulsing drumbeat that resembled nothing so much as one man pummeling another into submission. The music made Miletich sick. He'd later grow to appreciate Metallica, AC/DC, and the rest of the "fight genre." But at the time he would have preferred the country-western crooner Jerry Jeff Walker. Plus, he thought that if you needed heavy metal music to pump yourself up, you were probably toast.

Battle of the Masters was fighting's equivalent to drinking at a speakeasy. It wasn't quite subversive enough to be underground. But it was unclear whether it was entirely legal — whether, say, the Illinois Athletic Commission had given it their blessing. Regardless, the promoters had done a fine job publicizing the event. Mostly on account of guerrilla marketing techniques — affixing posters to streetlamps, spreading the word in the Chicago mixed-martial-arts community — St. Andrew's Gym was stuffed beyond its three-thousand-seat capacity, fans shoehorned into the bleachers and onto the steps.

The air was hot, filled with equal parts cigarette smoke, testosterone, and body odor. The EMTs seated near the ring apron, arms wrapped around defibrillators, added a sense of danger. Miletich got a pleasant jolt when he came out of the locker room and heard fans chanting his name. The sports editor of the *Quad-City Times* had written a story on Miletich's preparation for this contest, calling it "the closest thing to a street fight today." Having seen the article, a few hundred

fans made the trip across Illinois to check out this curiosity for themselves and cheer on the guy representing the Quad Cities.

Before the fights, Miletich eyeballed the competition. They all looked like garden-variety badasses. Hairy, scowling, tattooed dudes, some outweighing him by more than a hundred pounds — in short, guys who surely knew how to take care of themselves. But none of them looked any meaner than the countless Midwest street toughs Miletich had pulverized. To his surprise, he grew supremely, unshakably confident. He figured it was less of a question of *whether* he would win the five grand than *how* he would win it.

One fighter was touted as the favorite: Yasunori Matsumoto, an experienced Japanese martial artist who'd won national titles in both bare-knuckle fighting and judo. A seventh-degree black belt, he was a three-time All-Japan full-contact champion and reportedly held a record in the U.S. Shidokan Association for the feat of breaking four baseball bats at once with his leg. Matsumoto had moved to suburban Chicago to teach martial arts at his own dojo, but, the rumor went, he was also being considered for a starring role in an upcoming kung fu movie.

In keeping with Miletich's bad luck, he randomly drew Matsumoto as his first opponent. Never having been in an official mixed-martial-arts fight, Miletich had little idea of what to expect. He was told in advance that the matches would be held in a ring and not a cage. He knew the fighters would wear small, minimally padded gloves and nothing on their feet. He didn't have a sense of the rhythm or pacing of the fights. He wasn't even sure about the dress code, choosing to wear a pair of Muay Thai trunks and hoping that would suffice. The promoter, a big Samoan with a deep laugh, told some of the fighters that Battle of the Masters would resemble "a Jean-Claude Van Damme movie set in a small gym." But what did that mean? Before his first bout, Miletich consulted with Hanssen, his cornerman. "If you're gonna fight three times tonight, stamina's gonna be important," Hanssen said. "Let's just get this guy out of here as quick as you can."

At its essence, fighting shares a great deal with casual sex. You might not "know" the other person, but you share an intense physical relationship. You smell the other person, hear his grunts, sense the contours of his body. You learn about his strengths and insecurities. You're

engaged in this chemically charged relationship. And when it's over, you go your separate ways. Sometimes you respect the other person in the morning. Other times you never lay eyes on him again.

In this case, Miletich barely knew his opponent's name. But seconds into the fight, they were in close physical contact. Following Hanssen's direction, Miletich charged at Matsumoto and soon caught him in an armbar. Though he was giving up fifty or so pounds, Miletich took Matsumoto's arm to tension and realized the joint was locked. Knowing how intensely this could hurt, he figured Matsumoto was going to tap out. But he didn't. Miletich thought immediately of the Japanese soldiers in World War II who had no concept of surrender, fighting until they killed someone or were killed themselves.

Jarred by his opponent's resolve, Miletich began to stretch Matsumoto's arm and could feel the tendons starting to snap one by one, like old guitar strings. The pain must have been unimaginable, but Matsumoto rolled out of the submission hold and returned to his feet. Using the arm that had just been shredded, Matsumoto somehow got Miletich in a guillotine.

While some of the crowd was surely there for the bloodletting, most were martial arts devotees and could instantly appreciate both Miletich's maneuver against such a decorated fighter and Matsumoto's skill and valor in getting out of it. As he fought the hold, Miletich tried to take inventory of what had just happened. In short, he was freaked out. Like a butcher deboning a steak, he had nearly ripped the meat of another man's arm from the ulna. Not only did the man not surrender, but, barely flinching, he had managed to extricate himself and use the same arm to apply a chokehold. *So this is what NHB fighting is all about. What kind of friggin' masochist am I in here with?*

After two minutes or so, Miletich fought out of the guillotine. Sensing that the initial adrenaline rush would wear off and soon Matsumoto's arm would *have* to start throbbing with pain, Miletich lunged at his opponent. He soon got Matsumoto in a rear naked choke, squeezing like a man trying to pop a balloon, and finally induced a submission nearly eight minutes into the fight.

When Miletich lifted his arm in triumph, the crowd went nuts. In addition to the sizable contingent from the Quad Cities, Miletich, the

underdog in size and experience, had won over others because of his balls-out fighting style. In the meager basement locker room, with a look of disbelief on his face, Miletich turned to Hanssen. "I broke the dude's arm, choked him unconscious, and it was still a close fight?"

From below, Miletich could hear the crowd cheering the subsequent fight. He was supposed to take on the winner, so he ducked into the stands, trying to gather a few mental notes on his next opponent's style and tendencies. In what was literally a knockdown-dragout, a kid of Croatian extraction pounded a tough named Smith. By the count of one ringside observer, the Croatian head-butted Smith no fewer than fifty-four times. Yet Smith kept coming and, half an hour into the fight, caught the Croatian in a nasty triangle choke, winning by submission. Glory was short-lived, however. Smith collapsed from exhaustion in the shower afterward and couldn't continue. Miletich was starting to understand what the promoter had meant by a Van Damme movie set in a small gym.

Miletich's next victim was Angelo Rivera of Morton Grove, Illinois. Though Rivera was a strapping fighter who might have flattened the much smaller Miletich in a boxing match, he lacked ground skills. Sensing this immediately, Miletich body-slammed Rivera, dropped a barrage of elbows on his face, and won by submission just two minutes into the fight. By now the smallest man in the field had the backing of the fans. Long after he raised his arm again, a cheer — *Mill-a-TICH, Mill-a-TICH* — echoed through the St. Andrew's sweatbox. With just one fight remaining, Miletich was uninjured and still relatively fresh. He could feel the $5,000 in his mitts.

Not so Kevin Marino, his opponent in the final, who had labored for twenty-some minutes to win his earlier two fights. He weighed in the neighborhood of 250 pounds and looked like an angry beat cop. As Marino warmed up in the locker room, Miletich could sense that his opponent was gassed. Marino's face looked drawn and tired, his eyes ringed with fatigue, his chin and cheeks caked with specks of dried blood.

As devoted as Miletich was to the craft — the technique and the science and the rituals that went with it — on this night his chief motivation was the money. The knowledge that he had used his skills

more adeptly than anyone else, that was all well and good. But he needed cash. "I'm either gonna win the money," he told Hanssen, "or I'm gonna die."

As if Miletich needed additional motivation, Marino was billed as the training partner of Keith Hackney, a Chicago fighter who had recently competed in the Ultimate Fighting Championship. At UFC 3 ("The American Dream"), held in a Charlotte, North Carolina, armory, Hackney weighed 200 pounds and in his first fight faced off against an African-American sumo wrestler, Emmanuel "Tiny" Yarborough. Tiny entered the ring weighing in excess of 600 pounds — *down* 200 from his career high. He was agile enough to dunk a basketball. Still, the disparity in body mass between the men was comic, resembling one of those state-fair man-fights-bear contests. But if Yarborough had the physique of a mountain, he had the mobility of one as well. At one point, Yarborough crashed against the cage and broke the Octagon, requiring several men to hold up part of the fence for the remainder of the fight.

Hackney repeatedly struck Yarborough in the groin and face, and delivered two dozen consecutive right hands to the back of poor Yarborough's head. Improbably, Hackney won by knockout. News of this bizarre battle and of Hackney's unlikely win rocketed through the Republic of MMA. (The fight is now a YouTube classic.) Instantly, Hackney won a small measure of fame as well as the nickname "Giant Killer." He would go on to fight the fearsome champion, Royce Gracie, in UFC 4.

Focused as Miletich was on his next fight, he couldn't stop watching Hackney, tanned and with perfect hair, strutting around St. Andrew's Gym, accepting slaps on the back and stopping to sign autographs. Wearing street clothes, Hackney was on hand to work Marino's corner. But it seemed that he was there to bask in his celebrity too. Miletich was filled with anger and envy. As he saw it, this was just another slight, another example of someone less deserving taking what was rightfully his. He was a better fighter than Hackney — more versatile, more knowledgeable in technique, more agile. That he knew for sure. Yet once again it was the other guy who'd gotten the lucky break. Hackney entered this newfangled contest, got on national television, played the role of undersized underdog, and was suddenly a hero. Even-

tually Miletich would become friends with him. But on this night he seethed just looking at the guy.

It was approaching midnight when the final match began. As Miletich walked out of the dressing room, intensity and rage illuminated his face like a flare. He stuck with his fight plan: attack early. As if ejected from a cannon, he shot out of his corner and mauled Marino in the middle of the ring. He lunged at Marino's waist, picked the bigger man up, and slammed him down on the canvas with a thud that resounded through the gym. He then put a series of jiu-jitsu moves on Marino, interrupting his twisting to unload a volley of punches to the head. Marino was a game and honorable opponent but, in the end, a limited one. After nearly four minutes, as if he had simply gotten bored, Miletich applied a rear choke and Marino tapped out.

Maybe Miletich, facing his first professional mixed-martial-arts title, was intoxicated from the speedball of adrenaline, rage, and ego coursing through his body. Maybe he was playing to a crowd that had not just embraced but adopted him over the past three hours. Maybe he was simply so locked into the fight that he didn't see the ref signal that it was over. Whatever, Miletich did something at odds with his character. He kept fighting, declining to relinquish his chokehold, and the referee had to shove him off Marino's limp body. Miletich then stood and, with his muscled arms pointed to the rafters, marched toward Hackney, glowering at him, as if to say, *I just annihilated your sparring partner but it could just as easily have been you, pal.*

As he walked out of St. Andrew's Gym and into a crisp Chicago night, Miletich reveled in what had been a wildly successful occasion. He had gone to Chicago, competed in his first pro MMA tournament, and thumped everyone, including guys who outweighed him by as much as 75 pounds. This was light-years away from Pat Miletich the hellion, lubricated on Southern Comfort, throwing punches in an alley or outside a bar. He had taken on three fighters who could hardly have been more different — different sizes, temperaments, skill sets — and used technical skill and strategy to triumph.

Plus, with the exception of a tweaked knee, he walked away unscathed. There were plenty of bloodstains on the canvas that night, but none was his. His toughness, his heart, and above all his mastery of a medley of combat disciplines had been validated. In what was then a

truism for MMA, the fighter with superior stamina and jiu-jitsu skills was likely to prevail. At the inaugural Battle of the Masters event, that fighter was Miletich.

He also got a pleasant surprise the next morning. The *Quad-City Times* had sent a writer to cover the event. The writer was open-minded, and there was no moralizing or finger-wagging in his account: "Miletich Wins 'Battle of the Masters' as Bettendorf Native Takes Home $5,000." In the article, Miletich claimed that it was time to find a less perilous hobby. "I'm planning on trying some mini-triathlons this summer — it's something I can do without someone trying to punch and kick me."

Who was he kidding? By Monday, Miletich was back in the Quad Cities karate studio. He thought of taking a few days off, but could think of nothing he'd rather be doing. Naturally, as he sliced the air practicing his kicks and taught his classes, he failed to mention his eventful weekend. Finally, a student who had read the *Quad-City Times* asked Miletich about his Chicago fights. "It wasn't that big a deal," he responded sheepishly. He then went back to his workout.

Meanwhile, Miletich had become fascinated with the UFC. He'd watch the pay-per-view fights, borrowing the money if need be, and his thoughts would tack between excitement and jealousy. It was thrilling that mixed martial arts — his sport! — seemed to be catching on. But damn if he didn't wish he were in that Octagon. Some of those guys, he reckoned, had such rudimentary skills they had no business being in there. Even the champs, like Royce Gracie, had holes in their fight games. *Man,* he thought, *what I wouldn't do to step into that cage and mix it up.* But he had no agent, no publicist, and he was too proud to pimp himself and call on his own behalf. One day, they'd come to him. That he knew.

Months went by and the UFC never called. But before long Tom Letuli, the Chicago promoter, did.

"I have good news and bad news," he said.

"What's that?" Miletich said.

"I'm holding another Battle of the Masters. And this time the prize money is ten thousand dollars. As defending champ —"

"I'll be there."

"The bad news is the competition is going to be rougher. I'm bringing in Andrei Dudko. Huge guy. Russian sambo champion. Guy looks like Ivan Drago. Hope that don't scare you off."

"Just give me the damn dates."

As if it had been hit with a closed fist, Miletich's profile began swelling. When he fought in Battle of the Masters II, in November 1995, he again rode in the shotgun seat as Hanssen drove across the guts of Illinois to Chicago. The difference was that this time Miletich was trailed by a convoy of supporters from the Quad Cities, maybe three or four hundred in all.

Even by his high standards, Miletich had trained intensely, sometimes putting in three separate sessions in one day. He sparred in the karate studio. He ran. He lifted. He spent his downtime reading martial arts texts and watching videos of submission techniques. Which is why he was furious when he tried to sleep the night before the fight. The promoter had arranged for the out-of-town fighters to stay at a motel near Midway Airport. Problem was, the place was hemmed between an interstate and an elevated subway. Serenaded by cars, semis, and planes overhead, Miletich slept fitfully.

Already simmering, his rage reached a full boil when he showed up at the fighters' meeting. Six other competitors had joined him, but Dudko was nowhere to be seen. Deeming it unworthy of his time, he had sent a representative, a shadowy Russian figure dressed in a three-piece suit with a silk handkerchief in the breast pocket. The message Dudko had surely intended to send had been received: he was at a different level than these lugs from the Midwest.

Like a lazy movie sequel, Battle of the Masters II played out with an almost eerie similarity to the first edition. Miletich and Dudko were, predictably, placed in opposite brackets, the promoters hoping the defending champion and the Russian ringer would meet in the final. As described, Dudko was a hulking figure who, at six-six, 230 pounds, really did resemble Ivan Drago's larger, more sculpted brother. When he walked into the locker room, Miletich and Hanssen looked him over, stared at each other, and, in stereo, muttered, "Holy shit, that's a big boy."

In his first fight, Miletich faced Rick Graveson, a prison guard from

outside Chicago who sported on his back a tattoo of Pinhead, from the horror flick *Hellraiser*. He sometimes wore a bone through his nose, which the tournament organizers asked him to remove before he fought. With the crowd firmly behind him, Miletich quickly flung Graveson to the ground as if he were a scarecrow and choked him out less than a minute into the fight. He then took on Bob Gohlson, a fighter from southern Illinois whom Miletich had seen before at martial arts tournaments in the Midwest. After an unremarkable first minute, Miletich feigned a takedown and clocked Gohlson with a right hand that opened a nasty two-inch gash under his left eye. The referee jumped in before any additional damage was done.

Apart from winning the fight, Miletich claimed a $500 bonus for winning from a standing position, a rarity in no-holds-barred events. But he'd come to win $10,000, and so far not even a towering Ivan Drago doppelgänger — billed in the program as "an expert in the art of breaking knees" — was an impediment. When Miletich returned to the locker room, he sought out Dudko, who was warming up. Miletich fixed his gaze on his opponent and laughed.

"Psyching him out?" Hanssen said in a whisper as he applied Vaseline to Miletich's face.

"I know I'm gonna win," Miletich said flatly.

"I think your hormones aren't right," Hanssen said, smiling in admiration at his buddy's confidence. "Too much testosterone."

"That may be."

When Miletich and Dudko emerged for the final match, the atmosphere was electric, the crowd split among the riot of Miletich supports from the Quad Cities, a vocal pro-Dudko sector from Chicago's large eastern European population, and hard-core no-holds-barred fans who just wanted a good fight. Two of the three contingents went home happy. Sticking to his simple fight plan — get the guy on his back — Miletich flew at Dudko, quickly got inside, and head-butted him. Then he lifted Dudko, all 230 pounds of him, and slammed him with a violent *ttttunnnnkkkkk*. On the ground, he blistered him with punches, elbows, and a few more head butts. Finally he folded Dudko as if he were a piece of origami and applied a choke that forced a tap-out.

With all those bodily chemicals coursing through his system, Miletich stood over his fallen foe and screamed. Lying on the mat, Dudko

flinched and instinctively covered up, the "muscular knee breaker" reduced to a fetal position. The crowd gave Miletich a standing ovation that lasted more than a minute. For the second time in less than a year, the undersized Hercules from Iowa had proven himself the master at Battle of the Masters. In total, Miletich required only five minutes and ten seconds of work.

Again, the $10,000 check, plus the $500 bonus, would go mostly to offset bills. But after doing battle, Miletich did buy a few rounds at an Irish pub on Chicago's South Side for Hanssen and some of Hanssen's colleagues on the Davenport police force who'd made the trip. Having gotten himself into what he called "freak shape" for Battle of the Masters, his body completely clean, Miletich realized that he was able to drink prodigiously without feeling the effects of the alcohol. In his sober state, he felt awkward about all the slaps on the back, the remarks about being a "bad motherfucker." As he saw it, it wasn't about kicking ass. He was just another elite athlete who had trained like hell, discharged his duties better than anyone else, and won a competition. Any fleeting doubts that he had been wasting his time with MMA were now officially roadkill.

As he and Hanssen drove home the next day, for the first time Miletich confessed that maybe he had a future as a professional fighter after all. "Let me ask you a question, Mark," he said softly. "You think this'll get me invited to the next one of those Ultimate Fighting Championships?"

Following the predictable rhythms of the Miletich narrative, success rode tandem with setback. Devastated as Miletich was by the death of his brother Bill in 1992, he was able to channel his grief into fighting. Perhaps because he lacked that outlet, or because he was wired differently, Tom Miletich reacted much more severely. Having gotten out of the Air Force, Tom was running his own company in Minneapolis when he received the news of Bill's death. He motored down to the funeral on Interstate 35, and at the mile marker where Bill had been killed just a few days earlier, Tom got out of his car. He walked on the side of the road and soon found surgical gloves, tubes, and other relics of the unsuccessful attempt to revive his brother. He looked closer and found Bill's

shoes, both split open, with chunks of bone inside. He took them and finished the drive to the family home in Bettendorf. He parked in the driveway and, holding Bill's shoes in his trembling hands, sobbed uncontrollably.

From that day, for the next three years, Tom was irreparably broken. He'd always been the straight arrow of the Miletich spawn, the college graduate and Air Force officer — "the one who always had his shit together in the family," says Pat. But simply incapable of dealing with the loss of a brother, he soon turned to drugs. Within months of the death, Tom had quit his job and left his family, a wife and three boys. He spent a few years trawling the Midwest, taking odd jobs to fund his habit. Calls from concerned family members went unreturned. In the early fall of 1996, he was found dead, an apparent suicide, in a motel room outside St. Louis, his death at once shocking and sadly predictable.

John Miletich received a furlough from the state penitentiary to attend Tom's funeral. Flanked by a pair of corrections officers, he returned to Bettendorf and saw his mother, brother, sister, and kids for the first time in years. It marked the first day since his incarceration that John hadn't attended his substance abuse counseling, shown up for work as a prison records clerk, and done some form of physical activity. He was one of the few inmates who was actually rehabilitating himself in prison, and Pat would later claim that he could tell just by looking at John that the guy was finally repairing his life.

After the service, Pat pulled his last remaining brother aside. "We gotta stick together, John. We're all we got, you know?" John nodded, slapped his brother on the back. His eyes didn't start misting until the drive back to prison.

6

FIGHTING SOLVES EVERYTHING

I FIRMLY BELIEVE THAT ANY MAN'S FINEST HOUR, THE
GREATEST FULFILLMENT OF ALL THAT HE HOLDS DEAR,
IS THAT MOMENT WHEN HE HAS WORKED HIS HEART OUT
IN A GOOD CAUSE AND LIES EXHAUSTED ON THE FIELD
OF BATTLE — VICTORIOUS. —VINCE LOMBARDI

AFTER HE'D DEFENDED his Battle of the Masters title, Miletich achieved a measure of cult popularity in the Quad Cities. Like a garage band starting to accumulate regional buzz, he claimed a group of devoted followers. The victories predated the mixed-martial-arts Internet underground and message boards, so stories spread by word of mouth about "the little guy from Iowa who gave worse than he got against guys a hundred pounds heavier." Even without the notoriety and autograph requests, Miletich was beginning to lose any self-consciousness about his career choice. Fighting had given him a sense of purpose, and for the first time in his life he'd become an overachiever. Plus, he saw friends and cousins shackled by their jobs, feeling imprisoned and emasculated sitting behind a desk or taking orders from an asshole boss. Whatever the drawbacks of fighting for a living — low pay, absence of benefits, risk of injury — at least it brought freedom.

If Miletich was almost genetically incapable of bragging, he was realistic enough to recognize his potential in this strange and evolving sport. One of the beauties of no-holds-barred was the extreme slope of the learning curve. No one who takes up baseball expects to throw hundred-mile-an-hour fastballs in the major leagues within a few years. No one who takes up tennis or golf or skiing in his twenties suddenly becomes a pro. Fighting was different. You could get good in a hurry. In part this was because the sport was so new that no one had been doing it for many years. More than that, it was the sport's requirement of a

mix of technical skills and mental toughness. "The most talented athlete who lacked guts had no chance," says Miletich. "But neither did the warrior who didn't know how to defend the takedown or avoid a kimura."

Miletich paid close attention to the sport's trends at the highest level — the UFC and, to a lesser extent, Japanese organizations like Pancrase and, later, PRIDE. Poor as he was, in the summer of 1996 he decided to watch a UFC card in person. He found a cheap flight to Atlanta, rented a car, and drove south to Fairgrounds Arena in Birmingham, Alabama, for UFC 10. The unpaved parking lot was a cliché, all dirty pickup trucks adorned with gun racks and Confederate flags. When Miletich walked up to the ticket window, he was told that plenty of seats were available. He spent $20 on a bleacher seat.

Sitting next to a knot of teenage kids getting drunk on moonshine, Miletich was among the four thousand fans watching a typical UFC card: tournament-type format, few rules, no weight classes. Some of the fights were electric; others were unwatchable mismatches. The winner was a big lug named Mark Coleman, once an NCAA wrestling champ at Ohio State, who beat up on another former college wrestler, Don Frye, in the final. One could make the case that Coleman initiated the ground-and-pound style that night, mounting his opponent and gradually weakening his defense with arm punches.

As UFC cards went, it was hardly a classic. Miletich, though, was transfixed. This was the promised land for any no-holds-barred fighter: the Octagon, the television cameras, the splashy ring intros. *One day I'll be in there*, he promised himself, ignoring the inconvenient fact that there were few other fighters even close to his modest size in the field that night.

Miletich was quick to recognize that the sport was no longer about a jiu-jitsu magician forcing a boxer into submission. Everyone had figured out how to sprawl, so jiu-jitsu alone was no longer enough. Mixed martial arts required a battery of skills. He compared it to a three-legged stool: one leg representing striking, another submission, and the third, wrestling takedown and defense. If one of the legs was weaker or less developed than the others, the stool would collapse.

He reckoned that the weakest component of his game was stand-up — boxing in particular. So when he returned to Iowa, he went to the Davenport Boxing Club, a hard-knocks gym in a largely boarded-up section of the city's downtown, a few blocks from the river. On his first day, Miletich bounded up a flight of creaky stairs and got hit in the face by a thick stench. Sweating through their undershirts, the fighters — exclusively black and Hispanic — skipped rope, rut-tut-tutted on speedbags, and chopped the air while shadowboxing. "What you want?" the craggy proprietor barked. "You a tough guy looking to fight? Get out!"

With skin of leather resembling a worn boxing glove and a head of straight silvery hair, Alvino Peña had run the gym since the late 1960s. He was pushing seventy but still walked the short distance from his modest Victorian home up the hill to this sweatbox. Peña had grown up in dust-choked south Texas, the son of cotton-picking immigrants from Mexico. The Peña clan had migrated to the Quad Cities in the forties, and Alvino was the Pat Miletich of his time, the toughest guy in town. He was a Golden Gloves champ and boxing star in the Army, knocking a lieutenant out cold in his first fight. He went on to became a pro boxer of some distinction, fighting mostly around the Midwest. Then he sank. "I boxed from 1947 to 1959," he says. "I got drunk from '59 to '69. If it was a rainy day, I got drunk. If it was a sunny day, I got drunk. If I was so drunk I couldn't tell what the weather was, I still got drunk again." When his son, Jesse, whom he called Pepe, went to Vietnam as a Navy medic, Alvino made a pact with God. "If my son comes back alive, I'll stop drinking."

Pepe was killed in an ambush, but Alvino quit anyway and started the gym, determined to devote the rest of his life to making his late son proud. He opened the boxing club with his own funds, and worked in the International Harvester factory and served in the National Guard to keep the doors open. The kids who came in were usually poor. He helped turn a few of them into champs, but he figured they could all use the structure and purpose and the time off the streets. Eventually he got funding from the City of Davenport and the local branch of the United Way, and he operated the gym as a nonprofit. "Not that it was making no money anyway," he says. By the eighties, Peña had developed a na-tional reputation as a first-rate trainer, and was invited to coach na-

tional teams that included Evander Holyfield, Oscar De La Hoya, and Mike Tyson.

Despite the many street fights Miletich had been in, he'd never learned to box properly. At Peña's gym he picked up the technique for throwing punches and, just as important, for rolling with punches when they collided with his face.* Like dance moves that felt awkward at first but eventually became second nature, he picked up the footwork too. He and Peña clashed plenty, however. When Peña explained that a boxer has to rotate his hips for maximum leverage, Miletich responded that if he ever assumed that stance and created that kind of spacing in a fight, his opponent would shoot for his legs or squeeze off a kick to his thigh.

"Shoot for the legs? Kick your thigh?" Peña said. "What the hell you talking about? I'm training you to box! If you want to do that crazy fighting, go somewhere else."

Rather than argue with the old man, Miletich absorbed what was useful to no-holds-barred fighting and quietly ignored the rest. If nothing else, Peña admired Miletich's work ethic and level of fitness. A few years earlier, he had trained Michael Nunn, a slick middleweight champ whose talent for boxing was matched by a talent for finding trouble. (Nunn is currently in jail for having sold cocaine to an undercover FBI agent in a Quad Cities motel.) In a weak moment, Peña expressed the belief that if Nunn possessed a fraction of Miletich's work ethic, he would still have been fighting for world championships. "That Miletich guy," Alvino recently barked, "that crazy son of a bitch, he don't never quit."

Monte Cox had always been one of those sportswriters who gravitated to obscure stories — he'd written features on cricket and rugby and trapshooting. A refugee from Indiana, Cox didn't know much about Pat Miletich. "I just heard that he was an ornery son of a bitch who was a hell of a high school football player but then got into drinking and

*An underrated aspect of fighting is learning how to take a punch. The fighter who announces "I've never been hit" is usually in a world of hurt the first time he catches a shot square on the chin.

fighting." When he first interviewed Miletich in 1995, Cox assumed that "here's this crazy local kid who goes around beating guys up." A former boxer, Cox, then in his mid-thirties, thumbed his nose at the idea of no-holds-barred fighting. He assumed he'd write a feature story on Miletich, peppering his piece with words like "barbaric" and "indefensible."

To Cox's surprise, his subject was strikingly thoughtful and philosophical. He was generous with his time and seemed to understand that his passion — like many, he was abandoning calling it "no-holds-barred" in favor of the more dignified-sounding "mixed martial arts" — would take some selling. In his feature Cox referred to the sport as "violent but exhilarating." And he was curious enough that he agreed to cover Miletich's fight in Chicago. As Cox sat ringside at the first Battle of the Masters, he was enthralled. Even as a loyal boxing fan, Cox thought that the action made conventional pugilism look like a quilting bee.

Riveted, he watched as the fighters won — and, for that matter, lost — in any of a dozen ways. Sure, you could detonate a punch in the other guy's face. But you could also kick him or flip him or twist his arm to the point of fracture or choke him out. Far from trashing the sport in the paper, as he'd anticipated, Cox was thinking about how easy it would be to sell this sport in Iowa, the belly of wrestling country. He recalls thinking: *Boxing is in a world of hurt if this sport ever catches on.*

At the time, in the mid-1990s, Cox was putting in seventy-hour weeks as a sportswriter and then as sports editor. He was making a decent living in a pocket of eastern Iowa where $100,000 bought a nice split-level house on half an acre. He had a company car. But he was getting restless and took on any number of sideline gigs. He dabbled in commercial real estate. He invested in a gym. Once a professional boxer of some distinction, he promoted boxing cards throughout the Midwest and eventually managed a few fighters, including Antwun "Kid Dynamite" Echols, a Quad Cities product who fought for various middleweight belts. Cox even returned to the ring, suffering a second-round knockout by someone named Rip Rogers, on the undercard of a Hector "Macho" Camacho fight held in the Quad Cities. Cox claims that he was in negotiations to fight George Foreman when Foreman made his comeback tour.

After Battle of the Masters, Cox and Miletich stayed in contact. Cox

hatched a plan to promote a local no-holds-barred card at The Mark, the Madison Square Garden of the Quad Cities. Miletich would be the star attraction, and he agreed to fight, but on one condition: there would be two weight classes, heavyweight and light heavyweight. That way, both he and his buddy Mark Hanssen could fight in front of the home crowd without having to face each other. Cox agreed, and the "Quad City Ultimate," a one-night, winner-take-all tournament, was promoted as a chance to see the "emerging sport of no-holds-barred fighting." Unofficially, Cox adopted a different strategy: "Come see the guy who's beaten up everyone in town! You know Pat Miletich from his countless bar fights. Now watch him go nuts in an organized bout."

The event was nearly ruined by the usual chaos that accompanied no-holds-barred fights. There were last-minute negotiations with the boys from the state athletic commission, who played weathervane, waiting to see how much political backlash there would be before sanctioning the card. Some fighters were unsure of the rules even as they entered the ring. Others mysteriously declined to show up, so overmatched replacements were quickly summoned.

Miletich was stunned, though, when he left his dressing room, entered the arena, and looked up at 7,500 fans, most of them there to cheer him on. Later that night, he told a friend, "Everyone should get to experience the feeling of walking out in front of a crowd cheering your name." Miletich didn't disappoint, making fast work of a substitute opponent. Within seconds, he could tell that the other guy had no business being in the ring with him. He let the poor guy off easy, taking him to the ground like a dancer leading his partner. After about a minute of fighting, he methodically applied an armbar and the fight was over.

Instead of retreating to the dressing room, Miletich stuck around to watch Hanssen, who had drawn Yasunori Matsumoto, the Chicago black belt whose arm Miletich had broken in his first pro fight. With Miletich shouting support louder than anyone in the arena, Hanssen controlled the first few minutes of the fight.

While Miletich had devoted himself to fighting full-time and training, Hanssen had been serving on the Davenport police force, sneaking in workouts when he could. Never fond of roadwork, Hanssen struggled with conditioning, and on this night he paid for it. After five min-

utes of fighting, he looked as if he'd been shot with a tranquilizer gun. Sluggish and slow-moving, he could barely lift a hand to defend himself. Suddenly Matsumoto mounted Hanssen and windmilled punches and elbows. The fight was called, and Hanssen stayed on the ground. Though he was more winded than hurt, the scary sight of the 275-pound local cop sprawled flat on the mat sucked most of the energy from the arena.

Miletich was stunned as well. His opponent in the final was Rick Graveson, the Illinois prison guard he'd fought in Chicago. But Miletich's thoughts were with Hanssen, now in a back corridor getting oxygen. Graveson lacked Miletich's range of skills, but he was unusually strong. Miletich took advantage of his superior wrestling moves and lay atop Graveson, yet he couldn't mount much of an offense. But two minutes into the fight, Graveson turned inward to try and free himself from Miletich's mount. It was the wrong move, and Miletich sensed it right away, rolling with Graveson and cinching up a choke. Graveson tapped out, and that was that.

Miletich had spent less than three minutes fighting. He had won the $3,500 prize, and Cox had given him a portion of the gate. He had dominated the action before thousands of his fans, fueling his underground popularity. But his joy was tempered. He felt for his buddy Hanssen, who'd lost in front of so many people he knew.

Besides that, Miletich wished he had been challenged a bit more. Interviewed by a *Quad-City Times* reporter, he couldn't hide his ambivalence: "I'm disappointed that two of the guys in my weight division backed out because it would have been a better competition if they hadn't. What I feel good about is that I was able to win without doing any damage to my opponents. No blood, no broken bones." The self-described thug who had once busted a toilet with another man's head was now sounding like John Lennon.

By then Cox was wearying of his day job. "I was a newspaper editor, but I found myself going in the direction of the thing that was putting money in my pocket." In the summer of 1996, four days after he became fully vested in his pension plan, he quit. His friends and colleagues asked what he was going to do next. With a straight face and no trace of irony, he told them he was going to promote cage fights. "It's the no-

holds-barred deal," he said. They all thought he was bat-shit crazy, not least his wife, who at the time was pregnant with their third child.

A full-time fighter, Miletich took work whenever he could get it, including entering Toughman contests. Often confused with mixed martial arts — at least among the uninitiated — Toughman is an indefensible competition that pits two rank amateurs against each other in a boxing ring. Toughman tends to operate in the shadows, making news only when a fighter dies in the ring, which occurs with alarming frequency. The promoter, a jackal from Michigan named Art Dore, has made millions off what he proudly calls "legalized assault and battery."*

In his first Toughman fight, Miletich lost a split decision to a bruiser from Oklahoma. He was annoyed at himself until he learned that the bruiser was a Toughman world champion. Miletich continued entering events, mostly in Iowa and Illinois. He fought in casino ballrooms and dingy armories and even a small rodeo arena, where fighters tracked through dirt to get into the ring. If he won $500 or $1,000, that was great. If the grand prize that night happened to be a satin jacket, well, hell, at least he got the blood pumping.

Still in its infancy, no-holds-barred fighting didn't have much in the way of pageantry. And that was fine by Miletich. Trappings were never his thing anyway. He paid little attention to his attire. He didn't give much thought to his entrance music. He'd resisted calls to adopt a nickname. Someone finally bestowed on him the nom de guerre "Croatian Sensation," and it stuck. But Miletich could not have cared less about that stuff. "I just wanted to get in there and get it on," he says. "That was my job. And I just wanted to go to work."

In the summer of 1996, Miletich fought on another Cox-promoted MMA card — "Brawl at the Ballpark" — held on a minor league baseball field. His opponent, Pat Assalone, was advertised as a formidable shoot fighter. Miletich needed less than a minute to take Assalone to the ground, ambush him with unanswered punches, and twist his elbow

*The cards are held mostly in backwaters in the Midwest, and Dore is a master of sidestepping regulations. One of his ploys: to avoid falling under the jurisdiction of commissions that regulate *professional* boxing, he doesn't pay prize money but gives the winner a satin jacket instead.

into a spiral. Fighting on an Extreme Challenge card in Davenport, Miletich was supposed to battle a jiu-jitsu specialist from Kansas. But shortly before the fight, the opponent pulled out with a hamstring injury. Instead Miletich faced a fill-in contender from Nebraska. A few seconds into the fight, Miletich drilled the guy with a forearm and followed up with a right hand. The punch exploded on impact and the fight was over. Only later was Miletich told that the blow forced a tooth down the guy's throat. By then Miletich had a professional fighting record of 15–0. And by then he sensed that this new style of fighting was here to stay.

His first loss came a few months later. After winning in the first three Extreme Challenge events, Miletich was asked to headline an Extreme Fighting card. Taking advantage of his regional popularity, the fight was in Des Moines. With a guaranteed purse of $10,000, it would potentially mark his biggest payday. His opponent was Matt Hume, a well-regarded fighter from Seattle whose father had once trained with Bruce Lee. Miletich and Hume were almost mirror images of each other. They had similar physiques of corded muscle.* They had similar styles of fighting, melding a wrestling base with a versatile skill set. They had a similar approach to training.

At the end of a back-and-forth first round, Hume threw a right hand and Miletich ducked. As Miletich's head bobbed down, Hume cradled it and connected with a series of crisp knees to the face, a classic Muay Thai move. Stunned, Miletich put his hand to his eyes and nose like a man trying to block out the sun. His nose resembled the smashed, squarish state of Iowa.

In high school, Miletich had ripped some cartilage near the bridge of his nose and never bothered having it fixed. When, between rounds, the ring doctor examined Miletich, he felt the gap in his nose and assumed it had been broken by Hume's knee. Despite Miletich's protests, the doc stopped the proceedings. Miletich had lost for the first time. He congratulated Hume, hugged him, and said all the right things publicly. But back in the locker room he raged. The loss suggested that he was only mortal.

*Unlike the UFC, the executives at Extreme Challenge had the good sense to institute weight classes.

Athletes in other sports talk cavalierly about losing. They "brush it off." They "come back strong." They "put it behind them." It's one thing to do that when the other guy circled the bases more often than you or needed fewer strokes to nudge a golf ball into a hole. But it's different in fighting. When someone imposes his will on you — when he literally beats you, drawing your blood and changing the architecture of your face — the loss tends to carry more psychological weight. Like ink on a greaseboard, an MMA loss is never fully erased, the slate never entirely wiped clean. The way a fighter responds to losing usually sifts out the champions from the pretenders. Now it was Miletich's chance to deal with defeat.

It's hard to pinpoint precisely what triggered the backlash against no-holds-barred fighting and the UFC in particular. Sensationally violent as the fights were, no combatant had been seriously injured. It wasn't as if groups of outraged citizens were organizing and pressuring politicians to ban no-holds-barred events. The sport was still so fringe that the media had scarcely taken note of its growth.

But by the mid-1990s, the whispers of criticism against the UFC had turned into a loud chorus. Soon the honchos at Semaphore Entertainment Group were spending a significant chunk of their time and resources fighting legal battles, fending off mounting criticism, and quieting calls that their "blood sport" be banned. Mayors held press conferences to announce that Ultimate Fighting wasn't welcome in their towns. The thirty-six member-states in the Association of Boxing Commissions unanimously agreed to ban no-holds-barred fights. According to the MMA historian Clyde Gentry III, hours before the UFC 9 card in Detroit, SEG representatives were locking horns with the Michigan district attorney, who was hell-bent on preventing the card from occurring. Finally, a last-minute compromise was struck: the card could go on, but head butts were forbidden and fighters would be fined $50 for open-glove strikes to the head.* Some fighters were apprised of these changes as they made their way from the dressing room to the Octagon.

Such pressure was soon applied elsewhere. A proposed show in In-

*According to John McCarthy, the referee that night, the rule was "very loosely interpreted."

dianapolis was canceled when politicians threatened to shut it down. Same in Denver. The UFC 7 card, held in Buffalo, went unnoticed, but when the organization returned to that city for UFC 12, the landscape had changed. A chain of politicians that extended all the way up to New York governor George Pataki looked to ban no-holds-barred fighting in the state. Bob Meyrowitz hired a high-priced lobbyist. The card was rumored to be off. Then it was rumored to be on. The *New York Times* ran a front-page story titled "Outcast Gladiators Find a Home: New York."

Anticipating trouble, Meyrowitz had booked a backup venue in Dothan, Alabama. The day before the fight, he was told that the New York legislature would let the fight happen only under the auspices of the state's athletic commission, which was demanding a series of rules, including a provision that fighters wear headgear. *Headgear?* That, obviously, wasn't going to fly. So Meyrowitz chartered three private planes, ordered the entire UFC menagerie aboard, and airlifted everyone south. They arrived in Dixie at 4 A.M. on the day of the fight. Bruce Beck, the voice of the UFC, recalls walking down the aisle of the plane doing his prefight interviews. "We were the band on the run," he says. "Every time there was a card, you could bet there would be some complication, some political battle." Though the small arena in Alabama was only partially filled, no one at home knew the difference, and the pay-per-views were unaffected.

It wasn't that the critics and clamoring politicians were necessarily wrong. Watch a video of the first few UFC events, and it's striking how little they resemble those of today. Observing the head butts and tufts of hair being pulled out, one can't really disagree with phrases like "morally indefensible." If some of the fighters were top-tier athletes, there were also the 600-pound sumo wrestlers and the big-bellied brawlers who undercut the sport's credibility. The absence of weight classes was troubling, and so was the tournament format, which demanded that a fighter with, say, a broken nose reenter the Octagon for a second time or else forfeit.

Perhaps the most grotesque part of the early UFC was the marketing. The organization unapologetically peddled the burlesque of violence, the rage, the blood, even the chance of death. The UFC hired a fancy Manhattan public relations firm, and one of its "selling points" was to note that the sport was banned. When you push your product as

"the world's bloodiest sport," as one UFC knockoff organization did, you're begging for trouble. The fighters didn't help either. One clip the critics circulated featured an unidentified winner characterizing his "tactics" as follows: "I was hitting him to the brain stem, which is a killing blow. And when he covered up, I swing back, with upswings, to the eye sockets, with two knuckles and a thumb. There was no other place I could hurt him."

Still, there was something suspicious about all the political outrage. Whenever Meyrowitz debated one of the figures calling for the UFC's abolition, he had a simple question: Have you ever seen no-holds-barred fighting? The responses varied: *I don't need to, to know it should be banned. I don't have such a strong stomach. My state is smart enough to outlaw it.* For all their firm convictions, it was clear that few if any of the opponents had ever actually been exposed to the product they were railing against. They had heard about the Octagon and the head butts and the blood; it offended them viscerally; and that was all they needed to take a position. And that position was politically safe — taking on a band of cage fighters and a New York–based entertainment company wasn't likely to draw much resistance from the constituency.* How many opportunities do politicians have to look tough and risk virtually nothing?

The most vocal critic was John McCain, then a respected Arizona senator yet to act on any presidential ambitions. It was odd that McCain, a libertarian of sorts and a member of the political party in favor of smaller government and free enterprise, would want to legislate the UFC out of existence. Yet there he was, taking up the cause at every opportunity. It was McCain who likened the UFC to "human cockfighting," a phrase that sticks to this day. It was McCain who personally wrote angry letters to governors and mayors in precincts where UFC cards had been held. Before UFC 7, McCain and Ben Nighthorse Camp-

*Theory: Another possible factor in the backlash against MMA: in the mid-nineties, the sport seemed culturally out of place. It might have been different in the eighties, a decade of military buildups that began with the taking of American hostages in Iran in 1979 and ended with the fall of communism. The eighties were full of cowboy boots and muscle and Mike Tyson — that decade could easily have accommodated two men head-butting in a cage. But in the eco-friendly, high-tech, Clinton-era 1990s, cage fighting and the UFC seemed to clash with the national vibe.

bell, a senator from Colorado, wrote the UFC, calling the product "a brutal and repugnant blood sport" that placed participants at risk for "serious injury or even death."

The conspiracy theorists in the mixed-martial-arts world were quick to suggest that McCain, a longtime supporter of boxing, saw the UFC as a threat to his favorite sport. Others have suggested that McCain was acting to protect a big campaign contributor, Anheuser-Busch, a company heavily invested in boxing at the time.* Both explanations are inadequate. The UFC was such a bit player that no one at the time foresaw it siphoning off boxing's market share. The more likely explanation — and certainly the more charitable one — is that McCain was genuinely concerned with the safety of the fighters. He was just misinformed.

McCain's ignorance was highlighted during an episode of Larry King's CNN talk show in late 1995. McCain and Marc Ratner, executive director of the Nevada State Athletic Commission — and, ironically, a future UFC executive — debated Meyrowitz and Ken Shamrock. King kicked off the show as only he can, intoning: "Roman gladiators at battle. Tonight, a look at a frightening new fad that may be coming to your town."

The next half hour was filled with the standard talk-show debate, each side sticking to its script. McCain asserted that the UFC was "so brutal that it nauseates people, even hardened individuals are repelled by this . . . This sport emphasizes blood, it emphasizes injuring or crippling one of the combatants." Shamrock and Meyrowitz — pointedly referring to no-holds-barred fighting by its kinder, gentler name, mixed martial arts — sounded the libertarian theme and trumpeted the safety record.

Meyrowitz recalls that during a commercial break, while chatting with McCain, he asked that the debate not turn personal. He promised not to mention the inconvenient fact that the senator had recently attended a boxing match during which one of the combatants, Jimmy Garcia, had died in the ring. Back on the air after the commercial, McCain himself brought up the boxing tragedy, noting, "But [at least] there was a referee in the ring." The implication was that the UFC had

*What's more, McCain's wife, Cindy, was an heiress who inherited her father's beer distributorship, one of the largest in the country.

no referee, which, of course, was untrue. Before McCain could be corrected, however, the discussion shifted elsewhere.

McCain also claimed that New York's boxing commissioner, Floyd Patterson, the former heavyweight champion, dismissed no-holds-barred fighting as "appalling and repugnant." What he failed to mention was that the dementia and mental deterioration Patterson had suffered as a result of his boxing was about to cost him his commissionership.

The show got weirder when the actor Robert Conrad called in to declare himself a fan of Ken Shamrock and then started hammering McCain. "Balance the budget, John," he said. "Legislating how we live our lives, that I find to be unkind and unnecessary. If Ken wants to get into the ring and compete, with another person willing, that's the American way. We don't need a senator telling us how to live our lives." On it went, neither side persuading the other. Finally King declared a draw. "Garth Brooks, the major superstar in the world of country music is next! Don't go away!"

A version of this same debate was played out in communities throughout the country, including the Quad Cities. On both the Illinois and Iowa sides of the Mississippi, a number of politicians took up the cause against no-holds-barred fighting. Again, after tackling so many controversial issues, here was a chance to score easy points on a safe position. What constituent could voice vigorous objections to banning a sport that encouraged head butts and choking?

Answer: Pat Miletich. Enraged by what he saw as an ill-informed debate, he wrote a letter to the editor of the local newspaper:

I am writing in rebuttal to a Letter to the Editor in Tuesday's editions of the Quad-City Times and all the people who are opposed to "no-holds-barred" fighting. The letter writer states sarcastically, "What a learning opportunity for our young people." What she doesn't know is that her statement couldn't have been more correct. This is what a real street situation looks like.

The main problem I feel for people who oppose this sport is that it's too real. Ask yourself how you would react in this type of situation. You couldn't because you have never been taught how to and I would be willing to bet your children haven't either. Scary thought, isn't it?

The techniques used by myself and Davenport police Officer Mark Hanssen (Brazilian jiu-jitsu) are not intended to injure opponents or attackers, but to simply subdue them so they have no choice but to give up.

I would think opponents of the sport would be happy to know there are police officers like Mark Hanssen who have taken the time to learn these techniques so they don't have to beat someone with their billy clubs or ultimately shoot and kill someone. There was a shooting last summer in which a police officer had no martial arts training and could not defend himself properly and had to kill his attacker with his gun. In my mind the blame for this lies not with the officers, many of whom are good friends of mine, but with the city council and the police chief who won't push for funding proper training for our police officers. Keep this in mind the next time someone is shot by the police.

I also work with many young people, teaching them martial arts techniques. The children I teach are told time and time again that these techniques are not for bullying people but only to be used if their safety or lives are in danger. I also tell them the best self-defense technique in the world is to run if possible. It's a great feeling to see children learn respect for other people, gain self-esteem and confidence and, most of all, improve their school grades through incentive programs we have for our students.

I also would like to point out that no one ever has died in this sport's 85-year history, unlike auto racing, boxing, rodeo, football, etc. So if politicians and citizens plan on banning this sport, I hope they would take a long, hard look at sports where people die or are seriously injured on a regular basis. Just for example, almost 400 boxers have died since World War II.

Pat Miletich, Bettendorf

Editor's note: Pat Miletich is a martial arts instructor and two-time "no-holds-barred" champion.

On a Sunday morning in the spring of 1996, Miletich drove himself to a studio at the Quad Cities NBC affiliate to appear on a political discussion program, *In Focus: A Show About Issues Facing Our Community.* The host, Marcia Lense, the Katie Couric of the Quad Cities, was conservatively dressed in a red blazer. To her right, Miletich wore a hideous

paisley golf shirt, looking as though it had been years since he last wore anything with a collar. His counterpart was Mike Boland, an Illinois state senator and a cosponsor of legislation to ban mixed martial arts.

For Miletich, the debate took on the cadence of a fight. He first felt out his opponent, trying to find weaknesses he could exploit and strengths he needed to neutralize. He attacked early, but with controlled aggression. He was defensive, but not unduly so. He was mindful of what played well and what didn't in the eyes of the judges. As for Boland, who phoned in from the Illinois statehouse in Springfield, it was clear he never expected such a battle.

In his opening remarks, Miletich explained the history of mixed martial arts and compared it to boxing. "A lot of people think boxing is safer because of the gloves, but that actually makes it worse," he said. "The boxers can take more punishment, and that's what leads to so many deaths. If lawmakers are really so concerned with the potential for injury, they should have banned boxing — a sport that's had four hundred deaths since World War II — a long time ago."

Despite never having seen one of the events he was advocating banning, Boland responded by mentioning that in boxing and wrestling, fighters are judged on their ability to accumulate points, whereas in mixed martial arts, the fighters simply seek a decisive win. "You might say [boxing and wrestling] are an art because there are combative skills and it's not an all-out fight," he said. Boland then parroted McCain and asserted, "We outlaw cockfighting and pit bull fighting; why should we allow humans to do this?" He concluded with two economic arguments: "Cutting off oxygen to the brain may result in some long-term injuries that may not appear right away. Well, who takes care of that when this person has to go on long-term care at a young age?" He also made the point that if MMA continued growing, "it's going to have a detrimental effect on boxing, wrestling, and martial arts, and those sports are a big contributor to the economy of Illinois."

Ignoring the absurdity of the last point — if candles are a big contributor to the economy of Illinois, should the citizens not indulge in electricity? — Miletich responded with facts. Sure, boxers accumulate points, but those points are earned by hitting the other guy repeatedly in the head, which is far more dangerous than a flash knockout. And how could mixed martial arts not be considered a combative skill when

most of the disciplines it encompasses are Olympic sports? Was Boland prepared to remove judo from the Olympics since it, too, involved choking? As for health and safety, Miletich said, "There are no injuries from chokeholds. It briefly cuts off the blood to the brain. The person becomes lightheaded and passes out. You let them go, they wake back up." Throwing in a quick body blow, he added, "Mr. Boland is an educated man, I'm sure, but in this particular field, he knows nothing."

The politician repeated concerns about injuries but had little follow-up when Miletich stressed there had been no deaths. In retreat mode, Boland admitted he might be amenable to compromise if fighters took safety precautions, "such as mouth guards." Miletich gently informed the senator that fighters were already wearing mouth guards and steel protective cups. Given the last word, Miletich ended with a fugue: "I would hate to think our fate would be decided by a bunch of people who know nothing about this sport."

As Miletich shook the host's hand and removed his earpiece, it was clear that, as far as televised debates went, his record now stood at 1–0. Not that it did much to persuade legislators. The bill passed the Illinois House by a vote of 98–8 and the Senate by a vote of 52–2. Jim Edgar, the Illinois governor at the time, signed the bill soon thereafter. "Ultimate fighting is violent, and it is dangerous to participants," Edgar said in a written statement. "It's no-holds-barred street fighting, and we do not need to promote this kind of violence with the youth of Illinois."

For the UFC, all of this swirling controversy began as a mixed blessing. It was no fun having politicians refer to your sport as "barbaric," "animalistic," and "amoral," comparing it to cockfighting and spectacles fit for the Roman Colosseum. It wasn't cheap or efficient to hire lawyers and lobbyists to confront athletic commissions and legislatures and city councils. On the other hand, the turmoil had the effect of killing off some of the rival organizations that had been opportunistically springing up to challenge the UFC. And, like anything controversial or on the cutting edge — hip-hop music, avant-garde art, the novel *American Psycho* — the blowback inspired curiosity. It gave birth to a counterculture of fans who began congregating on the Internet and only became more passionate when the sport was ripped by mainstream politicians and the media. Particularly when your market was mostly boys and young men, you could scarcely buy better pub-

licity than stiff politicians and columnists railing against your "extreme" sport.

Besides, the real revenue stream wasn't from attendance but from pay-per-view sales. The UFC could — and in fact did — hold a card anywhere, even outside the United States if need be. Attendance was almost irrelevant. As long as between 100,000 and 300,000 fans each paid $19.95 to watch the broadcasts — SEG usually took about 40 percent — and thousands more bought videos and DVDs of them, the organization was minting money.

It wasn't until McCain and the other critics got smart and pressured the cable systems that the UFC nearly got the life choked out of it.

7

THE CULT OF PAT

WE'VE ALL BEEN BLESSED WITH GOD-GIVEN TALENTS.
MINE JUST HAPPENS TO BE BEATING PEOPLE UP.
— SUGAR RAY LEONARD

FOR YEARS, as Miletich practiced in solitude, the rewards and the validation came from within, not from others. Even when he won an American Muay Thai championship in 1995, it barely rated a mention in the local newspaper. That was fine by him. He never had an interest in, much less the expectation of, notoriety. As long as his friends and his mother supported him, that was plenty.

But when he kept winning fights in the mid-nineties, he'd come to be regarded as a conquering hero in the Quad Cities. Almost in a classical way, he was a gladiator who represented the region with pride and honor. When he won a fight, it was as if the whole hometown had won. That Miletich reflected the local character — industrious, hard-nosed, scrappy, durable, distrusting of glamour — only boosted his popularity. He was becoming the closest thing the Quad Cities had to a pro sports franchise.

Soon the area's television and radio stations started calling, inviting Miletich on the air. His various fights began to warrant coverage in newspapers across the state of Iowa, a bonus to John Miletich, who could now follow his kid brother's fighting career from his prison cell. Pat's mystique also grew through word of mouth. He was teaching karate classes to the kids of the Quad Cities' movers and shakers. The doctors and lawyers and businessmen could see for themselves that this no-holds-barred fighter was hardly a derelict just released from a holding pen. Thanks to his friendship with Mark Hanssen, Miletich was on good terms with the area's police departments and was invited to instruct the men in blue in hand-to-hand combat. Old high school classmates would stop him on the street. If it wasn't quite Rocky Balboa

joined by Philadelphia school kids on his training runs, the sight of Miletich doing his prefight roadwork triggered honks of encouragement from motorists and yells of "Go get 'em, champ!"

Beyond the Quad Cities, Miletich's name was also spreading through the mixed-martial-arts community. It was the dawn of the Internet, and any fan with a browser and a decent connection eventually caught wind of the guy in Iowa endowed with wrestling skills, a karate black belt, a jiu-jitsu black belt, unmatched toughness, and an insane appetite for training.

Above all, Miletich was a master at melding these fighting forms. He knew just how to shift from boxing to jiu-jitsu to wrestling and back again. As if he had some sort of internal GPS, he knew exactly where to take a fight. He also had a bloodhound's nose for an opponent's weakness.

Soon aspiring fighters were trickling into the karate studio with hopes of training alongside Miletich. Steve Rusk was probably the charter member of the Cult of Pat. A stocky kid from the other side of the river, Rusk had recently finished a successful wrestling career at the University of Illinois. Rusk knew that, even in a best-case scenario, he had a limited future in wrestling. He could try to make the Olympics, but the odds of that were slim. And the money was nonexistent. He could try to become a professional wrestler, but that didn't suit him either, not with the emphasis on hype and predetermined outcomes. But this new mixed-martial-arts sport, now that intrigued him.

Around the same time, a gangly Nebraskan, Jeremy Horn, took an interest in Miletich. Horn resembled a paperboy, a clean-cut kid with an upbeat personality. He played no sports in high school and never considered himself an athlete, but he taught himself jiu-jitsu and cultivated a jones for fighting. He was working a construction job in Omaha when, on a lark, he entered the Quad City Ultimate II event in May 1996. He lost to Hanssen by submission, but he'd been seduced. He didn't want to give up his job in Omaha and the steady income that came with it, but he was willing to commute to Bettendorf on weekends to train. *How,* Miletich asked himself, *could I say no to a guy willing to drive clear across the state of Iowa to work with me?*

Shortly after that, Jens Pulver, a lightweight, arrived. One of Pulver's eyes was brown and the other blue, a perfect metaphor for a fighter

who freely admitted to having multiple personalities. Other fighters had soft and sensitive natures at odds with their ferocity in the cage, but in Pulver's case the contrast was particularly stark. Pulver was easily reduced to tears, often when describing the abuse he said he received at the hands of his father, a jockey in the Pacific Northwest. Then he'd throw on a pair of gloves and shove a mouthpiece under his gums, and any trace of sweetness or vulnerability would vanish.

Miletich wasn't just advising his fighters, explaining how to use leverage to avoid a kimura or telling them that "pain is weakness leaving the body." He was right there on the mat, coated with sweat, bleeding right along with them. He had a natural authority and ability to teach. But he also led by example. It was as if Bob Knight weren't just the Indiana Hoosiers' authoritarian coach but the team's point guard as well. As for Miletich, he was happy for the company. "I was training to become a world champion," he says. "Far as I was concerned, the more young guys I had to spar with, the better."

Probably because he was the youngest sibling, the runt of the family, Miletich never perceived himself as a natural leader. But now, that's precisely what he was. Part of that authority came from his sheer fighting ability. Much more of it, however, derived from his dedication, his training, his belief in the *process* of fighting. It was evident to all that Miletich was much more than a coach. To many of his fighters he became an ideal. He would bend the brim of his ballcap and soon everyone else would do the same. He would use a certain phrase and suddenly everyone else would adopt it. Says Rusk: "Just being with Pat, you sorta get this sense of purpose. It's weird."

As the Cult of Pat expanded, it became clear that Miletich was outgrowing the basement of the karate studio. He was torn between loyalty to the sensei who'd introduced him to martial arts and a deep desire to strike out on his own. Miletich finally decided to cut his ties to the karate school and the instructor. "I'm starting my own gym, guys," he told his minions. "Whoever wants to come, come, and whoever wants to stay, stay." And with that, the karate school lost its best fighters and the Miletich Fighting Team was officially born.

In truth, Miletich's new gym wasn't a gym at all. After leaving the karate dojo, Miletich made a deal with the owner of a Bettendorf health club, Ultimate Fitness. For a few hundred bucks a month, he would rent

a racquetball court that was going unused and transform it into a private "battle box." It was a cramped space, accessible only by a small door. Just getting inside the damn thing taxed the flexibility of the heavyweight fighters. The court contained three walls and a mirror, often befogged because of the humidity and collective body heat.* Within a day, the wrestling mat, glazed with sweat and blood, reeked of male body odor. The Iowa housewives there for aerobics classes made no secret of their disdain for the "crazy fighters" who occasionally trailed blood back from the drinking fountain. Still, it worked. What would eventually be an all-star team of UFC fighters arrived daily to train, spar, lift, learn — and, on occasion, leave sessions in an ambulance.

At a time when personal training had gone high-tech and up-market — a quick glance around Ultimate Fitness revealed an array of workout machines, most hooked up to television screens and telemetry monitors — Miletich was unmistakably old school. Instead of messing with Nautilus machines, the fighters lifted free weights and hit the pull-up bars and skipped rope. They worked out with medicine balls, metal sleds, Russian kettledrums, and Indian clubs. There was nothing in the racquetball court that suggested it was a day beyond the turn of the twentieth century. Maybe even the nineteenth century. "Functional fitness," Miletich called it.

The fighters were generally built in Miletich's image. They hailed from anywhere, from Maine to Alaska, but most had a background in wrestling and what those prone to cliché might call a "blue-collar work ethic." Like the Iowans engaged in tilling or detasseling corn or working the assembly line at the John Deere or Oscar Meyer plants, the Miletich team engaged in similar honest drudgery, learning and repeating moves until they became as burned in muscle memory as walking. In keeping with Miletich's metaphor of the stool that's only as strong as its weakest leg, fighters were expected to spend most of their time working on their deficiencies.

Just as Miletich trained like a manual laborer, the fighters followed suit. You show integrity in your workout. You look suspiciously at risk-taking. You prepare meticulously. You enter the cage or the ring with a

*If you wanted to guarantee yourself a heaping ration of shit from the other fighters, you preened at your reflection.

well-conceived fight plan, but you reserve the right to adjust it midfight. A favorite catch phrase: "You don't get broken arms and concussions from being a bad fighter, you get them from being a sloppy fighter."

Like all tribes, the Miletich fighters came to share a way of talking, a fashion sense, a diet, and values. They all ate the same version of Miletich's "fighter's diet," a Jack Sprat special consisting mostly of oatmeal, eggs, and skinless, boneless chicken. There was a clear hierarchy, with Miletich at the top. There were never any formal rules or a written contract or a cheesy mission statement, but a distinctly spartan code quickly hardened. Fighters were expected to take their lead from Miletich and train like maniacs. "You sweat so you don't bleed" became an unofficial motto. They were expected to keep their complaints to a minimum — no one was in perfect physical health, so you got no sympathy complaining of soreness or nagging pain. On one of his first days at the Miletich camp, Joe Jordan, an aspiring fighter from Kentucky, cut his eye while sparring. He figured he would need to leave and get it stitched up. "Where you think you're going?" Jens Pulver asked. Other fighters helped seal Jordan's cut with Krazy Glue. Then he resumed sparring.

Another part of the code: while internecine warfare might make for a better fighter, once the sparring session ended, your opponent was your teammate. If he needed a ride, you gave it to him. If he needed a place to crash, you offered him your floor. If he needed money — as most everyone did — you tried your best to lend it. If he had an upcoming fight in the area, you cleared your social calendar and got your ass there to support him. In what would later become a problematic mandate, two Miletich disciples would never take a fight against each other. No matter how much money was on the table.

During one heated sparring session, two fighters began talking trash and then fighting for real. Miletich broke them up and, red-faced with anger, explained that if they were so undisciplined and hotheaded that they would try to hurt a teammate, they were hopeless prospects.

"But he clipped with a cheap shot," one fighter complained.

"So you hit him back?" Miletich bellowed. "An eye for an eye and you both end up blind." With that Gandhian speech, he walked away.

In the gym, the students were expected to be teachers: Jeremy Horn would lead a jiu-jitsu workshop; Steve Rusk, the All-American wrestler,

would offer tips on takedown defenses; Miletich would give a Muay Thai seminar. In his excellent book about the combat arts, *A Fighter's Heart*, Sam Sheridan writes about the time he spent at Miletich's gym: "In MMA there are no grand masters, no belts, no fixed ranking systems. Knowledge is shared, so good strikers work out with good grapplers, and they teach each other . . . They were willing to take knowledge from anywhere."

There was also an unspoken recognition that Miletich had a reputation — in the Quad Cities and in the realm of MMA — to uphold. Occasionally Hanssen mentioned to him that one of his law enforcement colleagues had had a run-in with a fighter on the street. That fighter was put on notice: "another fuck-up and he could pack his bags." Once Miletich got word that a fighter had smacked his girlfriend. Miletich made it a point to spar with the offending fighter the following day. He put such a severe beating on the guy that he didn't come back. Message sent.

Miletich was breaking training in early 1998, settling in at a Davenport bar, when he heard giggles. He turned to see another patron pointing at him and laughing. Ordinarily this would have triggered a familiar choreography: (1) finish off remaining beer, (2) remove wristwatch, (3) roll up sleeves, (4) cock fists, (5) start blasting. But by this time, the intense, aggressive anger that had defined Miletich for so long had slipped away. Plus, the unruly patron was an attractive brunette resembling a petite version of the actress Minnie Driver. She continued pointing and, in a French-Canadian accent, shrieked, "What's wrong with your ears, man?"

The woman's boyfriend immediately recognized that his date was trash-talking Pat Miletich, the single baddest badass in Iowa. Nearly incontinent with fear, he was unable to explain the nuances of cauliflower ear, so he simply stammered, "That's Pat Miletich!" The woman, having had a drink or three, continued. "I don't care who he is. What's up with those ears?"

Lyne Bergeron had come to the Quad Cities from her home in Quebec in the summer of 1996 and vowed to return to Canada the day she graduated from Palmer College of Chiropractic. She had nothing

against Iowa per se; it's just that she felt as though she had been dropped on another planet. The daughter of a successful Montreal businessman, she was a sophisticated French Canadian, raised in a region that felt more European than North American. Suddenly she'd been transported to the belly of America, a land of pickup trucks, cornfields, manufacturing plants, big box stores, and all-you-can-eat buffets. As she stood in the bar, staring at this man with his low-riding baseball cap, puffy muscles, and deformed ears, her culture shock crystallized.

Finally Miletich responded. "Where'd I get these ears? They were burned in a fire. Is that funny?"

"Oh, my God," Lyne said. "I'm so sorry."

As if he were in an MMA fight, Miletich had gained leverage and put his counterpart on the defensive. But he loosened his grip. "No, I'm just kidding. I got these wrestling." He then launched into an explanation of cauliflower ears. How athletes — wrestlers in particular — are susceptible to ear injuries. How fluid builds up in the ear, the cartilage wastes away, and the outer ear becomes hard and deformed. How the ears can be drained, but the look is something of a badge of honor in Iowa, the mark that says you once wrestled.

When he sensed that his new friend was either bored or disgusted, he bailed out. "You asked me where I got these ears. Well, where did you get those legs?"

As Bergeron explained that she had been a competitive figure skater, she wondered why her boyfriend wasn't offended by this other man complimenting her legs. But she kept talking, telling him that knee injuries had derailed her skating career and led her to want to become a doctor. Which is how she ended up at a chiropractic college in eastern Iowa. By the end of the conversation — her boyfriend having faded into oblivion — she had agreed to come to Miletich's gym and take a kickboxing class.

Miletich gathered the courage to ask Bergeron out. His truck was on the injured list, so he asked a friend to chauffeur them. Miletich decided to impress his date by taking her to a Toughman contest in Burlington, Iowa. As they walked into a fairgrounds amphitheater, Miletich was mobbed. Everybody wanted to pose for photos with him. A woman asked him to autograph her bare chest. The referee in the ring saw him and said, "Hey, champ."

Different as they were, Lyne was oddly attracted to Miletich. He was nice-looking and had the body of an elite athlete. Above all, he just seemed so real.

Soon she called her parents to tell them about her new love interest. "What does he do, Lyne?" they asked.

"Um," she said, "he's one of those cage fighters."

The following day, Monsieur and Madame Bergeron flew from Montreal to Iowa to pay their daughter a surprise visit.

By late 1997, the political battles surrounding the UFC, which began as minor annoyances, became a crush. Every card seemed to be accompanied by a legal threat and some public relations controversy. Unfortunate and time-consuming as these were, the UFC could always find another jurisdiction. The real problems came when John McCain, who sat on the Federal Communications Commission, used his influence to pressure the cable companies to remove Ultimate Fighting from their pay-per-view offerings.

When Leo Hindery, a self-described "Colorado cowboy," took over as president of TCI, one of the country's largest cable systems, he announced that he had two initial goals. The first was to find out where the restroom was located. The next was to get Ultimate Fighting off the air. Time Warner and the conglomerate On Demand soon followed suit. As one media industry analyst described it, "If you were going to be fighting battles with government regulation and the FCC, do you really go to the mat to defend your right to show cage fighting?" Soon, many of the same cable systems that had no moral hang-ups about airing pay-per-view porn beat a hasty retreat from selling the UFC.

By the start of 1998, the UFC's pay-per-view profits were in free fall. Cards that previously generated 300,000 pay-per-view buys were now lucky to get 30,000. Starting with UFC 23, in 1999, the UFC entered a kind of dark age. Its hard-core fans still prowled the Internet and, in retrospect, did more than anyone to keep the sport alive. But when an organization loses 90 percent of its revenue stream, it's not going to survive much longer.

A connected insider in the telecom world, Bob Meyrowitz says he repeatedly asked cable chieftains, "What do we do to get back on the

air?" One of the few concrete responses he received was "You need to get regulated in a big state."

With the UFC bleeding money and desperate for sanctioning, it was forced to make rule changes that would dial down the violence. First among them was adding weight classes. The long-departed UFC pioneer Rorion Gracie had always deemed weight classes to be beside the point. He contended that an organizing principle of no-holds-barred fighting was the complete absence of restrictions. "If David can never fight Goliath, how do we know who's better?" he says. Meyrowitz had more practical reasons for disliking weight classes. To him, the entertainment value came from the sequoias, not the saplings. No one wants to see the little guys, he would tell his underlings. The bigger they come, the harder they fall.

Now that view had to be reconsidered. To curry favor with state athletic commissions, the UFC tried to make its rules conform to those of boxing. And a big part of this meant establishing a range of weights. To the uninitiated, at least, fighting is seen as less barbarous when guys pick on someone their own size.

This was fine with John Perretti, the UFC's matchmaker at the time. A combat sports purist, he'd always favored matching up like-sized fighters. As we have seen, he and others attributed Royce Gracie's early dominance of the UFC to "purposeful mismatches," and cringed at seeing rippled 190-pounders mauling plodding sumo wrestlers. "Those fights are jokes and they diminish your credibility," he said. "The two guys in there ought to be roughly the same size." Now that Perretti's bosses were reluctantly agreeing to hold a lightweight tournament on the next card, Perretti recalled "that tough son of a bitch from Iowa." He had been impressed when he'd watched Miletich in small shows, so he called Monte Cox, a Quad Cities promoter who was also managing Miletich.* Would Miletich be willing to fight in the UFC 16 show, "Battle in the Bayou," on March 13, 1998?

For his first thirty years Miletich had gotten the business end of life. His dad had beaten up his mom before splitting. He had carried the coffins of two brothers, and a third was "on vacation" in an Iowa prison.

*Their business arrangement was simple: Cox wouldn't accept a manager's fee until he got Miletich his first fight in the UFC.

His mom was ailing. His sport was embattled, in danger of being legislated out of existence. His finances were too meager even to be considered a joke. But on a bitterly cold day in the winter of 1998, Miletich at last got a blast of good news. It was the call he had been anticipating for years. He was finally getting his chance to fight in the UFC. Then, as now, of all the fighting organizations, the UFC was king. This was the equivalent of a pitcher's call-up from triple-A to the major leagues.

Miletich called Mark Hanssen to tell him the news, and, hard as he tried to play it cool and camouflage his excitement, emotion crashed over him like a wave. "Hey, buddy," Miletich said. "I'm in . . ." The rest of the words were slow in coming. It had been more than ten years since they had fought to a draw in Duck Creek Park, and since then they had become inseparable. It was never articulated, but both men instinctively knew that Hanssen was the closest thing Miletich had at the time to a brother. As he shared the news with Hanssen, snapshots played like a documentary in Miletich's head. Fighting in baseball fields and entering demeaning Toughman contests and foraging for dinner in dumpsters and worrying daily about Mom. "I'm . . . in the UFC."

The conditions weren't perfect. Miletich would have to shed some weight to make the 170-pound limit. The format was an elimination tournament, which requires competitors to ration their energy and fight several times a night. Financially, the UFC's offer was a modest "five-and-five." That is, he would be paid $5,000 to show up and another $5,000 if he won.

Miletich spent the next two months training as though his salvation rested on the outcome of the fight. He'd wake up early, throw on a ski cap, and sprint up "the Hill," the massive incline that rose above the Mississippi. He'd spar daily, replacing partners when they tired or doubled over in pain. He'd break for lunch or to give a private kickboxing lesson, to put gas money in his pocket. Then he'd return for another training session in the afternoon. After dinner, he'd go for another run, this time for distance.

The parlor game at the gym became Who Can Keep Up with Pat the Longest? "We knew we couldn't match him," says Jeremy Horn. "But we'd come back and say, 'I hung in there with him for twenty minutes this time.'" Among his charges, Miletich had the presence of a Bob Knight or a Vince Lombardi, an eminence whose authority was unques-

tioned. But there was this vital difference: he wasn't pacing the sidelines; he was sweating and bruising and bleeding just like everyone else.

Whenever Miletich started gasping during a sparring session or felt as if cinderblocks were tied to his legs as he ran past the Alcoa plant or the Riverboat casino, he could always locate inspiration. In his eyes, the fight was a sort of fulcrum for everything in his life. The future of the promising academy he'd started. The family name that had taken its beatings in recent years. The chance to provide his mother with some much-deserved, long-overdue happiness. Whenever anyone asked what really drove him, he had the same answer: "I want to see my mom smile." There was something almost funny about a ferocious cage fighter doing battle to make mommy happy. But to Miletich it made all the sense in the world.

Just as his training was peaking — his temperamental relationship with good fortune being what it was — doubts arose as to whether he would make it to New Orleans, the site of UFC 16. Rolling around in the tight quarters of the racquetball court, Miletich was wrestling with Horn one afternoon. The best fighter at the gym after Miletich, Horn had recently fought former world champ Dan Severn to a draw in Extreme Challenge, and would shortly thereafter beat the great Chuck Liddell. On this day, Horn had Miletich pressed up against a wall when another pair of grapplers going through their paces came tumbling into Horn and Miletich's space. One of the grapplers pinned Miletich's right knee against the wall and it buckled. His keening scream of "Fuuuck!" resounded off the walls. It was less a commentary on the pain than on the potential lost opportunity.

Fearing the worst, Miletich limped out of the gym and into his truck, physically ill over the prospect of having to withdraw from UFC 16. When the knee didn't feel any better after a few days (and countless ice-downs), he visited an orthopedic surgeon. The doctor examined the knee and told Miletich that with three months of rehab he would likely feel better. "Afraid that's not going to work for me, Doc," Miletich said.

At the suggestion of Lyne Bergeron, Miletich went to a Quad Cities chiropractor. "Does it hurt?" the man said, bending Miletich's knee.

"Hell, yeah, it hurts," Miletich said.

"I think your tibia is halfway out of the socket."

The chiropractor manipulated Miletich's knee and nodded. "That

should feel better. Stay off this for a few weeks and you'll be good to go." Sure enough, the soreness eased almost immediately. The next day, Miletich was back to running the Quad Cities roads in the snow and putting in three workouts in the days before UFC 16.

Miletich was lucky if he was clearing $1,000 a month at the time. The guaranteed $5,000 and the possibility of $10,000 in one night wasn't going to deliver him from dire financial straits, but it would enable him to fend off the bill collectors yet again. Miletich looked at it differently. This was the UFC, the Olympus of mixed martial arts, and he wanted to share the experience with as many people as possible, even if he had to blow his payday on airfare. So it was that the fighter, his manager (Cox), his best friend (Hanssen), and, naturally, Mona Miletich boarded a flight from the Quad Cities to New Orleans.

The main attraction of UFC 16, "Battle in the Bayou," was Frank Shamrock. A tanned Californian with superhero muscles and movie star looks — notwithstanding a small ball of cartilage for a nose, which looked as if it had been stuck on his face like a hunk of coal on a snowman — Shamrock belongs on the Mount Rushmore of MMA fighters. At the time he was an ascending star, emerging from the considerable shadow of his "older brother" Ken.

Shamrock had a backstory fit for Hollywood. Born Frank Alisio Juarez III, he had a brutal childhood. When Frank was three, his father split. The kid spent a good part of his childhood pinballing from one group home to another. At thirteen, he was taken in by Bob Shamrock, a saint of a man who devoted his life to welcoming troubled boys into his Susanville, California, group home. Dozens of similarly troubled kids lived at Shamrock's Boys Ranch, including Ken Kilpatrick, a scrappy runaway from Georgia who'd recently been stabbed in a fight. By necessity, Bob was a sort of benevolent despot, running the ranch by imposing his own inviolable rules, but doing so for the kids' benefit. (At one point, Bob figured that more than six hundred boys had spent time at the ranch.) Whenever a conflict arose, provided both parties were willing, Bob let the boys strap on boxing gloves and settle it in the back yard. In the late seventies and early eighties, Ken Kilpatrick had gener-

ally been considered the toughest kid on the property. When he left to begin a professional fighting career, the honor fell to Frank.

When Ken was eighteen, he was legally adopted by Bob and changed his surname to Shamrock. He discovered first pro wrestling and then Pancrase, and became known as "the World's Most Dangerous Man." Though eight years younger, Frank followed almost the identical path. He too was formally adopted by Bob and took the Shamrock name. After leaving the ranch, Frank began a fight career, training at the Lion's Den, the California dojo Ken had founded, known for its grueling regimens, including sprinting while carrying another fighter on your back. Like Ken, Frank first gained traction in Japan as a Pancrase fighter, a mixed martial art that emphasizes submission and forbids closed-fist punching to the face of grounded fighters. Adding to the symmetry between Frank and Ken, they even looked like biological siblings.

Shortly after joining the UFC as its matchmaker, Perretti seized on an idea: he would try to legitimize mixed martial arts by having an MMA fighter do battle against a traditional wrestler. In late 1997, the UFC 15 card, in Yokohama, Japan, featured a fight between Frank Shamrock and Kevin Jackson, winner of a 1992 Olympic gold medal in wrestling and a world championship in 1993 and 1995. "If UFC isn't legitimate, an Olympic gold medalist should have his way with a Pancrase fighter, right?" Perretti asked. The Shamrock-Jackson fight couldn't have been better if it had been choreographed. Jackson lunged at Shamrock. All too happy to give up the takedown, Frank executed an armbar and Jackson tapped out after sixteen seconds. With this fight the UFC earned a new measure of credibility. And Frank was no longer known, first and foremost, as Ken Shamrock's little brother. He was a star in his own right.

In a plot worthy of classical drama, Frank's success brought turmoil to the House of Shamrock. Frank asserted that Bob had always shown more support for Ken and hadn't lavished enough praise on his, Frank's, skills. Ken responded that Frank ought to show more respect for their father. Bob sided with Ken. Frank implied that Ken was jealous because his younger brother was eclipsing his fame. Soon Frank left the Lion's Den and was speaking openly about the prospect of fighting against Ken, stressing that he and Ken weren't real brothers anyway.

As if the plot needed more thickening, when Frank showed up for UFC 16 in New Orleans, he saw that three of Ken's protégés from the Lion's Den were on the card. One of them was the lightweight Mikey Burnett, an exceptionally strong boxer, college wrestler, and competitive power lifter from Oklahoma who Miletich suspected might be his biggest threat. Though Burnett would later reveal that he was addicted to drugs and alcohol at the time, he was a striking physical specimen. He was only five-six but was capable of dead-lifting 600 pounds and bench-pressing more than 400 pounds. When he removed his shirt, he showed off a full complement of bulging muscles. With his shaved head and red beard and mustache, he resembled nothing so much as a leprechaun who lived at the gym.

After discovering MMA, Burnett ventured from his home in Tulsa to the Lion's Den. Though he survived the initiation, he was hazed brutally. He recalls cooking dinner for the other fighters and having Ken Shamrock approach him from behind and choke him unconscious in the middle of the floor. *Aside from that, how was dinner?* Other times, Shamrock would wake him at five in the morning and declare, "I'm going to fuck you up this day," which made it difficult for Burnett to get back to sleep. Sometimes Shamrock *would* beat his ass. Sometimes he would joke around about the threat and then forget about it. "It was pretty much hell," Burnett recalls. "On the other hand, all the psychological warfare, all the beatings, all the tension that comes from five or six tough guys living under one roof — when the fights came, they were almost a relief."

At UFC 16, the other tribalists from the Lion's Den rabidly cheered for Burnett when he took on Eugenio Tadeu, a Brazilian jiu-jitsu, *vale tudo,* and *luta livre* specialist shaped like a trash can. In his previous fight in Brazil, Tadeu had battled Renzo Gracie, the gregarious Brazilian who introduced Miletich to jiu-jitsu. It had been an electric fight, filled with strategic shifts, desperate escapes, and swings in momentum. As one message-board poster colorfully recalled, "The crowd fell just short of autofellatio in expressing their excitement."* After nearly fifteen minutes, an exhausted Gracie sat on the mat, refusing to rise and beckoning

*Gracie would later recall that every time he was pushed against the fence, Tadeu supporters would reach through and jab him.

Tadeu to grapple. When an argument ensued, fans blitzkrieged the ring. With the fighters doubled over from exhaustion, fans threw cups of ice, then chairs, then punches. The fight — a seminal MMA contest — was called off. The official record reads: "No Contest; Fans Rioted." To this day, Gracie jokes that the biggest achievement of his mixed-martial-arts career was making it out of that arena alive.

While there was no such riot in New Orleans, Tadeu's fight against Burnett was similarly exhilarating. Almost like a slapstick routine, they flew at each other as if dynamited. When one man punched the other, the recipient would recoil and then fire back himself. At one point, Tadeu caught Burnett in a triangle hold and Burnett's shaved head turned the color of a strawberry milkshake. But Burnett escaped, and soon Tadeu was eating punch after punch. If the lightweights didn't throw the concussive blows of the big guys, their speed and superior conditioning more than compensated. The first fight of the UFC's "lightweight era" hadn't ended and already the little guys proved to be just as entertaining.

After nearly ten minutes of trading bombs, Burnett caught Tadeu with a flurry of stiff uppercuts, garnished with knees to the face. When the referee waved off the fight, Burnett reflexively sprinted at Tadeu and the Brazilian's corner, not to continue brawling but to offer a clumsy, exhausted hug of respect. It happens all the time in MMA: in a matter of seconds two men go from combatants to comrades. Sharing the intimate act of fighting can do that.

Burnett accepted slaps from his Lion's Den stablemates, who repeatedly yelled, "You're beautiful, man, you're beautiful." Even Frank Shamrock rushed over to congratulate Burnett. After taking a few moments to collect himself after the TKO, Tadeu wobbled away from the Octagon, looking like a man caught on a suspension bridge in a hurricane. He had to be held up by his entourage, and as soon as he had passed the television cameras and safely entered the dressing room, he collapsed from exhaustion.

It was about then that Hanssen sidled up to Miletich. "Pat, you're up. Let's go to work." Staring at his reflection in the dressing room mirror, Miletich looked like a modern-day caesar. His close-cropped hair hugged an impossibly round head. His small mouth was ringed by a goatee. As he walked from the arena's bowels to the fighters' entrance

area, he was overcome by a new emotion: runaway nervousness. Previously, even before the biggest games and wrestling meets and fights, against the most fearsome opponents, he had always felt almost immunized against pressure.

Yet here he was, minutes from his long-awaited UFC debut, and his body seemed to be turning to jelly. The emotion only intensified when he made his way into the Octagon. The strain of bugles — the cornball, vaguely medieval-sounding entrance music for all the UFC fighters — pierced the air. There were bright lights and television cameras and thousands of fans. The perimeter of the Octagon was filled with ring-card girls, a few journalists pecking at laptops, and hairsprayed officials. By the time Bruce Buffer — who had replaced his brother, Michael, as the UFC's ring announcer — introduced this "jiu-jitsu and Thai kick-boxing specialist from tiny Bettendorf, Iowa, PAAAAAAATTTTTTTT MMMMMMILLLLLLL-AHHHHHHH-TICHHHHHHH," the fighter was practically hyperventilating.

Here at last was the moment he had been anticipating for years — and the moment was kicking his ass. Instead of thinking about winning the fight, Miletich was thinking about all that was on the line. When he entered the cage and heard the gate lock behind him, he had half a mind to climb out.

Sensing that something wasn't right, Hanssen pressed Miletich's face against the Octagon fence and stared intently at his buddy. Instead of delivering an emotional, inspiring pep talk, Hanssen took a calm approach. "Just relax, Pat," he said in conversational tones. "Relax and you'll be fine. You know what you're doing, so there's no need to worry about anything." With that, the knot in Miletich's stomach untied itself.

Whatever chemical rush fighters experience when they enter the Octagon, it's rivaled by the surge that overcomes their friends and family. The wives who attend their husbands' MMA fights are often easy to spot. They're the ones leaking tears and watching through their fingers while straining their larynxes. The exercise of standing idly by while a loved one risks life and limb (and sometimes gets washed in blood) isn't for the faint of heart. Which is precisely what Mona Miletich — a few weeks removed from another coronary procedure — was. Yet there she was, surely the only grandmother in the building, a few rows back from the cage, watching her youngest son go into battle. Her inner Iowa prag-

matist surfacing again, she resolutely told herself that if he was going to fight, she was going to be there, and she'd "have to deal with the emotions as best I can." She'd always tried to make it to the fights, and this, after all, was her youngest son's big moment.

Miletich's opponent in his first fight was Townsend Saunders, a 170-pound block of granite who represented the ongoing improvement in the caliber of athlete drawn to mixed martial arts. No back-alley fighter, Saunders was new to administering and absorbing physical pain. However, calling Saunders a world-class wrestler would have been selling him short. He had taken the silver medal at the 1996 Olympics and was the reigning gold medalist at the Pan Am Games. If you saw Saunders enter the Octagon — his arms and legs laced with veins, his body fat negligible — you wouldn't imagine he was participating in the same sport as balloonish sumo wrestlers and beer-bellied bar fighters on the order of Tank Abbott.

When Miletich heard that Saunders would be his opponent, the news triggered mixed feelings. He was awed by the guy's Olympic pedigree. *I'm going up against a friggin' silver medalist.* For an Iowa boy, there was no higher place in the sports pantheon than that of a decorated wrestler, and Miletich knew he was going to have a hard time working up any animosity for a guy whose accomplishments he respected so much. Still, Miletich knew that Saunders couldn't possibly have mastered the broad palette of skills that were by now a prerequisite for success. This was the beauty of mixed martial arts. An Olympic wrestling medalist who lacked a stand-up game or the ability to unleash Muay Thai whip-kicks or defend a triangle choke was going to be as severely disadvantaged as a baseball player who could catch and field but had no idea how to swing a bat.

The Miletich-Saunders fight was everything the Burnett-Tadeu battle royal was not. It was tactical, technical, and tempered. The men spent the better part of fifteen minutes locked in stalemates that resembled hugs. The few punches unleashed were short arm punches. The few kicks thrown barely grazed flesh. The few attempted heel hooks were ineffective. Both men spent considerable time in the other's guard, neither able to gain an appreciable advantage. There were no high-speed collisions, no blows for a highlight video, and, consequently, no blood.

Yet in its own way this fight was just as entertaining as the previous slugfest. And for Miletich, his transformation as a fighter was nearly complete. As a street-fighting hellion in Iowa, he was all wild aggression. If he needed to eat a punch to land a punch, well, that was a tradeoff he would happily make. As a professional kickboxer and jiu-jitsu fighter, his aggression was layered with control. Now, fighting in a cage in the UFC — a league that prided itself on rage and anything-goes violence — he was the picture of studied calm. Having finally reached his promised land, Miletich figured that there was too much suspended in the balance to squander it all with a careless mistake. So he fought the most clinical fight imaginable, happy to sacrifice crowd-pleasing fireworks if the payoff was getting his arm raised by the referee at the end.

As the crowd sat restlessly, these two rippled gladiators nuzzled and clinched and locked each other up on the ground. Miletich was happy to get Saunders in his guard, sometimes achieving a full mount, and then controlling him. Saunders was content to do what he knew best, and he grappled. He seemed reluctant to throw punches, fearful that he'd leave himself open to retaliation. Hard as the referee tried to trigger some action — "Stay busy, gentlemen," he implored — the fighters stuck to the ground and intertwined themselves.

After the regulation twelve minutes, and a three-minute overtime, had elapsed, both men were tired, but neither was injured in the least. They hugged in the middle of the Octagon and nodded reverentially at each other. Out of character for such a firm believer in self-determination, Miletich said a quick prayer. And it was answered when Bruce Buffer announced that, by split decision, he was the winner. Miletich stoically raised an arm and hugged Saunders again. Mona Miletich exhaled and pumped a fist as well. Her son had beaten a recent Olympic medalist with his superior battery of combat skills, and he had emerged without a scratch.

Miletich had less than an hour to recover before the title fight, but he caught a break. Burnett, the leprechaun with the forty-eight-inch chest, who had repaired to the locker room after his titanic battle against Tadeu, had begun to vomit from exhaustion. He had also broken a finger. He was in no shape to fight again. So it fell to an alternate to take his place, a fairly common occurrence under the early UFC's tournament-style format. Instead of facing Burnett for the title,

Miletich would be pitted against a familiar opponent, Chris Brennan, a scrappy fighter best known as a sparring partner of Royce Gracie in Southern California. Brennan and Miletich had fought twice before in Extreme Challenge events, Miletich winning once and fighting to a draw the other time.

Brennan's admirable credo was "I'd rather lose an exciting fight than win a boring fight." But on this night he lost a boring fight. When he reentered the Octagon, Miletich was still depleted from his fifteen-minute war against Saunders. But since so little time had elapsed, his adrenaline high hadn't worn off. Without contending with his nerves, he took the fight to the ground, holding his opponent in his guard and using his skills and strength and stamina to wear him out. Someone in the crowd cracked that the "Croatian Sensation" should be renamed the "Croatian Sedation." But, again, Miletich reckoned that he was there to win the fight, not win the hearts of those who preferred blood and broken bones to technical expertise.

Around the nine-minute mark, he pinned Brennan against the base of the Octagon and dug his elbow into his opponent's throat. Brennan abruptly tapped out. Meanwhile, most of the crowd was either bored or distracted by a fight between two drunken spectators that had broken out in the stands, a common occurrence at UFC events back then. No matter: Miletich was now the first lightweight tournament champion in UFC history. He left the Octagon and headed straight to Hanssen. They embraced, and there was no need to say a word.

While Miletich's fight was an exercise in precision, the evening ended with base pyrotechnics, a reminder of how horrifyingly violent — and life-altering dangerous — the sport could be. In the middleweight championship bout, Frank Shamrock fought Igor Zinoviev, an expressive Russian whose parents once tried to suppress his urge to fight by sending him to cooking school. Shamrock was, however, on a different plane from Zinoviev. Right after Bruce Buffer had introduced the fighters and exited the Octagon, Zinoviev charged at Shamrock and threw a right hand. Shamrock slipped the punch and picked up Zinoviev by the back of the thigh, as though the Russian were no heavier (or more aggressive) than a piece of furniture. Shamrock then slammed

Zinoviev, who landed awkwardly on his neck and shoulder and lost consciousness. Shamrock would later recall hearing the sound of "a big bag of bones cracking" when Zinoviev hit the mat.

As he had done on other occasions, referee John McCarthy, wishing to prevent tragedy, hurled himself on the ground to break up the fight.* Shamrock had again needed just a few seconds — officially, twenty-two — to win a big fight. With his opponent flat on his back with a broken collarbone, a broken shoulder, and cracked vertebrae, Shamrock preened and climbed on top of the Octagon. Then he walked over to Zinoviev. "I know you'll be back, man," he said. Except he wouldn't. Zinoviev's fighting career was over. Shamrock smiled for the cameras, but he was full of remorse. *I've killed a man and ruined the sport,* he thought.

By then, the Miletich entourage, such as it was, had settled down to a celebratory dinner not far from the French Quarter. They relived the night of fights and speculated on Pat's next UFC opponent. When the first round of drinks arrived, Pat raised a beer bottle. "To my mom," he said, "the toughest Miletich of them all." Damn if Mona Miletich wasn't finally smiling.

*Earlier in the evening, McCarthy had stopped a fight when Lion's Den fighter Jerry Bohlander had grabbed Kevin Jackson's right arm and twisted it between his legs as if he were unscrewing a bottle top. When Jackson protested, McCarthy responded, "I can't stand by and let him break your arm, Kevin."

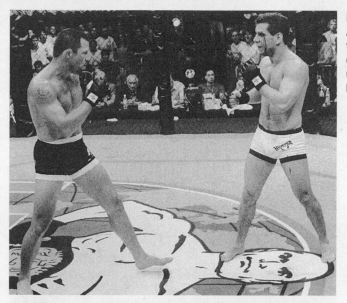

BLOOD IN THE CAGE: At UFC 21, Miletich tags his Brazilian opponent, opening up a gash over his left eye.

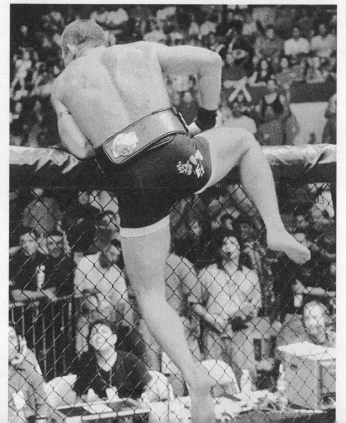

DEFENDING HIS HONOR: Pat Miletich celebrates another defense of his UFC belt.

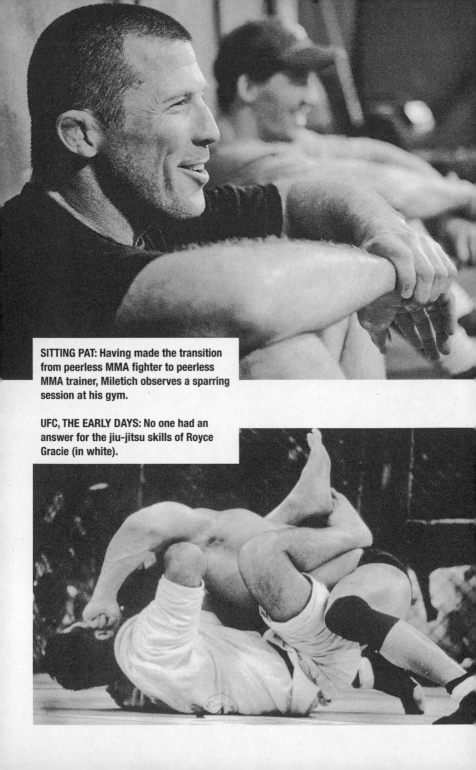

SITTING PAT: Having made the transition from peerless MMA fighter to peerless MMA trainer, Miletich observes a sparring session at his gym.

UFC, THE EARLY DAYS: No one had an answer for the jiu-jitsu skills of Royce Gracie (in white).

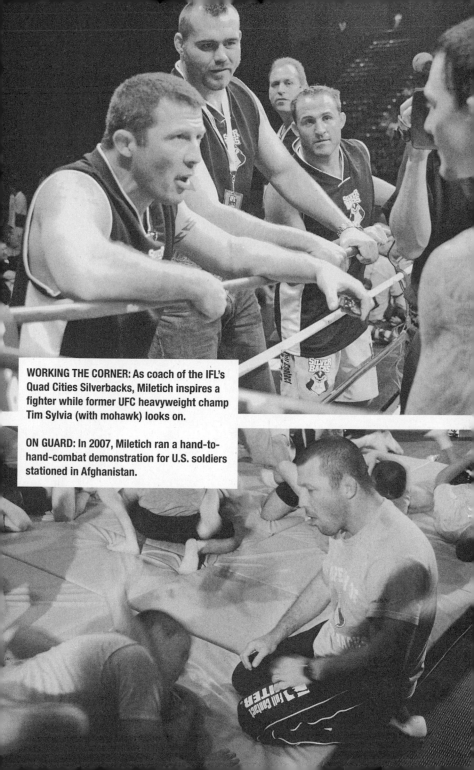

WORKING THE CORNER: As coach of the IFL's Quad Cities Silverbacks, Miletich inspires a fighter while former UFC heavyweight champ Tim Sylvia (with mohawk) looks on.

ON GUARD: In 2007, Miletich ran a hand-to-hand-combat demonstration for U.S. soldiers stationed in Afghanistan.

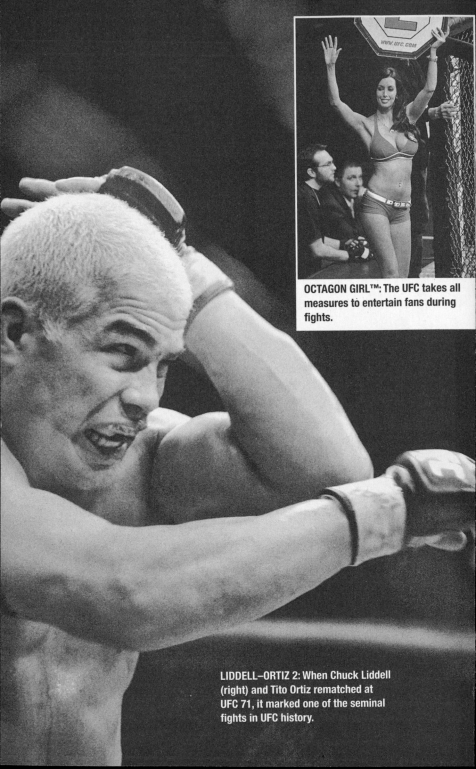

OCTAGON GIRL™: The UFC takes all measures to entertain fans during fights.

LIDDELL–ORTIZ 2: When Chuck Liddell (right) and Tito Ortiz rematched at UFC 71, it marked one of the seminal fights in UFC history.

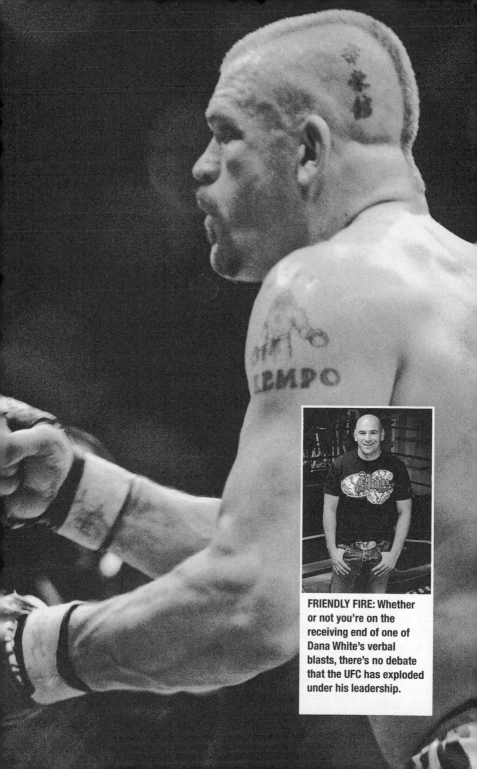

FRIENDLY FIRE: Whether or not you're on the receiving end of one of Dana White's verbal blasts, there's no debate that the UFC has exploded under his leadership.

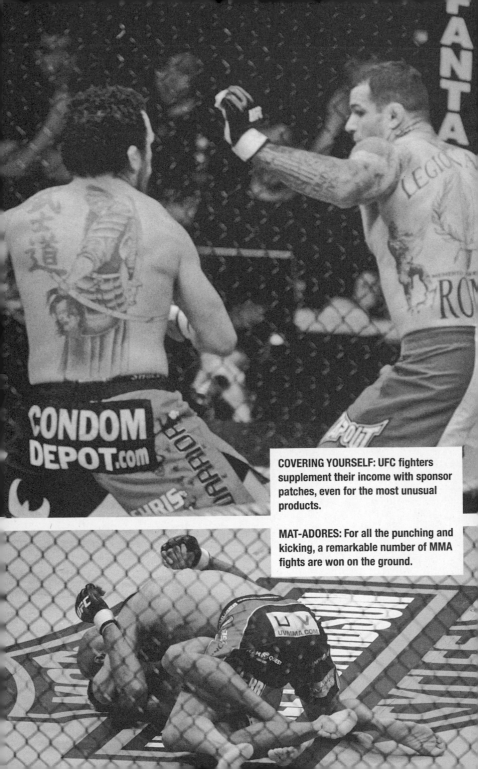

COVERING YOURSELF: UFC fighters supplement their income with sponsor patches, even for the most unusual products.

MAT-ADORES: For all the punching and kicking, a remarkable number of MMA fights are won on the ground.

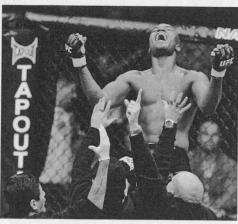

Above left: AND YOU SHOULD SEE THE OTHER GUY: Even the winning MMA fighters sometimes require medical attention.

Above right: KISS OF THE SPIDER: Anderson "the Spider" Silva exults after successfully defending his middleweight title at UFC 82.

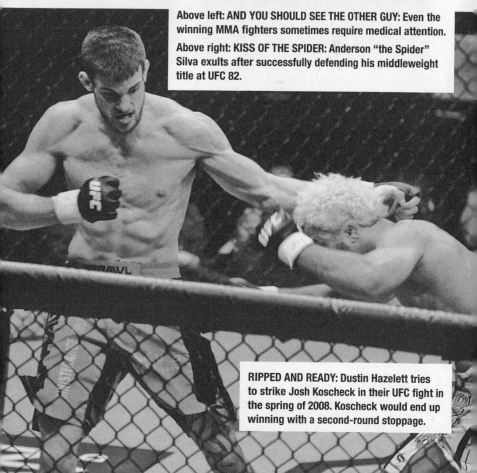

RIPPED AND READY: Dustin Hazelett tries to strike Josh Koscheck in their UFC fight in the spring of 2008. Koscheck would end up winning with a second-round stoppage.

BIG BEN: Heavyweight Ben "North Star" Rothwell is among the next generation of Miletich fighters.

FULL MONTE: After Miletich introduced him to mixed martial arts in the 1990s, Monte Cox went on to become the sport's premier manager and promoter.

WRESTLING MATT: Nicknamed "Pat Jr.," Matt Hughes is the most decorated UFC champ to come out of the Miletich camp.

HAUTE COUTURE: Even in his mid-forties, Randy Couture reigned as the UFC's heavyweight champ.

8

DEFENDING THE BELT

TO CONQUER THE ENEMY WITHOUT RESORTING TO WAR IS
THE MOST DESIRABLE. THE HIGHEST FORM OF GENERALSHIP
IS TO CONQUER THE ENEMY BY STRATEGY. — SUN TZU

THE STATE of Iowa has been steadily losing population over the past few decades, but the trend can hardly be blamed on Pat Miletich. By the beginning of 1998, more than two dozen fighters had migrated to Bettendorf. Having outgrown the racquetball court at Ultimate Fitness, Miletich moved his training center to a nearby Gold's Gym, where he would work as a sweat-equity partner. He would teach kids' karate classes, help out with some personal training, purchase and maintain the club's fitness equipment. In exchange, he was given a small ownership stake. He wasn't getting rich by any means, but he was a long way from scavenging scraps from a dumpster.

Meanwhile, the Cult of Pat kept growing. Most of its members had simply shown up and then displayed the necessary toughness and talent to last. But in some cases Miletich actively recruited fighters. One night in 1998, he made a few extra dollars refereeing a low-level MMA card, held, of all places, in the gymnasium of an all-girls Catholic school in Chicago. One of the fighters on the card was a pasty country boy, Matt Hughes, who, while at Eastern Illinois University, had been one of the nation's top college wrestlers. Though not particularly tall, Hughes was deceptively athletic and had strength to burn. A sort of anti-giraffe, Hughes had no discernible neck, just a thick silo of a chest that melded into a round face. He had little clue what he was doing, and a few seconds into the fight, he walked directly into a triangle choke. He escaped, though, and by sheer aggression — what Miletich immediately identified as "farmer strength" — brutalized his opponent. As Miletich lifted Hughes's arm in victory, he leaned in. "You serious about fighting?"

"Sure," said Hughes, then in his mid-twenties.

"Come train with me and I'll make a champion out of you. And first I'll teach you how not to get caught in that triangle."

Hughes was living in downstate Illinois, where his family ran a nine-hundred-acre farm. He decided to take Miletich up on his offer and relocate to Bettendorf. Too poor to afford a security deposit on an apartment, he crashed at the home of Monte Cox. Ten minutes into his first training session at Miletich's gym, Hughes was rolling with Ben Earwood, a veteran lightweight, when he caught a knee in the mouth. With blood gushing everywhere and his face resembling a Halloween mask, Hughes went to the hospital and was told he would need oral surgery. It wasn't a promising start. But Hughes returned to the gym the next day. Which was a good choice. Within a few years, under the strangest of circumstances, he would become the UFC's welterweight champ.

It's a unique breed of man who will devote his life to cage fighting. And it takes a rarer breed still to base his (highly uncertain) career in a gritty Iowa town on the banks of the Mississippi. Training near the beaches of Southern California, the aqua-and-pink glitz of Miami, or the seductive lights of Las Vegas is one thing. Training on the prairie is quite another.

As a result, the Miletich fighters have tended to be a self-selecting group. They're men of understated tastes, content to live in a town that lacks gorgeous weather, velvet-rope clubs, five-star dining, a thriving nightlife, and big-city electricity. They're cautious and methodical and make up for a lack of native athleticism with durability. They have wrestling backgrounds — and, therefore, wrestling mentalities — and are willing to work hard to learn the other disciplines. Most are staunchly conservative, none more than Miletich, who proudly asserts that his political views fall somewhere to the right of Genghis Khan.

There's also a current of patriotism. Miletich's fighters are the kind of boys who would have gone to serve in Vietnam a generation ago. They're the kids who, if given the choice, would have picked West Point over Harvard. And the dynamic is like that of a platoon — an analogy that's all the more logical given the patriotism that runs through the gym. Like a military unit, they eat together, live together, drill together. They all converged on this strange location and bonded

together. There is an unofficial but unmistakable hierarchy, with "General Pat" at the top.

Almost without exception, they had survived dysfunctional families. While Miletich had hit the trifecta in this regard, most had endured some combination of divorced parents, estranged siblings, and domestic violence. Jens Pulver often repeated the story that as a boy he was nearly killed by his father, a hard-drinking former jockey. "My dad put the gun in my mouth," he explains. "I begged for my life. He gave in, but you want to know why? He said, 'Son, you ain't worth the bullets.'"* One heavyweight fighter replayed voice mails that his alcoholic mother had left that included encouragement on the order of: "You're never going to amount to shit."

It didn't take a trained psychiatrist to speculate that fighting was an outlet, a way of transferring years of accumulated anger and aggression and stress. It also took something less than an expert to deduce that "Team Miletich," this odd cast of muscled misfits in eastern Iowa, formed a surrogate family. They fought and bickered and sometimes tormented each other, but they were, in the end, brothers. The fight club provided the support network and sense of place and — dare I say? — love that had gone missing at home.

As long as everyone had an unpleasant backstory, one more heartbreaking than the next, it was hard for anyone to summon self-pity. A rough childhood is the predictable fallback explanation when athletes in other sports beat their girlfriends or vacuum lines of coke. It wasn't a valid alibi in Bettendorf. Miletich once overheard fighters at the gym comparing their miserable upbringings in a bid to outdo each other. He grew irate. "Don't whine about how rough you had it growing up because most other guys here had it just as bad," he yelled. "You're not getting any sympathy here for a dad that hit you or a brother who died. How long you gonna use that for a crutch? Get over it."

Some of this was Miletich's intense dislike of coddling. But there was also a practical reason for his tough love. Comfort corrupts. He knew how much his own fighting had benefited from his anger and ten-

*Pulver recounts this in his fine biography, *Never*. While Pulver escaped, as did his brother Abel, currently a schoolteacher in Washington state, a third brother, Dustin, once appeared on *America's Most Wanted* and is now in jail on his sixth felony conviction.

sion. An effective fighter should be pissed off and feeling some despair. A contented fighter climbs into the cage at his peril. Miletich had heard of other gyms recruiting top fighters by paying them a weekly stipend. This made him laugh. "Great, your bills get paid off. But you lose your hunger," he said. "I'd love to fight a guy who's getting paid to train!"

His compassion, though, came out in other ways. The fighters were expected to help defray the cost of the gym rental. But most months Miletich ate it. He knew all too well how fighters struggled, and he couldn't bring himself to ask for money from guys who were barely making rent. With his meager income from fighting — maybe $20,000 a year in the late nineties — Miletich knew he was better off than any of his charges. A friend suggested that he ought to charge the fighters a training fee and figure out a way to take a management fee should they ever strike it big. Miletich said he'd consider it, but never did. A few fighters paid him voluntarily. Most didn't.

There's an old boxing saying: Styles make fights. The same holds in the UFC. In the fall of 1998, after his winning debut in New Orleans, Miletich was invited to fight for the newly created UFC welterweight title. His designated opponent was Mikey Burnett, the oxlike wrestler from Oklahoma. Though the two could have hopped in their cars, driven a few hours, and met in, say, Kansas City, the fight was held in São Paolo.

UFC 17.5, titled "Ultimate Brazil," was an attempt to both penetrate the South American market and hold an event without the usual pitched battle with a state athletic commission. While the card was generally successful,* it was no thanks to Miletich and Burnett. Their encounter was less a fight than a slow dance, two wrestlers hugging and clutching and failing to inflict anything resembling punishment for twenty-one excruciatingly boring minutes. Burnett's superior strength was undermined by Miletich's superior technique, which was undermined by Burnett's superior strength. Before the stalemate ended, the fighters shot each other frustrated looks, acknowledging that this was

*UFC 17.5 was punctuated by the spectacularly unsuccessful debut of the 205-pound Wanderlei "the Axe Murderer" Silva, who was knocked silly by fellow Brazilian Vitor Belfort.

one dog-ugly fight. Back in Bettendorf, Mona Miletich watched the fight from a bar, joined by her son's new girlfriend, Lyne. For all their partisanship, even they could tell it was not exactly a classic.

Rewarded for his aggression, Miletich won a split decision from the judges, taking the belt. Although the win guaranteed him more UFC fights, Miletich got word — never to his face, always through intermediaries — that he'd be well advised to adopt a flashier fighting style. The message was clear: the UFC was an entertainment vehicle, and fighters who weren't captivating fans weren't pulling their weight.

Around three months later, Miletich was asked to defend his belt at UFC 18, a card held in New Orleans, one of the few jurisdictions where mixed martial arts met with little resistance from politicians. In addition to Miletich, the program featured Tito Ortiz, a brash, temperamental, reformed crystal-meth addict from Southern California. It also marked the UFC debut of the successful Pancrase heavyweight Bas Rutten. But the underlying theme of the card was the awkward absence of the heavyweight champion, Randy Couture.

The most decorated heavyweight in UFC history, Couture had stumbled onto MMA fighting by chance. Not unlike Miletich, he was a decent wrestler in high school, his aggression fueled by an unstable home life. In the early 1980s, Couture attended Washington State University with vague designs of walking onto the varsity wrestling team. But in his first semester, an old girlfriend called to say she was pregnant. Determined to avoid the same mistake his own absentee father had made, Couture dropped out of school, married the girl, and joined the Army, lured in part by the $5,000 signing bonus. As far as he was concerned, he had just retired from wrestling; if he was going to be pinning anything in the foreseeable future, it would be diapers.

Stationed in Germany, he took to wrestling and improved radically. He won a few military tournaments, was invited to the U.S. Olympic trials, and ended up making the 1988 team as a heavyweight alternate. By the fall of 1988, having fulfilled his military obligation, he accepted a wrestling scholarship at Oklahoma State, a top program. Couture was a twenty-four-year-old freshman, married, with two kids. He befriended the only other married teammate, Don Frye. Couture wrestled successfully but was almost too mature for his own good. Blessed with the cluelessness of youth, the "kids" on the team wrestled with devil-may-

care abandon. In his mid- and late twenties, Couture was keenly aware of how momentous the biggest stages really were, and he couldn't fool himself into thinking otherwise. When he wrestled in the NCAA championships his junior and senior years, his nerves presented a bigger obstacle than his opponents did.

Same for the Olympic trials, where the weight of expectation felt like an immovable object. In 1992 and 1996, Couture lost decisive matches and made the team only as an alternate. In a way, joining the team as a backup — "You were close, so we'd like to have you around if someone gets hurt" — was worse than failing to make the team outright. At least that way you could retreat into yourself and move on to the next challenge. As it was, Couture spent those summers practicing with the team and assisting with their training. But he was ultimately an outsider, unable to share in any glory.

Still stung by disappointment, he took a job as an assistant wrestling coach at a college in Oregon. After a few months on the job, he saw a video of his old buddy Frye winning $50,000 at UFC 8.* Couture's curiosity was aroused, and, still motivated by his shortcomings as a wrestler, he began training. Through his connections in the wrestling world, Couture put out the word that he'd be willing to participate in a UFC fight. He was summoned as a last-minute replacement for UFC 13, in May 1997, won a staggering upset, and by the end of the year he was the heavyweight champ.

The wrestling component — that he had down to a science. Though he wasn't a skilled boxer by any stretch, like most American males of a certain sensibility, he knew something about using his fists. As for Muay Thai and jiu-jitsu, those were completely novel. He was the equivalent of a classically trained pianist suddenly trying to learn to play the drums. And by training obsessively he picked them up. More important, the nerves that had sometimes sabotaged his wrestling career had gone into hiding. Here he was, competing in a sport that permitted kicks to the head and elbows to the face and chokeholds that could bust his windpipe. And he wasn't nearly as nervous as he was when wrestling, where the worst fate that could befall him was being

*The competition was so shocking and controversial that when Frye returned home to Tucson, he was promptly barred from his job as a firefighter.

pinned. As he saw it, so much of his identity and honor was tied up in his wrestling that the pressure could feel incapacitating. "Everything hinged on whether I succeeded," he says. MMA was different. If he won, great. If not, well, shit, he'd only started competing in the sport in his mid-thirties. No shame in that.

Couture was a strong figure in an organization struggling for legitimacy. Here was a mature, well-spoken military veteran with a college education and an Olympic pedigree. Yet after taking the UFC heavyweight title, Couture was told that the organization couldn't abide by the terms of his contract. "But it's a contract," he said, dumbfounded. "But we're losing money and can't pay you that much," he was told. Couture stood on principle. In one of those past-as-prologue moments — he would go through the same drill with the UFC nearly ten years later — Couture abruptly gave up his title and decamped to rival organizations in Japan. His UFC belt was up for grabs.

The prosaic name of UFC 18, "The Road to the Heavyweight Title," tried to spin Couture's departure in the best possible way. In any case, the absence of the heavyweight champ was one more indication that the UFC was in dire straits. Pay-per-view buys were declining, guaranteeing deep financial losses. Despite holding the event in a small arena, swaths of seats remained unoccupied. Because of a soft athletic commission, SEG was able to economize on judges. Besides getting a real judge to fill one of the three slots, it enlisted two members of the media: Dave Meltzer, a Californian best known for his superb coverage of professional wrestling, and Eddie Goldman, a New Yorker with an encyclopedic knowledge of combat sports. While both scribes were plenty respected as journalists, it was, to say the least, highly unusual to put them in the position of determining the outcomes of fights.*

Nevertheless, as a sporting event UFC 18 was a success. Foreshadowing the future, Tito Ortiz put on a dazzling demonstration of his ground-and-pound game, savaging the Lion's Den fighter Jerry Bohlander. With Tank Abbott in decline, Ortiz made it his mission to become the sport's new villain. Seconds after the fight was stopped, be-

*This was thrown into sharp relief when heavyweights Pedro Rizzo and Mark Coleman fought a close match that resulted in a split decision, both journalists siding with Rizzo while the judge-by-trade chose Coleman.

cause of cuts to Bohlander's head and face, Ortiz preened and blew on his fingers as if they were smoking pistols. Then he put on a black T-shirt adorned with the message "I Just F**ked Your Ass." Ortiz tepidly embraced Bohlander in the center of the Octagon as they awaited the official announcement. Without irony, Jeff Blatnick, the television commentator, remarked, "They show good class and sportsmanship in the end," conveniently overlooking the message of man-on-man rape splayed on the back of Ortiz's shirt.

In a much-anticipated heavyweight fight, Bas Rutten, the charismatic Dutchman, justified the hype, annihilating the Japanese bruiser Tsuyoshi Kohsaka. A trained kickboxer, Rutten brought a unique skill set, using cinderblock feet to deliver shots to the opponent's liver. Rutten finished off Kohsaka with an unanswered hail of kicks, knees, and punches. Though an injury would limit his UFC career to just one additional fight, on this night he looked like a candidate to fill the void left by Couture.

Then there was Miletich. For his first lightweight title defense, he was pitted against a Brazilian *vale tudo* champion, Jorge "Macaco" Patino. Unlike Miletich's previous bout, against Mikey Burnett, in Patino he faced a fighter who was his polar opposite. Patino was a young lefty, Miletich an experienced righty. Miletich's conservative politics were matched only by his conservative fighting style. Patino, on the other hand, was flashy and volatile, known for spectacular maneuvers — he had a patented flying armbar — early knockouts, and memorable antics. In an earlier fight in Brazil, Patino won a measure of fame for ripping an earring from an opponent's lobe.*

Depending on one's taste, the Miletich-Patino fight was either an exceptional bore or an exceptional technical display. Defiantly ignoring the, ahem, suggestion that he fight more recklessly, Miletich relied on his technique. He was there to win, period. It was never about hurting the other guy, much less ending up on some highlight video. To some, this was a cardinal sin, and critics mocked Miletich's style as "lay and pray," "sprawl and stall." Yet there was a minority of fans who appreciated the precision and the complexity, and realized that, at a time when

*Why would any no-holds-barred fighter be so dumb/careless/arrogant as to wear jewelry into the ring?

the sport needed to prove it was more than a hockey fight in a cage, Miletich was the perfect exponent.

Just as the fighters were reinventing themselves — from street fighters to skilled artists, from specialists to well-rounded generalists — the UFC was constantly reinventing itself as well. In keeping with its instability at the time (and its desire to appease athletic commissions), the rules changed from card to card. For UFC 18, the fights entailed a fifteen-minute regulation round and a pair of three-minute overtime rounds. After the regulation period, Miletich had the fight in hand and knew that the only way he could lose in overtime was by making a careless mistake. So he went into MMA's equivalent of basketball's four-corner offense, fighting at a pace that recalled interest accumulating in a savings account: not at all sexy, and not at all risky either.

Miletich won by unanimous decision, and thus defended his belt, looking no worse than when he'd entered the Octagon almost half an hour earlier. Neither fighter left on a stretcher. For that matter, neither added to the accumulation of coagulated blood that streaked the eight-sided canvas. There had been no concussive blows or debilitating kicks or shattered jaws. To the critics and wow-hungry UFC executives, it was another example of Miletich's boring fighting style.

The previous year, when Miletich had made his UFC debut in the same arena, he fought twice on the same card. Fortunately, the UFC had since found the good sense to do away with that tournament-style format. So Miletich showered and changed in the cramped locker room and left the arena. He would, however, have one more confrontation that night.

After each card, the UFC holds a postfight party, a ritual both strange and endearing. Here, guys who were bloodying each other's faces in a cage a few hours earlier come together, along with their entourages, in some sterile Marriott ballroom to drink free beer and eat cocktail weenies. At the New Orleans party, Tank Abbott happened to be in the room. Miletich, who had seen Abbott fight on television and been amused by the villain heavyweight, decided to introduce himself. Accounts of what happened next vary, but Big John McCarthy, the esteemed former UFC ref, offers a reliable version:

"Pat says, 'Hey, I'm Pat Miletich,' in a genuine way. Tank was drunk and shoved him in the face and said, 'Aw, fuck off.' Pat starts taking

out his teeth and then looks to whip Tank's ass. That's the maddest I've ever seen Pat. Here's Tank Abbott, 280 pounds, and he starts backing away, apologizing. We're trying to hold Pat back, and he's trying to break free. Remember, Tank outweighs Pat by a hundred pounds. But he wants nothing to do with Pat. He knows Pat would have whipped his ass. That was the last we saw of Tank at the party that night. Pat put his teeth back in, went back to drinking his beer like nothing ever happened."

Today, fighters under contract with the UFC are in a closed shop, strictly forbidden from working for rival organizations. But in the late nineties, the UFC had no such leverage. After his win in New Orleans, Miletich stayed busy. Two weeks later, in January 1999, he fought on a pro boxing card held in a Davenport casino. The notion of a UFC champion lacing up boxing gloves and taking a pro fight between defenses may seem laughable,* but Miletich figured he could use the experience, and, Lord knows, he could use the money. So he agreed to fight a lightly regarded cruiserweight named Donald Tucker. Miletich had to remind himself that this was boxing, not MMA, and he battled the instinct to throw kicks or take the fight to the ground. He won a unanimous four-round decision. Apart from being $2,000 richer, he walked away thinking that boxing had nothing on mixed martial arts. "Honestly, I was bored by it," he says. "And I was the one in the damn ring!"

His next UFC defense was held that summer. Owing largely to Miletich's popularity in the area, the UFC held its twenty-first card — lamely labeled "Return of the Champions" — at a small arena in Cedar Rapids, an hour from the Quad Cities. The few thousand Iowa partisans in the stands were joined by a group of men who had flown in from Las Vegas. Desperate for legitimacy, the UFC had applied for sanctioning by the Nevada State Athletic Commission, and a few commission officials had chosen to attend this event to see for themselves what cage fighting was all about. Like an eager home seller sprucing up the place before

*In fact, in 2008 the UFC middleweight champ, Anderson Silva, expressed interest in fighting the legendary boxer Roy Jones Jr. The UFC immediately vetoed the idea.

potential buyers arrived, the UFC — in still another rule change — added a boxing-style "ten-point must system" for this card. There were also new time periods: three five-minute rounds for main-event fights, and five five-minute rounds for title fights.

Any hope of finding favor with the commission evaporated when Jeremy Horn, the rangy middleweight from Miletich's camp, fought Daiju Takase, a Japanese opponent. Because of what promoters called a "miscommunication," Takase arrived in Iowa weighing nearly thirty pounds less than expected. When Takase and Horn met in the Octagon, the effect was like that of a high schooler fighting a middle schooler. It wasn't that Takase was untalented (consider: four years after this disastrous fight, Takase would defeat the great Anderson Silva in a PRIDE event in Japan); he was simply physically overwhelmed. Using his superior size, strength, and reach, Horn repeatedly mounted Takase and battered him with forearms, elbows, and knees. Though defenseless and bleeding fiercely, Takase was slow to submit. So Horn continued, almost garroting Takase, until the referee, belatedly, stepped in. By then, the canvas resembled a Civil War battlefield. Even hardened MMA fans were sickened by the sight of Takase's face, which looked like it had been put through a deli slicer. So were the commission reps from Nevada. At least for the immediate future, the UFC had squandered its chances for approval.

Miletich's title bout was only slightly less gruesome. Stung by criticism that he was a "boring, intelligent" fighter who cared only about winning and not entertaining the audience, he vowed to stay on his feet and rely on his striking. His opponent, a Brazilian judo and jiu-jitsu expert named Andre Pederneiras, had the opposite objective, preferring to fight on the ground.

Like all the best fighters, Miletich displayed a gift for changing the angles and rhythms and making the opponent forget his plan. Skillfully avoiding a takedown, Miletich kept the fight upright and got the better of most exchanges. Midway through the second round, Pederneiras threw a roundhouse kick. Miletich timed it perfectly and snapped a right hand, a classic Muay Thai maneuver he had learned years before. The punch connected with Pederneiras's face and, even on video, made a hideous sound, like a water balloon exploding against a brick

wall. Miletich had barely recoiled when blood started to gush from Pederneiras's left eye. A streak of scarlet, easily an inch wide, ran down his chest and onto his shorts. As the fighters drew close, Miletich, too, was covered by so much blood he looked like he'd been in a slasher movie. Soon, referee John McCarthy summoned the ring physician, who examined Pederneiras's cut and determined him unfit to continue.

Interviewed in the Octagon after the fight, Miletich was ambivalent about winning by knockout. Yes, he had shown some flash. But part of him wanted a more technical fight. "I didn't put on a show for all the people who criticized me on the Internet. I put on a show for all the Iowa fans who came to watch," he said, barely breathing hard. "The main thing is, I try to win. Reality is not always pretty. I'm going to find a way to win no matter who it is I'm against, and that's just how it's gonna be. I plan on keeping this style for a long time."

It took a year before Miletich defended his UFC belt again. In the meantime, he took two fights with other organizations, winning one and losing the other. But that was nothing compared to the blows the UFC was absorbing. Succumbing to John McCain's pressure, virtually every cable system refused to carry UFC cards on pay-per-view. Starting with UFC 23, the cards were available now only on DirecTV, by satellite, and that represented fewer than 10 million households. So events that had reliably generated 100,000 pay-per-view buys were lucky to break the 20,000 mark. Unless distribution could be restored, thereby ending the "dark ages," the league was headed for bankruptcy, destined to join the XFL football league and Pro Roller Derby in the sports necrology.

Christened "Ultimate Field of Dreams," UFC 26, held in the summer of 2000, was less an MMA card than an infomercial for the Miletich camp. The event was held in Cedar Rapids, and almost half the fighters were based in the Quad Cities. Jens Pulver, sporting his trademark mohawk, won a unanimous decision over a Brazilian jiu-jitsu specialist. Already heavily touted in the MMA underground, Matt Hughes added to the growing hype surrounding him, body-slamming his opponent, Marcelo Aguiar, deploying the increasingly popular ground-and-pound technique, and finally ending the fight when he sliced open Aguiar's face with punches. A promising Miletich middleweight, Tyrone "Native Warrior" Roberts, won his fight by decision.

In the fight to defend his belt, Miletich was pitted against John

Alessio, a twenty-year-old Canadian making his UFC debut.* While Alessio would go on to have a decorated MMA career, on this night he was too inexperienced to threaten Miletich. In the second round, Alessio cinched Miletich in a standing guillotine. Miletich responded by slamming Alessio to the ground and assuming the half-guard. Incrementally, he moved to a full mount and began raining punches. When Alessio raised his arms to defend himself, Miletich grabbed hold of Alessio's left arm and wrenched an armbar. It was classic "position, then submission." Alessio, knowing he was stuck, tapped out.

Once again, the card didn't make it onto most cable systems, nor was there a home video release. SEG was inching close to bankruptcy, and the future of mixed martial arts looked grim. But as Miletich soaked up the applause, he focused only on what he could control. "I'm just glad I still have the belt," he said. "And that it's gonna stay in Iowa where it belongs."

Miletich took a break from fighting in the fall of 2000. He had been dating Lyne Bergeron for more than two years, and as different as they were on the surface — the salt-of-the-earth Iowa cage fighter and the chiropractic student from Montreal's upper crust — their relationship had clicked. Any concerns Bergeron's parents had about Miletich evaporated when they first met him. And with the UFC's popularity in Canada, Miletich was treated as a celebrity whenever he visited Quebec.

On September 16, 2000, Pat and Lyne were married in a Montreal church. The Quad Cities contingent was sizable, including some fighters from the gym, Monte Cox, and, of course, Mona Miletich. Mark Hanssen was the best man. A lavish reception followed the ceremony. Miletich was toasted with expensive champagne, and it was hard to picture him as a hard-drinking street fighter subsisting on bologna sandwiches just a few years before.

Two months after the wedding, Miletich was summoned for another title defense, this time at UFC 29, in Tokyo, on December 12. There would be no pay-per-view broadcast on cable, but by going over-

*It says plenty about the state of the UFC at this time that a young fighter making his debut could be in the mix for a title shot.

seas, SEG wouldn't have to contend with last-minute sprints to the courthouse steps. As it turned out, it would be the last UFC event held under the ownership of SEG. The card was notable for other reasons too. Tito Ortiz, the heir apparent to Tank Abbott — they even hailed from the same town, Huntington Beach, California — added to his legacy as both a supreme fighter and supreme jackass. After defeating his Japanese opponent with a vicious neck crank, Ortiz sported a T-shirt that read: "Respect. I Don't Earn It. I Just Fuckin' Take It." (Watch a tape of the fight closely and you'll see that as Ortiz preened, his manager at the time, Dana White, cheered enthusiastically.) Another ascending star, Chuck Liddell, was also victorious. As was Matt Lindland, a middleweight from Oregon, just a few months removed from winning a silver medal in Greco-Roman wrestling at the 2000 Olympics.

Before Miletich fought, Matt Hughes took on Dennis Hallman in a much-anticipated rematch. Hallman had served Hughes the only loss of his career, forcing his submission seventeen seconds into their first fight. Hughes, though, had won eighteen consecutive pro fights since, steadily improving at Miletich's gym. Though Hughes vowed revenge, the rematch was almost a replay of the first. Hallman charged and allowed Hughes to apply his patented body-slam, double-leg takedown. In midair, Hallman locked up an armbar. Once on the ground, Hallman caught it, rolled, and before the bone could be snapped like a toothpick, Hughes tapped.* The official time: a mere twenty-one seconds.

Hughes was devastated, and Miletich was only slightly less so. If there's a danger in having an emotional investment in another fighter on the same card, this was it. It took a concentrated effort for Miletich to dial down his emotions and focus on his own fight. By the time he walked into the Octagon to face Kenichi Yamamoto, Miletich had managed to alchemize his disappointment over Hughes and turn it into rage.

Like a classical sculptor, he was methodical, skillful, and workmanlike. His moves were unremarkable in themselves, especially compared to the titanic blows of Liddell or the dramatic armbar Hallman had

*Hallman trained for the match with Matt Hume, the Washington fighter who had defeated Miletich. Hume would later tell Hughes's manager, Monte Cox, that Hallman had been practicing that move for weeks. "Hughes is a creature of habit. We knew when he went for that body slam he was vulnerable."

put on Hughes. But, again like a sculptor, each deft maneuver had a purpose, and each revealed a little more of the shape of a completed work. Midway through the second round, Miletich had exhausted Yamamoto's defense and caught him in a guillotine choke. Position, then submission. Yamamoto quickly tapped out and, aware that he wasn't the crowd favorite, Miletich contained his elation.

He was now 7–0 in the UFC and had made his fourth successful belt defense — more than any fighter in UFC history. It was just his misfortune that so few fans were able to see it.

9
GREAT DANA

JUST TO BE TOTALLY CLEAR: YOU COULD ORDER PORN ON PAY-PER-VIEW NO PROBLEM. BUT THOSE GUYS WANTED NOTHING TO FUCKIN' DO WITH THE UFC. — DANA WHITE

IN THE LATE 1980s, Andre Agassi was back in his hometown of Las Vegas. An up-and-coming tennis star, Agassi was on furlough from a Florida academy and hanging out with Perry Rogers, his best friend. Rogers was a student at Bishop Gorman High, a Catholic private school favored by Vegas's elite, and one of his classmates was throwing a party. A hundred or so kids, most from the class of 1988, were expected to show up.

Agassi was already a celebrity in training. He had played professional tennis events all over the world, flown on private jets, and been courted by Nike. But he spent that Friday night with Bishop Gorman kids, happy to be a typical teenager. He swapped stories with the guys, checked out the girls, and perhaps he threw back a few cold ones. Driving home afterward, Rogers turned to Agassi: "Looked like you had fun. Who'd you like hanging out with?" Never mind the hotties in halter tops or the casino heirs and valedictorians and kids who would go on to own banks. Agassi raved about a stocky, fiercely funny loudmouth with a screechy voice who drove a beat-up car. "That Dana White guy," Agassi said. "Man, that guy was awesome."

Long before Dana White became a CEO, a celebrity in his own right, a millionaire many times over who tooled around Vegas in a black Bentley coupe — before he became a brash, boasting, bald despot, capable of inspiring fear, loathing, and affection, often in the same person — he could fill a room with his presence. Then, as now, people loved him and people despised him. But he always made an impression.

White was raised by a single mom, who moved the family from

Ware, Massachusetts, to Las Vegas in the 1980s. "It was either Vegas or somewhere in the Middle East," says Dana. "Thankfully we ended up there." Like Pat Miletich, White's mom was a hard-working nurse who scraped together enough money to send her son to the most distinguished high school in town. During an undistinguished academic career, White was known to nod off in class or tuck a boxing magazine into his open textbook and read about Hagler-Leonard while pretending to study. Residing somewhere between class clown and class burnout, White was loud and funny and relentlessly obnoxious.

Surrounded by rich kids at Gorman, White was conspicuously rough around the edges, bowing to no one and unafraid to throw a punch. "He didn't take school seriously but he always had tons of character," recalls Rogers, who would go on to become an agent for Agassi, a prominent businessman, and a friend of White. "He was one of those guys who didn't exactly have much of an academic profile in class. Then lunch would come or the weekend would come and Dana was everywhere. He had this *presence*."

It was also at Bishop Gorman that White came to know Lorenzo Fertitta, a member of the Vegas aristocracy, scion of the Station Casinos fortune. They played sports together and showed up at the same parties. But before a lasting friendship could form, White had to leave Las Vegas. Tired of grades that drifted ever further down the alphabet, administrators kicked White out of school. His mother shipped him off to live with his paternal grandparents in a tiny town in the middle of Maine. It was three thousand miles from Las Vegas, and culturally it was even more distant.

White didn't fare much better there. Once again he was fighting and hanging out, thoroughly bored by geometry proofs and the periodic table and symbolism in *The Great Gatsby*. After squeaking through public high school with a diploma, he returned to Vegas. When his mom moved to Boston, White followed, and spent a few semesters at a University of Massachusetts branch campus. Predictably, that didn't last long. Too restless — and, in a weird way, too ambitious — he dropped out of college.

Dana White's early résumé bears a striking resemblance to the dossier of Pat Miletich. White ricocheted from job to job. He poured con-

crete. ("The worst fucking job you could ever have.") He was a bouncer. He worked as a bellman at the Boston Harbor Hotel, wearing a demeaning uniform, lugging suitcases, calling "big swinging dicks" (his term) sir. What White lacked in formal education, he made up for in native intelligence, street smarts, and an unerring bullshit detector. And he was doing okay, bringing home fifty grand or so a year by the time he was twenty-one, thanks in part to a smooth manner that generated generous tips. He realized, though, that his future in a bellhop uniform was limited.

Again recalling Pat Miletich, White worked off some of his aggression and frustrations in the boxing gym. He could give a decent accounting of himself in the ring but never reached the point where he could completely give himself over to the sport. It wasn't a fear of getting hit, or getting hurt, so much as it was a more general fear of failure, of waking up in his mid-thirties with a middling record and only welts and bruises to show for his career. At odds with his personality, he pulled his punches — literally, in this case — and never turned pro, a decision that would eternally gnaw at him. Still, after all that time in the gym, it became clear that the fight game had hardened into his passion.

He was seduced by it all. The sound of leather popping on flesh. The smell of sweat and Vaseline and liniment and tape. The stories and the characters. The abundance of testosterone. Above all, White loved the rawness, the lack of pretense, the human element. Two guys. One winner. One loser. No bullshit. No spin. The rich guys didn't have an advantage, no matter how many roman numerals came after their name or what kind of car they had parked outside.

Realizing he had a talent for teaching and motivating, White started a youth boxing program at a gym in blue-collar South Boston. Soon he quit his bellman job, and he moved back to Vegas and opened an unremarkable boxing gym, with designs of becoming a big-time promoter or manager. He'd be Lou Duva without the jowls, or Don King without the hair. As he figured it, his combination of New England work ethic, South Boston scrappiness, and Vegas do-it-up-big attitude could transform him from an average Joe one step ahead of the bill collectors into a kingmaker.

One of the middleweights he managed, Derrick Harmon, rose through the ranks and was once fodder for the great champion Roy Jones Jr., who knocked him out in eleven rounds. Mostly, though, White was a fringe player, supplementing his meager income as a promoter by leading boxercise classes and giving lessons to Las Vegas's wealthy for $45 an hour. In a good year, White claims that he might have grossed in the six figures. Particularly in Vegas, a city where success and money don't exactly hide, reminders that he wasn't making it big were everywhere.

Because of his work in boxing, White had rekindled his high school friendship with Lorenzo Fertitta and his older brother, Frank. Lorenzo served on the Nevada State Athletic Commission and, in what would later prove to be a rich irony, had distinguished himself by taking a hard-line stance during Mike Tyson's infamous ear-chomping episode. Frank, like Lorenzo, was amused by White, a genuine what-you-see-is-what-you-get guy amid all the fakery of Vegas.

One night in the late nineties, White and Frank Fertitta were hanging out at the Hard Rock Casino in Vegas. John Lewis, a wiry, dipstick-thin, heavily tatted-up jiu-jitsu specialist, walked by. "Aw, that's John Lewis," White said, starstruck. "The dude just fought in one of those Ultimate Fighting things. Awesome fighter."

"I've always wanted to learn submission fighting," Frank said.

"Me too!" said White.

Like teenage boys eyeing the prettiest girl at a school dance, White and Frank Fertitta dared each other to approach Lewis and strike up a conversation. They soon gathered their courage and found Lewis to be thoroughly engaging. They arranged for him to give them a jiu-jitsu lesson a few days later. Lorenzo Fertitta showed up too.

Half an hour into the session with Lewis, White was hooked. Two men standing toe to toe and striking each other? That he'd always understood. But now he was rolling around on a sweat-saturated mat, being exposed to a whole new way to fight. There were moves and countermoves and ways to steal victory with a subtle maneuver. There were also ways to relinquish your advantage.

White never had illusions about being book-smart. In fact, his bad grades were almost a badge of honor. But he knew he was smart in other

ways. This exotic, tactical discipline — conceived by the Japanese, refined by the Brazilians — played to his core strengths. Here was a sport in which a shrewd, conniving mind and a bottomless appetite for work and technique could offset physical limitations. "How have I walked the earth for thirty years and not known about this?" White wondered.

The Fertitta brothers were enthralled too. Like so many practitioners, Lorenzo likened it to "human chess." Soon they were training with Lewis four or five times a week, grappling with each other after the lesson ended. Intensely competitive, White arranged his own training sessions with Lewis, to learn additional moves on the sly that he could use against the Fertittas. He'd later claim that he knew then and there that if it could shed its outlaw reputation, mixed martial arts, with its beguiling combination of stand-up, kicking, and jiu-jitsu, would have limitless potential.

Through his relationship with Lewis, White was introduced to a number of UFC fighters, and eventually he agreed to represent or manage a few of them. One was Chuck Liddell, a light heavyweight who looked like a paroled felon, what with his haunted face and the Japanese characters inked on his head. He was in fact a college graduate with a business and accounting degree from Cal Poly, hardly a diploma mill. Liddell had just lost a UFC fight to Miletich's protégé Jeremy Horn, and was angling for a rematch. The other was Tito Ortiz, that talented, moody light heavyweight, who was then feuding with SEG over his contract.

The UFC, now hemorrhaging money, was seeking sanctioning in Nevada. As a member of the state's athletic commission, Lorenzo Fertitta agreed to travel to Iowa for a "fact-finding" trip. He was impressed by the sheer athleticism of the fighters. Strength, speed, flexibility, endurance, coordination. He was struck by how different the reality of MMA was from the perception of it. He was also struck by how amateurish the events looked, the lack of polish, the inattention to detail. The lighting was inadequate, the ring announcer oversold the violence, the music was too loud, the fighters' quarters were shabby. Fertitta wanted to buy a souvenir T-shirt and was shocked to learn there were none for sale. Of course the mismatches, the bloodletting, and the absence of rules were troubling too.

In the fall of 2000, White and the Fertittas decided to take a road trip to Atlantic City to watch their buddy John Lewis take on Jens Pulver, the colorful Miletich fighter. Apart from watching Pulver stun their man with a first-round demolition job, the boys from Las Vegas spent most of the time discussing how they would improve the product and presentation. From his work representing fighters, White knew that the UFC was in trouble and that the moral arbiters of pay-per-view were submitting to political pressure and declining to air fight cards. So he hatched an idea: *Why don't we buy the thing?* By "we" he meant that Lorenzo and Frank would put up the cash and he, White, would run the operation.

In 2000, Bob Meyrowitz prepared to plead his case before Nevada's athletic commission, aware that MMA sanctioning in the state was crucial for getting the UFC back on pay-per-view and, thus, crucial for the organization's survival. He had hired a high-priced lobbyist to assist him. Told that his application was "looking good," Meyrowitz flew to Las Vegas. According to Meyrowitz, the night before the scheduled hearing he got a call at his hotel. "Withdraw your bid," the lobbyist said urgently. "I hear they changed their mind and you don't have the support after all."

Meyrowitz says that this was the final body blow. He had always seen the potential of the UFC, and was certain that with political approval would come social approval, and with social approval would come unchecked growth. But he'd tired of the struggles and, above all, the financial losses. Without sanction, the sport wasn't going to return to cable. Without pay-per-view revenue, there was no hope of turning a profit. So he was tapping out. He'd had huge successes as a sports and entertainment impresario. But the Ultimate Fighting Championship would not be one of them.

A few weeks later, Dana White contacted Meyrowitz and learned about a sale. White says that, at the time, he was about to go to work as an executive for the World Fighting Alliance. Before taking the job, he told the Fertittas that the UFC was on the block. The brothers talked White out of accepting the World Fighting Alliance job so they could

pursue the purchase. "I'm telling you," says White, "that's how it went down."*

Sale talks proceeded. At first Meyrowitz discussed selling half of the company. But by the end of the negotiations, the Fertitta brothers bought the whole shebang for $2 million and formed a company they named Zuffa, a slangy Italian word meaning "scrap" or "street fight." In retrospect, the $2 million was less a sale than an act of larceny, the Louisiana Purchase of sports. But it hardly looked that way at the time. What, really, were the Fertittas buying? Not much besides a trademark, some unpaid bills, and a few fighters' contracts. One business publication went so far as to call the UFC "the most damaged, worthless brand in America that doesn't make cars."

While the brothers didn't buy the property with the intention of losing money, their net worth, then reportedly in excess of $500 million,† would adequately provide the necessities of life should the venture fail. Suggesting that the purchase was as much a hobby as a business, the ownership contract included this dispute-resolution clause: "In order to resolve a deadlock among [board] members, Frank and Lorenzo shall engage in a jiu-jitsu match."

For White, the purchase of the UFC was something else entirely. According to sources close to the sale, White took a 10 percent ownership interest in Zuffa, mostly in exchange for serving as the UFC frontman. There was plenty of financial upside, but that wasn't the appeal. No, after all those years of wearing a uniform and taking orders from hard-driving bosses and teaching friggin' boxercise classes to desperate housewives with money in their pockets and having little to show for it in the world's capital of conspicuous consumption, this was his big

*The timing has been a source of controversy. In the December 13, 2007, airing of the CNBC documentary *Ultimate Fighting: From Blood Sport to Big Time,* Meyrowitz intimated that when serving on the Nevada State Athletic Commission, Lorenzo Fertitta had voted against the UFC's bid for sanction because he had wanted to buy the organization himself.

Meyrowitz quickly recanted this, and on March 7, 2008, released a statement: "Robert Meyrowitz does not believe that Lorenzo Fertitta misused his regulatory authority for private gain or committed any improper acts or exercised any undue influence as an NSAC commissioner in relation to SEG's effort to obtain NSAC approval of mixed martial arts."

†That was then. Now it's reportedly in excess of $1 billion.

chance to be a somebody. To traffic in cliché, this was his once-in-a-life-time title fight, his shot at glory.

After White severed ties to the fighters he managed, avoiding a conflict of interest, he set about changing the corporate culture. Like a kid tracking mud through the house, White put his prints all over "Zuffa's UFC." Now that he was on the other side of the bargaining table, he became a ruthless negotiator. He made decisions based on his gut, not on some econometrics model learned in business school. He cussed heroically.

He also seemed to be in perpetual search of a battle. Under White's reign, fighters — including Ortiz — who ran afoul of the UFC paid stiff penalties. Competing MMA organizations didn't just need to be beaten; they needed to be destroyed. Journalists, no matter how profes-sional or loyal to MMA, who wrote anything White considered inaccu-rate sometimes faced the possibility of banishment. White didn't exactly cut the figure of a traditional sports executive. (Try, for example, to pic-ture the NBA's staid boss, David Stern, calling an underperforming player a "whiny little bitch.") His style was intensely polarizing. One man's hard-charging leader is another man's volatile nightmare boss.

But in many ways White was precisely what the UFC needed just then. In many ways he was the perfect man for the job. For a sport that had prided itself on unambiguous outcomes and lack of gloss, it needed an outspoken frontman who gave opinions bluntly no matter how many bridges he might torch. It needed a top executive who made deci-sions based on common sense and instinct, not after consulting the boys in the marketing department. It needed a figure who might lack Wall Street polish but knew the fight game, grasped the flaws of boxing, and had man-on-the-street bluster and bravado. It needed a commit-ted, hard-core fight fan who thought little of staying at the office until the sun came up. In short, White ran the UFC like the superfan he was. Soon, like the professional wrestling impresario Vince McMahon, White became a figure every bit as prominent — and as vital — as any UFC fighter.

Zuffa's first priority was sanctioning. Like Meyrowitz, White and the Fertittas were fully aware that pay-per-view was the sport's oxygen;

it wasn't likely to survive without the blessing of athletic commissions. White spoke of "running to and not away from" governing bodies. "We want to be safe! We want regulation!" he said repeatedly.

As for John McCain, the man whom SEG viewed as the devil incarnate, White expressed admiration for the man. "I *want* to be regulated!" he pleaded. "I want to be sanctioned by athletic commissions. I want someone to come in independently and do drug testing. I want someone to make sure the promoter can pay the fighters. In a way, McCain created the sport. If he hadn't pushed [his agenda for cleanup] this thing wouldn't have become a sport now."

White's many critics have chided him for promoting what they call the "Zuffa myth." That is, spreading the misconception that under the previous ownership the sport was an amoral, no-holds-barred abomination. That it became a legitimate enterprise only when the white knights of Zuffa took over. These critics note that before the transfer of ownership to Zuffa, New Jersey had sanctioned mixed martial arts by adding a number of regulations and safety precautions, including a prohibition on kneeing a downed opponent in the back of the head. In fact, UFC 28, held in Atlantic City under SEG, actually featured *more* rules than UFC 31, the first card held under Zuffa's auspices. Lorenzo Fertitta himself once conceded, "Without the New Jersey State Athletic Control Board, this sport would still be dying a slow death."

True as that may be, White had either the good values or simply the good business sense and public relations instincts to trumpet improvements such as penalties for unsportsmanlike conduct. He pressed the flesh of plenty of athletic commissioners, and weeks after the Zuffa purchase the sport received sanctioning in Nevada. With that, it was back on pay-per-view. And as long as the sport had the blessing of the state, all the grandstanding politicians — the ambitious city councilmen holding press conferences and waving injunction orders hours before the UFC fights — would find another cause.*

White also had the good sense to resist suggestions that he get rid of the Octagon. The barbaric imagery aside, White recognized that the cage was vital to marketing and distinguishing the product from

*It was also Zuffa's good fortune that by 2001, John McCain was gaining prominence in the Senate and had more important issues to address than the morality of cage fighting.

other combat sports in a ring. And it served a practical purpose. When fighters compete in a ring, the ground action tends to spill under the ropes and onto the apron. The referee is then forced to intervene and reposition the fighters, which kills the rhythm of fights and sometimes gives a disadvantaged fighter an unfair opportunity to recover. With a steel cage, the fight is usually uninterrupted.

White also added undercard fights and improved the lighting. He scrapped the cheesy bugle strains and let fighters pick their own entrance music. Aware that the cage sometimes obscured the spectators' view when the action went to the ground and the fighters became a tangled mass of limbs, White made it a point to hold cards only in arenas equipped with Jumbotrons. Fans could watch the ground action on the screen, and so develop an appreciation for the subtleties — how the slightest repositioning can make all the difference. "It made no fucking sense," he says of the way things were done in the past. "The guys in the arena are paying more fucking money than the guys at home. Starting with the first fucking fight they've got to feel entertained." He upgraded the telecasts too, rehiring the popular and knowledgeable commentator Joe Rogan, the comic who had left the original UFC and gone on to host the reality show *Fear Factor*.

White, however, avoided dolling up the sport so much that it would become unrecognizable to the hard-core fans who had sustained the UFC through the down years. The Fertittas' Station Casinos is one of the five largest gaming companies in America, but odds are you've never heard of it. While most casinos, planted on the Strip, transformed themselves from dens of sin into glitzy, gaudy properties that serve $45 kobe beef burgers and derive less and less of their revenue from gambling, the Station is known as "old Las Vegas," a throwback to a time before garish lights, frequented by locals and slots players. It's expanded and adjusted to the times, but the flagship property hasn't changed all that much since Frank Fertitta Jr.* built it in the mid-seventies. It's now a $9 billion empire. The Fertittas (and White) took a similar approach to the UFC, upgrading the product but maintaining its authenticity.

In part because of White's age — he was in his early thirties when

*Like Dana White, Frank Fertitta Jr. was a former bellman who worked his way up.

he became the UFC's president — in part because of his experience representing Ortiz and Liddell, and in part because of his boxing background, he had a unique relationship with the fighters. Some revered him and others wanted to kick his ass, but they *got* each other. He understood the fighters' divergent personalities and styles. He understood that fighters cutting weight could be moody and that most of them had a love-hate relationship with their managers. He knew which fighters he could lure from other leagues and which UFC talent was expendable. He knew which fighter was broke and which could use a bonus — a practice that became increasingly problematic as the sport grew.

White became less a corporate leader than a dictator who ruled his subjects with a sort of benevolent paternalism. The UFC sometimes felt as though it were being run under martial law. White would make fights and choose announcers and determine color schemes and decide which media members would attend and which fighters were forbidden from freelancing in other organizations. If fighters and their managers hated this restriction on their earning potential, White saw the "closed shop" as a necessary way to achieve global domination for the UFC.

But his passion was never subject to question, and this was critically important. "One thing about Dana White," says Joe Rogan, the UFC commentator. "If he tells you it's thirty fucking degrees out, you don't have to check the thermometer. He tells it to you straight up. There's something to be said for that, especially from a guy in a political position."

Rogan is right. Ask the man a straight question, you get a straight answer. To wit:

- Would he ever consider taking the UFC public? "Never! Have a bunch of pencil-necks in New York telling me how to run my business? These guys who went to fancy colleges, they're programmed the wrong way. They're scared to take risks. They stay away from things that don't make sense, but you gotta have some balls sometimes. 'Waaaaah, the fucking numbers don't work.' They analyze and do a fucking market research study on it. I do things by gut and want it done yesterday. Not tomorrow. I'd say one of the best things is how aggressive I am and it's probably one of the worst.

The shit we do makes no sense to Wall Street [but] I'm not gonna ask anybody anything. I'm gonna fuckin' do it the way I want to do it."

- Does he foresee a day when women will fight in the UFC? "Nah. I hate to sound chauvinistic, but women are pretty. I don't like to see women fight. Nah, I don't like it . . . But girls come to our events. They take girl UFC trips. And you'll notice blocks of girls on their own and they're hot chicks! If you own any club, the goal is to get the hot chicks in town, and then the guys will come. It's crazy."

- Does he worry about the underbelly of the UFC's success? "I'd love to keep it pure, to tell you that the crazy shit in other sports isn't going to happen in mine. I can't tell you that. It's inevitable. The sleazy agents are going to come slithering out of the fucking woodwork. All the dirtbags that are attracted to money and sports are going to end up over here someday. But hopefully I'm long gone before that happens."

- What does he think of the charge that the UFC makes money at the fighters' expense? "Let's say you're in the tobacco industry. You make Marlboros. Look how many people are dying from fucking cancer every year, buying fucking cigarettes. But people buy the stock. Look how much goddamn revenue they're making . . . People drink and ruin their lives and shit like that. But damn, Anheuser-Busch is a powerhouse. The casinos? Guys blow their fucking check and have no money to pay bills or take care of their families. And the stocks are going crazy. But if you're a fight promoter and you make money, you're a piece of shit. You're a scumbag. 'You shouldn't be making any money! That's the fighters' money!' Every business we want to do well. But when it's promoters [who do well], you're a fucking scumbag."

In the mass media's retelling, the day Dana White and Zuffa took over the UFC, the organization's meteoric rise began. The reality was much different. There were all sorts of missteps, small* and large. While

*Like the decision to hire Carmen Electra as the organization's spokeswoman — not exactly ideal for a brand trying to extinguish the notion that its product is for knuckle-dragging degenerates.

UFC 30, the first card under Zuffa, was indeed on pay-per-view — a cause for celebration — the fights were not only dull but ran beyond the allotted time slot, necessitating refunds for fans in much of the country. What's more, to win back the affections of pay-per-view, Zuffa guaranteed In Demand a quotient of buys it could never possibly meet. When the figures fell short, Zuffa had to cut a check to cover the difference.

Even with the Fertittas' lavish spending on marketing, the organization continued to bleed money, with losses allegedly approaching $40 million. In 2004, fearful of blowing through the family fortune on cage fighting, they asked White to search for a buyer. When the best offer White could court was $4 million, the Fertittas grudgingly decided to soldier on. To his credit, White freely admits that the Zuffa-era UFC was no overnight financial success story, as it's sometimes described.

Still, what of White's detractors, who assert that the Fertittas' money alone was responsible for the growth of the UFC? They're distorting history as well. White's tenacity, his messianic zeal, his undeniable passion for fighting, his Everyman sensibilities — it all played an outsized and undeniable role in shaping the UFC as we know it today.

When the UFC was off pay-per-view and the mainstream media showed no interest in mixed martial arts, the Internet ensured that a dying sport sustained a pulse. One could suggest that the Internet is singularly well suited to UFC Nation. The rat-a-tat back-and-forth of message boards mimics the action in the Octagon. The username persona resembles the transformation of fighters when they enter the cage. There's probably some truth to that. But really, the Internet's value to the sport was always more practical than abstract. The far-flung underground of fans had a means of spreading news and discussing fighters and slinging opinions. Soon web-based video enabled fans to watch highlights of even the obscure fights.

Like everyone connected to the sport, Pat Miletich trolled the message boards and the underground more than he cared to let on. The UFC's sale to Zuffa triggered analysis and is-this-good-or-bad? debate. Having always tried to divorce himself from the business side of fight-

ing, Miletich wasn't sure what to make of the new owners. He figured it didn't hurt to have deep-pocketed leaders. Miletich could also appreciate that Lorenzo Fertitta had served on the Nevada State Athletic Commission and Dana White had managed both boxers and MMA fighters. If the guy had never been in the cage, at least he had some sense of the species. Miletich appreciated Zuffa's outspoken desire to get the sport sanctioned in more states, embracing regulation, not juking past it. And after years of risking life and limb for as little as $1,000, Miletich was happy when he heard assurances — rumored assurances, anyway — of bigger fighter paydays. For his next fight, his fifth title defense, he was being paid "forty-forty," that is, $40,000 to show up and another $40,000 if he won, far more than he'd ever made in a year.

At the same time, the guys from Las Vegas, with their expensive suits and buffed loafers and polished presentation, roused the distrust of Miletich. Like other midwesterners, he took an anatomical view of the country. The East Coast was the head, the Midwest was the backbone, and the Los Angeles–Las Vegas corridor was the ass — alluring and attention-getting but ultimately of limited use. "They might not be our type of people," he told friends, "but if they grow the sport, we all win." Besides, with another belt defense coming up, Miletich had more pressing concerns.

UFC 31, the second card under the Zuffa regime, was held on May 4, 2001, in the Taj Mahal casino in Atlantic City. The fight, as usual, came with a typical cheesy tag line, this time "Locked and Loaded." And, as in the past, the casino had to paper the floor with free tickets to ensure the seats would be filled. But there were noticeable upgrades, from improved camera angles for the broadcasts to slicker ring entrances for the fighters to mainstream company logos — including Expedia.com — adorning the Octagon. The Zuffa promos promised, "It's a whole new Ultimate Fighting Championship!" and the new owners appeared to be delivering.

In retrospect, the card could have passed for a Legends event. The undercard alone featured the victorious UFC debut of B. J. Penn, a chunky Hawaiian lightweight who had needed only four years to get a jiu-jitsu black belt.* A welterweight bout pitted an outspoken Long Is-

*Why Penn never took the nickname "Hawaiian Punch" is an enduring mystery of MMA.

land jiu-jitsu specialist, Matt Serra, against a more outspoken Chicago fighter, Shonie Carter, who took the nickname "Mr. International" and dressed in the manner of an inner-city pimp. Matt Lindland, the Oregon car salesman and Olympic wrestling medalist, was appearing on a UFC card for the second time. Chuck Liddell was fighting as a light heavyweight. Again, that was the *undercard*.

There were two main events. One was a heavyweight championship featuring the former UFC champ Randy Couture — who had resolved his contract dispute and was back in the fold — against a Brazilian *vale tudo* fighter, Pedro Rizzo. Couture was thirty-seven, and broadcaster Jeff Blatnick remarked, "Is his age finally going to catch up with him?" As it happened, Couture would still be the UFC heavyweight champ six years later.

The other main event featured Miletich, making his fifth defense. His challenger, Carlos Newton, was an enigma. Newton, a Caribbean-born Canadian with a head abloom with braids, looked starkly different from any other MMA fighter; he fought differently too. Born in the British Virgin Islands, Newton was raised primarily in a Toronto ghetto. While his friends played hockey or basketball, he would roller-skate for an hour through biting cold to get to a karate dojo.

Through martial arts, he fell in love with all things Japanese. He learned the language, adopted the nickname "the Ronin" (a kind of freelance samurai), and took on a decidedly Zen — others would say flaky — disposition. He dubbed his fighting style "Dragon Ball Jiu-Jitsu," a nod to a popular Japanese anime character. The style resisted conventional definition, but it was essentially a judo-heavy ground game predicated on his athleticism and agility. Even when Newton simply warmed up and pranced around the Octagon, his movements had a liquid quality.

As usual, Miletich radiated calm in the dressing room. Plenty of fighters look like world-beaters in the gym. Then, when it's time to fight for real, they crumble. Most become so rattled by the magnitude of the moment, either their skills desert them or their stamina goes to hell and they're out of breath after a few minutes. A few are so successful tamping down their emotions that they lack the required intensity. Miletich always managed a nice balance. "You can't be too nervous," he says. "But if you're not a little bit nervous, that's a problem too. I mean, it *is* a

fight." On this night, he spent those agonizing prefight hours talking casually with Hughes and other fighters in the cramped dressing room and trying to keep his muscles loose. Just another day at the office.

The preliminary fights were electrifying, won (and lost) in various ways. Liddell ended his fight in the first round, nearly splattering the brainpan of his opponent, Kevin Randelman, with a hail of punches. He used his $20,000 purse to buy a Ford Explorer, "the first real car I ever owned." Serra and Carter had engaged in an entertaining tactical fight that Serra had been winning decisively. Then, with nine seconds left, Carter delivered a sensational spinning backfist, reminiscent of Bruce Lee, that clipped Serra in the face and left him unconscious. As Mr. International preened in his pink skivvies — looking absurdly effeminate seconds after pulling off the most macho feat imaginable — the crowd was thoroughly puzzled as to how to react.

By the time Miletich and Newton entered the cage, there was a sense that every fight was an exercise in can-you-top-this? In keeping with the showbiz feel of the "new" UFC, Newton emerged from his dressing room wearing a black suit and black sunglasses. His braided hair bounced to the beat of the hip-hop that accompanied his entrance. As if to underscore the contrasts, Miletich came out to some standard angry, pulsing heavy metal. He wore a track suit, a baseball cap, and a scowl that said, "Let's cut the marketing department bullshit and just fight already."

For the first two rounds it appeared as if Miletich and Newton were less opponents than partners. There was an air of complicity as they acted and reacted, attacked and counterattacked. Inasmuch as artistry can occur on a blood-splattered canvas enveloped by a chain-link fence, this fight came close. Newton offered a tasting menu of his skills and athleticism; Miletich fought with typical precision. Overall, his long experience and superior technique were the perfect antidotes to Newton's great strength, quickness, and energy. And when Newton took the fight to the ground, he was unable to inflict damage. Lying flat on his back, Miletich controlled the action with clever defensive moves and opportunistic arm-punching.

Miletich had selected Matt Hughes, the camp's chunky up-and-coming welterweight, as his cornerman. "Um, keep, uh, fighting your

fight," Hughes offered between rounds. "He's more tired than you. One more round, buddy." If it wasn't exactly wisdom worthy of Confucius, Hughes could hardly be blamed. Miletich was controlling the fight and, despite spending ten minutes locked in combat, he wasn't even sucking air. Newton, meanwhile, was wheezing audibly.

In all sports there are costly errors — dropped passes in the end zone, missed free throws, shanked tee shots, "soft" goals. But these lapses aren't often fatal: there's usually another down, another at-bat, another chip shot, another chance to reverse the damage. Mixed-martial-arts fighters aren't afforded this luxury. One ill-considered move — one typo in a set of encyclopedias — and you're toast. In real life, 99 percent gets you a grade of A. In MMA 99 percent can get you an F. If this is a beauty of the sport, so too is it a danger. Miletich had made a career out of exploiting errors, but this time he was the one who got caught.

The third and final round began as an extension of the previous two. Miletich was winning the stand-up exchanges and squeezing off punches, punishing Newton for lapses in concentration; Newton was taking Miletich to the ground and trying desperately to pass guard. Halfway through the round, Miletich's technique took a disastrously timed coffee break. After Newton scored a double-legged takedown, Miletich writhed out of the mount and tried to return to his feet. It was a standard maneuver, one that he'd executed countless times before. But for whatever reason — fatigue? the weight of the occasion? an unexplainable fluke? — he failed to backstep and he dropped his left shoulder. With hummingbird quickness, Newton slid his left arm over Miletich's shoulder, clasped his hands, and positioned Miletich on the ground. It was a perfect bulldog choke. In less than a second, the entire fight had changed.

Fighters describe the experience of getting choked in a variety of ways. Jens Pulver once likened it to feeling as though your brain was toothpaste being squeezed out of the tube. Rich Franklin analogizes it to having your head held under water, and similarly Frank Shamrock compared it to "what water torture must feel like." Others have characterized it as entering a zone where nothing makes sense and everything is confused and out of sequence. As his head was turning various shades

of purple, his oxygen facing a major roadblock, Miletich could relate. Recognizing that he was in the MMA equivalent of checkmate, he angrily slapped his hands on his legs in surrender.

And, just like that, there was a new UFC welterweight champion.

In Miletich's corner, Matt Hughes thought he was hallucinating. As he later recalled: "It was a fluke, plain and simple. I wanted to ask Pat what that move was, because if you had a question about fighting, he was the person you asked. But I just stood there trying to make sense of what I had just seen."

As Newton collapsed in unadulterated joy, Miletich rose and paced the cage, looking delirious. He was no longer being choked, but his face remained red, now with boiling rage. Though he had never been knocked out in his career, he could have accepted losing a fight on account of an incapacitating punch or a devastating roundhouse kick. If the opponent had been too big or too strong or too fast — simply better — so be it. But to lose a fight because of carelessness? To Miletich, that turned the sting of defeat into real, searing pain. "Fuck!" he yelled, still pacing around the Octagon and chucking his mouthpiece to the ground in anger.

When both fighters finally lost their extreme emotions, they reunited in the middle of the Octagon, hugging and congratulating each other. Miletich couldn't resist asking about that blindingly fast submission: "How'd you do that?" Newton smiled and, in typical Zen fashion, responded, "I'll tell you later. I'm not here, man, I'm in heaven." Interviewed a moment later in the Octagon, Newton had a simple explanation for why he was so deliriously happy: "To be a legend, you got to beat a legend. I just did that."

After the adrenaline rush had worn off, Miletich was still boiling with . . . well, what, exactly, he didn't know. He respected Newton plenty, so there was no shame in losing to him. Besides, Miletich was rational enough to know that competition, by its very essence, breeds winners and losers. He'd missed out on $40,000, yet money hadn't been a driving motivation for years. Still, he couldn't shake the sense that he had lost because of an unforced error. It felt weirdly treasonous, as though he had somehow betrayed himself.

If there was any consolation, it was this: under UFC policy, he was

entitled to a rematch with Newton, provided he first won a "tune-up" bout. Plenty of other fighters did this. Randy Couture, in fact, would beat Pedro Rizzo in UFC 31, but in the ensuing years he'd lose and then reclaim his heavyweight title on three different occasions. One win in his next fight and Miletich would be back in the Octagon with a chance for vengeance against Newton. Or so he assumed, anyway.

10

REMATCH?
WHAT REMATCH?

A FIGHT IS NOT WON BY ONE PUNCH
OR KICK. EITHER LEARN TO ENDURE OR HIRE
A BODYGUARD. — BRUCE LEE

MILETICH NEVER INVESTED a dime in advertising his gym. Not exactly a born promoter — much less a born self-promoter — he hardly ever talked it up, even in casual conversation. Until Jens Pulver, the outgoing lightweight, came up with the idea to call the joint Miletich Fighting Systems (MFS), Miletich never considered lending his name to the place. Too showy. Still, the mystique of Miletich and his training den was ricocheting around the mixed-martial-arts community. There were gyms on the West Coast and gyms on the East Coast. And in between there was the "Miletich battle box" in Bettendorf, Iowa.

Every Monday a new raft of hopefuls would show up, sometimes arriving straight from the Greyhound station or by Amtrak. Some had donated blood to raise the cash to rent an apartment. They all came to train with the UFC champion and see if they had what it took to join his stable of fighters.

In contrast to the unchecked growth of Miletich Fighting Systems was the fate of another Quad Cities fight club. Alvino Peña's gym in downtown Davenport — the rickety sweatbox where Miletich once learned how to cut off the ring and use his legs for leverage when he punched — was dormant much of the time. Peña, the tough-love proprietor, spent most of his afternoons at home, complaining about the diminishing state of the sweet science. "All the kids, they don't like boxing no more. They want to do that crazy fighting they see on TV. That Ultimate Fighting shit, that ain't no motherfucking sport. That's street fighting. You want to hit a man, hit a man. Don't knee him in the head."

As it happened, Peña's grandson Matt was working as a boxing coach at Miletich's gym, teaching footwork and holding the mitts as fighters whap-whap-whapped them.

The uneasy relationship between the two gyms is as good an illustration as any of a larger shift in the combat sports. As the UFC began its ascent — and with it every McDojo started offering mixed-martial-arts training — boxing gyms were becoming cultural relics.* With UFC stars penetrating the mainstream, boxing was losing its relevance, and more and more Americans were hard-pressed to name a single contemporary champion. As I write this, in 2008, the title of Heavyweight Champion of the World, once the most esteemed mark in sports, is simultaneously held by five different men, none of them American. As the UFC gained credibility, boxing — thanks to the likes of Mike Tyson, Don King, corrupt judges, and an alphabet soup of indistinguishable boxing organizations — steadily and sadly became increasingly farcical.

It's up for debate whether the UFC is the proximate cause of boxing's demise or just a lucky beneficiary. Boxing's defenders point out that reports of its death have been greatly exaggerated and that big fights still generate enormous pay-per-view numbers. What's more, they wonder how the UFC can siphon boxing's fan base when the demographics are so different. Boxing draws an older, disproportionately Hispanic crowd; the UFC caters overwhelmingly to young white males. If anything, the UFC imperils professional wrestling, a quasi sport with a similar demographic, similar theatrics, and the vital difference that in UFC matches, outcomes are real, not predetermined.

But at a bare minimum, the Zuffa-era UFC has done a masterly job of cherry-picking boxing's virtues and avoiding its vices. For one thing, as the main promoter, the UFC has the luxury of making its own matches. If a fighter is under contract, he's told when and where to fight. There is as yet no confusing stew of sanctioning organizations. Unlike boxing, the UFC doesn't subscribe to the (dangerous, unethical) practice of "building a fighter up," larding his record with mismatches. As Chuck Liddell once put it to me: "In boxing, a guy could be 30–0 and not fought anyone worth a shit. In the UFC, you can be 4–4 and be a

*In my town, New York City, twenty years ago, there were more than 150 gyms scattered through the five boroughs. Today there are 7.

great fighter. Everyone loses, but that's okay. Fans see the fights they want to see. If there's an obvious fight in the UFC, it's probably going to happen within a year."

As the lone promoter, the UFC has an incentive to support the brand and invest in the sport, rather than simply market it for short-term gains. Here's the inimitable Dana White: "Blame Don King and Bob Arum. Those two have sucked all the life out of boxing and stuck it in their pockets . . . Those guys did nothing to secure the future of boxing. It was 'How much money can I make right here, right now?' That's not what we're doing . . . We just had a CFO — one of these guys from a corporate structure — and he saw how much money we spent [promoting the UFC in England]. He came to me and said, 'This is fucking insane, this makes no sense. You can't spend this money. You know how long it's gonna take to make this back?' I don't care if you live in London or if you're a fucking sheepherder in the middle of fucking nowhere. You'd better have heard of the UFC."

The UFC has also been skillful in promoting the fighters as decent people outside the cage. Boxing is still populated largely by the re-formed thugs who "fought to escape the street," an admirable story line that gets repetitive and doesn't always resonate with the ticket-buying public. For instance, Floyd Mayweather, boxing's current beau prince (though at the moment he claims to be retired), has fathered children out of wedlock and has a habit of vile trash talk that alienates far more fans than it attracts. This is at considerable odds with the average MMA fighter, who tends to be college educated, middle class, and able to suppress most of his jackass tendencies. Otherwise, it will cost him his UFC contract. Even Tito Ortiz, the self-described bad boy, is really not bad at all; he's simply an opportunist who filled a void when the organization needed a World Wrestling Entertainment–style villain.

There is, of course, an undercurrent of race in this discussion: the UFC is unmistakably whiter than boxing. And many will suggest that it's popular because, like NASCAR, it's the rare sport in which white fans can root for white athletes. But in truth it's much more about class than race. There are African-American UFC fighters, there are Hispanic fighters, there are sizable contingents of Brazilian and Japanese fighters. And fans are able to see a little of themselves in each. Says Liddell: "The

typical fan can relate to the typical UFC fighter. They can look at [Ultimate Fighters] and say, 'That could be me. He could have my job. Maybe if I had gone that way I could be there [in the Octagon]'. They can't do that with athletes who came out of the ghetto, guys who are like, 'Hey, I'm a gangster.'"

Another feature distinguishing MMA from boxing: safety. While boxers don't battle in a steel cage or punch opponents when they are on the ground, they do something much more perilous: they trade head shots for three-minute rounds. Factor in sparring sessions, and the cumulative effect is devastating. If Muhammad Ali, the sport's most decorated champion, is an uncomfortable reminder of boxing's brutality, there are thousands of others who share his fate.

Mixed martial arts might involve more blood and broken bones, but repeated head trauma is not part of the equation. A downed fighter isn't given a standing eight count to "clear the cobwebs" before his opponent delivers more blows to the head; rather, he can take the fight to the ground and ward off punches with wrestling moves. A staggering fighter can clutch and grab all he wants. And if he's truly in danger, he can tap out without being stigmatized as a coward. What's more, the average boxing match is more than three times as long as the average MMA fight. "You're going to see worse cuts in MMA than in boxing, especially with longer rounds, and there are more knockouts," says Dr. Margaret Goodman, past chairwoman of the Nevada State Athletic Commission's Medical Advisory Board. "But overall, is it safer than boxing? I think so. Absolutely. You don't have ten rounds of guys taking shots to the head."

Moreover, while historically it was taken as an article of faith that the heavyweight boxing champ represented the masculine ideal — that is, "the world's biggest badass" — the UFC has challenged that. How would, say, Floyd Mayweather or Mike Tyson fare against a UFC champ? The conventional wisdom: if a boxer ever connected with a power shot, the fight would be over. But if an MMA fighter slipped the punch and kneed the boxer with a Muay Thai clinch or got him on the ground and manipulated a joint, the fight would be over just as fast.

So the UFC offers more competitive fights with better presentation and less promoter corruption. Its fighters are more versatile athletes. Collectively, they're better educated, better behaved, and better mar-

keted. Mixed martial arts is less dangerous, and it has also undercut boxing's symbolic masculine ideal. Is it really a mystery why one combat sport is expanding as quickly as the other is collapsing?

Only a few days after his stinging loss at UFC 31, Miletich was given a bit of good news: he was being summoned to fight on the very next card, six weeks later. The unspoken assumption was that if Miletich won at UFC 32, he would be granted a rematch against Carlos Newton and a chance to regain the belt he'd held for nearly three years. Miletich's spirits were further brightened when he learned that he would be facing a familiar opponent for this tune-up fight: Shonie Carter.

Among all the colorful characters populating UFC Nation, Mearion Shonie Bickhem III (d/b/a Shonie "Mr. International" Carter) cut a singular profile: an African American raised in inner-city Chicago, he was a college art major who later did a stint in the Marines. He brings an endless supply of one-liners to every conversation. Why did he assume the nickname "Mr. International"? "Man, I've been to so many places, I need a backpack just for my passports. I've kissed girls close to heaven and I've been to places so low down the sun had to come up twice just to make daylight."

Carter was a formidable, small college wrestler at Carson-Newman College in Tennessee — one of his many wins came against Matt Hughes — when, on a bet, he entered a local no-holds-barred fight. To protect his wrestling scholarship, he entered under the name "Sergio Maximilian." He won the wager, and he won the fight. The purse was a measly $100, but he was hooked. "I was like, why wrestle for plaques and medals when I can fight for money?"

Entering both sanctioned and underground fights whenever he could, Carter's was often the only black face in the arena — never mind on the card. Nevertheless, he claims he's never experienced a whiff of hostility. "I don't see myself as a racial athlete, so fans don't see me as one either," he says. "I don't care if you're black, white, green, or blue. I'm gonna hit you the same way: hard and frequently. I'm going to kick you, choke you, and manipulate your joints. Then I'm gonna shake your hand and buy you a drink, because I respect you for getting in that cage!"

If Carter has a race-related complaint, it's that despite the fact that African Americans have made a big impact in the UFC, the organization hasn't done much to market the sport in the inner city, including the neighborhood on Chicago's West Side where Carter lives. "Until that happens, the brothers are still gonna play basketball and run track and box before they're gonna get into mixed martial arts," he says. "I've won world titles in MMA, I've fought around the world, my pretty face has been on TV. And the only way people in my hood know all this is if I tell them myself."

As likable and entertaining as Carter was, he was the perfect opponent for the more analytical, intense Miletich. He was only a few years younger than Miletich, but lacked his experience. He was a well-rounded fighter but lacked Miletich's depth of expertise. In addition, Carter was a known quantity. Besides running into each other at MMA shows around the Midwest, Miletich and Carter had faced each other two years before at an Extreme Challenge event in the Quad Cities. After twenty minutes of fighting, mostly on the ground, Miletich won a close and controversial decision. "I love Pat," says Carter. "But I'll go to my grave thinking I won that fight."

UFC 32, "Showdown in the Meadowlands," was held in New Jersey, where MMA had been sanctioned. Before the fight, Miletich was visited by an emotion he hadn't felt since his UFC debut years before: anxiety. The fight was supposed to be a formality before the rematch with Newton. But what if Miletich lost? In the current, evolved model of the UFC, a fighter who takes two straight defeats is often cast aside. Plus, Miletich and his wife had just signed a mortgage on a new home in Bettendorf. If he lost the fight, he wouldn't be able to cover the note. What would he and his new bride do, move in with his mom?

With all the swirling stress and doubt, Miletich had trouble focusing on the fight and dropping 20 pounds from his "walking-around weight" to make the 170-pound limit. Cutting weight is one of those excruciating rituals that weed the undisciplined from combat sports. Miletich had been doing it since his days in junior wrestling,* but this time he struggled. He deprived himself of food and jumped rope in a

*In fact, he believes his cutting weight as a young wrestler was what stunted his growth.

rubber suit to sweat off pounds, and he became so dehydrated he hallucinated.*

The morning of the fight, barely able to stand, he made weight. But then the pain came. Unable to replenish the water loss quickly enough, he began to cramp. When his feet throbbed, he put on his wrestling shoes and tied them as tightly as he could. Then the cramps climbed up his body: calves, thighs, abs, biceps, forearms. His vision blurred. In agony, he rolled up in the fetal position on his hotel bed. When neither pain nor double vision subsided, he called a friend, Tom Sauer, a well-liked Florida fighter who moonlighted as a paramedic and fireman. "Get me to a hospital, Tom."

Sauer told him it was a bad idea. "If any doctor sees how depleted of fluids you are, he'll never let you fight." Sauer and Miletich drove around New Jersey trying to find an IV line that Sauer could hook up back at the hotel. When they were unsuccessful, they finally went to an emergency room, staying silent about Miletich's plans for the evening. The staff was predominantly African American, which wouldn't have been a problem except that Sauer suffers from Tourette's syndrome, a neurological disorder that can cause people to blurt out obscene or inappropriate remarks. "If something makes you nervous, it makes me say Words of the Day," Sauer explains. "I think it's God's little joke."

Sauer had to warn the nurses that he was not racist, and if he happened to use the N-word, it was inadvertent, a function of the Tourette's. As Miletich was administered three liters of saline, Sauer involuntarily muttered "Fuck, fuck, nigger, nigger," as the nurses tried not to take offense. A few hours later, Miletich was due to battle in the Octagon. As prefight preparation went, it was something less than ideal.

UFC 32 represented the improving and evolving product under the Zuffa ownership. There were some fireworks on the card, including Tito Ortiz defending his light-heavyweight title by pummeling the Australian fighter Elvis Sinosic. (Afterward, Ortiz donned a relatively tame T-shirt: "That's American for Whoop Ass, Mate.") Most of the other fights were

*A less conventional technique for cutting weight: profuse spitting. At one card I attended in 2008, a featherweight tipped the scales at half a pound over the 145-pound limit. He walked around the perimeter of the arena, letting loose a steady flow of loogies. An hour later, he had lost almost 9 ounces.

tactical affairs, far removed from mindless street brawls and hockey-style pile-ons.

Miletich was still suffering blurred vision when he walked into the cage, but at least he was no longer cramping. After his flash loss to Newton in his previous fight, he was clearly cautious in the early moments, circling Carter and flicking off jabs and controlling ground fighting without inflicting any real punishment. But in the second round, aware that his stamina was going to work against him after his battle with dehydration, Miletich grew aggressive.

Preparing for this fight, Miletich had noticed that every time Carter saw a kick coming he hunched down and ducked. Remembering this, Miletich aimed a kick at Carter's shoulder. When — sure enough — he ducked, the kick drilled him not in the shoulder but square in the back of the head. Carter crumpled like a condemned building. It was yet another example of a fighting truism: the most dangerous blows are the ones you don't anticipate.* Before Miletich could inflict follow-up damage, the referee, Mario Yamasaki, hurtled himself on top of Carter, stopping the fight.

Miletich was now 8–1 in the UFC. His last four wins had come by virtue of a kick to the head, a guillotine choke, an armbar, and a brutal boxing punch that split open the other dude's face. Mixed martial arts indeed. But on this night Miletich wasn't thinking about his versatility. He was just happy that he'd returned to the business of winning fights. And now he needed only to regain the welterweight belt to feel completely restored.

When he returned to Bettendorf, Miletich resumed his maniacal training, hell-bent on reversing history against Newton. The knockout against Carter was further proof that Miletich was at the peak of his powers and that Newton's bulldog choke was only an unfortunate fluke.

The other fighters at the gym seemed to improve by the week, which was fine by Miletich. The more they could challenge and push one another, the easier time they'd have when they fought for real. After

*All the more so with kicks. One of the truisms of MMA: a leg can generate more force than an arm. And unlike a fist, a fighter's leg isn't padded in the equivalent of a glove.

a particularly grueling session, Miletich's manager, Monte Cox, came to the gym and pulled Miletich aside.

"We gotta talk," Cox said.

"What's up?"

"Your rematch against Newton, it looks like it's off."

Cox went on to explain that the headliner for the UFC 34 card was a heavyweight fight between Randy Couture and Pedro Rizzo, a rematch of their classic at UFC 31. "If they put you and Carlos on, it will mean having two rematches as the co–main events. It'll be like running the whole card again, and they don't want to do that."

"Okay," Miletich reasoned, "so I'm fighting Carlos at UFC 35?"

"Not quite," Cox said. "They still want Carlos to fight at UFC 34. And here's the real bitch: they want to put him in there against Matt."

"Hughes?"

"Yeah, that Matt."

One didn't need to squint to see the anger and disappointment on Miletich's face. Postponing his fight was one thing. But denying him a rematch and then summoning Matt Hughes — the fighter many had nicknamed "Pat Jr." — was below the belt. This opened a rift with Zuffa, and Dana White in particular, that would only widen in subsequent years. Finally Miletich spoke.

"Does Matt know about all this?"

"He doesn't want to take your fight."

Miletich sighed and cursed. Apart from the insult of it all, there was an awkward reality: Hughes might win and become champion, and Miletich would no sooner fight him than he'd fight his own brother. Another unwritten camp rule: one MFS fighter doesn't fight another. Even with a belt — even with a *career* — on the line. Miletich would have to switch weight classes. Or something.

After a therapeutic workout, Miletich called Hughes, who was away at his farm in Hillsboro, Illinois, harvesting soybeans. "I know I'm getting screwed here, but you have to take the fight."

"It's your fight, Pat," Hughes said.

"If you don't take it someone else will, and they'll become world champion. If someone else has to take my place, it may as well be another guy from the gym."

"It's your fight," Hughes repeated.

"Listen," Miletich said, "I promised I'd make you a world champion, didn't I? Get your ass off that tractor and get in here so you can win that title."

Hughes left the farm and returned to Bettendorf to train. It was Miletich who spent hours rolling with him on the mat, simulating Newton's unique style and fashioning a fight plan that would enable Hughes to use his strength and short arms to counter Newton's quickness and agility. In November, Hughes and Miletich boarded a plane for Las Vegas. Hughes would be fighting for the UFC belt and Miletich would be working his corner.

Deploying his patented body slam and thwacking Newton like a man beating a rug, Hughes controlled the action for the first five minutes. The second round began with more of the same. Then, in one of those "Immaculate Reception" or "Shot Heard 'Round the World" moments, what came next was immediately embedded in MMA lore. About a minute into the second round, Hughes lifted Newton off the ground and prepared for a slam. Newton, while suspended in the air, grabbed the top rail of the cage. When the ref, John McCarthy, demanded that he release his grip, Newton applied a triangle choke to Hughes.

The blood supply to his brain dwindling, Hughes took a step back and dropped Newton onto the mat. Newton landed on his back, his braids spraying out as his head bounced off the canvas. He was knocked out cold. But he had company. It appeared that Hughes was momentarily unconscious too, as a result of the choke. As McCarthy leaned in to check on Newton, Miletich scaled the Octagon and screamed to Hughes, "Wake up!" Sensing that Newton was unconscious, McCarthy waved off the fight, and by the time McCarthy turned around, Hughes had come to and sat alongside the fence, stunned.

It took Hughes several seconds to realize that he'd won. Then he rose and began celebrating. The UFC had a new welterweight champion. The first man to rush into the Octagon to lift Hughes in the air was Pat Miletich, no trace of disappointment on his face.

Over the next few months, Miletich went through a swirl of emotions. His camp had established itself as *the* nerve center of mixed martial arts.

Miletich Fighting Systems was minting world champions, and at least a dozen others were rapidly ascending the MMA food chain, not least Tim Sylvia, a heavyweight Goliath who got out of his own way long enough to win every fight he took. A Who's Who of the sport regularly parachuted into Bettendorf for a week or two of training, aware that there was no better place to sharpen skills before a fight. Hardly a day went by without this Big Ten wrestler or that Golden Gloves boxer showing up, prepared to sacrifice pints of blood for the chance to train with Miletich and his stable of tough guys.

While the buildup had been gradual, the success of Matt Hughes seemed to have a particularly galvanizing effect. If a Brazilian weaned on exotic jiu-jitsu was winning the belts, that was one thing. But if a thick-necked, aw-shucks All-American boy from a downstate Illinois farm was becoming a champion, well, success seemed a lot more attainable to other aspirants. To Miletich it was all slightly surreal. His gym's success was akin to that of an entrepreneur who starts a business in his basement and soon finds himself running a multinational firm with hundreds of employees. Were they really coming to the friggin' Quad Cities from as far away as Japan to train with *him*?

At the same time, he was concerned about his own fighting career. As it stood, he was not only no longer a champion; he exiled himself from his own weight class. He wanted desperately to keep fighting, but knew he'd have to do so at 185 pounds. Apart from putting on weight, the dynamics of his fighting style would have to change to accommodate heavier — and probably taller and rangier — opponents. As Miletich bulked up and resumed training, his anger toward the UFC intensified. He had been a good soldier, sticking with the organization in its lowest moments. That his loyalty wasn't repaid was a cardinal sin in his bible.

Miletich didn't feel any better about the organization when he was assigned Matt Lindland as his next opponent. Lindland was known as "the Law," less a reference to his authority in the cage than to his litigious past. Vying for a spot on the 2000 U.S. Greco-Roman wrestling team, Lindland lost at the team trials. He protested the match, claiming that the opponent used his legs, forbidden by Greco-Roman rules. The opponent claimed it was incidental and countered that Lindland had bitten him on the ear. An arbitrator ordered a rematch, which Lindland

won. After lengthy appeals and tribunal hearings, days before the Olympics' opening ceremony in Sydney, Australia, Lindland was awarded the spot. That he took home the silver medal was a testament not just to his skill but to an uncanny ability to compartmentalize distraction.

Before his training for the Olympics, Lindland had become obsessed with the UFC. He had befriended Randy Couture when they were both All-American college wrestlers — Couture at Oklahoma State and Lindland at Nebraska. Their friendship grew after each had settled in the Pacific Northwest. When Couture left wrestling and found a fruitful second career in the UFC, Lindland was inspired. Without telling the Olympic team's coaches, he sneaked off and fought on small MMA cards, one in Alabama, another in South Dakota. He won both fights — in one case head-butting his way to victory — and got an adrenaline spike unmatched by wrestling. He went back to his Olympic training confident of what he'd do after his wrestling career ended.

Home in Oregon after the Olympics, Lindland worked at a car lot he managed in the Portland suburb of Gresham. He and Couture seized on the idea of turning an unused warehouse on the lot into an MMA training gym. They spent a day installing drywall and floor mats. The place was a small, unheated box, hemmed by three walls and a sliding garage door. Team Quest was born that day.

Couture would tell anyone who'd listen that his buddy was picking up submissions and striking at an alarming speed. Lindland quickly became a UFC darling. His pedigree as an Olympic silver medalist gave him instant credibility. And he kept winning. After he had won his third UFC fight in less than a year — beating veteran tough guy Phil Baroni in one of the preliminaries to Hughes-Newton — Lindland was a star. The UFC clearly hoped that his official coronation would come when he beat Pat Miletich.

UFC 36 was held at the MGM Grand in Las Vegas in the fall of 2002. The UFC was still bleeding money — cards routinely lost in excess of $1 million. But the organization could hardly be accused of scrimping on the marketing. It mounted abundant advertising and media campaigns and elaborate prefight weigh-ins. For all the gladiator hype, Miletich and Lindland couldn't dredge up much animosity for each other. A longtime UFC fan, Lindland lionized Miletich as a five-time champ, referring to him in one interview as a "fighting legend."

Iowan that he was, Miletich had boundless respect for anyone who'd won an Olympic wrestling medal. The day before the fight, they chatted easily and introduced each other to their respective families.

When they met in the Octagon, their affair was less a fight than an act of regicide. Despite carrying the extra weight, Miletich looked appreciably smaller than Lindland, a lanky fighter who didn't have a bronzed-god body but had the wiry strength that's often more dangerous. Deferring too much to Lindland's wrestling talent, Miletich was cautious to the point of being passive. Lindland smelled chum in the water — as the best fighters always do — and simply dominated the fight, flipping Miletich, mounting him, then peppering him with punches. Miletich's eating a cow's worth of leather recalled his description of his first fight, thirty years earlier, when, as a kindergartener, he was overwhelmed by the bigger bully.

Though Miletich didn't tap out, he did not strongly object when the ref stopped the fight midway through the first round. Maybe he had faced a bigger and stronger opponent. Maybe, firmly in his mid-thirties, he felt the sting of age. Maybe, as Miletich himself suggested, he'd been so affected by how shabbily the UFC had treated him that his "head wasn't in the right place." Maybe with a wife at home, a daughter on the way, and a successful gym bearing his name, he could no longer channel the fury and resentment that had been his jet fuel in the past. Whatever, something had gone out of him. The gate clanged angrily behind Miletich as he left the Octagon. He would never fight in the UFC again, an anticlimax to a legendary MMA career.

There was another possible reason for Miletich's vacant performance against Lindland. A few weeks before the fight, he'd gotten a call from his brother John. He was being paroled from his "vacation." They had barely spoken since John's incarceration. Pat was furious at his brother for any of a hundred reasons, but most of all for the pain he had inflicted on their mom. Letters and calls to Pat had gone unreturned. When John once asked for a color TV for his jail cell, Miletich told him to forget it. "You're not there to watch TV," he snapped. "You're there to do right by the state of Iowa."

When Pat and John reunited, they each thought the other looked

the same. Though north of forty, John still had the tall frame and sinewy-strong physique that Pat would've killed to have inherited; in John's eyes, Pat still looked like a pocket Hercules. But internally, they had both changed radically since John's incarceration. Pat, of course, had transformed himself from a confused and angry raiser of hell into a disciplined fighter, a married father-to-be, and the owner of a gym that had placed the Quad Cities at the center of an entire sport. As for John, as much as one hears about "the revolving prison door," he came out reformed, sober, and determined to do "a heck of a lot better in the second half of my life than I did in the first." As he told Pat, "The way I look at it, they did me a huge favor when they locked me up. The way I was going, I could easily have been the third brother to die."

For the first six months after his release, John was required to "re-integrate" into society. That meant living in a halfway house in Davenport and holding down a part-time job. If a job in the Quad Cities was hard enough for anyone to find, it was infinitely harder for a convicted felon. Pat created a job for John at the Gold's Gym.

"It's only six bucks an hour," Pat apologized to his brother.

"For a guy making fifty cents an hour in the state pen, that's a hell of a raise."

When Pat started to apologize for the modest nature of the work — scrubbing toilets and maintaining the weight equipment — John put his hand up like a stop sign. "I'll take it," he said. "And I'm going to take all the pride in the world in it. You built our name back up, and you don't have to worry about me causing any more embarrassment. I know the reality: my trust account is in a negative balance. But I'll be building it back up." Before either of them could get teary, John added, "Man, it's a weird feeling trying to live up to the standard set by your younger brother."

11

THE HEAVYWEIGHT'S
HEAVYWEIGHT

BLOOD IS JUST RED SWEAT.
— **ENSON INOUE,** MMA heavyweight

MIXED MARTIAL ARTS is not about two reprobates beating each other senseless. It's not populated by some hooligan army just out of the drunk tank. It's not a form of Toughman. It's not — all together now — human cockfighting. It's not much more dangerous than any of a dozen other sports.

But, like anything else, it's not without flaws. For all of MMA's virtues, you'd be hard-pressed to name a sport more susceptible to performance-enhancing drugs. Combining relentlessly vigorous activity with slipshod testing, MMA almost begs for PED abuse. The fighters stand to benefit from the slightest edge in strength and stamina — which can be achieved through anabolic agents. And because their bodies are constantly banged up, they stand to benefit from accelerating recovery from injury — which can be achieved through human growth hormone. On top of that, drug tests are usually given before and after bouts, so fighters have plenty of advance warning and lots of time to "cycle off" a doping regimen. What's more, the tests are often administered by state athletic commissions, which are rarely beacons of competence. After the UFC 69 event in Houston in 2007, for instance, the Texas Athletic Commission simply neglected to subject the fighters to drug tests. Oops.

There's no way to quantify accurately just how deeply performance-enhancing drugs have infected mixed martial arts, but the anecdotal evidence is overwhelming. A number of stars have failed drug tests, from heavyweights to lithe tacticians no less than the great Royce Gracie. According to the California State Athletic Commission, MMA fighters flunk drug tests at double the rate of boxers and kickboxers

combined. When, in the course of researching this book, I asked MMA fighters, managers, and trainers about the prevalence of drugs in the sport, their estimates ranged from one-third to three-quarters of the fighters (though some of that amount, I hasten to point out, referred to the generally undetectable human growth hormone, usually used not to gain a competitive advantage but to speed recovery from injury). "I think what we know about is only the tip of the iceberg," says Dr. Margaret Goodman, former chairwoman of the Nevada commission's Medical Advisory Board. "Fighters are always telling me that more use than don't. Until testing is stepped up and fighters get tested out of competition, they're going to know how not to get caught."

When one fighter in the EliteXC organization failed a doping test in 2007, he expressed shock and outrage with the result. Not because he denied the drug use, but because, as he told a friend, "I tested myself a few days ago and it came back clean." Without confirming or denying that he had ever used performance-enhancing drugs, one rising middleweight star told me it was simply a matter of the rewards outweighing the risks. "Your window in this sport is so short, you do anything to help yourself. I think it's human nature, but especially in this sport, you want to be the best you can absolutely be."

The Miletich camp hasn't been immune from doping either. Tim Sylvia was a goofy, six-foot-eight kid with a bread-dough physique when, in 2000, he traveled from his home in Eastbrook, Maine, to watch a UFC show in Atlantic City. He introduced himself to Miletich, and when Miletich invited him to "haul your big ass out to Iowa to train," Sylvia accepted. At first the lug was so uncoordinated that he took on the politically incorrect nickname of "Polio." He was relentlessly hazed by the other fighters. The joke was that he spent so much of the first few training sessions outside the racquetball court, bent over vomiting, everyone thought he was four foot eight, not six foot eight.

Sylvia had never been comfortable in his own skin, stemming, he says, from an emotionally abusive childhood. The harassment at the gym was more of the same. Stifling tears, Sylvia once complained to Miletich about it, and about Jens Pulver in particular. "He tells me I

suck. He tells me I'm fat. He tells me I should quit and go fucking home."

"He's testing you, and you can prove him wrong," Miletich said. "But here's what I don't understand: you're twice as big as Jens is. Why don't you throw his ass on the ground, punch him a few times. He'll never bother you again."

Sylvia took a moment to think about it. "I always felt smaller than him."

Sylvia kept showing up at the gym. He'd train until he vomited and then push on, working doubly hard at his weakness — submissions — while clinging to everything Miletich said and did. When the nickname "Polio" fell out of favor, Sylvia took on another: "the Maine-iac."* Mostly by virtue of sheer physical dominance, he was winning fight after fight. Mixed in with the first-round stoppages were some tougher wins that demanded stamina and large reservoirs of courage that few — not least Sylvia himself — suspected he had in him.

By the fall of 2002, less than two years after Miletich had invited him to Bettendorf, Sylvia was a fast-rising heavyweight who, with a pro record of 13–0, was invited to appear on his first UFC card. He won that debut fight with a vicious onslaught of punches and knees. At UFC 41, in 2003, he beat Ricco Rodriguez and became heavyweight champion. "It took months for me to accept just that I was *good* at something, much less a world champion," he says. Seven months later, at UFC 44, he defended his belt against Gan McGee, mauling him with punches and knocking him down in the manner of an axed sequoia. He now had a professional record of 16–0. Back in Eastbrook, Maine, Route 200 was renamed "Maine-iac Highway."

Sylvia's joy, though, was short-lived. A postfight drug screening revealed that he had tested positive for stanozolol, a banned anabolic steroid. When Miletich heard about Sylvia's drug test, one could practi-

*It's reasonably clever, as these things go. Like mobsters and pool hustlers, fighters haven't truly been "made" until they take on a nickname. Most MMA handles derive from either geography ("the Huntington Beach Bad Boy," "the Alaskan Assassin") or death/pain ("the Executioner," "the Axe Murderer," "the Terror"). My personal favorite is the handle of the Miletich heavyweight Brad Imes. Calling yourself "the Hillbilly Heartthrob" suggests an irony appropriate to the whole nickname tradition.

cally see cartoon puffs of steam rising from his ears. Sylvia had disgraced himself, disgraced his teammates, disgraced the gym, and, worst of all, disgraced the sport. The image of MMA was rising in the public's consciousness, slowly converting the skeptics — and now the heavyweight champ tests positive for steroids. Miletich also considered an angle that too often gets lost in the discussion of performance-enhancing drugs in sports. What about the "clean" fighters? What about the guys busting their asses without any help from the pharmacy? "You cheat *everyone* when you do that shit," he said.

Miletich stopped short of kicking Sylvia out of the gym. "You made a hell of a mistake," he said. "But how can I, of all people, not give a guy a second chance?" As Sylvia awaited his fate from the UFC, he took heaps of criticism. The online fans made him a pariah, a status that persists today.* Yet instead of "lawyering up," or mimicking other pro athletes by offering a dubious alibi,† Sylvia did something rare: he took ownership of a galactically stupid decision. Before any punishment had been handed down, he agreed to be interviewed on the popular MMA website Sherdog.com. He admitted that a few months before the McGee fight, in an effort to "trim my physique," he had injected the steroids. "Whatever they decide to do with me, I agree with, because I screwed up," he said. "I can't say I'd be pissed [if my belt was taken away], because I screwed up. If they decide to do that, it's nobody's fault but my own. I'm the one who chose to do what I did."

In part because of his contrition, Sylvia got off with a relatively light punishment. He was stripped of his UFC title, fined $10,000, and suspended for six months by the Nevada commission, which was almost laughable given that top fighters seldom compete more than twice a year.

In the summer of 2004, Sylvia was back in the Octagon, fighting for the heavyweight championship against Frank Mir. A well-liked Las Vegas–based fighter with a black belt in jiu-jitsu, Mir had a job moon-

*In April 2008, Matt Serra, the opinionated New Yorker, took on Georges St. Pierre in St. Pierre's hometown of Montreal. Asked how he would cope with being booed relentlessly, Serra shrugged and said, "It'll be like what Tim Sylvia experiences every time he fights."

†"I didn't know what I was taking" (Marion Jones). "I thought it was flaxseed oil" (Barry Bonds). "The testing was botched" (Tour de France winner Floyd Landis). My best friend "misremembered" details when he implicated me (Roger Clemens).

lighting as a bouncer at the famed Spearmint Rhino strip club — which says plenty about the UFC wage scale at the time. Sylvia arrived looking lumpy, as usual, but still physically fit. With Miletich's help, he had a thorough fight plan that involved taking advantage of his reach to keep the shorter, stockier Mir at a distance while peppering him with jabs and kicks.

Early in the first round, however, Mir flipped Sylvia on the ground and applied an armbar. "Reverse roll!" Miletich yelled from the corner. By that point, it was akin to explaining aerodynamics to a skydiver without a parachute. Mir wrenched Sylvia's right forearm and used his thigh for leverage. He continued to apply pressure, though Sylvia, looking more annoyed than in pain, showed no inclination to tap out.

The action was on the ground, difficult for the fans to see. And the fighters had their backs to the media section. When Herb Dean, a former MMA fighter and little-known referee, rushed in and stopped the fight, confusion reigned. The fans booed and began the obligatory "Bullshit!" chant, angry at the premature call. "If this is a mistake, it's a colossal one," a television commentator said of the abrupt stoppage. Sylvia went ballistic, complaining that he was fine. "Your arm's broken," Dean responded coolly.

When the fighters met at the center of the ring, Mir graciously offered a rematch. "Let's fight again."

"Let's fight now," Sylvia shot back.

Someone in the production booth had the good sense to put a slo-mo replay on the overhead monitors. The crowd looked on, and their confusion melted into horror as they watched what had happened. Mir gripped Sylvia in a textbook armbar. Sylvia's right forearm continued to hyperextend until it snapped like a raw carrot. There were reports of fans vomiting while watching the replay. Shaquille O'Neal, seated a few rows from the Octagon, watched the replay and made an O with his lips before covering his mouth with his hand. Though Sylvia was still protesting — "I'm fucking fine!" — needless to say, Dean, the referee, had been vindicated.

Amid the tumult, Miletich stood next to Sylvia in the middle of the cage and asked his fighter, "What's up with your arm? That looked bad, Tim."

"It's broken," Sylvia admitted.

"Well, you had a pretty good poker face there," Miletich said, starting to laugh. "You have to keep faking it now."

And Sylvia did, lifting his broken arm high in the air and waving to the crowd as he left the Octagon.

As often happens to MMA fighters, once Sylvia had reached the locker room and the adrenaline had worn off, mere discomfort turned into intense pain. He looked down at his swelling arm and quickly averted his eyes. His face sagged and twitched in agony.

Miletich gave Sylvia the "everyone loses, it's part of the sport" speech, but Sylvia was barely listening. "Ow," said the now former UFC heavyweight champion. "Ow! This hurts like a motherfucker! Ow!"

The next few months were unpleasant for both Mir and Sylvia. Sylvia needed a titanium plate implanted in his forearm. Compounding matters, a few weeks later he appeared on the cosmically tasteless reality show *Blind Date,* now a YouTube classic in UFC Nation. Sylvia endured the indignity of his date explaining on national television, "I don't find myself overly sexually connected with you." Then again, maybe it was for the best for Sylvia: she also bragged, "I'm not an alcoholic because I don't go to meetings." In any case, this gave the army of Sylvia critics still more fodder.

As for Mir, a few months after the fight he was riding his motorcycle around Las Vegas when a car clipped him. He flew eighty feet from the point of impact, broke his femur, and ripped all the ligaments in his knee.* His injuries prevented him from defending his UFC heavyweight title. As of this writing, he is back on the comeback trail, having beaten the pro wrestler turned MMA fighter Brock Lesnar at UFC 81. Regardless, the Mir-Sylvia fight was a seminal moment in UFC history. Indirectly, anyway, it birthed the UFC's life-saving reality show.

*At least he kept his sense of humor. The story goes that as paramedics frantically cut away Mir's pants, he asked for a towel. "The grass is cold and wet," he told the EMTs, "and I don't want people to get a false sense of me."

12

TUF ENOUGH

IT'S A REVERSE SOCIALIZATION PROCESS. THERE ARE 16 DUDES
WITH THAT KNUCKLE-DRAGGER IN THEM, AND IF YOU PUT
THEM IN THAT SITUATION, THEY'LL DEVOLVE. WE ALL TURNED
INTO CAVEMEN. IT TOOK ME TWO WEEKS AFTER I GOT BACK
TO RETURN TO NORMAL.

— FORREST GRIFFIN, describing *The Ultimate Fighter*
reality show, in the *Augusta Chronicle*

BRIAN DIAMOND HAD SAT a few feet away from the Octagon the night Tim Sylvia fought Frank Mir, not quite sure what to expect. An executive at Spike TV in New York, Diamond had been tasked with finding a combat sport that could be aired on the network. Viacom and CBS had recently merged, and in the course of the marriage, the Nashville Network, a hokey country entertainment channel, had been converted into Spike. As the name suggests, Spike was interested in action, particularly the kind that could win over the coveted, elusive 18-to-34 male demographic. It even branded itself as "the First Network for Men." Spike already had the rights to broadcast professional wrestling and wanted that audience to stick around after the WWE show ended. Diamond and his colleagues had watched all manner of men pounding on each other, including PRIDE events in Japan and a K-1 card at the Bellagio in Las Vegas. "But," Diamond complained, "it all felt low rent."

Then he attended UFC 48. Ever the promoter, Dana White stroked the egos of the TV execs, giving them the full VIP treatment. Diamond sat at "the table" ringing the Octagon and wore headphones tuned to the pay-per-view commentary of Joe Rogan and Mike Goldberg. Lorenzo Fertitta stopped by to "answer any questions." Diamond was impressed by the audience — its size, its diversity, its celebrity quotient. He spotted Shaquille O'Neal, Cindy Crawford, and Juliette Lewis, all sitting nearby. When Mir broke Sylvia's arm, Diamond watched the reaction of the crowd. He was surprised that they weren't horrified so much

as they were in awe. How, after all, could this be considered assault and battery when the dude with the broken arm was begging to continue fighting? Diamond later told his boss, "This could be a hit."

If Spike had the distribution channel but needed the programming, the UFC had the opposite problem: it had the "content" but needed an outlet for it. If the sport was truly going to reposition itself — up from the underground and in from the margins — it required the legitimacy that comes with television. Time and again White and the Fertittas approached various networks about airing cards but were turned away, told that Ultimate Fighting was too risky. What if someone died in the cage? How could a network justify airing a sport that wasn't sanctioned in most states? How could it air a sport unsuitable for kids? Why would a network already locked in a continual ground war with the FCC want to get in the crosshairs of the political establishment?

In retrospect, it was one of those "duh" ideas, hanging in the ether, waiting to be seized. But after so many rejections, the Zuffa brass had a new concept: why not create a UFC reality show? Reality TV was no longer a fad but an enduring shift in the culture. Since the beginning of television, viewers watched actors performing scripts conceived by writers and directors; now the shows were often more entertaining when cameras simply rolled on reality. Critics called it "voyeur TV," but it sometimes made for gripping drama.

The Fertittas contracted with Craig Piligian, a co–executive producer on the wildly popular reality show *Survivor*. Piligian ran his own production company, and his reality concept for the UFC borrowed heavily from *Survivor*. A pair of eight-man teams would be "marooned" in a Las Vegas mansion. The fighters would be deprived of creature comforts like phones and Internet access. Instead they would devote their energies to competing in an elimination-style tournament. The grand prize? A six-figure, multifight UFC contract. Part of the drama was the winnowing of the field. But of course the real theater was the dynamic of the testosterone-palooza, observing how these gladiators — each convinced he was the baddest motherfucker on the planet — would coexist under one roof.

The fighters selected weren't well known, but most of them had a few pro fights on their record and were on the cusp of making it to the

UFC on their own merits. They were clearly elite athletes. The majority had college educations. They would show that technique and precision were crucial. The instances of shield-your-eyes violence would be minimal. (And, by controlling the production, the UFC could rest assured that any unflattering scenes would end up on the cutting room floor.) The episodes would showcase the personalities of the two coaches — well-established MMA stars — while minting the next generation of stars. They would demystify mixed martial arts and demonstrate that it was something you could let into your home. Perhaps above all, the reality show would double as a weekly infomercial for upcoming pay-per-view cards. When White first called the show "the Trojan horse," he didn't know how right he was.

Diamond, the Spike executive, returned to New York and shared his experience of the Mir-Sylvia fight. His exuberant account of "watching a dude getting his arm snapped" raised eyebrows around the conference table. Nevertheless, a few weeks later a half-dozen Viacom executives and network tastemakers — including Kevin Kay, then best known for his work at Viacom's Nickelodeon channel and for bringing SpongeBob SquarePants to the world — piled into a limo and headed to Atlantic City to watch UFC 50.

"The War of '04" wasn't a particularly memorable card. Matt Hughes regained the welterweight belt by upsetting Georges St. Pierre, and Tito Ortiz beat a last-minute replacement and then donned a tame T-shirt. (No references to anal sex, its bland message read: "Who's Next?") The network executives left feeling much more comfortable with mixed martial arts. One described it as "extreme boxing," another as "something I wouldn't be against taking kids to." The decision was made to take a gamble and air the UFC show on Spike.

The timing was right. If Americans could watch the folks on *Fear Factor* take part in a larvae-eating contest, could they really be offended by one man slicing open another's face? And though pro wrestling was less a sport than a choreographed soap opera, didn't the huge cable audiences for WWE suggest a certain acceptance of violence?

Besides, it may have been politically controversial for Spike, but there was little financial risk. The UFC was shelling out $10 million to produce the first season, and the deal was essentially structured as a barter arrangement, whereby the UFC would buy the time and then turn

around and sell the sponsorships themselves. Spike would license the show and air the episodes at 11:05 at night — after the WWE show, an ideal lead-in — so kids would be asleep. If the UFC show flopped, few would notice. Spike made no multiyear deal, in the off chance the show was a hit. It had no interest in locking up digital rights. As for the artistic merit of cage fighting: the show that had been running on Spike in that time slot was an animated series starring Pamela Anderson, titled *Stripperella*. Enough said.

Yet before the first episode was filmed, problems arose. Days after the deal was announced, Phil Mushnick, the strident sports media critic at the *New York Post*, wrote a withering column, part of which said:

> UFC is one of those shows that can't be excused or rationalized by enabling TV execs as "fantasy." It's boxing without gloves, sanctioned street-fighting. Just what the doctor ordered. Spike TV is advertised as TV's "First Network for Men." That's a lie. It's actually TV's latest network that caters to young punks, wannabe young punks and all other forms of desensitized and vulnerable young and mostly male viewers. Spike TV, along with MTV and BET, is part of the Viacom stable of networks that are largely and indisputably dedicated to bringing out the very worst in young America. Spike TV promotes all the redeeming values of a switchblade.

Fearing a similar backlash elsewhere, Spike decided that it wouldn't spend a dime promoting the show. Nor would it send out review copies on DVD, as networks usually do. The audience would have to come from promos run on the preceding pro wrestling broadcast. The marketing would have to be paid by Zuffa. When Dana White heard this, and caught wind that Spike was spending millions marketing another reality show, *I Hate My Job*, starring the controversial Reverend Al Sharpton, he naturally went ballistic. White flew to New York and demanded meetings with executives at Viacom's Times Square headquarters. Employees still recall a combustible man with a shaved head popping into their offices. "We have a great show, and that Sharpton show is the stupidest fucking thing I've ever seen. And he's the one you're promoting? What's wrong with you fucking people?"

Soon a catch phrase made the rounds at Spike: "If you see Dana White, hide. And if he finds you, tell him I'm busy."

The first thirteen-week season of *The Ultimate Fighter* — shrewdly, the title not only reinforced the UFC brand name but came with the handy acronym *TUF* — would premiere in January 2005. After a series of auditions and casting calls, sixteen middleweight and light-heavyweight fighters were selected to converge on a large house in the Las Vegas suburbs, not coincidentally a short drive from UFC headquarters. The "cast members" were a diverse lot, ethnically, temperamentally, physically. They fought on two teams in an elimination-style tournament. While the two coaches, Chuck Liddell and Randy Couture, were permitted to reside in corporate housing, the fighters lived together under one roof. To "elicit personality" — that is, manufacture conflict — they were plied with alcohol. Either by accident or by design, the first episode didn't feature a single combat scene: the fighters were that colorful outside the cage.

Had the first season been scripted, it could scarcely have made for more arresting television. For those who watched the show — and an increasing number of people did in the succeeding weeks — it was difficult not to be riveted. There were plenty of "reality" moments, these untrained actors shooting off their mouths or getting drunk on camera or engaging in Machiavellian conniving. Thanks partly to Piligian's expert editing, there were developing plot lines and narrative tension. But the beauty (if that's the right word) of it also lay in the complexity of the characters and the contrast between their physical and emotional profiles. Here were these tough guys with bulging muscles and veins and badass tattoos, and they were just as vulnerable and insecure and sensitive and hung up on petty annoyances as the ditzes on *The Bachelor*. They too bickered over who left the asparagus tips on the countertop or drank someone else's soy milk. They too had plenty of emotional scar tissue.

If there was a star of the show, it was the most complex character, Chris Leben, cocky and generally unlikable, as when he drunkenly urinated on a housemate's mattress. ("It was just a spritz!" he con-

tended.)* Yet you had to feel for the guy when, having recently met the dad who had abandoned him as a child, he was called a "fatherless bastard" by another fighter, Bobby Southworth. Redundant, yet cruel. Leben could have been forgiven for taking a swing at Southworth, but, aware it could lead to dismissal from the show, his cool head prevailed and he slept outside the house. Then Southworth and another fighter, Josh Koscheck, approached Leben in his sleeping bag and doused him with a hose. Again Leben showed restraint (sort of), punching out a window instead of one of his tormentors.

The season also featured a classic labor-management dispute, one that foreshadowed a significant problem for the UFC in the coming years. Word had leaked to the *TUF* contestants that *The Contender,* a similar reality show on NBC featuring aspiring boxers, was paying contestants $25,000 a fight. The *TUF* fighters banded together and threatened a work stoppage unless they got paid. In perhaps White's finest moment as UFC frontman, he arrived at the gym and delivered a blistering speech to the fighters that is still quoted liberally. It bears repeating in full:

> Gather round, guys. I'm not happy right now. I haven't been happy all day. I have the feeling that some guys here don't want to fight. I don't know if that's true or not or whatever, but I don't know what the fuck everyone thought they were coming here for. Does anybody here not want to fight? Did anybody come here thinking that they weren't going to fight? No? Speak up! Anyone who came here thinking they weren't going to fight, let me hear it. Let me explain something to everybody: this is a very — and when I say "very," I can't explain to you what a unique opportunity this is. You have nothing to fucking worry about every day except coming and getting better at what you supposedly want to do for a living. Big deal, the guy sleeping next to you fucking stinks or is drunk all night making noises and you can't sleep. You got fucking roommates, we picked who we believed are the best guys in this country right now. We did, and you guys are it. Fucking act like it. Do you want to be a fighter? That's the question. It's not cutting weight. It's not about living in a fucking house. It's about: do you WANT to be

*One recalled this episode in 2008 when Leben, by this point a top UFC fighter, was jailed in Oregon for a parole violation stemming from a DUI offense.

a fighter. It's not all fucking signing autographs and banging broads when you get out of here. It's no fucking fun. It's not. It's a job like any other job. So the question is not: did you have to make weight? Do you think you had to do this? DO YOU WANT TO BE A FUCKING FIGHTER? That is my question. And only you know that. Anybody who says they don't, I don't fucking want you here. I'll throw you the fuck out of this gym so fucking fast your fucking head will spin. It's up to you. I don't care. Cool? I love you all. That's why you're here. Have a good night, gentlemen.

Again, it was gripping theater. Of course, few of those in the room realized that White's speech was rooted in desperation. Had the fighters "gone on strike" in midepisode, the entire UFC — to say nothing of the *TUF* series — would have been severely imperiled. But after the speech the fighters dropped their demands. And, according to several sources, White quietly sent word the next day that he would pay the fighters $5,000 for knockouts and submissions. Typical White. Typical UFC. But the mortal crisis was averted.

Like all reality shows, the "reality" here was subjective, culled from thousands of hours of video. The producers spliced and diced, often at the expense of context.* Even so, the subject of fighting was perfect for the reality format. Hollywood can put a gloss on high-strung chefs and desperate bachelors and snarky singing judges, but there are few subjects more real than two guys throwing down.

Largely through word of mouth — which has come to mean message boards and the Internet "UG" — the show resonated with viewers and with those coveted males in particular. The first season was watched by an average of 407,000 males in the 18-to-34 age group. For the sake of comparison, ESPN's glitzy NFL pregame show attracted an average of 411,000 male viewers in that age category. As White once put it to *Playboy*: "Suddenly people were watching mixed martial arts without realizing they were watching it because they got caught up in the story lines. You get to see these guys aren't a bunch of fucking gorillas

*In a memorable scene from season four, contestant Mikey Burnett — an early UFC opponent of Pat Miletich; see chapter 7 — lost his fight and, before his formal elimination from the show, put on a pair of goggles, inserted a mouth guard, and hurled himself into the door of the house. Never once was it mentioned that his father had died that night.

who rolled in off a barstool. You can see how hard they train and that they have real lives and real families."

With a season's worth of accumulated momentum, the *TUF* finale was held on April 9, 2005, in a Las Vegas amphitheater, marking the first time MMA was broadcast live on cable television. During the undercard fights, White, the Fertitta brothers, and Kevin Kay, now the president of Spike, walked out a back door. Wedged between production trucks, they negotiated a contract extension for the show. Spike would air an additional season of *The Ultimate Fighter,* and this time the UFC wouldn't foot the entire bill. Sources say Spike paid Zuffa roughly $10 million per season.

Inside the arena, there were no stars on the card. There were no belts on the line. Spike's publicists recall that the press seating consisted of one credentialed media member, Josh Gross, of Sherdog.com. Yet the most important fight in UFC history was almost under way.

But before that, a quirky New Age New Mexican, Diego Sanchez, had beaten up a likable Boston College grad, Kenny Florian,* in an underwhelming final to win the middleweight UFC contract. Then came the light-heavyweight finalists, Stephan Bonnar and Forrest Griffin. Both fighters dripped with character. A native of Indiana, Bonnar was a recent Purdue University graduate who trained with Carlson Gracie in Chicago and was also a Golden Gloves boxer. Griffin cut a classic good ol' boy figure, given to delivering homespun aphorisms — "Pain ain't nothin' but a feelin'" — in a hickory-smoked drawl. A political science major at the University of Georgia, he had joined the cast at the last minute, struggling with the decision to quit his job as a small-town policeman to appear on the show. As different as Bonnar and Griffin were on the surface, both splintered the stereotype of the hooligan as cage fighter.

Though there was little apparent dislike between the two during the show, Bonnar and Griffin declined to touch gloves before referee Herb Dean — the man who had made his name at the Mir-Sylvia fight — instructed them to fight. For the first five minutes, the fighters pulverized each other. Mostly with a shower of overhand punches, Bonnar would pummel Griffin. Then, as if the wounds instantly healed, Griffin

*The son of a surgeon, Florian gave up a banking job in order to fight for a living.

would go on the attack. Finally, after eating a steady diet of punches, Bonnar would regain the advantage, locking Griffin in a Muay Thai clinch and delivering knees to the face. It was as if those comic-strip bubbles hovered over the fighters' heads and each punch and kick and elbow landed with a "Kaboom!" or a "Wham!" It was an exceptionally brutal first round, the "Hagler-Hearns" of MMA, as Joe Rogan called it.

Between rounds, dozens of fans texted friends or were on their cell phones with fingers pressed to their ears, no doubt yelling, "Flip over to Spike. You gotta see this friggin' fight!" The Spike executives and UFC honchos smiled and shook their heads, aware that, as far as live programming went, they could scarcely have asked for more. That handshake agreement they had just consummated out back? It was looking better by the minute. White kept glancing at his BlackBerry. "I'm getting fucking steamrolled with texts!" he shouted to no one in particular. Perhaps the only person in the arena who wasn't enthralled was Bonnar's girlfriend. She was crying hysterically.

Liddell and Couture, the coaches for Griffin and Bonnar, respectively, worried that their guys were fighting at an unsustainable level. But the second round was every bit as spellbinding. Griffin landed haymakers, some from angles that violated the laws of physics. Bonnar threw a jab that split open Griffin's nose. Dean halted the fight and called for a doctor, but when it was determined that the cut was above the nose and not near the eye, the fight continued. Though Griffin was absolutely irrigated in blood, he not only carried on but stung Bonnar with punches and leg kicks. With more than a minute left, both fighters were visibly exhausted and the canvas resembled a Jackson Pollock. Other *TUF* cast members were seen on camera mouthing "Holy shit."

Improbably, the banquet of violence persisted in the third round. The fighters moved as though cinderblocks were tethered to their legs but still managed to connect with concussive punches. Griffin's face had been turned into steak tartare, but he continued to press the action. During a rare lull, Diamond looked over at Lorenzo Fertitta and said, "Give them both a contract!" Fertitta looked back and grinned. He had already made up his mind.

Remarkably, for such an intense and explosive fight, all three judges ruled the same way: 29–28 for Griffin. When the scores were announced, Griffin, surely too weary to do much more, let out a Georgia whoop.

Bonnar collapsed on the canvas. His disappointment was short-lived. Nothing if not a born promoter, White smiled and announced that Bonnar was worthy of the six-figure UFC contract as well.

The live finale drew a 1.9 rating — representing 2.6 million households — an exceptional cable number by any measure, particularly on a Saturday night. And it was an almost unthinkable rating for a show about a sport that had been banned from pay-per-view not long before. The Spike executives, who did not exactly dive into the show headfirst, nearly displaced their rotator cuffs patting themselves on the back for this ratings bonanza.

Parlaying the buzz from the Bonnar-Griffin insta-classic, *TUF* continued to post strong ratings in the ensuing seasons. The show lacked novelty but the casts were generally strong, as were the conceits. In one season, the two coaches genuinely hated each other. In another season, the cast members were all former UFC fighters who had fallen on hard times and were attempting comebacks. Spike also aired sporadic "UFC Fight Night" cards, often featuring *TUF* veterans. By 2006, the network was airing more than 160 hours of mixed-martial-arts programming. As of this writing, the eighth *TUF* season is under way and Spike is in the middle of a contract that pays the UFC $100 million. And the UFC is convinced that Spike underpaid.

As is always the case, the sponsors slavishly followed the viewers. The initial *TUF* featured promos for upcoming UFC cards and a few commercials for fringe energy drinks and now defunct cell-phone service providers. Before long, the breaks were filled with thirty-second spots for Burger King, Slim Jim, and Coors Light.

If the show was making millions for Viacom, it was also priming the UFC's pump. Never mind the ad revenue; the real value, as Zuffa originally hoped, came from a surge in pay-per-view buys. The audience that had tuned in for the subplots and characters and MTV-style quick-cut editing was, without knowing it, also getting previews of coming attractions. Before the TV series, the most successful UFC pay-per-view card in the "Zuffa era" was 150,000 buys for the Ken Shamrock–Tito Ortiz fight. Suddenly even unremarkable cards were exceeding 300,000 buys. It was no coincidence that by 2006 the UFC's estimated pay-per-view revenue had — pardon the pun — spiked to more than $220 million.

If anything, it might have reached a point where the *TUF* show had gone *too* far: the popularity of the TV stars was outstripping that of the real UFC stars. Diamond recalls going to a UFC fight in Atlantic City a few months after the final *TUF* episode of season one. Griffin attended as a fan, and when he was spotted, the place erupted. He was treated like a rock star, and every spectator with a camera phone turned into a paparazzo. Not long thereafter, Josh Koscheck, the villain from the recent *TUF* season, was shown on the Jumbotron, eliciting a loud, sustained chorus of boos. Later, Matt Hughes, the reigning welterweight champ, was spotted walking near the Octagon. One fan trailed behind him and asked for an autograph. "At first I was like, 'This guy [Hughes] has the belt! How could Forrest Griffin be, like, ten times more popular?'" says Diamond. "Then I remembered: Forrest Griffin had been on TV for thirteen straight weeks." Sure enough, soon the top fighters, including Hughes, were asking White to let them appear on the show.

In just one season of television, *TUF* had done what ten years of lobbying could not do: it had legitimized mixed martial arts. Dana White, Pat Miletich, and the other advocates could reel off their talking points to skeptical reporters and state athletic commissioners and girl-friends' fathers. But the reality show was a much more effective vehicle. *Hey, don't take my word for it that these guys are elite athletes. Watch Joe Stevenson and Mike Whitehead do "the Scarecrow"* — *a training drill that entails one fighter circling the body of another without his feet touching the ground* — *for almost two hours. Hey, think these guys don't have technical skills? Watch how much intricate detail goes into the simplest maneuver.* And in part because the UFC controlled the show's production, the fights featured no more blood or gore or general mayhem than most other programs on cable.

Maybe it's nothing more than a sign of the times, but it's no exaggeration to say that a reality show saved the sport of mixed martial arts. And by extension — that is, by hyperextension — Tim Sylvia's broken arm was partly to thank for that.

With Pat Miletich having established himself as an unrivaled MMA trainer, Dana White seized on an idea. For the third season, he would name Miletich as one of the *Ultimate Fighter* coaches. The opposing

coach would be Carlos Newton, the eccentric Canadian who'd beaten Miletich in their dramatic welterweight title fight at UFC 31. The contrasts that made their fight so textured — black versus white, Canadian versus American, spiritual versus salt of the earth — would make for great television. And in the season finale, Miletich would get the rematch he'd never been granted.

Miletich agreed, in theory. He told his wife the exciting news, as well as a few of his fighters in Iowa, though he asked them to keep it under wraps. Then he left for Mexico to appear as a fight coordinator for a John Herzfeld movie titled *The Death and Life of Bobby Z*. Miletich wasn't thrilled about the prospect of relocating to Las Vegas to tape the reality show, but he recognized the power of television. In a weak moment, he'd admit to being jealous of the name recognition conferred on Chuck Liddell and Randy Couture after they'd coached the first series. And there was the lure of finishing unfinished business with Carlos Newton.

Meanwhile, at a UFC Fight Night event, White took his usual seat directly behind the Octagon. At the time, White had been feuding with Tito Ortiz, the temperamental champion he'd once managed. From the start, they'd had the relationship of dysfunctional siblings. White nearly did a spit-take of his bottled water when he looked up to see Ortiz sitting on the opposite side of the Octagon. "Who put Tito in those seats?" White barked to a UFC staffer. "I have to sit here all night and look at his fat fuckin' head?" Irate, White fired off a text message to Ortiz. "I think it was something like, 'U R a fuckin pussy,'" he recalls. Ortiz responded accordingly.

After a few more exchanges, the tone softened. The ice broken, during a pause in the fights White and Ortiz talked cordially. Ortiz explained to White that he was excited about continuing his career. In particular, he wanted to take on Ken Shamrock. White had heard that Shamrock had been calling out Ortiz as well. Inspiration struck: why not make them the coaches for the third season of *The Ultimate Fighter*?

Problem was, White never conveyed this change of plans to Miletich. "I fucked up," White admits.

One night on the movie set in Mexico, the crew was watching an episode of *The Ultimate Fighter* and the coaches for the third season were going to be named. Miletich shushed everyone in the room and

prepared to hear his name. He was stunned when White announced the selection of Ortiz and Shamrock instead.

There are two ways to land on Miletich's dead-to-me list: betray his trust or humiliate him. Here White had managed to do both at once. White later called Miletich to apologize. "You should have heard from me first. I promise I'll make you the coach of season four." But by then it was way too late. Miletich would happily train UFC fighters, but he was through dealing with the UFC.

13

THE MMA GODFATHER

PONCHO: YOU'RE BLEEDING, MAN.
BLAIN: I AIN'T GOT TIME TO BLEED.
— *Predator*, starring ARNOLD SCHWARZENEGGER

ON A LONE AND LONESOME highway east of Omaha, cars are parked three deep in the lot of the Lumber Yard II. Nestled in the guts of the Iowa prairie a ninety-minute drive from Bettendorf — past the World's Largest Truck Stop, the University of Iowa campus, endless fields of corn stubble, and the rancid-smelling Ralston Purina plant — the Lumber Yard II is a Cedar Rapids strip club the size of a high school gym. On an unseasonably warm night in mid-March, spring about to tap out winter, the crowd has gathered not to leer at scantily clad women but scantily clad men. It's Tuesday, which means it's Amateur MMA Night at the Lumber Yard II.

It's a running joke in Iowa: the social options are limited to "fucking and fighting." You might say that at this event they are combined. In between traditional pole dances, two men strip down to a pair of shorts and compete in unsanctioned, unregulated MMA fights in a boxing ring installed on the main stage. Eliciting much the same stares, whoops, and wolf whistles reserved for "Amber" and "Desiree" and the other pole-lympians, a card full of "Kyles" and "Clints" and "Kevins" beat the shit out of each other.

With the exception of the waived $15 cover charge, the fighters have no financial incentive to get in the battle box. Both the ringside EMT and the plain-speak liability waivers the fighters are required to sign — "I am an adult. I take responsibility for my actions. I know there is risk when I enter the ring" — suggest a significant degree of danger. Losing triggers embarrassment, and the loss of honor can be accompanied by a shower of beer and a chorus of boos on the way out of the ring. Still, the contestants trip over one another to enter. Organizers claim that they

have to limit the cards to ten or twelve fights, first come, first served. Otherwise they'd be there till sunrise.

The whole scene savors of Real America. On this night, the parking lot at the Lumber Yard II (motto: "Where real men go for wood!") was overflowing, trucks outnumbering cars four to one. On an ordinary weeknight the place might draw a hundred patrons. On fight night, the crowds can number five hundred. Approaching midnight, the place was packed, mostly with young white males, including members of Lamb of God, a popular heavy metal band that had played a show at the local Hawkeye Downs Speedway earlier in the evening.

At the entrance, a kid applying a pack of ice to a bloody ear — but wearing a smile that suggested he'd won a tough fight — chatted up an off-duty stripper. A curtain of cigarette smoke shrouded the place. The prevailing fashion statement was a tight-fitting "Miletich Fighting Systems" T-shirt tucked into tight jeans. Knots of kids toggled between the poles and the ring, gnawing on meat skewers selling for $2 at the concession stand. Others sat on benches, mainlining cans of beer nesting in tubs of ice. (Like all Iowa strip clubs, the Lumber Yard II is strictly BYOB. The state legislature is, apparently, fine with naked contortionists and underground MMA fights but firmly draws the line at these establishments selling bottles of Bud Light.)

An early fight on this night paired a lanky, curly-haired kid with the body of a swimmer against a typical Iowa wrestler in the mold of Matt Hughes — squat, neck-deprived, short-armed, short blond hair. As Lynyrd Skynyrd's "Simple Kind of Man" played in the background ("Boy, don't you worry . . . you'll find yourself / Follow your heart and nothing else"), the two fighters ducked under the ropes and entered the ring. No sooner had the bell angrily clanged than Swimmer threw a wild roundhouse kick that sliced through the smoky air. Stocky Boy caught Swimmer's right leg, gripped tight, and drove him to the ground. When the canvas smacked and the turnbuckles wobbled from the impact, the crowd cheered. In less time than it will take you to read this sentence, Stocky flipped Swimmer and executed a perfect armbar. Swimmer knew it immediately and tapped out. Fight over. They shook hands, smiled, nodded respectfully at each other, and left the ring as if they had done nothing remarkable.

Tableaus like the one at the Lumber Yard II trigger extreme ambiv-

alence at the UFC's Las Vegas headquarters. It's obviously a testament to the appeal of mixed martial arts that amateurs will converge on an Iowa strip club on a Tuesday to try out their heel hooks and guillotine chokes. Popular as professional wrestling might be among kids, how many of them think of it as a participation sport? By contrast, kids are not just watching mixed martial arts but *doing* it too, which bodes favorably for the future.

But these unregulated shows have the potential for disaster. Because the sport is growing so quickly, the number of aspiring fighters is far outstripping the number of competent refs who, like John McCarthy,* know instinctively when to stop a fight. There is a very real fear that some kid with an outsized ego and undersized skills will suffer a lapse in judgment and fight on an amateur MMA card in some backwater town. Unaccustomed to getting hit, he'll get thumped on the head and die in the ring. And in the aftermath, no one will draw a distinction between the highly trained and conditioned athletes in the UFC and some poor yutz trying to impress his girl on amateur night. Apart from being tragic in its own right, the death will create a media and political firestorm, all of mixed martial arts will be indicted, and the entire Jenga tower will collapse.†

Though not discussed, one also wonders about the possible risk at these cards of transmitting disease through bodily fluids. For sanctioned fights, competitors are usually given blood tests, which screen for everything from HIV to mad cow disease. That obviously doesn't apply when you decide to fight a few minutes before entering the ring. What

*In 2007, Big John retired from the UFC to — what else? — think about starting his own MMA organization. He is also working on an autobiography.

†In the winter of 2007, a Texas fighter, Sam Vasquez, became the first mixed martial artist to die from an injury sustained in a sanctioned MMA fight. A thirty-five-year-old father who trained when he wasn't working as a restaurant manager, Vasquez never recovered from a third-round knockout sustained in an Extreme Fighting show in Houston. While the UFC endured some backlash, it seemed to be mitigated by the fact that the fight had been sanctioned, the promoter was reputable, and the fighters had been screened in accordance with the Texas Department of Licensing and Regulation, which oversees combat sports in the state. In a perverse way, from a public relations standpoint a death that occurred on an unsanctioned, unregulated amateur card could have been worse for the sport. Surprisingly, few seemed to make the opposite case: if a fighter can get killed in a sanctioned fight, imagine how dangerous the unsanctioned ones must be.

happens when an HIV-positive fighter bleeds profusely on a (near-naked) opponent who may have an open wound?

Fortunately, on this night at the strip club, the fighters were remarkably skilled. They *looked* like athletes, all abs of steel, muscles of granite, and ears of cauliflower. They had removed their shirts, their shoes, and the fishing tackle piercing their faces before getting into the ring. And once the bell rang, they showed a high level of technique and some strategic competence. Most looked to be former high school wrestlers now in their early and mid-twenties, falling precisely within the UFC core demographic. These were kids weaned on Pat Miletich, not "Stone Cold" Steve Austin or Mike Tyson. And it showed in the ring. Apart from the wrestling moves that were second nature, they knew how to throw punches and apply submission holds once the action went to the mat.

A few weeks earlier, the University of Iowa wrestling team — once the benchmark against which all other college programs were measured — lost badly at home to the University of Minnesota. This didn't sit well with Iowa's iconic former coach, Dan Gable, now a sort of honorary assistant. "Three takedowns!" he growled to *Sports Illustrated,* referring to the team's pathetic output. "I can get three takedowns before I get out of bed." He then lamented that the best college wrestlers no longer came from the Hawkeye State. He suggested that as family farms and manufacturing jobs — both incubators for toughness — disappeared, the state's citizenry was getting softer.

Yet the scene at the Lumber Yard II suggested a different explanation. Iowa was still clearly flush with tough and tenacious kids with Popeye muscles, fighting instincts, and an undeniable work ethic. It's just that they were gravitating not to wrestling but to a new sport, one that offered more ways to win, incorporated more fighting disciplines, and elevated the risk of both dispensing and absorbing pain. One that, unlike wrestling, offered a chance to earn some money if you got good enough.

A few of the kids at the Lumber Yard II entered the amateur card simply for kicks, for something to do on a slow Tuesday. "I figured there wasn't much else going on, so I may as well fight tonight," a twenty-two-year-old from Waterloo, Iowa, explained with a what-the-fuck shrug a few seconds before he entered the ring. "If nothing else, I'll get a good

story out of it."* But the savvier fighters were there for another reason: like fledgling comedians performing in front of a booker for *The Tonight Show,* they were hoping to catch the eye of the fight's promoter. Monte Cox, after all, could deliver them to the big time.

As mixed martial arts has exploded, so have the opportunities for vast wealth. And few have profited more than Monte Cox. Like a fighter, Cox has used savvy, guile, and sometimes brute force to insinuate himself into advantageous positions. From his base in Bettendorf, he promotes forty or so MMA shows a year in venues ranging from Iowa nudie bars to twenty-thousand-seat arenas. He manages more than fifty professional MMA fighters, including a long roster of past and current UFC world champs. In late 2007, he was named CEO of the ill-fated M-1 Global, yet another organization hell-bent on poaching some of the UFC's market share.† Now in his late forties, Cox is an irrepressible hail-fellow-well-met type with a head of hair more salt than pepper, a well-upholstered pillow for a belly, and a trim goatee that frames a mouth that never stops moving. The man is a mix of Don King, Don Corleone, and Don Rickles.

Cox promoted his first MMA show in the mid-1990s. He "made out like a motherfucking bandit" (his words) and did another, and then another. He noticed a recurring theme: for every fan who was there just to see plasma and pain, there were five others who were as knowledgeable as they were passionate. The crowds would roar when fighter A knocked fighter B out cold, but they were also vocal with appreciation when fighter A cleverly rolled over to avoid a leg lock. In what would become a prophetic statement, Cox told anyone who'd listen that the day the sport went mainstream, he'd be a millionaire.

He promoted more and more shows, and most were simple affairs: he'd rent an arena, pay the insurance, pay for the promotion, pay the

*Good news: he got the story. Bad news: he absorbed a series of stiff right hands and was counted out by the ref.

†Another example of how rapidly the plot can shift in this sport: M-1 Global essentially collapsed under its own weight before it ever staged a card. Cox then became CEO of a spinoff league named Adrenaline.

fighters, and keep the profit. He could also be resourceful. In 1997, he organized an Extreme Challenge card in Battle Creek, Michigan, that was drawing little attention. Days before the fights, only a few hundred tickets had been sold. Cox contacted a sports editor in hopes of pitching a story and was told, "Check with entertainment; we only cover real sports." Desperate, Cox paid three friends in the area $50 to picket during the weigh-ins. "Too violent!" their placards read. Without revealing his identity, Cox then called local TV stations to tip them off to the protesters. Suddenly he was being interviewed, and the event sold more than three thousand tickets.

Cox had promoted shows on the Illinois side of the Mississippi, but realized that if he ever wanted to promote in Iowa, the sport would first have to be declared legal. Instead of ducking the authorities, he approached the athletic commission — he knew most of the members from his work in boxing — and offered to write the rules and regulations himself. This was a bit like Donald Trump offering to dictate zoning laws. The commission went along with Cox, and he wrote the Iowa legislation. The law was approved by the legislature, and Cox was open for business in his own state. To this day, the Iowa rules contain some obscure clauses, such as one governing the dimensions of the cage: it must be twenty feet square, eight feet high, and sealed with polyurethane. Why? That happened to be the type of cage Cox owned at the time.

Given Cox's business acumen, his outgoing personality, and his connections in the fight game, it was only a matter of time before fighters in Bettendorf requested that he manage them. He took on Miletich but declined the other fighters — there was no money to be made. If he skimmed the standard 20 percent cut off a fighter, in a best-case scenario his take might be, what, $400? That would barely have covered the cost of his phone calls. While the UFC traditionally pays for trainers to attend the fights, it doesn't extend that courtesy to managers. So if Cox wanted to watch a fighter in person, he might well lose money on the deal.

Gradually, however, the prospect of managing fighters became more appealing, in part because, as a promoter, he could always stock his shows with his own guys. (Conflict of interest? What conflict of interest?) The money wasn't much, but it was becoming clear that no one

had a better grasp of the emerging MMA landscape. Cox was able to tell fighter A, "You don't want to face that guy — he only weighs one-eighty but he has the wingspan of a pterodactyl." He could tell fighter B, "This guy is a good opponent for you because once you take him to the ground, he'll be defenseless."*

By the late nineties, Cox was representing most of the brightest stars in the UFC cosmos. At the UFC 26 card, Cox not only served as the local promoter but also represented seven of the sixteen fighters. (Conflict of interest? What conflict of interest?) All the while, he was promoting his Extreme Challenge shows with increasing frequency. In addition, the weekly cards in the strip clubs might draw a few thousand fans, all paying in cash. Cox's income and power grew in lockstep with the popularity of MMA. Within a few years of his bold career change, Cox was clearing in excess of $500,000 a year. His wife was no longer second-guessing that change.

Like every promoter, Cox has positioned himself as the "anti-promoter," a good guy willing to sacrifice his own financial well-being for the sake of his fighters' careers. Only the most gullible rube doesn't instinctively view fight promoters with skepticism. But Cox scores points for this: he has no contracts with his fighters, only handshake agreements. "I tell them, 'It's simple: if you think I'm doing my job, great. If not, you're free to leave me.'"

Living a few miles from Miletich's gym and within a ten-minute drive of most of his fighters, Cox sometimes doubles as a surrogate father. When Matt Hughes moved to the Quad Cities, he crashed with Cox and, a year later, still hadn't moved out. Hughes won twenty-one of his first twenty-two fights. When he lost two in a row and contemplated quitting MMA, Cox not only delivered a fatherly get-back-on-the-horse

*Kerry Schall was the victim of one of Cox's few whiffs. A six-foot-five, 300-pound heavyweight from Ohio, Schall was rising quickly in the ranks. Cox landed him a fight on a King of Rings card in Japan. The opponent was a pudgy Russian who was barely six feet tall and weighed 235 pounds. "This one will be easy," Cox assured his fighter. "Those Russians are usually just big, strong guys with no skills." Unfortunately for Schall, the obscure, lumpy opponent was Fedor Emelianenko, who would later become a legendary MMA figure, arguably the best fighter ever. He needed less than two minutes to bloody Schall and force a submission.

pep talk but devised a comeback strategy, matching Hughes up against lesser fighters until his confidence was restored. Within a year, Hughes was a UFC champion.

Fighters routinely drop by Cox's house and invite themselves to dinner. They are free to borrow one of his trucks when their vehicles are in the shop. They rely on him for loans and lines of credit. He's spent more nights than he cares to recall counseling fighters about girlfriend problems. Put another way, early on, Cox realized that for these fighters, "managing" was an all-encompassing term. It entailed much more than just landing them bouts.

Though they never formalized their partnership, Miletich and Cox developed a symbiotic relationship. Most fighters came to Iowa to train with Miletich, and, as a bonus, they had access to Cox, who would get them fights. As long as Miletich was there, they never had to worry about finding adequate training. As long as Cox was there, they had a manager/promoter. For fighters, it amounted to one-stop shopping.

While some of Cox's top fighters — Matt Hughes, Tim Sylvia, and Jeremy Horn — came to him because of his ties to Miletich, Cox soon realized that his amateur cards were rich with talent. Sure, the overwhelming majority weren't UFC caliber, but there were a few standouts, and Cox would be first on the scene. One of his first finds was "Ruthless" Robbie Lawler, who, like Miletich, had been a hell-raising football star at Bettendorf High School. After a few appearances at Cox's Iowa strip club shows, Lawler showed toughness to match his raw athleticism. Cox persuaded him to train with Miletich. Within two years, he was winning UFC fights. On a small card held in a Minnesota ballroom, Cox discovered Roger Huerta, now a rising UFC star. "Half the fun of promoting," he says, "is finding the next big star before anyone else does."

Cox's best discovery may have come in the late nineties when he held an amateur card in Cleveland. He was struck by a powerful, agile heavyweight who looked like a thickly muscled version of the comic actor Jim Carrey. The fighter arrived late because of a scheduling mix-up. Then he took a head butt that cracked his cheekbone and caused a disqualification. Feeling bad for the guy, Cox offered him another fight a few weeks later. After the guy pummeled his opponent with a flurry of

punches and added a knee to the face as a final grace note, Cox approached and asked the fighter what he did for a living.

"I'm a math teacher," he said.

"No, seriously."

"Seriously. Oak Hills High School. Everything but calculus."

The teacher, Rich Franklin, wasn't kidding. He'd always been a good athlete, physically gifted and emotionally hard-wired to succeed in sports. Like Miletich, Franklin was a high school football standout who combined decent native talent with a taste for competition that bordered on obsession. He was a midwestern realist, though, and early in his high school career he knew he wasn't NFL material. When it was time to pick a college, sports didn't enter his thought process. He went to the University of Cincinnati with plans of becoming a teacher. He graduated, picked up a master's degree in education, landed a job in a top district in the Cincinnati suburbs, married a colleague in the school's English department, and figured he'd put in his thirty years before retiring.

After three years of teaching, he knew he wasn't long for the job. He loved getting in front of a class, educating kids, and going home at night secure in the knowledge that he was making a difference in their lives. It was everything else that drove him nuts. The grading, the proficiency tests, the insufferable faculty meetings, the calls to parents during his free period to explain that their darling Johnny was acting like a jackass in class.

His impatience with his work was intensified by a hobby that was turning into a passion. In college, Franklin had developed a taste for the UFC. After watching a few pay-per-view cards, he and a buddy installed a mat inside a small backyard shed, and together they practiced moves they'd picked up watching videos and DVDs of past UFC fights. Franklin had an unshakable sense that he had some aptitude for mixed martial arts and that, contrary to his friends' and colleagues' suspicions, this wasn't simply a case of arrested development. He entered a few "Meanest Man" boxing contests around southern Ohio and won most of them. He then joined a Gracie Jiu-Jitsu academy in Cincinnati and eventually hired a boxing coach, a fight coach, and a strength and conditioning coach.

Franklin would fight on weekends and occasionally show up for class on Monday with a black eye, a misshapen nose, or stitches on his face (which, of course, only enhanced his popularity and mystique among his students). Surprisingly, in suburban Cincinnati, one of the more politically conservative precincts in America, Franklin's moonlighting was met with approval. He figures that if parents and administrators didn't necessarily condone no-holds-barred fighting, they applauded a guy who had a dream and was chasing it.

Franklin kept winning, mostly by virtue of his stand-up game. He quit teaching in 2002. Hell, he could always return to the classroom. At Cox's suggestion, Franklin drove to Iowa to train at the Miletich camp. Suddenly, teaching trig and algebra for a living didn't seem like such a bad way to spend an afternoon. On the first day he sparred with Miletich, Franklin took so many body blows he began wishing Miletich would simply slug him in the face. He then sparred with Jeremy Horn and Tony Fryklund and felt like a human piñata. Yet he persevered. He returned to Cincinnati with the ideal mix of motivation and confidence. He'd stuck it out in Iowa and showed enough heart and skill that Pat Miletich extended a personal invitation to "come back any time you feel like it."

Cox worked to provide Franklin with a steady flow of fights all over the country. Franklin — by now nicknamed "Ace," a nod to Carrey's movie *Ace Ventura* — did his part and kept winning and ascending the MMA ladder. In addition to his success in rings and in cages, his easy, clean-cut manner won him fans. He starred as a coach in the second season of *The Ultimate Fighter*, and mauled the great Ken Shamrock. By June 2005, Ace had pummeled Evan Tanner to win the UFC middleweight belt, a title he would defend twice.

I visited with Franklin on a scorching Ohio evening in the late summer of 2007. At his suggestion, we met at a suburban sushi joint. He was meticulously monitoring his diet, and as he ate raw fish and absently used his tongue and teeth to tie a knot in a maraschino cherry stem (talent!), he reflected on his ascent. A few years before he'd been a math teacher, wiling away his free time emulating Royce Gracie in a backyard shed. Now, at the age of thirty-three, he had a book deal, a clothing line, and a business manager. His various sponsors included

Campbell-Hausfeld, an Ohio manufacturer of air compressors. He would be the headliner and main draw on an upcoming UFC 77 card, to be held in his hometown in an eighteen-thousand-seat arena. (He would lose the fight, a rematch against the Brazilian colossus Anderson Silva; as six-figure paydays go, it was hard-earned. Still, the thought of standing before a chalkboard and expounding on the Pythagorean theorem or a trigonometry proof seemed unfathomably far away.)

"It's been an amazing chain of events," he says. "When I step back and realize that I'm a professional athlete in a major league, I just laugh. Kids today grow up on the UFC and set their goals. But for most of us, this wasn't a serious option. It might sound funny to say this about fighting, but it was a gift from above."

If Cox was both prescient enough and lucky enough to gain a toehold in MMA right before the sport exploded, he's worked plenty hard to keep his dominant position there. He spends most of his waking hours on the phone, trying to place his fighters on cards. During one thirty-day billing cycle, he used more than twenty thousand cell-phone minutes. Anticipating the question, he volunteers that it meant an average of eleven hours a day for all thirty days. Then again, this is a man who rarely sleeps more than four hours a night and pulls an all-nighter once a week, "because I forget to fall asleep." He estimates that he logs 180,000 air miles and attends at least seventy-five shows a year.

He represents a healthy chunk of the UFC fighters under contract, but he does so without speaking to Dana White. The two share a genuine dislike of each other that goes beyond the natural distrust and posturing between capital and labor. White has often been quoted as saying, "Monte is not my kind of guy." Which is fine by Cox. "Thanks for the compliment, Dana . . . That guy is a control freak. He doesn't want to deal with managers; he wants to deal directly with fighters. Well, guess what? That's not how it works." Instead Cox deals almost exclusively with Joe Silva, the UFC matchmaker.

If their interests are opposed — particularly now that Cox heads a rival organization — he and Silva both say the relationship works because their dealings are open and honest. Cox will offer Silva a fighter

and give a candid assessment of the guy's strengths and limitations. Silva, Cox says, "doesn't bullshit" with him. "If I suggest a fight, he'll consider it. If something is not going to work out for one of my fighters, he tells me. Joe's fair. That's all you can ask for."

To shadow Cox for a day is to get an instructive look at the MMA landscape. Operating from a home office — basically a desktop computer, a landline, a cell phone, and a swivel chair under a framed photograph of himself in a boxing match — he spends business hours shifting between offense and defense. One minute he's playing publicist, telling Tim Sylvia, the terminally disrespected heavyweight, that there's a fine line between brutal honesty and brutal stupidity. In a recent interview Sylvia had dismissed the fighters who'd appeared on *The Ultimate Fighter* as "useless." Cox called Sylvia in a rage. "Tim, what do you gain by saying that? Let me explain something. Every fan of Forrest Griffin, every fan of Josh Koscheck, any fan of any guy who came out of that show, they now have a reason to hate you. You're booed everywhere you go. Shit like this isn't going to help, Tim."

The next minute he's lining up a venue for his upcoming Extreme Challenge card. Then a call from a Russian promoter comes in, inquiring about a possible M-1 Global event. Then a longtime Miletich fighter calls with a business dispute. The fighter had been on a recent UFC card and lost in the Octagon, but he'd received a $40,000 bonus for being in the "Fight of the Night." Now he contended that Cox's 20 percent management fee didn't apply to bonus money. Cox sighed. Without a written contract with the fighter, he had to appeal to common sense. "If you don't think that's fair, don't pay me," Cox said. "But I charge all my guys twenty percent, and I can't start making exceptions. If you want to keep the money, that's cool. But we're done. You'll have to get a new manager." During the call, Cox, a regular on MMA message boards, was scanning the forum page of the popular website mmatv.com.

When he finally gets a break, Cox tries to enjoy the trappings of his success: a new nine-thousand-square-foot mansion a mile or so from Interstate 80, a kind of monument to the popularity of mixed martial arts. The elaborate home theater in his basement? It's his because fans and corporations are willing to pay big money to UFC stars. The armada of cars in the garage? They exist because a new generation of fight

enthusiasts attend his shows and a new generation of aspiring UFC stars fight in the strip clubs. "I don't have any illusions," he says, giving a guest a tour of his property. "Matt Hughes and Rich Franklin and Tim Sylvia and Pat Miletich built me this house. And so did —"

Monte Cox can't finish the sentence. His cell phone starts chirping again.

14

KING OF PAIN

I HAVE HAD TO FIGHT LIKE HELL, AND
FIGHTING LIKE HELL HAS MADE ME WHAT I AM.
— ADMIRAL OF THE FLEET
JOHN ARBUTHNOT FISHER (1841–1920)

LIKE SPACE TRAVEL or neurosurgery, fighting doesn't lend itself to simulation. There's a world of difference between a real fight and a practice fight. Unless there's truly something at stake — honor, money, a belt, a career — it's almost impossible to mimic the emotional investment of a fight contested before a crowd. For this reason, sparring ranks among the stranger training rituals in all of sports. In a typical sparring session, a fighter is expected to hit and get hit. Hard, if necessary. At the same time, if the session crackles with too much voltage, it's self-defeating. No one is supposed to get hurt. So in sparring sessions, fighters must absorb punishment and demonstrate self-restraint, a delicate balance that few master.

In 2003, Miletich was preparing for an upcoming fight and sparred with a talented but undisciplined fighter in his gym. At the time, he was trying to apply the defibrillator paddles to his career. On the outs with the UFC, he took a fight in an organization called the World Fighting Alliance, against the veteran welterweight Frank "Twinkle Toes" Trigg. In the sparring session, Miletich landed a few demoralizing body blows that angered his partner. Unable to harness his emotions, the partner retaliated by cracking Miletich in the back of the head.

It would have been considered a cheap shot in a sanctioned fight. In a sparring session, against a comrade preparing for a big fight, it was outrageous. Miletich recalls feeling as if his neck was "exploding." It was, he says, the most pain he'd ever felt in all his years fighting. When he realized that his spinal cord hadn't been ruptured, as he had feared,

pride-slash-stupidity took over. He continued fighting and dropped the guy with a combination to the head. It wasn't until the adrenaline wore off that Miletich realized he had a serious neck injury — a bulging disk, it turned out, which bothers him to this day — and had no chance of making his fight against Trigg. In barely a year's time, Miletich had gone from a UFC champ to a wounded warrior in his late thirties, his body starting to betray him and his fighting odometer down to its last few clicks. So it goes with even the best fighters, but it's especially so in MMA: stars fade fast and are replaced faster. The window ain't open for long. And when it shuts, it often slams.

If Miletich took any compensatory comfort in his dwindling career, it was this: the pleasure and fulfillment he got from combat was matched by the pleasure and fulfillment he got from training his fighters. If he wasn't in the Octagon himself, well, pressing his face to the cage and instructing a protégé was just as good. Miletich had no sons,* but he took a paternal pride in his fighters. Not just in their successes, but in the process of making them tough.

He had always possessed a gift for teaching the mechanics of fighting and devising strategy. But he was also a master psychologist. As a former fighter, Miletich knew when to lead by example and when to lead by doing nothing. He knew when to butt in and when to butt out. He knew when to scream and when to coddle. Says Jens Pulver: "Pat knows exactly what to say, when to say it, and how to put it." Pulver recounts the time he was supposed to fight John Lewis† in the UFC. "Pat said to me, 'You have your team in one fist and your mom in your other fist.'" Pulver knocked out Lewis fifteen seconds into the fight. L. C. Davis, another Miletich fighter, puts it this way: "When you're about to fight and need the [ego] boost, Pat has a way of making you feel like a hero."

Miletich's renown was such that fighters from other camps would contact him to work with them before big events, going to Bettendorf for a crash course with the master. Mark Coleman, for instance — the heavyweight Miletich had watched a lifetime ago in UFC 10 from a seat

*Iowans call this "the Curse of Gable." Dan Gable, the iconic I-eat-barbed-wire-for-breakfast wrestler, had four daughters, more proof that someone Up There has a sense of humor.

†Lewis, you'll recall, was the UFC fighter who introduced Dana White and Lorenzo Fertitta to mixed martial arts.

in the bleachers — came to Iowa to train. He then flew Miletich to Japan to be his cornerman in a PRIDE tournament, which he won.

Of all the fighters who had been drawn to Bettendorf, Miletich's true protégé was Matt Hughes, the UFC welterweight champ. When Hughes and Carlos Newton fought a rematch at London's Royal Albert Hall in UFC 38 ("Brawl at the Hall"), Miletich was again in Hughes's corner. He had helped Hughes develop a ground-and-pound style that enabled Hughes to muster his superior wrestling strength. He also played chief motivator, explaining to Hughes that this was his chance to prove that his controversial win over Newton the first time was no fluke. Following Miletich's advice, Hughes won again, this time decisively, pummeling Newton and winning by TKO in the fourth round. And no one in the arena was happier than Miletich.

That card, however, is best recalled for what happened afterward. In an effort to spread the gospel of the UFC in Britain, the organization brought its brightest stars across the pond, including Tito Ortiz and Chuck Liddell. At the postfight party, the fighters got (typically) sloppy. Relieved of the pressure of making weight and doing battle, they mainlined alcohol at a London club. "Fight like a tiger, drink like a fish," someone joked. The UFC stars who hadn't been on the card drank copiously as well.

The party died down around 4 A.M., and though the UFC had bussed the fighters to the club, there was no transportation back to their hotel. They all spilled outside in search of cabs. Stumbling down the street, Miletich felt a body on his back. It was a running buddy of Ortiz and a longtime acquaintance of Miletich. The guy was giving Miletich a playful, drunken bear hug. No problem. Suddenly Miletich felt the guy getting ripped off his back. A middleweight from the Miletich camp, Tony Fryklund, had assumed that his mentor was being attacked, so he grabbed Ortiz's friend and choked the poor guy to the point that his eyes bulged.

When Miletich told Fryklund it was a misunderstanding, he let go. In the mayhem, Paul "the Enforcer" Allen looked over. Allen was buddies with Lee Murray, an up-and-coming British fighter who had recently done a tour of duty learning the ground game at the Bettendorf gym. Fearful that Miletich was in trouble, Allen blasted Ortiz's friend with a right hand, knocking him out cold.

This triggered what might rank as the mother of all street fights. A Who's Who of the UFC and their entourages, polluted-drunk on the

streets of London, began throwing haymakers indiscriminately. One posse member was knocked to the ground and somehow got his arm run over by a cab. Chuck Liddell got slugged in the back of the head and went ballistic. "I still don't know exactly what fucking happened," he recalls. "I turned and was like 'Motherfucker!' I'm hitting guys with spinning backfists, just dropping guys. It was a classic street fight. 'If I don't know you, I drop you.' There are no cheap shots in a street fight."

Eventually Ortiz and Murray squared off. Accounts — as one might expect — vary. But several observers recall that Ortiz threw a left hook with murderous intent. He missed, and Murray fired off a combination that decked Ortiz. The reigning UFC light-heavyweight champ, the self-proclaimed bad boy, fell to the ground. As Murray prepared to stomp on Ortiz with his boots, Miletich stepped between them. "Get outta here, Lee!" When the bobbies showed up armed with mace, Miletich jumped in. "You think you've got problems now? Spray a bunch of fighters with mace and we'll all be in real trouble." Miletich returned to the hotel and woke Hughes to give him the play-by-play. They were both on a flight to Iowa in the morning.*

<center>*</center>

*Indulge this further digression; the payoff is worth it. On the night of February 21, 2006, the branch manager of a Securitas bank depot outside London was stopped by what he thought were policemen. They were impostors who kidnapped the branch manager. Separately, the man's wife and son were kidnapped too. Once together, the family was taken to the bank depot — basically, a warehouse for cash — where the manager opened the vault. The robbers saw before them £200 million (roughly $350 million) in used bills. Unfortunately, they could fit only £53 million in their truck. Still, the haul was the largest cash robbery in history.

After a series of arrests and interrogations, the police believed the mastermind was none other than . . . Lee Murray. He was allegedly aided by a team that included Paul Allen. By the time the investigators had determined this, Murray had left his wife and kids in Britain and relocated to Morocco, the birthplace of Murray's father. Murray's new million-dollar home included a mosaic, positioned above the hot tub, depicting Murray fighting in the UFC.

At the behest of Scotland Yard, Moroccan police put a twenty-four-hour security detail on Murray shortly after his arrival. In the summer of 2006, he was arrested at a Rabat mall on a series of charges that included drug possession. Britain, however, does not share an extradition treaty with Morocco. And because of Murray's lineage, he is considered a Moroccan national. As of this writing, Murray sits in a jail awaiting his fate, the cage fighter caged. But he has yet to face charges for orchestrating one of the most brazen bank robberies in history. Miletich is as awed as anyone: "When he was here in Iowa, Lee was the most humble guy in the world. Great athlete, great puncher, and he just wanted to work hard to figure out the ground game. Never would have pegged the guy for a suspected bank robber, I'll tell you that . . . But then again, I always did wonder how he afforded to send me and my wife such a nice wedding gift."

In the late summer of 2004, the owner of the Gold's Gym in Bettendorf summoned Miletich to his office. The management had abruptly decided that the gym was going to rebrand itself as an upscale "indoor country club." This, of course, was at odds with the dozens of sweaty, shirtless MMA fighters flooding the place with testosterone. Though Miletich had sensed a growing unease among other members of the gym, he was confused. To his thinking, if people wanted to play golf, they'd go to a country club. If they wanted a workout, they'd go to a gym.

He pressed the owner, asking if any fighter had ever behaved disrespectfully toward a member. *No* came the response. Had any members complained specifically? *Well, no, not specifically.* What was to become of the downstairs fighting area? *We might turn it into a Pilates studio.*

What next, herbal body wraps? Chakra cleansing massage?

This may as well have been a metaphor for mixed martial arts everywhere: it was gaining popularity and gradually being demystified, but it was still a long way from finding acceptance among the general public. Too sweaty and bloody and strange for the Pilates crowd.

Left without a permanent place to train, the Team Miletich fighters, now numbering upward of forty, were homeless. So they improvised. They held grappling sessions in the weight room of Augustana College, across the river in Rock Island, Illinois. They finagled their way into high school wrestling rooms. They did their core training outdoors, in the sweltering Midwest summer heat and in the crunching winter snow. Understandably, Jeremy Horn, the flexible Nebraskan who'd taught everyone jiu-jitsu, couldn't abide the instability. Horn, in the prime of his fighting career, now had to prepare for title defenses under makeshift conditions. Plus, he had fallen in love with a girl in Utah. He explained the dilemma to Miletich.

"Think you might marry her?" Miletich asked him.

"Yeah," Horn said.

"Then why are we even talking?" Miletich said. "Get outta here."

And Horn did, leaving Iowa to start his own gym in Salt Lake City. But every other fighter — despite being recruited by rival camps from Vegas to Virginia — stayed loyal to Miletich.

For years, Miletich had dreamed of opening his own facility, where he'd be answerable to no one, subject to no boss's whims. He figured

this was his chance. Friends advised him to hold on to his $40,000 equity stake in Gold's Gym. But damn the money; he refused to be associated with a business that had treated him, his fighters, and his sport so shabbily. Miletich cashed out and found a few financial backers, calling in some of the good will he had accumulated in the community. He stalked local real estate and finally found a twelve-thousand-square-foot shell of a building in downtown Bettendorf, about a mile from his childhood home.

Inasmuch as Miletich's story has the trajectory of a screenplay, here's one of those plot points where the syrupy, sentimental piano music kicks in. For the next few months Miletich and his fighters worked to transform this glorified warehouse into a functional gym. Miletich donated the food, and the fighters donated much of the labor. One group would put up beams. Another would hang drywall or dig pits for plumbing or lug the hundreds of two-by-fours. There was a general contractor, but the head of the construction project? John Miletich. He would arrive at 7 in the morning, work until 4:30 in the afternoon, take a nap, eat dinner, and return at 8 at night and work until 3 in the morning. Then he'd collapse into bed and repeat the process the next day. "I had paid my debt to the state," John says. "This was a way of paying off my debt to Pat."

The gym included a battle box in the back room and a spartan three-bedroom apartment above, where fighters down on their luck had a place to stay, cheap. The gym and the apartment were nice, but not too nice. It was a gym, not a health club — much less an "indoor country club." In the winter of 2004, Champions Fitness opened. It was somehow appropriate that, after the dozens of fighters came, one of the first "civilian" members to work out on the weights was Mona Miletich.

With the new gym up and running, each Monday brought with it a raft of new fighters. Each had a unique backstory, but in the end they were all similar. Each fancied himself the baddest motherfucker in his town. Each was willing to leave his job, his girl, his wife, his life, and relocate to the easternmost town in Iowa to try and become a pro fighter. Friends encouraged Miletich to make a fast buck off these pipe dreams and charge the fighters some sort of initiation fee to train. Miletich, though,

stuck with his open-door policy. If someone was willing to make such an extreme sacrifice, he ought to be able to follow his bliss for free. Besides, only the fittest would survive. Nine times out of ten, the guy would be served a heaping portion of humility in the gym and he'd be gone by Tuesday.

But every few months there'd be exceptions, dreamers who were sufficiently tough/skilled/stubborn to endure the hazing and pledge the fraternity, and they would form the next generation of Miletich fighters. One was Ben Rothwell, a massive six-foot-five heavyweight from Wisconsin, who didn't take up fighting until his late teenage years. Another was Ryan McGivern, a deeply religious former Iowa Hawkeye wrestler, who looked like an insurance salesman but fought like an assassin. McGivern worked for the Army as a civilian general engineer and trained after hours with Miletich.

There was also Rory Markham, a thick, almost pudgy Chicagoan, who "did the bushido thing" and had also had some amateur boxing bouts, some full-contact karate matches, and had done plenty of bare-knuckle street brawling. When he realized his urge to fight wasn't subsiding, he figured he might as well try to make some money doing it. By the end of his first session in Bettendorf, Markham felt as though he'd been in a car wreck. Before he could retreat to his motel and test the structural integrity of the ice machine, Miletich invited him to attend an amateur MMA show Monte Cox was promoting at a Davenport strip club. Markham was flattered, especially after hearing that Hughes and Lawler would be there too. This was Markham's chance to hang out with the cool kids. Then, as they walked into the place, Miletich turned to Markham and smiled. "Oh, I must've forgotten to mention it. You're fighting tonight."

Markham knew immediately that he had arrived at one of those leave-the-chrysalis moments. He could choose to listen to common sense and his aching body and go home, untested. Or he could step up and fight. "Mentally, I was hyperventilating," he says. But with Miletich — the great Pat Miletich with the chewed ears and calm voice and thousand-yard stare — essentially daring him to be a man, the choice was really no choice at all.

Markham threw on a pair of gym shorts he happened to have in his bag. Half an hour later, he walked across a stage and clambered into the

ring. When he jacked his opponent with a combination, Hughes and Lawler, who were working his corner, went nuts. "You have him stepping in potholes," Lawler yelled. When Markham laid his man out cold, they reacted as if he had won a world title. And Miletich said, "Hey, Rory, get your shit from Chicago and move down here. I can work you." For most of the past five years, he's lived in the apartment above the gym.

The UFC may have been gasping for breath a few years earlier, but by 2006 it was the hottest sports property going. *The Ultimate Fighter* served as a Rosetta stone, translating an obscure sport into a language the mainstream could understand. By the time Chuck Liddell fought Quinton Jackson in the summer of 2007, pay-per-views had surpassed 650,000 buys. In addition to the reality show and the clever marketing, there were cultural forces at play. After the September 11 attacks and the start of the war in Iraq, attitudes toward tough, aggressive American men generally improved.

It's as much a part of human nature as the impulse to watch two men fight: thriving enterprises breed competition. Lately the sport's fiercest battles have not been between fighters but between the UFC and the upstarts trying to break its stranglehold. It was more than a fight over money; it was a fight for the sport's soul. And fans came down on both sides. Those supporting the challengers contend that the UFC's virtual monopoly is problematic for all sorts of reasons, not least for holding down fighters' purses. Rival organizations are needed to grow the proverbial pie. The UFC's supporters are intensely loyal to their brand. They like having standard rankings and rules, a sense that fans are watching the best fighters. They worry that without the UFC, mixed martial arts will come to resemble boxing, a hopeless swamp of competing organizations and meaningless belts.

The upstarts angling for a piece of the UFC's market share have been as varied as they are numerous. Old organizations have reformulated. Everyone from the former boxing referee Richard Steele to the Dallas Mavericks' owner Mark Cuban has tried to catch the wave. The fugitive billionaire Calvin "Catch Me If You Can" Ayre, a pioneer in offshore Internet gambling, promoted cards through his controversial

company Bodog, allegedly offering Matt Hughes more than $5 million to break his UFC contract. (Hughes declined.) Gary Shaw, who made his name as a conventional boxing promoter, signed the street-fighting Internet sensation Kimbo Slice and made him the star of his new business, EliteXC. Even Bob Meyrowitz began hatching plans to promote MMA cards, partnering with the early UFC fighter Oleg Taktarov to form a brand called YAMMA.

Gareb Shamus, a New York comic-book mogul, thought he could use an MMA organization to tap into the same demographic group — young, impressionable adult males — that bought books about superheroes. He founded the International Fight League, which added intriguing twists to the conventional business model. In a relentlessly individual sport, the IFL would create teams, so Chicago would fight against Los Angeles, or New York would take on Seattle. The league's shares would be publicly traded, so its ledgers would be open to everyone. Elbows would be banned, to cut down on bleeding. The fighters would be mostly up-and-comers, including unsuccessful contestants from *The Ultimate Fighter.* They would be paid a salary and given health benefits, enabling them to train full-time. Yet the real stars would be the teams' coaches — former UFC stars on the order of Matt Lindland, Carlos Newton, and Frank Shamrock — who could both draw fans and instruct their fighters. Naturally, the IFL put a franchise in the Quad Cities and named Miletich as coach. Drawing on his stable of fighters, including Rothwell, McGivern, and Markham, Miletich coached the Quad Cities Silverbacks to the first IFL team title.

In the Silverbacks' 2006 home opener, the team took on the New York Pit Bulls, coached by Renzo Gracie. After the Silverbacks won the match, the two coaches took part in what was called a "superfight." It was a reunion of mentor and pupil. More than a decade earlier, Miletich had attended one of Renzo Gracie's seminars in the Midwest and received his introduction to jiu-jitsu, which marked a turning point in his fighting career.

Gracie, who had fought mainly in Japan, had come immeasurably far since then too. He belongs, alongside Miletich, in the MMA Hall of Fame. In his best-known fight, Renzo took on the Japanese dervish Kazushi Sakuraba. At one point Sakuraba locked Gracie's arm in a kimura. Though his left elbow was being twisted inside out, before it

was gruesomely snapped, Gracie refused to submit. Finally the referee stopped the fight. When I visited Renzo at his gym in midtown Manhattan one day, I was surprised to see, propped in his office, a framed photograph commemorating this hideous injury. "It's motivation!" Renzo explained cheerfully. "You know, I still thought I could win that fight with a broken arm!"*

Over the years, an almost Shakespearean plot line beset the House of Gracie. With much of the clan having moved to the United States, the descendants of Carlos Gracie, including Renzo, fought with the descendants of Helio Gracie, including Rorion and Royce. In short, both sides of the family claimed credit for the popularity of jiu-jitsu. But on this fall night in Iowa, Renzo would add to the Gracie family legend. With the Quad Cities crowd squarely against him, Gracie turned to his team as he left the locker room. "There's nothing sweeter," he said, "than quieting a crowd that's against you and earning their respect." When the fight started, Gracie and Miletich neutralized each for the first few minutes. Then, with the fighters locked near the ropes, Gracie slid up Miletich's body. Miletich had control of Gracie's hand but then inexplicably let go. Straddling Miletich in midair, Gracie sunk in a guillotine choke. He worked his hold for a solid minute before Miletich relented.

In pin-drop silence, Gracie celebrated with what seemed like every Brazilian in town. Miletich shook his head. If this marked his last fight, he could do worse than an honorable loss to a mentor. Asked whether he would ever fight again, Miletich was philosophical. "I don't want to go in and fight a guy just so I can get a victory," he said. "It's like, why should I be climbing a hill when I should be climbing a mountain?"

As mixed martial arts was dealing with some of the pangs that unavoidably come with expansion, the Miletich gym went through its own growing pains. Inasmuch as the team was a surrogate family, it wasn't without its share of dysfunction, squabbles, and sibling rivalries.

One of the great ironies of combat sports is this: brutal as the job

*A few weeks later, during a *60 Minutes* segment on the emergence of mixed martial arts, Gracie was asked about that grotesque photo. "I saw the ligaments going," he explained with no trace of exaggeration. "And I embraced that as punishment for the mistake I had made."

is, fighters are often remarkably sensitive. Their hard muscles and scar tissue tend to mask all sorts of internal insecurities. The same men who regard broken bones as minor annoyances can be driven to tears by the smallest perceived slight. In the Miletich camp there sometimes seemed to be a daily drama. Fighter A was envious that fighter B was receiving more attention from Miletich. ("How come Pat held mitts for him and not me?") Fighter C was upset that he had been excluded from a Monte Cox card and that Miletich hadn't intervened on his behalf. Fighter D complained that Miletich hadn't considered him for the IFL team. In the fall of 2007, I visited the gym on a particularly tense day. In a moment of frustration, Miletich talked of hiring a full-time babysitter at the gym. "I have two girls at home. One is six, one is four. And these tough guys who fight for a living are much bigger babies."

Battle lines were also drawn when Tim Sylvia regained the UFC heavyweight title and, in the eyes of some, became so arrogant and insufferable that several fighters begged Miletich to kick him out of the gym. Aware of Sylvia's rough childhood, fragile ego, and insecurities that even a heavyweight belt couldn't overcome, Miletich declined to send Sylvia packing. But he did sit down with the fighter and ask, "Doesn't having people dislike you get old, Tim?"

Later that year, Matt Hughes announced that he was leaving Iowa and opening his own gym outside St. Louis, closer to his family farm. And he was taking Robby Lawler with him. If Miletich was wounded that two of his "Mini-Me's" were defecting, he was too proud to let on. "Do what you have to do," he told them. "I respect your decision." Other fighters seethed at what they saw as an act of family betrayal. On a Sherdog online forum Ben Rothwell was asked about the atmosphere at Miletich Fighting Systems now that Hughes and Lawler were preparing to leave the camp. In true no-holds-barred fashion, Rothwell responded: "FUCK Matt Hughes and he knows it, how he went about the gym and Pat Miletich was complete BULLSHIT besides other things."

Rothwell later clarified this: "He treats people around him poorly and has no respect. Really, when I hear him talk about God and do this and do that and 'I love my wife,' I want to puke. You [Hughes] couldn't look anyone in the face anymore, and you fucked Monte [Cox] and Pat [Miletich] over and the fucking gym that MADE YOU."

Big money has intruded on the place too. Like pioneers in all

sports, Miletich has mixed feelings about the explosive growth of MMA. He's thrilled that fighters make enough money to devote themselves to the sport without having to moonlight as concrete pourers or bouncers. He's delighted that fighters are bona fide celebrities who appear on television and get sponsors to pay big bucks for the real estate on the butt of their shorts. He's elated that shows are held not in church basements or rodeo arenas but in some of the biggest sports stadiums in America.

But there is some lingering unease about the money. The same way that Pete Rose made less in his entire baseball career than current stars like Alex Rodriguez earn in a single season, Miletich had the misfortune of coming along too soon. In his heyday as a UFC champ, the most he ever made for a fight was $40,000. By 2007, marginal UFC fighters could make $40,000 just for getting the Fight-of-the-Night bonus. Miletich's successor, Matt Hughes, made millions of dollars over the course of his career. And *after* Hughes lost the welterweight title, he made $150,000 in base pay for his next fight — and that doesn't include sponsorships and bonuses. Every day that Sylvia announces his top-dog status by parking one of his many expensive cars in front of Miletich's gym is another reminder that the gym's owner preceded the era of big money.

Money also began to affect his relationship with Monte Cox. For years, theirs was a mutually beneficial relationship. Each gained from the presence of the other. Miletich trained the fighters; Cox got them opportunities. It was one-stop shopping, and it made the Quad Cities the unlikely center of MMA. Lately, however, the arrangement had come to feel parasitic. From Miletich's perspective, as the former champ he had the bruises and the expertise; Cox was merely the dealmaker. Yet Cox was making millions on fighters while Miletich was lucky to make a small fee for working their corner. In Cox's view, Miletich might well have been an unrivaled trainer, but that wasn't relevant. Cox was the one who worked through the night, negotiated with the UFC, signed up sponsors, and ultimately got the contracts. "At the end of the day, I'm the one making them money," Cox says flatly. It's easy to see the merits of both sides. It's also easy to see how this could cause a rift between two men who were once as close as brothers.

Adding to the dissonance, in what could well serve as a metaphor

for all of Iowa, the Miletich gym began facing increased competition from elsewhere. Just as the Quad Cities economy had been hit by downsizing and layoffs and plant closings, other, spiffier MMA gyms were sprouting all over the country. In New Mexico, an ambitious young trainer, Greg Jackson, was luring top fighters to his Albuquerque fight club. As Randy Couture's reputation as a fighter grew, so did the popularity of his gym in Las Vegas. In suburban Portland, Oregon, Matt Lindland's Team Quest had evolved from a converted car lot to a top-flight academy. In southern Florida, the American Top Team claims more than fifty pro fighters and employs Howard Davis, a 1976 Olympic boxing gold medal winner, as a stand-up coach.

When Miletich steps back to reflect on his life, the view looks much better. The sport he helped pioneer has taken off, and he still gets to spend his days at the gym. His reputation carries sufficient weight that he's able to franchise the Miletich Fighting Systems brand to gyms around the country. In addition to training local cops in hand-to-hand combat, he's worked with Army Special Forces and Navy SEALS. Recently the Croatian government called, asking if Miletich, the Croatian Sensation, was available to train its soldiers. Instead of payment, he was offered a villa on the Adriatic Coast. In 2007, he was part of a USO tour that entertained U.S. troops in Afghanistan. In addition to running the gym and coaching in the IFL, he is an executive of WAMMA, the World Alliance of Mixed Martial Arts, a Florida organization with the ambitious goal of unifying the sport.

While he's no multimillionaire, he leads a comfortable life and resides alongside the lawyers and doctors of the Quad Cities in a spacious, tastefully decorated home with a three-car garage.* The refrigerator is stocked with food and imported beer, mocking the days when he was desperately poor. The house is about one mile and a world away from the small place on the hill where he and his brothers shared bunk beds in the garage. Miletich, however elevated his station in life, did not travel far from his roots.

He has never completely gotten over the loss of his two big brothers or the unfinished business with his late father. But, if nothing else,

*For some reason, I never quite got over this: Pat Miletich, once the baddest motherfucker in America, now is a member of the local country club.

these sources of woe reinforced the importance of family. He's happily married to Lyne and they have two daughters who don't fight, though they ice-skate and dance and chase the dog in the back yard. He's as close as ever with his older brother John, who remarried, now runs a successful Quad Cities landscaping business, and recently celebrated his fifteenth year of sobriety. Mona Miletich, the gray eminence, still works out at her son's gym and defiantly refuses to move out of her home. Miletich has his health, his family, and his honor. And, he says, "as a guy from Iowa, what else could you ask for?"

In the fall of 2007, Miletich got a call that offered perhaps the clearest sign of just how far he and his sport had traveled. He received word that John McCain was trying to contact him. *What could he possibly want from me?* Miletich wondered. If McCain hadn't totally abandoned his crusade against MMA, he was no longer on the front lines. I tried to contact McCain when I was writing this book, seeking his current stance on the issue, but he didn't return my calls — understandable, since he was, after all, running for president at the time. In a National Public Radio interview, he said this about mixed martial arts: "They have cleaned up the sport to the point, at least in my view, where it is not human cockfighting anymore . . . They haven't made me a fan, but they have made progress."

When Miletich got the message from McCain, he wasn't sure what to expect. As it turned out, the man who'd once made it a mission to ban MMA wasn't calling about fighting at all. No, McCain had heard about Miletich through the Republican Party grapevine while campaigning for the presidency in Iowa. He seemed like McCain's kind of guy. McCain was calling with a simple request. Did Miletich want to accompany him on a hunting trip sometime?

15
THE FINAL ROUND

"UFC! UFC! UFC! Ticketsticketstickets. Whoneedstwo? Whoneedstwo? Whoneedstwo? UFC UFC UFC!"

Forget the searing wind and the temperatures firmly below freezing. The scalpers, easily a dozen of them, were out in full force on this March night, lining Front Street in downtown Columbus, Ohio. The city was playing host to the Arnold Schwarzenegger Sports Festival, known to all as the Arnold Classic, an annual testosterone-a-rama that drew more than a hundred thousand health and fitness freaks to central Ohio. The UFC wisely homed in on this demographic — this muscle mass, as it were. The capstone of the Arnold Classic was the Saturday-night UFC fight card, held across the street from the convention hall at Nationwide Arena, a huge coliseum that, on most nights, houses the city's pro hockey team, the Blue Jackets.

The previous year, the Columbus UFC card featured forty-three-year-old Randy Couture, who won an upset victory over Tim Sylvia (cornered by Pat Miletich) to regain the heavyweight title, a performance that played perfectly to the weekend's theme of anti-aging and beating back the ultimate opponent, Time. In 2008, the UFC 82 card ("Pride of a Champion") featured a full boat of top fighters, including the great Brazilian middleweight Anderson Silva, the sport's dominant star at the time.

A UFC card today must resemble boxing in its 1940s heyday. It is the rare sporting event that feels like just that: an *event*. And the presence of scalpers is the least of it. A day before the fights, thousands of rabid UFC fans wreathed the Columbus arena just to attend the weigh-in.

After a brief introduction from Joe Rogan and some pro forma waves and blown kisses from the Octagon Girls™ — yes, the term is really trademarked by the UFC — the twenty-two fighters on the card stripped to their shorts or skivvies, stood on a scale, and posed with their opponents for a photo op. Wearing distressed jeans, a leather jacket, and a sly smile, Dana White* stood behind the fighters. When he smacked them on the back, they released their pose, left the stage, and went to rehydrate, adding as much as fifteen pounds in water to their frames. This weigh-in could have been quietly conducted in some sterile hotel ballroom, the way boxing has done it for years. Instead the UFC has shrewdly used it as another means of cementing the bond between consumer and product.

The day of the fight brought an unmistakable current of anticipation. At the Arnold Classic, the prevailing question was "Are you going to the show tonight?" as if UFC 82 were the Grand Cotillion. The fights were a hot topic on sports radio and television. Limos and cabs lined the street outside the arena. As the Octagon was being assembled inside and the techies did their last sound checks, the fighters were back at the hotel, engaging in the fool's errand of trying to relax. They meditated. They went through light workouts. They fired up the PlayStation. They drank their own piss. (More on this later.)

At 6:30 or so, I made my way to the arena press room. The boys with lacquered hair from the Ohio Athletic Commission were setting up ringside. "We do everything from drug testing to making sure their entrance music doesn't have profane lyrics," one of them explained. Waitresses in the luxury suites were arranging the premium booze, microbrews, and novelty martinis. As I foraged at a media buffet, which included fresh mozzarella salad and fancy Italian pastries, it was hard not to marvel at how far the sport had come since Pat Miletich fought in a Cedar Rapids convention hall or a dank armory in the bayou outside New Orleans.

When Nationwide Arena's doors opened to the public at 7:30, a

*The more the UFC succeeds, the more casual White's attire becomes. His suit and tie were replaced by a sportcoat and an open collar. Today he'll show up for interviews wearing a form-fitting T-shirt, tattered jeans, and a belt buckle adorned with a skull.

tidal wave of fans — a near-capacity crowd of 16,431 — filed in. This wasn't boxing, where only the die-hards condescended to watch the preliminary bouts. Before the first fight, most of the seats were filled. The real UFC tribalists were easy to spot, with their abundant pierces and tats, their UFC hoodies, and their angry T-shirts. ("You Say Tomato, I Say Fuck You." "Exercise Your Demons.") But there were just as many young, professional-looking guys in their go-out shirts and designer jeans. There were siliconistas whose breasts could be measured not in inches but in quarts. There were blacks and whites and Hispanics and, no doubt because of Silva's appearance on the card, a knot of crazy-loud Brazilians. Based on a quick inventory of the license plates in the parking garage, the fans came from all over the Midwest. The tickets weren't cheap, ranging from $50 to $400, but the crowd was as diverse as any audience you'd find at an NBA or NFL game.

The fighters, too, were remarkably varied, ranging in age from twenty-one to thirty-seven. There were, as usual, a few local boys on the card. But aside from three Ohioans, the event resembled a model United Nations. In addition to Silva, the slate of fighters included a Japanese refugee (Yushin Okami), a black Frenchman (Cheick Kongo), an Italian (Alessio Sakara), a Swede who trained in Brazil (David Bielkheden), and a former U.S. Olympic wrestler (Dan Henderson, Silva's opponent). There were three alums of the first season of *The Ultimate Fighter* (the impish Chris Leben, the wacky Diego Sanchez, and the swaggering Josh Koscheck), each of whom would win his fight.

The diversity extended to the fighters' bodies as well. Sure, UFC fighters shared some physical traits: skin stained with tattoo ink,* protruding muscles, gargantuan thighs, short, unpullable hair or simply a clean-shaven head. Like human NASCAR-mobiles, they wear shorts slathered with all manner of sponsor patches, another source of revenue. (Leben's patch for Condomdepot.net was particularly memorable.) But their body types offered variety, from the fat-free 155-pound whip Jorge Gurgel to the rangy Jon Fitch to Heath Herring, a burly Texan who looked like a beef-fed lineman right out of *Friday Night*

*Theory: because fighters wear neither uniforms nor shoes, tattoos have become almost a fashion accessory to them.

Lights. In short, inasmuch as the Octagon is a sort of terrarium, it contains a broad range of species.

Rounding out this menagerie was Luke "the Silent Assassin" Cummo, far and away the most, um, unique fighter I would meet. A former cab driver, Cummo discovered mixed martial arts while living on Long Island and became a protégé of Matt Serra. As Cummo ascended the MMA ladder, appearing on *The Ultimate Fighter* and eventually earning a four-fight UFC contract, he gave up nothing to convention. When I first met him at a UFC fight in Houston, Cummo explained that he ate only "life food for a sustainable future," a diet that excluded beans, grains, and all animal products. A typical meal was a bowl of soup containing onions, garlic, buckwheat,* and sunflower seeds.

When Cummo won his fight that night in Houston, at UFC 69, and was interviewed in the Octagon by Joe Rogan, he blurted out, "All politicians are puppets, and the only way to make a difference in the world is the way you live your life!" This didn't play too well in the heart of Texas, the epicenter of Bush Country, and Cummo left the stage to boos. Curiously, when UFC reps handed reporters a sheet of Cummo's postfight quotes, there was no mention of corrupt politicians. Cummo's remarks were condensed and distilled to the following verbal pabulum: "Even though I got the win there is always room for improvement. I got taken down so I need to work on my defense . . . I'm now going to hit the gym and prepare for my challenge here in the UFC."

In Ohio, I saw Cummo outside his locker room and remarked that he looked decidedly smaller than his opponent, Luigi Fioravanti, a veteran of the Iraq War. Perhaps that was because while Fioravanti was adding body mass — gulping water and gorging himself following the weigh-in — Cummo had had nothing to eat all day. Not only that: without a trace of self-consciousness Cummo explained that he had "purified" himself by practicing "urine recycling." Come again? "I drink my own urine. I had my last meal last night, and then I continually drink my urine. Eventually when I poop — you know, when I do number two — all that comes out is urine. Then I know my digestive system is completely empty. At first I used to put some honey in it, heat it up

*Not a grain but a fruit.

and drink it like a tea. But now I just drink it fresh. That's when it's most delicious." Okay.

There is a certain sense of ritual to a UFC card. At 8 P.M. sharp, the lights go down. The fans perk up. The slick presentation begins. Fighter A comes out to a suitably upbeat, pulsating number, something on the order of Rage Against the Machine's "Killing in the Name Of" or the White Stripes' "Seven Nation Army."* As he makes his way to the cage, the fighter slaps hands with fans leaning over the rails. The place is illuminated by a blitz of camera-phone flashes. Once at the cage, the fighter hugs his entourage, adding to the sense that he's a warrior going off to battle. As he gets a last check and greasing from the ringside doctor, the entourage hangs a sponsor's banner from the cage, advertising anything from a car dealership to a brand of nutritional supplement.

This exercise always struck me as somewhat amateurish, not unlike a minor league baseball stadium that has outfield signage for Pearlman's Ale House or Verona's Used Cars. But given that fighters can double their salary with these endorsements, easing the pressure on promoters to raise purses — for the previous UFC show, Frank Mir was supposedly paid $100,000 by a single sponsor — it's not hard to see why the UFC permits this bit of crass commercialism.†

Fighter B then goes through the same drill. He leaves a shared dressing room — only the belt holder, in this case Silva, gets his own backstage suite — jogs through a tunnel, and enters the arena. Between rounds, the Octagon Girls™ orbit the cage and wave to the crowd, wearing little more than plasticized smiles and navel rings. During the fight they sit a few feet back of the cage, swaddled in official UFC robes, sometimes fiddling with their PDAs when the fights don't captivate them.

But the predictability ends once the fights start. Each takes on a unique rhythm. On this night, some were all-out slugfests. Competing for the $60,000 Fight-of-the-Night bonus, the combatants launched haymakers, trying to scramble the other guy's internal wiring. On the

*On this night, Sakara, the Italian, won the award for Most Creative Entrance Song when he selected the theme music from *Phantom of the Opera*.

†The UFC's sponsor policy, in fact, is a hot topic. Not unlike the NFL or NASCAR, the UFC athletes — or their managers, anyway — contend they could make a ton more money if the conflicts policy weren't so restrictive.

Columbus card, Koscheck won with a devastating kick to his oppo-
nent's temple. Leben brawled and ate a buffet of punches before catch-
ing Sakara and dramatically winning by TKO. Okami broke his hand
during the fight but ended up winning by knockout when he landed a
vicious Muay Thai knee to the face of his opponent, Evan Tanner.

Others were more technical affairs, including Cummo's loss by de-
cision to Fioravanti. (Cummo, not surprisingly, looked significantly
outweighed and low on energy.) Still others were just weird. Herring
and Kongo, two heavyweights weighing more than 500 pounds be-
tween them, spent most of their fight tangled on the ground in bizarre
yogalike configurations, sometimes suspended upside down like bats.
At one point Herring disengaged a limb and began kneeing Kongo in
the ribs and obliques. Owing mostly to this odd attack, Herring won,
unexpectedly, by decision.

Every fighter, it should be noted, left the Octagon under his own
power, many losers jogging back to the lockers as if they had done noth-
ing more physically taxing than dropping a postcard in a mailbox.
Overall, there were few mismatches and no instances of fighters simply
bloating their records against "bums of the month," as they say in box-
ing. Even the most knowledgeable insiders confess they rarely bat over
.500 when asked to predict the outcome of fights. This parity is electri-
fying for the fans. In truth, the fighters love it too. They may not get
through a year without at least one loss, but they fight the best competi-
tion. Randy Couture put it to me this way: "You do this sport for the
challenge. And there's no challenge when you know you're gonna win in
advance."

While I was researching this book, folks unfamiliar with the UFC
frequently asked me the same question. Acknowledging that the UFC
was popular, they still wondered whether it was just a wacky, campy fad.
In a few years, would we be talking about Ultimate Fighting the same
way we now speak of roller derby or *American Gladiators* (the original,
not the ironic comeback version) or the XFL, Vince McMahon's ill-
fated pro football league? It was a valid question, but the answer I gave
was an unequivocal no. In part it's because the UFC has penetrated
mainstream sports, and thus mainstream culture, in a way that goes
well beyond a fleeting trend. But it's also because the action is, almost
without fail, so gloriously real and compelling. You can love the UFC or

you can hate it. But you cannot doubt that it is intensely real. Had the skeptics and protectionists been in Columbus that Saturday, they would have understood this.

Maybe an hour before the fights, I walked alongside the Octagon and spoke with Joe Silva, the UFC's matchmaker. Though he doesn't cut much of a public figure, Silva deserves heaps of credit for the UFC's rise. From his base in Richmond, Virginia, he watches countless prospects, live and on tape, in cages and in rings. He is largely responsible for selecting the 250-plus fighters the UFC has under contract and pairing them up for the organization's twenty or so cards a year. The job is loaded with potential conflicts. Yet as far as I can tell, the next person to speak badly of Silva will be the first. He's not a bombastic talker or a hulking physical presence, but he's widely respected in the Republic of MMA. He has a hell of a tough job, and he does it well.

As we talked, Silva made some interesting observations. We were speaking casually, but I asked whether I could quote him on the record. He grew visibly uncomfortable and said he'd be happy to, but first I needed to get clearance from the UFC's public relations staff. This struck me as odd. I've interviewed countless athletes and sports executives in every major sport, and they've always decided for themselves whether they were comfortable being quoted. Not wanting to put Silva in an awkward position, I did as I was told. When I asked a UFC publicist if she could deputize Silva to speak with me, I got a cold response: "Don't talk to Joe Silva."

Excuse me?

"Don't talk to Joe Silva. He's not a source. Only Dana White speaks on behalf of the company."

But I'm not asking Silva to speak on behalf of anyone but himself. "How did he get into this? What does he look for in a UFC fighter? What makes a good fight?" *That kind of thing.*

"Don't talk to Joe."

I just want to be sure we're not misunderstanding each other.

"Don't. Talk. To. Joe."

Fearful of getting my press credentials yanked, I walked away, agreeing not to speak to Joe Silva.

I recount this awkward exchange not to call out the public rela-
tions employee who, no doubt, was simply following the orders of her
superiors. I bring it up because, on a small level, it highlights the real
tension the UFC will continue to confront. Put simply, the organization
wants it both ways. It wants to be "bigger than the NFL and soccer"
(Dana White's words), and it wants to go on luring the largest sports
marketers and placing more of its athletes on Letterman's couch and the
cover of *Sports Illustrated*. Yet it wants to remain a tightly controlled,
privately held company, free from scrutiny or unflattering coverage.*

Days before the Columbus card, CBS announced that it had
reached a deal to broadcast MMA fights on Saturday nights in prime
time. This was stunning news. The sport that U.S. senators had been
lobbying to ban not long ago was going to be aired, not on pay-per-
view, not on cable, but on network television — the same network that
employed Edward R. Murrow and Dan Rather and airs *60 Minutes*. By
all rights, the deal should have been with the UFC, the preeminent
league. Instead the contract went to its rival, EliteXC.

A source close to the deal says that Dana White was unwilling to
give up control of production or let the network use its own commenta-
tors, who, as objective journalists, might be critical of the product.
What would happen when a cameraman zoomed in on a fighter's grue-
some injury, or when the network had breaking news about, say, a
fighter failing a drug test? This scenario mirrored the talks between the
UFC and HBO months earlier. Those discussions, too, broke down over
White's refusal to share the steering wheel. White says that as much as
he respects CBS president Leslie Moonves, "I'm not going to make a
deal that doesn't make sense." Fair enough. But the fact remains: the
competing league was able to make a deal that could represent a major
breakthrough.

The same tension exists with respect to media coverage. The UFC
wants coverage, of course, but only if it's favorable. When I covered my
first UFC fight, I was surprised by how few online journalists were sit-
ting in the press row. Wasn't this the sport that *lived* on the web while

*It's worth pointing out that this isn't unique to the UFC. For instance, NASCAR went
through the same dilemma when it exploded in popularity. The latter organization came to
the unhappy conclusion that criticism and scrutiny are byproducts of growth.

the mainstream media stayed away? I came to learn that when some on-line journalists had written something uncharitable about the UFC, they were thereafter denied press credentials to events. Many such journalists — including some of the most prominent and respected voices — often traveled to events, interviewed the fighters in hotel lobbies and diners, and watched the card from their hotel rooms on pay-per-view.

Zuffa, as a privately held company, keeps its financial information secret. Most fighters have independent employee contracts with the UFC — in many ways a brilliant setup that enables the organization to make matches without haggling with managers and cut fighters who perform disappointingly. Traditionally, fighters are paid a base amount per fight, which doubles if they win. For example, in Columbus, according to the Ohio Athletic Commission filings, Silva's contract entitled him to $70,000, with a $70,000 win bonus. Koscheck had a $20,000/$20,000 deal. On the low end, the loser of the first fight, an Iowan named John Halverson, made only $3,000.

As the sport grew and the pay-per-view buys exploded,* the fighters, predictably, grew resentful of their contracts. Some quick math suggests that when 16,000 fans buy tickets to an event, and a few hundred thousand more buy pay-per-views, broadcast for $50 a pop, and the top draw is making only $70,000 as a base, the promoter is cleaning up. A particularly striking example: in 2007, Keith Jardine clocked Chuck Liddell in the main event of a card that generated hundreds of thousands of pay-per-view buys. Jardine's purse was $14,000.†

White's Band-Aid solution has been to boost the various "bonuses" awarded to fighters for "Submission of the Night," "Knockout of the Night," and "Fight of the Night." With White making the final determination, combatants can earn as much as $60,000 in supplemental fees. There are other "spot bonuses" as well: the Canadian fighter Georges St. Pierre reportedly received $500,000 and a Hummer when he defeated Matt Hughes at UFC 65. But if such riches appease a few stars and lucky winners, the subjectively determined payouts only fuel the conspiracy theorists.

*According to *Forbes*, the UFC did 145,000 pay-per-view buys in 2001; in 2007 they racked up more than 5.1 million buys.

†The UFC contends that the test of a fighter's worth is how many tickets or PPV buys he generates. At the time, Jardine was not a big draw.

White has a set speech he gives fighters and managers when they complain about money. He repeated it to me: "If you do your job and take care of business, money is going to fall on your fucking head. Chuck Liddell never, ever talked to me about money. It was 'When am I fighting? Who am I fighting? I'll fight anyone who fucking wants, anytime, anywhere. Let's do this now.' Now Chuck doesn't have enough time in the day to grab all the fucking money people are throwing at him. And he doesn't have some douchebag walking around him saying, 'You should have this, you should get that.' Just do what you have to do, and the money is going to fall on your head."

He delivers this with almost evangelical passion. But not everyone's buying. One manager — unwilling to give his name for fear of retaliation — noted that it's easy for White to be cavalier about money when he probably had a 10 percent stake in a company valued at somewhere between $500 million and $1 billion dollars. In the fall of 2007, Randy Couture, at the time the sport's Zeus figure, walked away from the UFC because of a financial dispute.* Never one to back down from a fight, White called a press conference to refute Couture's claims. When Couture lent his name to a team in the competing IFL, the UFC claimed he had breached a noncompete clause in his contract. The day before the Columbus card, a Nevada court enjoined Couture from allowing the use of his name by the IFL fight team. All told, it was an ugly, petty, mutually destructive feud that — and White will hate hearing this — recalled the boxing business.

Fighters such as Couture who run afoul of the UFC can expect some form of excommunication. Former champs who have bitterly parted with the organization have seen their photos and profiles deleted from the UFC website. It's as if the NBA were to say: *We hate Kobe Bryant. We're going to act as though his MVP season never happened.* White makes no apologies for his hardball tactics. "It's a war," he says of the competing organizations trying to siphon the UFC's market share. "And in a war there's gonna be some casualties. Whether you're a fighter or an employee, you need to pick sides."

White, to his credit, is quick to admit that his pugnacious nature is

*In September 2008, Couture abruptly reversed course and announced that he would return from exile and once again compete in the UFC — another example of the plot twists endemic to the sport.

both his greatest strength and his greatest weakness. It's the reason the UFC is where it is, and it's also the reason so many are eager to see it fall. But White isn't changing his ways. "I don't want to sound like a cocky fucking idiot, but no one knows this sport like I do, and I will not be led off the path no matter what happens. I will not fuck this up . . . I love to fucking fight. Love to compete. Love to win. Anyone who has a desire to win jumps out of bed every morning ready to kick some ass. All the negative shit? That's what gets me out of bed. If you're cruising, that gets boring quick. The adversity is what makes life fun."

And there, in a nutshell, you have Dana White.

A year or so into this project, I was asked on a radio show whether my respect for Dana White and the UFC had declined after spending that much time examining the sport. It was a typically loaded question — I was clearly supposed to join the chorus, ripping the organization and its tyrannical leader. I replied that, if anything, my respect had grown. The Phoenixlike revival of the UFC is a tremendous business success story and, love him or hate him, there's no denying that White led the resurgence. By the same token, in the course of researching this book, I was often left thinking: can an organism continue to grow if it doesn't always expose itself to light?

The UFC card before the one in Columbus was headlined by Brock Lesnar, a monstrous Minnesotan who had won the NCAA wrestling title and become a star professional wrestler in the WWE. His MMA game, however, was still a work in progress, and this was put in boldface and italics by Frank Mir, the veteran heavyweight, who nearly broke Lesnar's femur during their fight.* A few weeks later, Kimbo Slice, the Florida fighter who gained sign-of-the-times notoriety after his street fights became a YouTube sensation, beat up ancient Tank Abbott in a disgraceful EliteXC mismatch.

If these fights were cases of style over substance, the UFC 82 headline bout was the opposite. The main event in Columbus featured Silva's belt defense against Dan Henderson. A former Olympic wrestler,

*Acknowledging that Lesnar needed some seasoning, the UFC announced that his next fight would be against Mark Coleman, the "early era" UFC champ, who was in his mid-forties.

Henderson, like his stablemate Randy Couture, made a second career in MMA. After just a few years in the sport, he was a PRIDE champion in Japan, in the 183-pound weight class. When the UFC purchased PRIDE in April 2007, Henderson returned to the States, and his match with Silva was seen as a unification of sorts between the reigning UFC middleweight and the best PRIDE fighter in a comparable weight class. In the months after the acquisition, PRIDE fighters were generally losing to their UFC counterparts, bolstering claims that the UFC had always been the preeminent league. And that theory got yet another squirt of fuel in Columbus.

It was already after midnight when this, the eleventh fight of the night, began. Henderson emerged first, to the classic rock standard "Lunatic Fringe." The crowd went nuts. A former U.S. Olympian who's thirty-seven years old, an obvious underdog, and, by all accounts, a cool, down-to-earth dude is going to be well received. Especially in central Ohio. Especially during the Arnold Classic. Especially when his opponent is a Brazilian who speaks Portuguese and has demolished Ohio's Rich Franklin in his previous UFC fight. By the time Silva entered the Octagon, the cheers of "USA USA USA" echoed through the arena.*

In the first round, Henderson stuck to his fight plan and used his superior wrestling skills to take Silva down and get a side-mount position. As he pinned the champion to the ground and elbowed him in the head until the round ended, the crowd roared approval. "Fuck him up for America," someone yelled from the stands.

This bit of assault and battery seemed only to make Silva angry. Unlike most of his countrymen, Silva is not a Brazilian jiu-jitsu specialist who added serviceable striking skills to his fight game. Quite the opposite. Lean and athletic, he's a nasty striker who can hold his own on the ground but would just as soon stay on his feet. He came out for the second round and gave a comprehensive MMA demonstration. Nicknamed "the Spider," Silva spun a brilliant web, luring Henderson into punches and kicks. Henderson would shoot and Silva would sprawl. Henderson would block a punch and Silva would crack him with a hard knee. Henderson would take down Silva, yet suddenly Silva would roll

*Silva's manager, Ed Soares, told me before the fight that Silva had recently applied for a green card. "Anderson knows that the United States is where it's happening for him. He's already more recognized in New York or Miami or L.A. than in Rio!"

and Henderson would find himself in the duck-and-cover position. Violent as the fighting was, there was something elegant about Silva's performance. Here was this alloy of strength, speed, skill, and, above all, agility. Watching the virtuoso moves, I scribbled the word "ballet" in my notes.

With fifteen seconds left in the round, Silva had gained back-control of Henderson and cinched his UFC gloves around Henderson's neck in a rear naked choke. In Henderson's corner, his Team Quest consorts, including Matt Lindland, yelled either "Aw, shit" or "Aw, fuck" in stereo. With eyes bulging from his head like a character in a comic book, Henderson tapped out. Silva stood on the Harley Davidson logo in the middle of the Octagon and celebrated. It's true, the plots change quickly in the UFC. Within two bouts, a fighter can go from ripe to rotten and back to ripe. Before the Columbus event, Silva was considered the best fighter in the UFC-osphere. After defeating Henderson, the label was beyond debate.

Those lucky enough to score press credentials get a bonus at UFC events, the equivalent of an outtakes segment on a DVD. The after-fight press conference is like no other postmortem in sports. The big winners in Columbus were trotted into a room and sat like experts on a panel, and White, naturally, stood in the middle, behind the podium, dominating the microphone. After giving a preamble — in this case he revealed that the gate for the fight was $2.2 million and announced that Silva had won $120,000 in compensatory bonuses for Fight of the Night and Submission of the Night — White opened the floor to questions.

Asked, through a Portuguese interpreter, if he considered himself, pound for pound, the best fighter in the world, Silva thought for a moment. In a high-pitched voice at odds with his toughness, he responded softly and modestly: "I still don't consider myself the best pound-for-pound fighter in the world. Maybe when I retire, I can look back and then say I was." Then White interjected: "It's Anderson. And all the knucklehead websites — you can hate me all you want, you can hate the UFC — but give the guy his due. He's it. Deal with it."

White was asked about EliteXC's deal with CBS.

"Everyone thinks the mixed-martial-arts market is so hot right now. Look, the UFC is hot. Every week it's a new — the IFL was gonna take us out last year, offering stock and all this other stuff to the fighters.

Some guys I have long-term relationships with left and went there. A year later it's gone. Now the big, scary Mark Cuban is coming in. Mark Cuban doesn't give a shit about mixed martial arts. Mark Cuban has dumped millions of dollars into HDNet and he wants subscribers. He'll build up subscribers and sell it to Comcast and get out . . . For eight years there's been a new three letters popping up, they buy a cage and suddenly they're in the business. We love this shit. This is what we do. We do this 24/7 and no one is going to beat us."

Why hasn't the UFC been able to cut a deal with mainstream television? "It's a lot of things. Creative control. I'm a dick. A lot of different things."

It was nearing 2 A.M. when the session finally broke up and UFC Nation headed to a makeshift postfight party near the downtown hotel. Five hours later, I was strolling through Port Columbus Airport when I saw Cheick Kongo, the unsuccessful heavyweight, on his way back to France. Even in street clothes, his eyes obscured by shades, Kongo was instantly recognized on the concourse. He gamely signed autographs and posed for pictures, appearing none the worse for having just spent fifteen minutes fighting inside a cage.

Offhandedly, I asked him how his side was feeling. "Side?" he said, puzzled.

I reminded him that just a few hours earlier a 250-pound Texan was repeatedly drilling him in the kidney with his knees.

"Really?" Kongo said, genuinely surprised. When I tried my best to mimic Herring's flying knee thrusts, Kongo professed ignorance. "He did that?"

The next day, I looked forward to reading the recaps of UFC 82. The blogs and boards and websites were filled with reactions and analyses and video snippets of the postfight press conference. Oddly, the *New York Times* I was reading — purportedly the country's newspaper of record — didn't print a single mention of the card. No write-up of Anderson Silva's command performance. No mention of an event that drew 16,000 fans and as many as 500,000 pay-per-view buys, that served as the capstone to Arnold Schwarzenegger's health-and-fitness trade show. No results in agate type. No nothing.

Then I turned to the business section. A column discussed the fact that the season's *American Idol* debut had outdrawn the recent Academy Awards broadcast. Buried in the piece, the writer noted: "A network-confected competition starring people named Ramiele Malubay and Robbie Carrico trumped a show with eight decades of history and stars like George Clooney and Cate Blanchett for the ultimate achievement in entertainment? That's the Hollywood equivalent of an Ultimate Fighting Championship outdrawing the Super Bowl (just wait, that's coming, too)."

Hey, I thought, at least *someone* over there gets it.

A few weeks after UFC 82 in Ohio, I caught up with Pat Miletich at an International Fight League card in New Jersey. Because New York is one of the few states yet to sanction mixed martial arts,* the league holds its New York–area events on the other side of the Hudson River, at the Izod Center, an indoor arena across a swamp from Giants Stadium.

It had been a rough year for the IFL. The company's stock price, soaring above $15 a share a year earlier, was now worth less than a dime. According to public filings, the IFL's losses from the previous fiscal year were nearly $10 million. There were rumors that the league would soon be out of cash.

In the fiercely individual sport of MMA, the franchise concept of the IFL never caught on — you might say there was no team in "I" — and the league had recently re-formed itself. Instead of pitting New York against Chicago, for example, it now pitted one fight camp against another. On this night, the Miletich Fighting Systems camp was taking on opponents from American Top Team. Fighters from Renzo Gracie's New York Academy took on counterparts from Midwest Combat in Chicago. There were also representatives from Randy Couture's Xtreme Couture gym in Las Vegas.†

*Though MMA's status may have changed by the time you read this.

†Because of his noncompete dispute with the UFC, Couture's camp was renamed Team Tompkins. Looking remarkably fit and trim for a forty-four-year-old man who hadn't fought in months, Couture was at the event, but the IFL did not advertise his presence in the arena. Don't ask.

Miletich was on hand to coach and corner three of his fighters. Their backgrounds spoke volumes about the diversity of his Iowa gym and the diversity of MMA in general. L. C. Davis, a fleet-footed, soft-spoken African American, was fighting as a featherweight. Davis had hurt his foot in training, but after "praying about it," he took the fight anyway. "That," he said, "and I needed the money." Mike Ciesnolevicz, a burly former college wrestling star from central Pennsylvania, fought as a light heavyweight. And Jesse Lennox, a typical Iowa tough-guy wrestler who resembled a young Pat Miletich,* fought as a welterweight.

With twenty IFL fighters on the card, the combatants had to share locker rooms. The pregame scene in most sports is usually light and lively: towel-snapping players tearing through a buffet table and huddling together before taking the field or court. This contrasts with the prefight tableau in combat sports, which is intense. Fighters bundled in sweats, headphones wrapped on their ears, go through a quick physical with the docs from the state's Athletic Control Board. Then they retreat to get their hands taped and muscles stretched. Some try to meditate. Others fiddle with their phones. Still others shadowbox and pantomime jiu-jitsu moves on the ground. They resemble travelers delayed at the airport, filled with tension and anxiety, killing time until they finally leave the boarding area and get on with their lives.

Miletich and his fighters shared dressing room 4 with Randy Couture's team. At one point, Miletich attempted to lighten the mood. Couture had fallen asleep on the floor, his mouth agape. Miletich grabbed his Treo hand-held, snapped a photo, and announced, "I'm going to put this on my MySpace page. The caption's gonna be 'This is what happened when I hit Randy.'" Everyone laughed. And then went back to stressing out.

Davis was the first Miletich fighter to get into the ring. Trotting through fog generated by a machine, he stared straight ahead like a man who had forgotten how to blink. Miletich followed, wearing a ballcap and a shirt bearing the name of a sponsor, Muscle Milk. As Davis fought a Brazilian jiu-jitsu expert, Rafael Dias, Miletich kept up a running

*Lennox wrestled at Kirkwood Community College in Cedar Rapids — where Miletich had made a cameo appearance as a student in the late 1980s — before fighting on one of Monte Cox's cards and being discovered as an MMA prospect.

stream of concise instructions, calmly but forcefully delivered. "Control that arm." "Watch that key lock." "Watch your position." "Rest your knuckles on his chin." "Head in center, head in the center." "Way to control but lift the underhook." "Watch the triangle." "Wide and low." "Get your guard back." "Movement, movement." "Don't let him circle out." "Work your knees."

Largely by obeying Miletich, Davis controlled the fight. Though Davis was a college wrestler "by trade," one wouldn't have guessed his background by watching the fight. He popped Dias with stinging jabs. He was sprawled on the ground. He was clearly the superior athlete. With seconds left in the fight, Davis and Dias stood in the center of the ring. Though neither fighter looked particularly tired, some fans expected them to clinch for the final few seconds and await the judges' decision.

Then it came, a maneuver that encapsulated everything exhilarating and repelling, beautiful and disgusting, about mixed martial arts. Davis hadn't thrown a single kick in the fight. In fact, he could scarcely recall having attempted a kick in his entire MMA career. But now, with just a few seconds to go, he took a running start and leaped at Dias with his left foot in the air. Dias was angling low, and Davis's shin caught him flush on the head. The sound of a man getting kicked in the head isn't nearly as benign as Hollywood would have us believe. It's not a hard smack but a squishy sound, a reminder that there's a lot of liquid and pulpy gunk surrounding that hard skull. Dias may or may not have been knocked out on impact. He certainly was unconscious when the back of his head collided violently with the canvas. From my seat a row behind the ring, I could see that his eyes had drifted back in his head. Tastelessly, Metallica's "Enter Sandman" boomed on the PA system.

From my trips to Iowa, I learned to lean in when talking to Davis. He was that reserved. But now his shy nature was hopelessly over-matched by his adrenaline. He preened on the ropes and thumped his chest to the crowd, a gesture of self-love. He calmed down only when he looked over and saw the EMTs frantically attending to Dias, the dude he'd just kicked. Unconscious and immobilized, Dias was put on a stretcher and taken to Hackensack Hospital. An hour after the fight ended, Davis seemed almost embarrassed by the damage his 145-pound body had inflicted. "It feels great to win. But putting a guy in the hospi-

tal? That's never what you want to have happen." Thankfully, Dias didn't even suffer a concussion. He stayed the night, underwent some tests, and returned to Florida.

At the behest of the New Jersey commission, the fights could not continue until the ambulance used to transport Dias to the hospital returned to the arena. The emcee tried to entertain the crowd of five thousand or so with a T-shirt giveaway while Bas Rutten — the charismatic Dutch heavyweight who had left the UFC to become an IFL star — ad-libbed on television. Maybe two hours after Davis's harrowing fight, the second Miletich protégé, Lennox, entered the ring against another jiu-jitsu expert, from Top Team in Florida. Lennox dominated the first round with superior punching. The second round offered more of the same — until Lennox let out a keening scream and fell flat on his back. It was a classic what-the-fuck-just-happened? MMA moment. A replay showed Lennox getting caught in a viselike jiu-jitsu knee bar. His knee had been hyperextended, and he immediately submitted. It might as well have been a commercial for the damaging power of jiu-jitsu.

Lennox had barely finished limping dejectedly to the dressing room when Ciesnolevicz, the third Miletich fighter, ducked under the ropes. Before either man could mount an attack, he and his opponent, Carmelo Marrero, butted heads. The impact opened a gash on Marrero's head, and soon both fighters were covered in blood. We're talking *covered* — chest, face, legs. It was like Blue Man Group, only in crimson. They continued the battle as if nothing out of the ordinary was occurring. Between rounds, when the ring doctor examined Marrero, he deemed the cut too severe. The fight was declared a no-contest. Both Marrero and Ciesnolevicz were furious. They wanted to keep going. They had trained for weeks for this and wanted a decisive result, one way or the other.

Back in the dressing room, as Ciesnolevicz washed off his blood in a small shower stall, Miletich was philosophical about what had transpired. One of his fighters had won with a concussive kick. One had lost by virtue of a brilliant and sneaky knee bar. One had been coated in plasma. So it goes in mixed martial arts.

Later, as Miletich walked on the concourse, he was spotted by Patte and Todd Smith. A fit-looking New Jersey couple in their early forties, the Smiths had discovered the UFC in the mid-nineties and often

watched the pay-per-views. Here they were on a Friday night, their three kids in tow, taking in the IFL show the way other clans might have family movie night.

To them, Miletich was a celebrity. Patte asked him to pose with her for a picture. The Smiths' older daughter asked for an autograph. Todd Smith looked at Miletich and smiled. He didn't have time to explain it all. How he and his wife had admired Miletich as a fighter. How their fondness for MMA had led them to enroll their kids in judo and wrestling classes. How they had witnessed the explosive growth of MMA and felt a sort of pride of ownership. How they appreciated how far the sport had come, how far it was going to go, and Miletich's role in the revolution. Todd simply stuck out his hand.

"Thanks, Pat," he said. "Thanks for everything, man."

POSTSCRIPT

In December 2008, Pat Miletich let his retirement lapse and accepted an offer to headline an Adrenaline mixed-martial-arts card. It was like old times. Monte Cox promoted the show, which featured various Miletich fighters on the undercard and was held in Moline, Illinois, across the river from Bettendorf. The difference was that this fight was held in no minor league baseball stadium or church basement but at the i wireless Center, which seats twelve thousand. The event was also available for purchase on HDNet. In the locker room before the fight, Miletich had a brief conversation with himself: "I accomplished something just by getting back into the shape I am — win, lose, or draw." There would, though, be neither a loss nor a draw. Now in his early forties, he fired up something for the memory banks. In front of hundreds of friends and family members (including, yes, his mother) Miletich mauled his opponent, Thomas Denny, and won the fight with a nasty second-round knockout.

When it comes to fighters, one never says never. But if, in fact, this was Miletich's last fight, it was a hell of a way to wrap up a career. We should all be so productive on our last day of work.

GLOSSARY

Armbar: Any popular submission technique that isolates and then hyperextends the elbow.

Brazilian jiu-jitsu (BJJ): The form of jiu-jitsu most relevant to mixed martial arts. This form of ground fighting is based on submission and grappling.

Choke: A hold that usually involves applying pressure to the carotid artery, impeding the flow of oxygen to the brain.

Fishhook: Banned in the UFC, this move entails prying apart an opponent's mouth or nostrils with the fingers.

Gi: A traditional Japanese martial arts uniform.

Ground and pound: A technique whereby a fighter takes down an opponent, mounts him, and delivers repeated strikes from close range.

Guard: In the guard position, a fighter wraps his legs around an opponent to gain control. In a closed guard, a fighter locks his legs around the opponent. In an open guard, the feet are unlocked.

Guillotine choke: A choke that is usually applied while standing, when an attacker attempts a takedown and the defender is able to grip the neck.

Heel hook: A leg lock that puts pressure on the knee and ankle joint.

Kimura: A shoulder lock that puts pressure on the shoulder joint.

Knee bar: A submission hold that hyperextends the leg at the knee.

MMA: Mixed martial arts. The generic term for the sport of which the UFC is the dominant brand.

Mount position: A dominant position whereby a fighter straddles his opponent on the ground.

Muay Thai: A form of Thai boxing, the style includes kicks and the strategic use of elbows and knees.

NHB: No-holds-barred, a precursor to the more refined-sounding MMA.

Rear naked choke: A choke executed from behind, once a fighter has "taken" his opponent's back.

Side mount: A position achieved when one fighter is perpendicular to his opponent.

Tapping out: Submitting or surrendering. When a fighter wants to give up, he taps the mat or the opponent's body.

Triangle choke: A popular choke executed with the legs.

ULTIMATE FIGHTING CHAMPIONSHIP RULES

As Approved by the Nevada State Athletic Commission, July 23, 2001

Weight classes:

> Lightweight — over 145 lbs. to 155 lbs.
> Welterweight — over 155 lbs. to 170 lbs.
> Middleweight — over 170 lbs. to 185 lbs.
> Light Heavyweight — over 185 lbs. to 205 lbs.
> Heavyweight — over 205 lbs. to 265 lbs.

Bout duration: All non-championship bouts shall be three rounds. All championship bouts shall be five rounds. Rounds will be five minutes in duration. A one-minute rest period will occur between each round.

Fouls:

1. Butting with the head.
2. Eye gouging of any kind.
3. Biting.
4. Hair pulling.
5. Fish hooking.
6. Groin attacks of any kind.
7. Putting a finger into any orifice or into any cut or laceration on an opponent.
8. Small joint manipulation.

9. Striking to the spine or the back of the head.
10. Striking downward using the point of the elbow.
11. Throat strikes of any kind, including, without limitation, grabbing the trachea.
12. Clawing, pinching or twisting the flesh.
13. Grabbing the clavicle.
14. Kicking the head of a grounded opponent.
15. Kneeing the head of a grounded opponent.
16. Stomping a grounded opponent.
17. Kicking to the kidney with the heel.
18. Spiking an opponent to the canvas on his head or neck.
19. Throwing an opponent out of the ring or fenced area.
20. Holding the shorts or gloves of an opponent.
21. Spitting at an opponent.
22. Engaging in an unsportsmanlike conduct that causes an injury to an opponent.
23. Holding the ropes or the fence.
24. Using abusive language in the ring or fenced area.
25. Attacking an opponent on or during the break.
26. Attacking an opponent who is under the care of the referee.
27. Attacking an opponent after the bell has sounded the end of the period of unarmed combat.
28. Flagrantly disregarding the instructions of the referee.
29. Timidity, including, without limitation, avoiding contact with an opponent, intentionally or consistently dropping the mouthpiece or faking an injury.
30. Interference by the corner.
31. Throwing in the towel during competition.

Ways to Win:

1. Submission by: Physical tap out or verbal tap out.
2. Technical knockout by the referee stopping the contest.
3. Decision via the scorecards, including: Unanimous decision [all judges pick the same fighter as the winner]. Split decision [one judge picks one fighter, the other two judges pick the other fighter]. Majority decision [two of three judges pick the same fighter as the

winner]. Draw, including: Unanimous draw, Majority draw, Split draw.

4. Technical decision.
5. Technical draw.
6. Disqualification.
7. Forfeit.
8. No contest.

Referee may Restart the round: If the fighters reach a stalemate and do not work to improve position or finish.

ACKNOWLEDGMENTS

ON A DISGUSTINGLY HOT August day, midway through researching this book, I made plans to meet up with Pat Miletich in New Jersey. The International Fight League team he was coaching was competing in an event held in that state. The previous night, I'd gotten a call from Eddie Goldman, a classic New Yorker whose knowledge of all combat sports is without parallel. Eddie suffers from four different eye diseases and is unable to drive. Could I give him a lift to the IFL show?

I picked Eddie up in Manhattan at the appointed time, and he asked if I had room in the car for his friend. Sure. Five minutes later, a dignified, attractive African-American woman approached. She introduced herself as Malaak. The Lincoln Tunnel was choked with traffic and, as we idled, we talked about mixed martial arts, the rise of the UFC, the deterioration of boxing. Occasionally Malaak's cell phone would chirp, to the theme song from *Hawaii Five-O*. Soon she'd be back, knowledgeably and passionately discussing the reign of Dana White, the IFL's prospects for survival, and the virtues of learning jiujitsu from a real Brazilian.

At one point Malaak casually noted that her father was a believer in martial arts. Eddie interjected, "He said, 'All Negroes should learn judo and karate.'" Puzzled, I asked Malaak if her father had been a fighter. "You could say that," said Eddie. He then let me in on the joke, explaining that Malaak's father was Malcolm X.

Suddenly I felt like I was having one of those bizarre dreams in which former presidents are playing billiards against habanero peppers. How did I end up driving to a mixed-martial-arts show with the inimi-

table Eddie Goldman riding shotgun and Malcolm X's daughter in the back seat?

But when I thought about it, it occurred to me that this unlikely tableau said an awful lot about the broad appeal and legitimacy of mixed martial arts. Clearly, MMA was no longer relegated to the underground. A thirty-something magazine writer, a forty-something daughter of a renowned black activist, and a fifty-something Jewish fight fan were crossing state lines to attend an event at the Izod Center, a venue Beyoncé was going to play the following night. We'd be watching Brazilian jiu-jitsu specialists, former All-American college wrestlers, Japanese strikers. I suspect that, fifteen years earlier, when Pat Miletich was beaded in sweat in an Iowa martial arts studio, pondering a career in this weird, exhilarating renegade sport, he'd never have pictured this.

Just as you'd be hard-pressed to come up with a more solitary activity than fighting in a cage, you'd be similarly challenged to come up with an activity more collaborative than writing a nonfiction book. I relied on the information and recollections of too many people to name here. But why not try at least a partial list?

Lori Allison, Bruce Beck, Jason Black, Mikey Burnett, Jim Byrne, Shonie Carter, Dr. Carlon Colker, Randy Couture, Luke Cummo, L. C. Davis, Brian Diamond, Fedor Emelianenko, Dave Epstein, Joe Favorito, Rich Franklin, Eddie Goldman, Dr. Margaret Goodman, Renzo Gracie, Rorion Gracie, Salil Gulati, Mark Hanssen, Jeremy Horn, Chris Horodecki, Roger Huerta, Loretta Hunt, Brad Imes, Rampage Jackson, Joe Jordan, Robbie Lawlor, Gene Lebell, Chuck Liddell, Matt Lindland, Rory Markham, John McCarthy, Ryan McGivern, Dave Meltzer, Dave Menne, Bob Meyrowitz, Jerry Milani, Jane Miletich, John Miletich, Lyne Miletich, Mona Miletich, Tito Ortiz, Alvino Peña, John Perretti, Jens Pulver, Gideon Ray, Joe Rogan, Perry Rogers, Ben Rothwell, Steve Rusk, Dave Schwartz, Matt Serra, Frank Shamrock, Sam Sheridan, Tim Sylvia, Jennifer Wenk, and Dana White.

Special thanks to Monte Cox, my fellow Hoosier, who reshaped my image of a fight manager. Paul Thatcher, Mike Lebrecht, and Donovan Craig were terrifically generous in providing photography. Thanks to a

team of readers for improving this work beyond measure: Josh Gross, Rich O'Brien, Will Vincent, and Jeff Spielberger. A tap of the gloves to Jeff Pearlman, whose friendship and encouragement helped me when I was sucking air between rounds. Terry McDonell, Chris Hunt, and the other *Sports Illustrated* higher-ups were typically accommodating.

Though she knows no jiu-jitsu, my editor, Susan Canavan, repeatedly went to the mat for me and this unusual project, and I'll forever be grateful for that. Thanks, too, to her assistant, Elizabeth Lee. Larry Cooper again showed why he's considered the world's best pound-for-pound manuscript editor. My literary promoter, Scott Waxman, "got" this idea immediately and helped make it possible. Thanks too to Ellie, for her support, love, and absence of judgment when she caught me staring raptly at the TV as two men bled in a cage.

My deepest gratitude goes to Pat Miletich, who, without knowing me from Adam, agreed to share his story, his time, and his home with me. Throughout this project, I heard many people describe Pat with the same phrase: "He's a great guy." That hardly does him justice. While you'd never hear him make the claim, he deserves as much credit as anyone for the success of MMA. And I would say that even if he couldn't kick my ass from here to next week. Pat himself would like to thank "my mom, who believed in me when it all started; Collin Carney, who saved my team financially; and my wife, who puts up with me."

If you think you have what it takes to train with Pat Miletich, go to www.mfselite.com/index.html and, well, good luck.